Modern Art and
Modern Science

Modern Art and Modern Science

THE PARALLEL ANALYSIS OF VISION

Paul C. Vitz and Arnold B. Glimcher

PRAEGER SPECIAL STUDIES • PRAEGER SCIENTIFIC

New York • Philadelphia • Eastbourne, UK
Toronto • Hong Kong • Tokyo • Sydney

Library of Congress Cataloging in Publication Data

Vitz, Paul C., 1935–
 Modern art and modern science.

 Bibliography: p.
 Includes index.
 1. Art — Psychology. 2. Visual perception.
3. Art and science. I. Glimcher, Arnold B.
II. Title.
N71.V58 1983 701'.1'5 82-22256
ISBN 0-03-062466-5
ISBN 0-03-062467-3 (pbk.)

Published in 1984 by Praeger Publishers
CBS Educational and Professional Publishing
a Division of CBS Inc.
521 Fifth Avenue, New York, New York 10175 U.S.A.

©1984 by Praeger Publishers

456789 052 98765432
Printed in the United States of America

For my Mother

Paul C. Vitz

For H.L.

Arnold B. Glimcher

Acknowledgments

We are indebted to many people and institutions for their contributions to this project. Dr. Edgar Coons, Professor of Psychology at New York University, was instrumental in getting the two of us together in the fall of 1973 and in encouraging our collaboration. He has been an important friend throughout.

Several visual scientists have been helpful in reading early drafts of the manuscript and in giving needed corrections and suggestions. In particular, we would like to thank Dr. Lloyd Kaufman, Professor of Psychology at NYU; Dr. Jacob Beck, Professor of Psychology at the University of Oregon; and Dr. Floyd Ratliff, Professor of Biophysics at Rockefeller University. Helpful comments also came from Dr. Julian Hochberg, Professor of Psychology at Columbia University, and Dr. Anthony Movshon, Associate Professor of Psychology at NYU.

Most especially we would like to express our indebtedness to George Zimmar, our editor. From the start his response has been a perfect mixture of enthusiasm and critical help; he was throughout a rock of professional support.

Because of the large number of images, the editing, layout, and production of this book proved to be unusually complex. However, we were most fortunate to have Marie Donovan and Gordon Powell as production editors. Their knowledge and persistent attention proved to be an indisensable, positive contribution.

We would also like to thank Susan Grace Galassi and Margi Conrads for their knowledge and criticism.

The financial contributions of certain foundations and organizations have been indispensable to this research. We are especially grateful to the W. P. Cohen Foundation, the Shalom Foundation, and one anonymous foundation.

We also very much appreciate the people and programs at New York University that provided support. A seminar at NYU on the subject of modern art and modern science taught by one of us (Paul C. Vitz) in fall 1981 contributed significantly. This course was sponsored by the Humanities Council of NYU. The council, headed by Mrs. Leslie Berlowitz, is supported by grants from the Andrew W. Mellon Foundation.

We would also like to thank Dr. Richard A. Turner, Dean of the School of Arts and Science, for his official help.

The gracious and thoughtful response of the library staffs at New York University's Institute of Fine Arts and its Department of Fine Arts was most appreciated.

Finally we would both like to acknowledge our debts to our wives, Timmie and Milly, who provided many positive suggestions and much other support.

Contents

ONE

The Problem

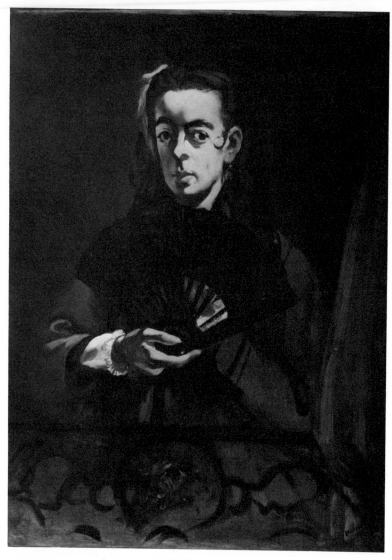

Fig. 1.1 Manet, *Angelina.* 1865

Modernist* art, despite its familiarity, continues to exist as a perplexing phenomenon inviting explanation. The distinctive characteristics, which account for much of its novelty and power, have been isolated by art historians over the last several decades. Although these characteristics will be familiar to many readers, it is essential at the outset to briefly describe them. Once this has been done, the question of the origin of these characteristics can be investigated.

Abstraction

Certainly the most notable characteristic of modernist art is its propensity toward abstraction. The series of paintings consisting of Figures 1.1-1.4 begins in the mid-nineteenth century and demonstrates the process of abstraction (reductionism) in historically successive treatments of the human

*The term "modernist" art is technically more precise than "modern" art, since the latter is too general, referring to any art of the modern period, including such non-modernist movements as the pre-Raphaelites, with their revival of medieval imagery, or the paintings of artists such as Gustav Klimt, and Andrew Wyeth. The expression modernist refers exclusively to the avant-garde artists of interest here. For most readers this is what the term modern art connotes and occasionally in the interest of linguistic variation the more familiar "modern" art has been used.

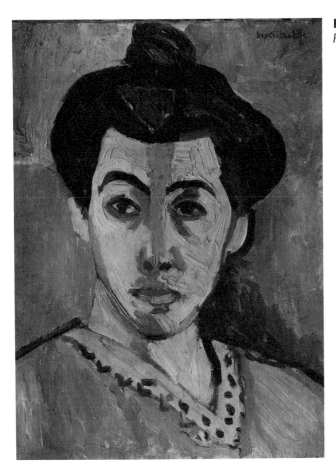

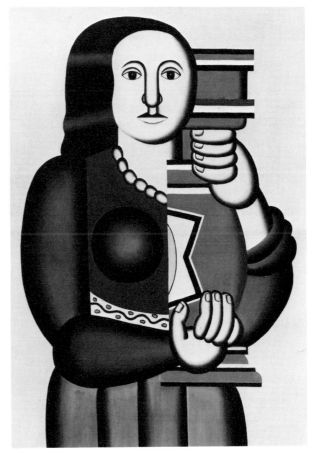

Fig. 1.2 Matisse, *Madame Matisse: Portrait with a Green Stripe.* 1905

Fig. 1.3 Léger, *Woman Holding a Vase.* 1927

Fig. 1.4 Jawlensky, *Large Meditation.* 1936

face by different artists. By the early twentieth century a common pattern was for the work of many important artists to change from an initial preoccupation with portraying recognizable scenes or images to a distinctive mature period of completely or almost completely abstract style. The works of Wassily Kandinsky, Robert Delaunay, Nicholas DeStael, Jackson Pollock, and Willem De Kooning show this development.

In some instances the process of abstraction can occur in an artist's treatment of a particular image. For example, Piet Mondrian produced a series of paintings of a tree that progresses over a few years from the simple image of a tree to an abstracted field of vertical and horizontal lines (see Figs. 1.5–1.7).

During the twentieth century in the modernist tradition, abstraction from reality and the removal of recognizable objects from paintings steadily progressed toward images containing such minimal information and lack of obvious visual incident as the black paintings of Ad Reinhardt (Fig. 7.88), the pencil grids of Agnes Martin (Fig. 7.43), the white textures of Robert Ryman (not shown), and the white translucent "walls" of nylon sheeting (scrim pieces) by Robert Irwin (Fig. 7.91). This extreme reduction or preoccupation with more elementary levels of perception was clearly

prefigured in Kasimir Malevich's suprematist composition, *White on White* (1915; see Fig. 6.23).

Flattening of Picture Plane

The elimination of perspective space, resulting in the "flattening" of the picture plane, has been the other most noticeable and integral tendency of modernism. The artist has not sought literal flatness, but recognition of the painting's surface as a major arena for artistic statement about space and depth; as a result, the manner in which an artist treats the painting's surface and in turn the canvas as a real object rather than an illusionistic "window" often becomes a distinctive stylistic feature. Barbara Rose has observed, in characterizing modernist art, "That art is illusion, and the revelation of the nature of this illusion—which in painting concerns the projection of a spatial dimension on a flat surface—are at the heart of the modernist consciousness of all the arts." Of course, even in the flattest paintings some illusionistic space still occurs. A Rothko does not offer the traditional perspective clues to the space within a painting, but its expansive areas of color do create an illusion of cloud-like atmospheric space.

Whether described as a "retreat from likeness" or "shattered

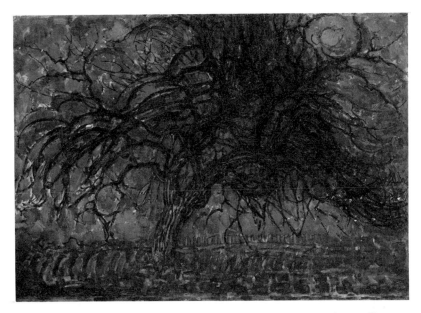

Fig. 1.5 Mondrian, *The Red Tree.* 1909–10

Fig. 1.6 Mondrian, *Tree.* ca. 191

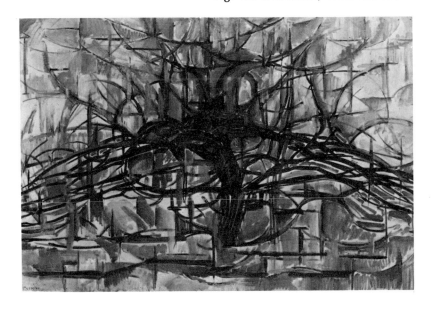

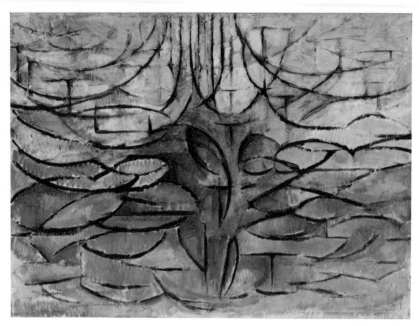

Fig. 1.7 Mondrian, *Flowering Appletree.* 1912

surfaces, broken color, segmented compositions, dissolving forms and shredded images," extreme abstraction and flattened space have become international phenomena to which the most energetic artists and critics have directed their talent and intelligence.

Theorizing Tendencies

A third prominent characteristic of modernist art has been its conscious preoccupation with its own historical accomplishments and particularly with theoretical interpretations of the different movements. The rise of this strong theoretical emphasis, alongside modern art, cannot be explained as the natural outgrowth of art criticism itself. Instead, the critics have analyzed, recognized, and articulated the theoretical contributions made by the artists themselves. The artist's visual statements have served as catalysts both for the production of art and for further critical interpretation. This theoretical significance is especially clear, for example, in Pablo Picasso's series of works about the paintings of Edouard Manet (*Déjeuner sur l'herbe*), Velasquez (*Las Meninas*), and Eugène Delacroix (*The Women of Algiers*). More recently, Roy Lichtenstein has produced works influenced by the achievements of Claude Monet, Picasso, and Fernand Léger.

When from the critic's perspective Hilton Kramer wrote "given the nature of our intellectual commerce with works of art, to lack a persuasive theory is to lack something crucial . . . the means by which our experience [of works of art] is joined to understanding of the values they signify," he did not mean that the artist needed overtly to acknowledge his theoretical objective, but rather that his unique perception is implied in the art that he produces. If a particular artist's perception is important it feeds back, often with the help of critics, into the stream from which it came and becomes part of an inextricable influence on the artists that follow. Indeed, the artists themselves have often provided much of the written theory needed to interpret their works. Thus the manifesto declaring and explaining the intent of a particular group of artists is a distinctive characteristic of modern movements, particularly in the twentieth century, although in the nineteenth century Delacroix, Seurat, and others also made significant statements.

But, it is not merely the artists and critics who have contributed to this development of theoretical formulations: scientists, for example, Chevreul, Helmholtz, and many others have also made major contributions. (The way in which this has happened will be a primary concern of subsequent chapters.) Certainly the growth of this theoretical inter-

pretation, from whatever perspective, is an extraordinary phenomenon that requires an understanding of why it developed and how it functioned for artists and their audiences.

Perceptual Character

The fourth characteristic of modern art has been what can be called its "perceptual" nature, that is, its involvement in what and how we "see." From the beginning, modernist art has suggested to sensitive observers that much of its significance is derived from the artist's new emphasis on purely perceptual phenomena, such as the use of color contrasts, ambiguities in figure-ground relationships, illusions, and other expressions of a profound and as yet vaguely sensed underlying perceptual logic. Indeed, the very name "Impressionism" announces this in describing perhaps the earliest modernist movement. The perceptual aspect has become increasingly obvious during the twentieth century and has established itself, along with general abstraction, as one of modern art's dominant properties.

The Thesis:
Brief Introduction

It will be argued here that the modern period of art is not inter-

pretable without an understanding of the powerful contributions of modern science, most especially the contributions of visual science.

Thus, we assume science as a conceptual framework within which to view the history of recent centuries. Certainly an attempt to understand the art of the Middle Ages would be impossible without an understanding of medieval theology. Likewise, the theology, as it were, of the past 150 years or so has been the conceptual framework provided by modern science.

In particular, each of the four distinctive features of modernist art already enumerated derive from and were nurtured by that special expression of modern science that has characterized the nineteenth and much of the twentieth century.

The claim of the significance of visual science—and of visual technology—for the understanding of modern art has in some respects already been made by others. For example, the profound and continuous impact of photography on the development of modern art has been convincingly demonstrated by Aaron Scharf (*Art and Photography*, 1968) and Van Deren Coke (*The Painter and the Photograph*, 1964, 1972). Yet one looks in vain for any real appreciation of this research in most of the standard introductions to modern art. (Apparently in some art history quarters there still remains a fear of photography—or photophobia.)

As for the effects of science, it is common to admit this influence in the case of Seurat, which can be credited to Seurat himself, who made his preoccupation with visual science fairly obvious, and to the outstanding book *Seurat and the Science of Painting* (1964), by William Innes Homer. Even with Seurat, however, there has been a tendency to acknowledge the role of science grudgingly, and to downplay the influence—through Seurat—of science on the many subsequent artists affected by him.

John Adkins Richardson's *Modern Art and Scientific Thought* (1971) does constitute a modest, but welcome, bow in the direction of the influence of science, but this work concentrates on only a few rather abstract aspects of science (for example, non-Euclidean geometry) and does not really concern itself with visual science. Furthermore, Richardson's book is rarely mentioned by other art historians. Obviously there exists some antipathy to science in much of modern art history.

Standard Art History: A Criticism (or Two)

An individual commonly is introduced to the history of modern art through a college course or series of museum-sponsored lectures. Alternatively—or in conjunction with these first two experiences

—the student may read a textbook on the history of modern art. The courses, the lectures, the textbooks, are usually very similar in approach. The material is typically sound and thorough in its scholarship, often going into great detail about the life of the artist, the historical influences of earlier artists or movements; some of the aesthetic theory of the artist and of the general milieu of the time is frequently provided. Unfortunately modern art history has suffered from its failure to investigate science and technology, which have been the two most dynamic factors of recent history.

This neglect may be just the natural antipathy of one specialization for those outside, but there is probably something of a clash of the two cultures as well. Certainly, there is a considerable difference between the two fields—the two cultures—in what might be described as their style of discourse. To scientists the use of language commonly found in art history, and even more so in art criticism, is offputting if not completely foreign. One frequently finds vocabulary so obscure and ornate, and syntax so convoluted that the writer's meaning is lost in the flow of words. Indeed, on occasion one wonders what idea, if any, the writer had in mind. Conversely art historians and critics might well complain that scientific writing has no style at all and further, scientific language has its own considerable difficulties. Apparently vague convoluted expression and precise but very dull technical prose are the natural weaknesses of the two disciplines. Still, these uncertainties need not prohibit understanding.

However, the lack of appreciation of science by historians of modern art has more defensible bases than the still existing antipathy between science and the humanities. First, art historians have been extremely occupied in documenting and describing the character of the extraordinarily varied and complex modern period. This task of characterizing the primary phenomena of modern art without being overly concerned with other contemporary events except those most obviously influencing artistic achievement is now largely completed. A truly extensive job of documentation and scholarship has been achieved as demonstrated by the large number of books devoted to major artists and major movements of the modern period.

Second, art historians are rarely scientists or cultural historians. Art history, a specialized field, like so much of contemporary scholarship, tends to cultivate its own garden, to be preoccupied with its particular specialized interests and topics as, for example, they are defined in university art history departments. No doubt the parochial interests of almost all university departments

including science and psychology have done a great deal to create the fragmented, specialized, and hermetic nature of so much of today's knowledge. (Only recently have universities shown any evidence of trying to break out of this pattern by developing interdisciplinary programs where the concern is on integrating a great amount of specialized knowledge.) The third reason for art history's neglect of factors outside of art is that the modern period is still, in many ways, too close. It is difficult to step back and see the larger context within which this art has been operating. Within painting, the hold of modernism has been broken only in the last decade, as witnessed by the unexpected revival of realistic, figurative, and expressionist painting. It is probably not coincidental that during the same period science has been subject to intense criticism and has also lost much of its hold on important segments of society.

Finally, over the past few decades, a number of theories of modernist art have been developed, the best known being the formalist interpretation, as represented by such critics as Clive Bell, Roger Fry, and Clement Greenberg. The position or thesis proposed here is also, of course, a theory of modernist art, but the thesis will be developed before turning in the last chapter to a discussion of its relation to existing theories.

TWO

The Thesis of Parallelism

Two of the essential terms of the thesis that will be elaborated over the course of this chapter—and in the coming chapters—are "analytic" and "reductionist."

Analytic-Reductionist Thought

The terms "analytic" and "reductionist" refer to a particular mental attitude or manner of thinking that has dominated the modern period. As an intellectual approach, this attitude assumes that understanding a given phenomenon requires first, the discovery of a new, more fundamental level of reality that lies beneath or behind the familiar level of understanding, and second, that this new basic level can be analyzed or broken down into subsystems, elements, relationships, processes, and so on, which account for and explain the observations at the familiar level.

Such thought is reductionist because it reduces the explanation of a phenomenon to a presumed more basic and underlying level, and it is analytic in that processes and problems at the familiar level are analyzed in terms of the elements and structures at lower levels. For example, psychoanalysis (literally, the breaking down of the psyche into parts) both as a theory and procedure is typical of the analytic-reductionist approach. It starts with our conscious awareness of ourselves, of others, and of reality in general and then challenges this natural level of conscious experience. Psychoanalytic theory postulates a more fundamental level of mental life—the unconscious—a procedure for analyzing the unconscious, for example, dream analysis, and new structures and forces at the unconscious level, for example, libidinal energy. The surface—the original and natural level of experiencing and understanding—is now analyzed and dissected in terms of the properties at the lower level.

Synthetic-Hierarchical Thought

The analytic-reductionist approach contrasts with the synthetic and hierarchical pattern of thought. Instead of breaking apart by analysis, this opposite approach synthesizes and integrates, and, instead of reducing explanation to a lower, more specific level, it uses higher, more general concepts in its search for explanation. A major example of this approach is the philosophy summarized under the phrase "The Great Chain of Being." This general intellectual position brilliantly presented in Lovejoy's classic treatment represents the dominant world view of the Middle Ages and Renaissance. Both the Fabriano (Fig. 2.1) and the Rembrandt (Fig. 2.2) show this emphasis on hierarchy

and spiritual realities in contrast to the modernist concern with the non-hierarchical portrayal of elements in the picture frame.

The chain or hierarchy of life and material things is briefly described as follows:

all things follow in continuous succession, degenerating in sequence to the very bottom of the series, the attentive observer will discover a connection of parts, from the Supreme God down to the last dregs of things, mutually linked together and without a break. (Macrobius, early fifth-century philosopher)

Vast chain of being! which
 from God began,
Nature's aethereal, human,
 angel, man,
Beast, bird, fish, insect,
 what no eye can see,
No glass can reach; from
 Infinite to thee,
From thee to nothing, —
 On superior pow'rs
Were we to press, inferior
 might on ours;
Or in the full creation
 leave a void,
Where, one step broken,
 the great scale's
 destroy'd;
From Nature's chain what-
 ever link you strike,
Tenth, or ten thousandth,
 breaks the chain alike.
 (Alexander Pope,
 eighteenth-century poet)

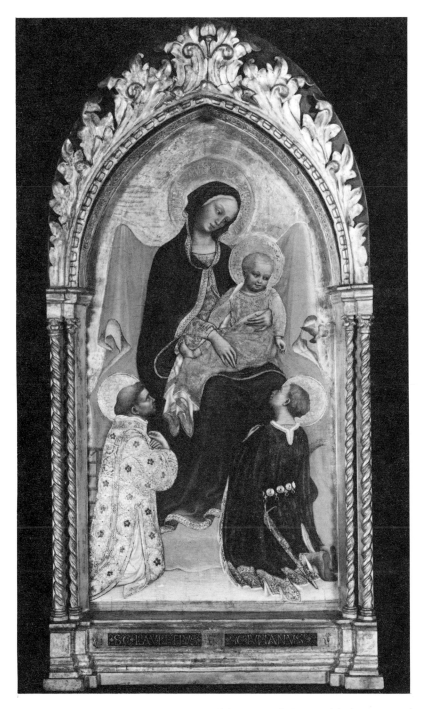

Fig. 2.1 Fabriano, *Madonna and Child, with Saints Lawrence and Julian.* ca. 1424

TWO: THE THESIS OF PARALLELISM **13**

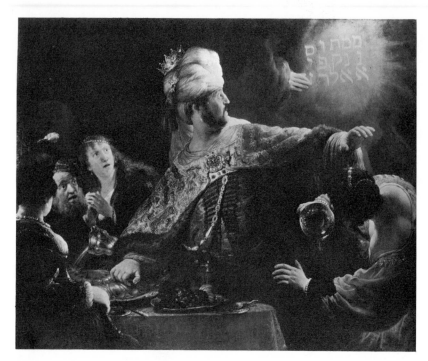

Fig. 2.2 Rembrandt, *Belshazzar's Feast* c. 1637. (*The Handwriting on the Wall.*)

In this type of system the higher category includes, and, therefore, accounts for the lower. The hierarchy, by including all existing things, integrates everything and emphasizes mutual dependence. The assumption that the "lower" must derive from the "higher" is in many respects the opposite of the modern view that ultimate meanings ascend from the underlying basic material world—rather than descending from a higher spiritual reality.

An important recent exhibit of French painting from 1774–1830 (at the Metropolitan Museum of Art, New York) focused on the end and culmination of the hierarchical and synthetic period. Two paintings from this show have been selected to exemplify the dominant theme of the period (Figs. 2.3 and 2.4). In Scheffer's *St. Thomas Preaching During a Storm* (Fig. 2.3) the obvious support for religious and political values comes from the pictorially positive way in which the virtues and power of the saint have been expressed. Paintings such as Ingres's *Portrait of Napoleon* (Fig. 2.4) clearly support the political values of the Empire. (A critic of these two historical figures would have painted them quite differently.)

In the introduction to the exhibit's catalog Pierre Rosenberg summarizes this emphasis: "While this hierarchy of content is not understood today, it had a profound

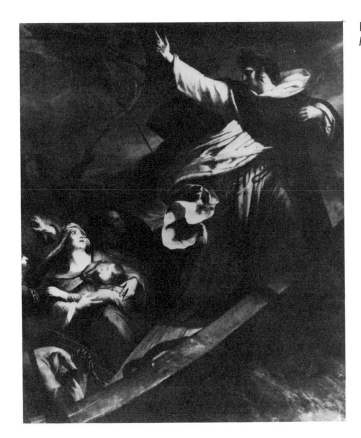

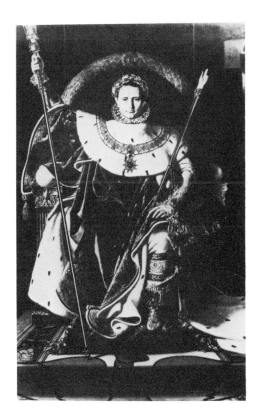

Fig. 2.3 Scheffer, *Saint Thomas Preaching during a Storm.* 1823

Fig. 2.4 Ingres, *Portrait of Napoleon I on His Imperial Throne.* 1806

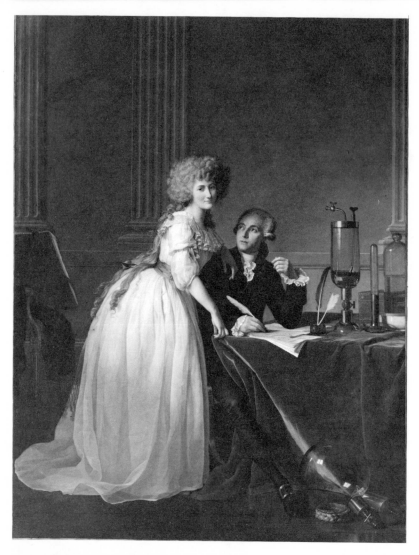

Fig. 2.5 David, *Antoine Laurent Lavoisier and His Wife.* 1788

significance during an epoch in which painting sought to, at times had to, have a profound meaning, elevate the spirit, present a moral lesson or serve as an example."

Other artists of the same period portrayed situations expressing desirable moral values such as married love, courage, and devotion to high ideals. For example, David's portrait of the famous chemist Lavoisier and his wife (Fig. 2.5) is a work that celebrates aristocracy, science, marriage, and also feminine beauty. David's famous *Death of Socrates* (Fig. 2.6) is an obvious homage to the great philosopher's courage and commitment to his uncompromisable principles.

Less obvious but of equal significance is the way in which premodernist paintings show a hierarchical pictorial organization that implicitly supports the content. For example, in the Scheffer, the greatest emphasis centers around the head and heaven-pointing hand of St. Thomas — high up on the picture plane. A secondary focus is the woman's face, and less significant interest centers on the other faces and parts of the boat, while sections of the background are of little psychological importance. Scheffer uses traditional perspective accentuated by chiaroscuro to bring our attention to certain parts of the painting's deep illusionistic volume and to diminish other parts of the space. The painter's skill with color,

depth, forms, and compositional organization, are all synthesized in the service of the picture's message. This hierarchical organization could be made explicit and measurable by dividing the painting into a large number of squares creating a grid and then rating each square on a scale from low (1) to high (7) in terms of its importance within the entire painting. The difference in the importance of the highest and lowest squares then could be used to measure the painting's degree of hierarchization. Similar expressions of pictorial hierarchy exist in all the works already mentioned in this chapter. The same analysis applied to typical recent modernist painting would have very different results. Here the concern is often to make each part of the painting equal in significance — a kind of visual egalitarinism in which no part of the painting is of more importance than any other. For example, see the Jasper Johns (Fig. 2.7) with its grid of thickly textured numbers. Even when this extreme is not realized there is no doubt that modernist painting tends very much in this direction as modern flatness is not possible without breaking down pictorial hierarchy.

Although Delacroix's famous *Victory Leading the People* (Fig. 2.8) still respects the hierarchical pictorial tradition, in various ways it anticipates coming dramatic changes. This painting is an obvious depar-

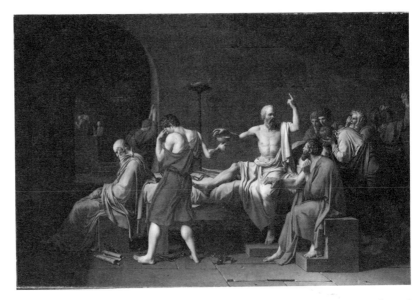

Fig. 2.6 David, *The Death of Socrates.* 1787

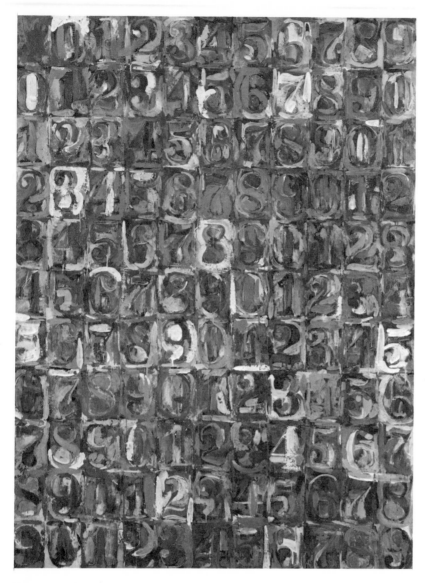

Fig. 2.7 Johns, *Numbers in Color.*
1959

ture from traditional content as its support of the revolutionary mentality is support for antihierarchical moral values. But in the painting as well, Delacroix occasionally presents part of a figure as a flat silhouette or shape thus prefiguring the modernist changes yet to come. He employs experimental color especially in his use of the contrast of red and green and his concern with color as an autonomous property to be considered somewhat independent of the painted content is very much in the spirit of modernism.

Analytic-Reductionism as the Basis for Abstraction and Flatness in Modernist Art

The properties of abstraction and flatness mentioned in Chapter One as major stylistic characteristics of modernist art are a natural consequence of applying an analytic and reductionist attitude or strategy to the problems of picture making. Analysis breaks the original complete scene into parts or separate dimensions of visual experience; reductionism is the concentration on or the preoccupation with the refinement of one dimension or aspect, such as color or form. This concern with a part or subsystem of the original whole reduces the painting to the level of the part and of course allows for future analysis of the

part still further and thus supports moves to an even more reduced level. This process as it develops historically will become clearer through the examples provided in subsequent chapters.

Artists and critics have long been generally aware of the analytic and reductionist character of modernist painting. Apollinaire wrote in 1912 "A man like Picasso studies an object as a surgeon dissects a cadaver," a statement clearly implying that the artist will cut out certain aspects of the object for emphasis and that in so doing he will also go beneath surface appearance (see Fig. 2.9). This theme of the modernist as a dissector can be found quite early, as it was also used to describe the distinctive quality of Flaubert's writing in the 1850s. (See below).

In 1942 Duchamp wrote about his innovations (for example, *Nude Descending a Staircase,* 1912 [Fig. 5.21]): "I felt justified in reducing a figure in movement to a line rather than a skeleton. Reduce, reduce, reduce was my thought." (Incidentally he added, "and for all this reduction I would never call it an 'abstract' painting.") In a similar vein the critic Harold Rosenberg observed:

Most significant painting (though not all) since Matisse's *Joie de Vivre* (1905–06) [Fig. 2.10] has

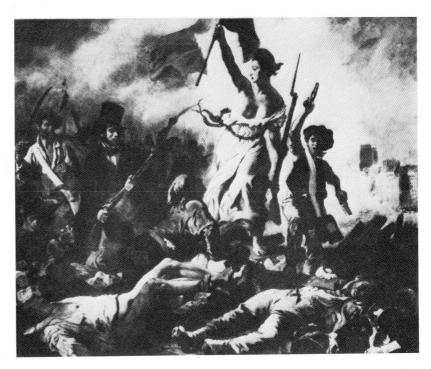

Fig. 2.8 Delacroix, *Liberty Leading the People.* 1830

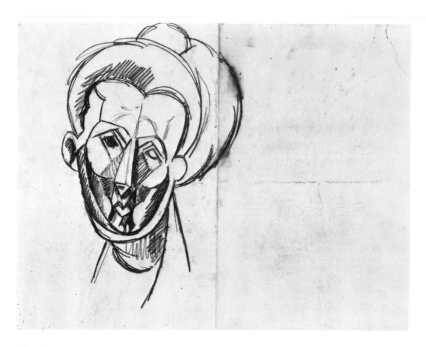

Fig. 2.9 Picasso, *Visage, trois-quart gauche.* 1908–9

Fig. 2.10 Matisse, *Joie de Vivre.* 1906

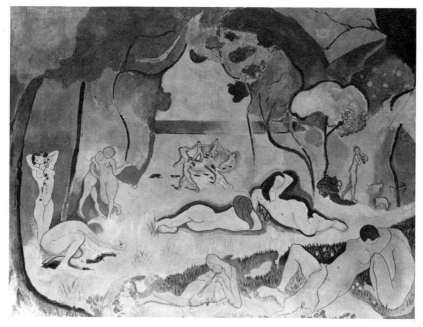

been reductive. Reductivism does not belong to any one style; it is as operative in painting conceived as a gesture as in painting cut down to a line or a square. The traditional aim of reduction, however, even at its most extreme, has been to augment through compression the emotional or intellectual statement. In slicing away residues of imagery of manner that have lost their relevance, the artist seeks, as a European writer recently put it, to transform the apple into a diamond.

As for an analytic emphasis, the very terms Pointillism and Divisionism, which are commonly applied to Seurat's style, directly inform us of that painter's approach to his subject.

While this is not a novel perspective on modern art, we will propose, quite significantly, that the source of this new attitude was science.

The integrative and hierarchical world view, as documented by Lovejoy, reached its culmination in the eighteenth century, then broke apart rather rapidly and was replaced in the first half of the nineteenth century. The static, divinely created, and dependent hierarchical world gave way to modern materialism with its familiar assump-

tions of analysis and independent units, of lower levels explaining the higher, and of dynamic "progressive" change. Although it had its basic antecedents in the prior centuries, this new view accelerated greatly in the early nineteenth century and by mid-century became dominant in the intellectual community. For example, around 1850, extreme enthusiasm for science, "scientism," was common in Western Europe. It was at roughly the same time that modernist art began, but before turning to art it will be helpful to provide further examples of analytic-reductionist thought as it began dominating the science of the early and mid-nineteenth century, a dominance that has continued more or less to the present. This summary material provides some of the evidence that the artists' analytic and reductionist approach arose from this source.

Examples

Biology

Although fundamental advances had been made in the seventeenth and eighteenth centuries, only in the nineteenth century did biology become a modern science. Probably, the central development for its modernization was the emergence of the cell theory of biological tissue. This theory was firmly established by Schleiden (1838) and Schwann (1839). Today the concept that cells compose plant and animal tissues is considered obvious; yet this knowledge was not always obvious and the emergence of this understanding is a clear example of analytical-reductionist thought, for beneath the familiar level, visible to the unaided eye, there exists the more fundamental level of the cell (see Fig. 2.11). A generation later, from within this cellular theory, arose the observation of a still more basic level within the cell—the chromosome level in the cell nucleus. This level was described by Strassburger in 1875, who studied cell division (mitosis) in plants. The name 'chromosome' was given some years after his study (see Fig. 2.12). The continuation of this analytic-reductionist procedure led to the development of the gene theory—the gene being named in 1903 and identified as a discrete unit or part of the larger chromosome in 1913. Later, with the discovery of the chemical nature of the gene, new theory moved to the still lower level of the molecule, the level of RNA and DNA, the building blocks of the gene itself. It is important to recall that this fundamental reductionist trajectory, the latest point on which is the double-helix of Watson and Crick, was firmly established over a century ago (see Fig. 2.13).

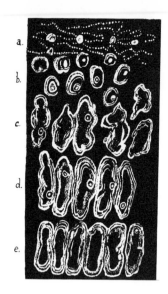

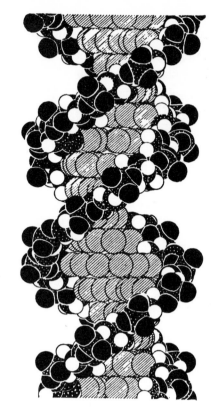

Fig. 2.11 M. J. Schleiden, Cellular tissue in plants *(left and upper right);* T. Schwann, Cellular tissue — tadpole *(lower right)*. 1838–39

Fig. 2.13 Double helix. ca. 1953–55

Fig. 2.12 W. Fleming, Chromosomes. 1882

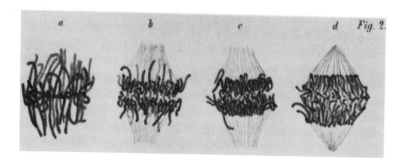

Even aside from the emergence of these new levels and new elements, biology was in a period of rapid discovery of new processes and new interpretations of previously known phenomena. Evidence for the germ theory of disease, that is, small units of life acting below the visible surface, was developed by the mid-nineteenth century. Pasteur's work in 1857–80 showed with special clarity that small organisms, invisible to the naked eye, were often causes of diseases and fermentation.

Chemistry and Physics

In the last quarter of the eighteenth century, the first significant modern concepts were developed in the field of chemistry. At this time, Lavoisier established the modern notion of the underlying chemical elements as distinct from the higher, more easily observed, compound. In the early nineteenth century the British scientist Dalton proposed the chemical atomic theory (1808–10), in which he assumed "that all elements are made of small indivisible particles called atoms" (see Fig. 2.14). Dalton, a genius of wide-ranging interests like many scientists of this earlier period, also discovered the existence of color-blindness, an anomaly still called "Daltonism" in France. (The significance of color vision, including color blindness, for the Impressionists and, especially, the Neoimpres-

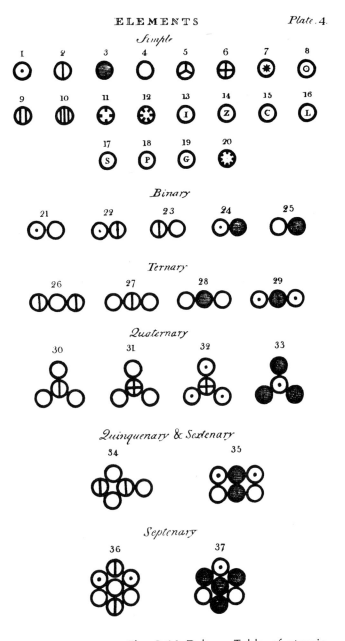

Fig. 2.14 Dalton, Table of atomic elements. 1808

sionists such as Seurat, is discussed later.) From 1820 to 1870, much time was spent trying to absorb the discovery of increasing numbers of new elements, of organic molecules, and the implications of the atomic theory.

During this period of strong growth, chemistry was an extremely influential science and its concepts and language were used in many other fields. Thus, thinking itself was described as a kind of "mental chemistry," and terms from chemistry began showing up in art criticism, for example, Baudelaire's discussion of the nature of color in his review of the Salon of 1846: "Let us suppose a beautiful expanse of nature . . . where all things, variously colored in accordance with their molecular structure. . . . For if you admit that every molecule is endowed with its own particular tone, . . . Chemical affinities are the grounds whereby Nature cannot make mistakes in the arrangement of her tones." In Baudelaire's comments the analytic and reductionist sympathy is already present since colors are discussed in terms of the new science — of small elements existing beneath the normal visual experience of color.

In 1869 came the development of the periodic table, which systematically classified the elements and successfully predicted new ones. This well known accomplishment of Mendeleev (and to a lesser de-gree, Meyer) was a hierarchical and synthetic contribution. That is, his table interrelated and synthesized the confusing and rapidly growing collection of new elements. But, after a brief respite from the confusion resulting from the previous growth of analysis and reductionism, the analytical process began again in the early twentieth century when the previously indivisible particle, the atom, was conceptually broken down into its constitutive parts and a primitive model of the new atom developed. This model, roughly like a miniature solar system, was the result of the work of Rutherford, Bohr, and Mosley, and represented the atom as having a large core of neutrons and protons encircled by electrons (see Fig. 2.15). Although the theory of how these subatomic parts related to each other was a synthetic and integrative contribution, the major impact of this work was reductionistic — the discovery and conceptualization of a dramatic new level of reality below the atomic level. Furthermore, the subsequent discovery of many new subatomic particles destroyed the original synthetic aspect of the Rutherford-Bohr model and once again, today, at the subatomic level, analysis has created an intellectually chaotic world of independent units awaiting a new synthesis, one which, if it occurs, could easily produce a new still lower level and hence, implicitly start the reduc-

tionist and analytic process over again.

Thus, in spite of the theories that provided brief interludes of synthesis, the general trend of analysis and particularly reductionism soon asserted its dominance. Each new breakthrough has been a further retreat from the likeness of the familiar natural level. In so many ways the scientists were the first to shatter, break, segment, dissolve, and shred the old reality. Most important for the present thesis, by mid-nineteenth century, the analytic-reductionist attitude was the preeminent methodological approach of science and—as we will see—it had also spread to other domains, including the arts.

Mid-Nineteenth Century: A Special Situation

Although the physical theories of Newton go back to the end of the seventeenth century, and modern chemistry is acknowledged to have begun in the late eighteenth century, the situation in the mid-nineteenth century was quite distinct from the immediately preceding period. As previously noted, the late eighteenth century was still largely under the sway of the integrative philosophy of the Great Chain of Being. Further, the mechanistic Newtonian paradigm, so widely influential at this time, was

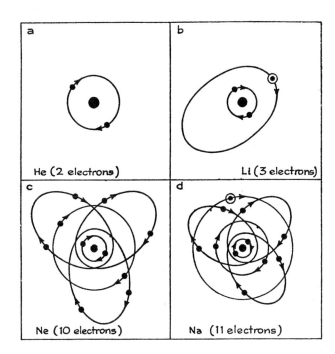

Fig. 2.15 N. Bohr and A. Sommerfeld, Patterns of electron motion in the atoms of various elements. 1913–15

Fig. 2.16 Newton splits up sunlight into the spectral colors by means of a prism. 1666

in many ways compatible with the religious Great Chain philosophy. Newton's gravitational laws were essentially synthetic, not analytical; that is, visible and familiar objects were interpreted as controlled by fixed immutable laws. No new level of physical reality, no new kind of physical stuff was discovered—instead, familiar things like "falling bodies" or the planets were integrated into a lawful, harmonious, unchanging system: a system certainly compatible with the static, integrated, dependent (on God) world of the Great Chain. Newton's own serious religious writings and his public reputation as a theological expert can be seen as evidence of the basic consistency between his physics and traditional religious thought. An exception was Newton's work on light which was predominantly analytic, in that he observed that white light could be broken down into separate colors and he suggested that the various colored rays excite different vibrations in the retina. He also speculated that light consisted of underlying discrete small particles (now known as quanta) (see Fig. 2.16). This work, however, was insignificant in its impact on the contemporary intellectual climate, as compared to his gravitational and mechanical theories. There was also other analytic and reductionist science occurring during the seventeenth and eighteenth centuries, but

it was being done under the cover of the dominant, rational, harmonious, Newtonian position coexisting with the Great Chain world view in a still aristocratic, hierarchical society.

A major contribution to the situation in the mid-nineteenth century was the emergence of the industrial urban society into a position of great cultural power—a society widely understood as coming into existence in Europe in the first decades of the nineteenth century, though somewhat sooner in England. It was the intellectual, economic, and social attributes of this new urban condition that allowed science to have its first widespread, transforming impact. The long-lived French chemist M. E. Chevreul is exemplary (see Fig. 2.17). In the 1820s, his work on fats helped to improve substantially the soap and candle industry and contributed greatly to the new field of organic chemistry. In 1824, he became director of the dyeing process at the famous Gobelin tapestry works. Here Chevreul set up a laboratory to systematically study the dyeing process. His innovations met with hostility from workmen accustomed to the personal rule-of-thumb methods typical of pre-industrial crafts. Successful in demonstrating the superiority of the scientific approach, he later published a two-volume work on the chemistry of dyes. Chevreul then

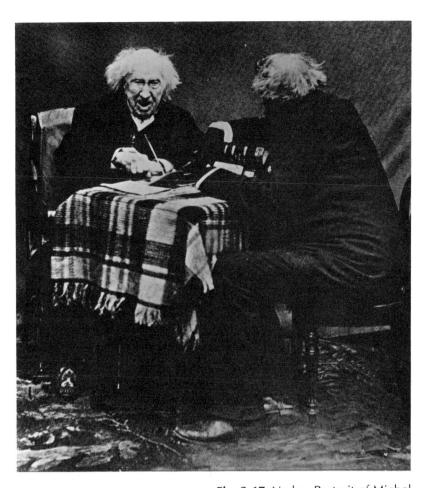

Fig. 2.17 Nadar, Portrait of Michel-Eugène Chevreul. 1886

Fig. 2.18 M.-E. Chevreul, Early scientific arrangement of color "elements." 1839

turned to the problem of color contrasts and pioneered in developing laws of color harmonies. His *The Law of Simultaneous Contrast of Colors* (*De la loi du Contraste Simultané des Couleurs* 1839) is apparently the first scientific, modern treatment in what is now a long series of studies of the aesthetics of color combination and contrast. Something of the analytic character of Chevreul's investigations can be seen from his use of color diagrams—these show the emergence of the new "elements" of color (see Fig. 2.18; also, Figs. 4.3, 4.4 and 4.5). This book, translated into English and German (still available in a recent edition) served as an important source for several major modernist painters. Although Chevreul was not a great theoretical chemist, his kind of impact on the industry and society of his time and his introduction of a scientific analysis of color is typical of the influence science had during this period. Clearly, Chevreul's contributions are a product of the emerging urban scientific-industrial world and they could not have occurred much earlier.

Another factor contributing to the special character of science in mid-nineteenth century is that after 1850 specialization set in rapidly and the age of the great all-purpose scientist ended. (Whitehead calls this specialization within science "professionalism.") Helmholtz,

whose wide-ranging important work spanned the middle of the century, is often considered the last of the great generalists. Specialization is one of the primary symptoms of the dominance of analytical over synthetic contributions since analysis results in more and more areas of knowledge functioning as independent and theoretically unrelated. This historical change is further evidence that modern science had become dominated by the analytical-reductionist mentality. Science was breaking into more schools and fields than was modern art. By contrast, the seventeenth and eighteenth centuries were a remarkably different world where scientists were often generalists making their early contributions in fields now widely separated. They were frequently self-trained or trained in a simple apprentice system. In this earlier society, there was still a place for the talented 'amateur' (for example, Priestley).

Mid-Nineteenth-Century Psychology

Before we move to the expression of analytic-reductionist thought in the arts, it is important to document the strength of the tendency to interpret conscious mental life as controlled by underlying forces in the period 1840–70, first, because this mid-century moment is the initial period of modern art, and also because it is largely believed today that Freud discovered the unconscious in the early twentieth century. Freud's great contribution was to systematically analyze and conceptualize the nature and effects of the unconscious. But his work came after a great deal of now forgotten but once well known earlier work on the problem.

The drive to understand mental experience by probing, dissecting, and describing the layers and forces underneath consciousness is a major example of analytic and reductionist thought. The probing of the unconscious, as L. L. Whyte demonstrates in his study *The Unconscious Before Freud* (1960), "started moving with a rush" in the mid-nineteenth century, and he furnishes a long list of important works describing and emphasizing the unconscious at this time, which will be briefly summarized below. This was the time of Kierkegaard's psychological masterpieces, *Fear and Trembling* (1843) and *The Concept of Dread* (1844). A great work on the mind and its development, *Psyche* (1846), by Carus starts: "The key to understanding of the character of the conscious life lies in the region of the unconscious."

In 1853 Carpenter introduces the phrase "unconscious cerebration," which is in common usage around 1870; and the Scottish art

critic E. S. Dallas wrote in 1866 in a study on the theory of art criticism:

> Between our unconscious and our conscious existence, there is a free and a constant, but unobserved traffic forever carried on. . . : The spectator brings to the art object a total experience far deeper than he could consciously fathom.

A few years later the French aesthetician H. A. Taine stated, in reductionist language rich with metaphors from chemistry:

> We get a glance here at the obscure and infinite world extending beneath our distinct sensations. These are compounds and wholes. For their elements to be perceptible to consciousness, it is necessary for them to be added together, and so to acquire a certain bulk, and to occupy a certain time. . . . The elementary sensations directly making up our ordinary sensations are themselves compounded of sensations of less intensity and duration, and so on. Thus, there is going on within us a subterranean process of infinite extent, its products alone are known to us, and are only known to us in mass. As to elements and their elements, consciousness does not attain to them, reasoning concludes that they exist; they are to sensations what secondary molecules and primitive atoms are to bodies.

In philosophy we have Hartmann's lengthy but popular *The Philosophy of the Unconscious* (1868), which went through many editions. It summarized what was known on the topic.

Scientific psychology was just getting established at this time, and the sensations of light, of color, and of sound were rigorously studied. In their analysis of sensations these scientists were led to a concern with the unconscious by the discovery of the rapid automatic way that perceptual experience was structured and interpreted; and by the concept of a threshold below which sensory stimulation was not consciously experienced. Best known was the work of Helmholtz who formulated his famous concept of "unconscious inference" in the 1860s (see Fig. 2.19). Fechner, who began the experimental measurement of sensation (*Elements of Psychophysics*, 1860) was making his contributions about this time with his work on the threshold of consciousness: "he compared the mind to an iceberg mainly below the surface and moved by hidden currents as well as the winds of awareness" (see Fig. 2.20); and the first experimental psychologist, Wundt, wrote:

Fig. 2.19 Portrait of Hermann von Helmholtz (1821–94).

Fig. 2.20 Portrait of Gustav Theodor Fechner (1801–87).

Our mind is so fortunately equipped, that it brings us the most important bases for our thoughts without our having the least knowl- of this work of elabora- tion. Only the results of it become conscious. This unconscious mind is for us like an unknown being who creates and produces for us, and finally throws the ripe fruits in our lap.

Whyte comments that "the un- conscious" had become a fashion- able topic by 1870. He sums up his evidence as follows: *"In any case it cannot be disputed that by 1870– 1880 the general conception of the unconscious mind was a European commonplace, and that many spe- cial applications of the general idea had been vigorously discussed for several decades."*

In short, throughout Europe, science had thoroughly begun the analysis of internal mental pro- cesses and the reduction of higher conscious experience to underlying factors.

The General Thesis — Conceptual Parallelism

In its most general form the thesis of this work is that modernist art begins with the acceptance by artists of the analytic-reductionist approach to painting and that much subsequent historical development has expressed the unfolding of this basic principle. To support this claim evidence will be presented of the influence of analytic and reduc- tionist concepts on art from the mid-nineteenth century to the pres- ent. Additional support will be pro- vided by illustrating that over this more than 100-year period, modern art and modern science have devel- oped at about the same time similar interpretations of the *visual signifi- cance* of such fundamental concepts as: light, depth, color, space, time, form, visual elements, optical ef- fects, randomness, and redundancy. The expression "conceptual paral- lelism" will be used to refer to the simultaneous development and ex- pansion of these basic ideas in each discipline, which were guided in both areas by the same analytic and reductionist attitude.

The difficult question of his- torical causality plays a role, but not a crucial one, in the present discussion. In general, the evidence will show that many artists adopted and adapted the ideas and even the iconography of scientists. In some instances, for example, Seurat and Signac, the direct causal influence of science is well documented. In some cases the scientist seems to have arrived at an expression of modernist imagery well in advance of its occurrence in painting. Take the case of Johann Wolfgang von Goethe (1749–1832). A contempo- rary portrait of this great German

intellectual is shown in Figure 2.21; Figure 2.22 is a recent adaption by Andy Warhol that is flatter and more modernist in style. Goethe's extensive, very early scientific investigations of light, color, and vision often led him to strikingly modernist imagery. For example, Figure 2.23 shows a very Picasso-like watercolor image by Goethe, in which he painted his experience of the after-image of a young woman. (See also Fig. 7.47 for another Goethe anticipation.) An even clearer example of modern flatness can be noted in the Gestalt after-image of Paul von Hindenburg, former president of Germany (Fig. 2.24). Besides flatness, this stimulus also expresses aspects of figure-ground reversal — a phenomenon that was first articulated in science and in art in the period 1910-20 (see Chapter 6). It is of some interest to note that the Warhol portrait of Goethe (Fig. 2.22) is less flat, for example, than the after-images by the scientists (Figs. 2.23 and 2.24) — and less reductionist than his own paintings of the early sixties. That is, the Warhol 1982 print looks closer in style to the 1786 portrait of Goethe than to the style of Goethe's scientific after-image. These "revisionist" innovations of Warhol suggest the expression of a post-modernist aesthetic.

Often the relationship appears to be that vaguer type of causality summarized by the term "Zeitgeist": the simultaneous emergence of the same kind of interpretation in different fields. In other instances, however, the artists appear to have been in advance of science or to have quite independently arrived at visual discoveries. Although the causal effects of science on art support the parallelism thesis, they are not necessary for it: whatever caused it, the parallelism is there.

Other writers have previously shown connections between science and modern art, and their contributions will be used when appropriate; however, the position taken here is distinctive. First, the argument will be developed over the entire period of modernist art, not just for one artist or one movement. Second, the argument of parallelism requires roughly the same sequence of development of basic ideas in both art and science, not any historically haphazard connection between the two. Third, many of the connections documented here, particularly those related to the topics of stereoscopic vision, depth perception, early Gestalt psychology, visual elements, randomness, and redundancy, have apparently been largely neglected in the existing literature. Fourth, there does not appear to be any systematic treatment of the analytic-reductionist mode of thought with emphasis on its expression in both art and in science.

Finally, our major concern is with discoveries and concepts generated by the scientific study of vi-

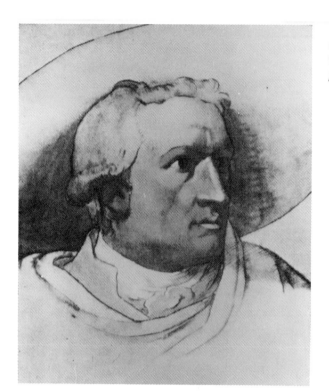

Fig. 2.21 J. H. W. Tischbein, *Goethe in Italy* (watercolor study for the oil painting *Goethe in the Campagna Romana*). 1787

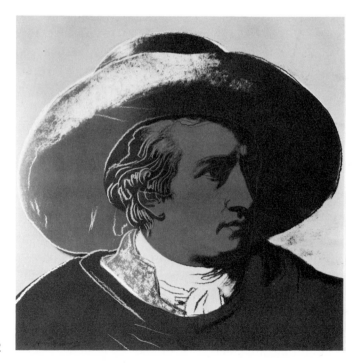

Fig. 2.22 Warhol, *Goethe.* 1982

sion, not with science in all its many fields and ramifications. The thesis is not about science in general but is primarily restricted to visual science, which refers to the modern scientific investigation of visual experience. As such, visual science has three major aspects. The first, most important, and largest, is the scientific study of visual sensation and perception. Well known examples of this kind of science are research on color perception, for example, Herman von Helmholtz; the study of form perception, as in Gestalt psychology; and the work on the depth information in the stimulus field, as in the studies of J. J. Gibson. This research, heavily scientific in its methods and theory, is by far the most important source of evidence for the thesis.

A second part of modern visual science is the technology of vision or the engineering approach to vision, primarily photography, although in principle it includes the entire technology of image making. This technological part of visual science will be treated as a separate factor even though it often shades imperceptibly into the first — just as all technology and engineering though performing a separate role are still thoroughly related to various theoretical and experimental topics. For example, the structure of the camera has, from its beginning, served as a model, even if a very simplified one, of how the eye works. The use of

Fig. 2.23 Goethe, Bust of a young girl in the reversed colors of an after-image. ca. 1810

Fig. 2.24 Gestalt after-image of German President Paul von Hindenburg. 1935

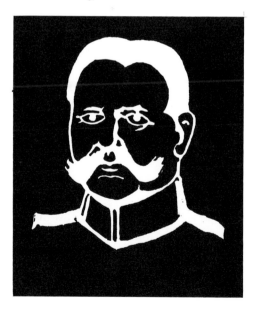

evidence based on the scientific aspects of photography will be modest and primarily restricted to new material, since major recent books have covered the general impact of photography on art with considerable thoroughness.

The third aspect of visual science consists of the contributions of those thinkers—themselves neither artists or scientists—who provided analyses of art and aesthetics heavily influenced by science. For example, Charles Blanc's *The Grammar of Painting and Engraving* (*Grammaire des arts du dessin*), had a significant effect on French painters from the book's first publication in 1867. His influential chapter on color is scientific in character, very much in the tradition of Chevreul. There were also many others who throughout the modern period served as important conveyors of scientific ideas to the artistic community.

The Specific Thesis — Pictorial Parallelism

The most particular statement of the parallelism thesis is the claim that modern art has been, to a large degree, an investigation and exploration of visual perception. With the collapse of the old hierarchical values supporting the moral and social significance of painting, and along with this the collapse of the rules of painting used in constructing hierarchical pictorial representation, artists like their contemporaries in other fields began looking inward to analyze the mind itself. Being artists, they chose for investigation the processes involved in visual experience. Here analytic-reductionism served remarkably well, as it brought them like the scientist to successively lower levels of artistically unexplored visual material.

The modern artist, therefore, was not just fleeing the hierarchical system, not just breaking the image and changing the older higher meaning. Instead, these artists were moving toward something: they were expressing in positive terms a new understanding of visual experience thereby revealing the role of art as a tool by which perception could be extended.

As a consequence of this mutual study of visual processes, modern paintings are often literally similar to the scientific stimuli created by scientists investigating the same perceptual processes. The pictorial or physical similarity between the visual stimuli of the scientists and modern paintings, then, provides the most dramatic evidence for the thesis. These similarities cannot be treated as accidental because, as it will be shown, often the two works occur at about the same time, and frequently the artist's comments make it clear there was influence

from visual science or that the artist on his own had discovered the same visual phenomena that contemporary scientists were investigating. Thus, it is argued that the artists' and scientists' parallel conceptual approach to vision frequently resulted in the construction of pictorially similar or even identical "works."

The possibility of such a parallel analysis of vision has been sensed by important art critics for many years. For example, in 1920 Roger Fry wrote:

> I find something analogous in the new orientation of scientific and artistic endeavour. Science has turned its instruments in on human nature and begun to investigate its fundamental needs, and art has also turned its vision inwards, has begun to work upon the fundamental necessities of man's aesthetic functions.

Even more explicit is Clement Greenberg in 1965:

> One begins also to realize that the Impressionist, or at least the Neo-Impressionist, were not altogether misguided when they flirted with science. Kant's self-criticism, as it now turns out, has found its fullest expression in science rather than in philosophy, and when it began to be applied to art, the latter was brought closer in real spirit to scientific method than ever before. . . . That visual art should confine itself exclusively to what is given in visual experience, and make no reference to anything given in any other order of experience, is a notion whose only justification lies in scientific consistency. [See for example the expression of this spirit in Figs. 2.25 and 2.26. The cathedrals of Lichtenstein parody images that were additively created out of small incremental elements to investigate color sensation by Monet. Lichtenstein reduces the images to benday dots, (used in the photographic reproduction of images) but maintains the process of image construction by means of incremental elements.] Scientific method alone asks, or might ask, that a situation be resolved in exactly the same terms as that in which it is presented. But this kind of consistency promises nothing in the way of aesthetic quality, and the fact that the best art of the last seventy or eighty years approaches closer and closer to such consistency does not show the contrary.

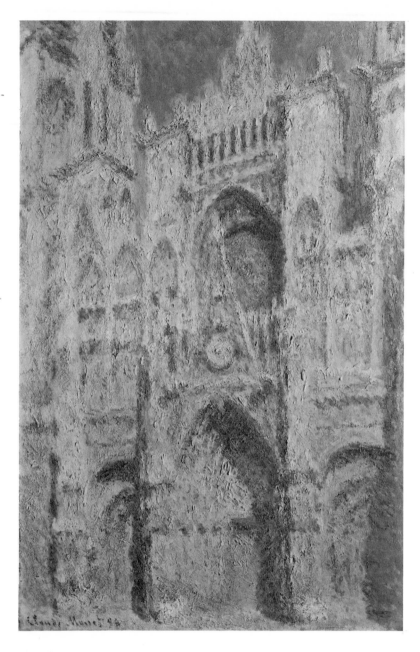

Fig. 2.25 Monet, *Rouen Cathedral.*
1894

From the point of view of art in itself, its convergence with science happens to be a mere accident, and neither art nor science really gives or assures the other of anything more than it ever did. What their convergence does show, however, is the profound degree to which modernist art belongs to the same specific cultural tendency as modern science, and this is of the highest significance as a cultural fact.

In spite of Fry's refusal to follow up his intuition and Greenberg's strange disavowal of any true connection ("mere accident," and so on), the possibility that parallelism should be taken seriously continues to suggest itself to art critics and historians as shown in a 1974 essay by Christopher Finch:

A remarkable aspect of the art of the present century is the range of concepts and ideologies which it embodies. It is almost tempting to see a pattern emerging within the art field — or alternatively imposed upon it *a posteriori* — similar to that which exists under the umbrella of science where the general term covers a whole range of separate, though interconnecting, activities. Any parallelism is however — in

this instance at least — misleading. A scientific discipline develops systematically once its basic tenets have been established, named, and categorized as conventions. Many of the concepts of modern art, by contrast, have resulted from the almost accidental meetings of groups of talented individuals at certain times and certain places.

The avoidance of a scientific connection by the critics is puzzling as the impact of science has been expressed by many artists. Hans Hofmann's diagram (Fig. 2.27) is an excellent example. In addition to being a well known painter, Hofmann was the major teacher/theorist influencing the development of abstract expressionism. In his diagram representing the creation of a painting, inspiration comes from physical matter and visual input. The presence of scientific influence is strongly represented here.

Further examples abound and a detailed attempt to demonstrate that the objections to parallelism do not hold will follow. One can expect in advance that the parallelism explanation will have its omissions, exceptions, and distortions; however, it should provide not only many examples of the profound interrelation of art and science, but also new concepts for understanding modernist art and for sharpen-

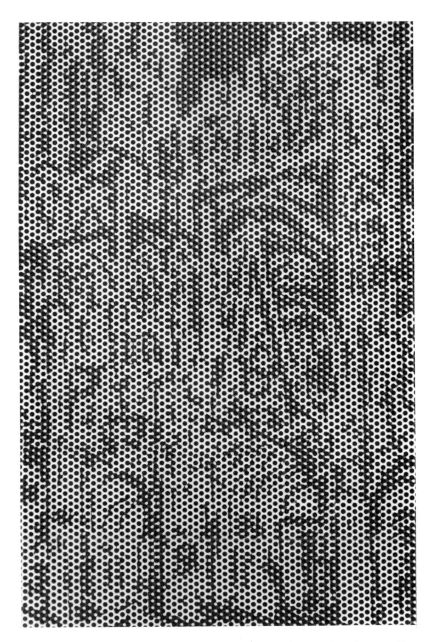

Fig. 2.26 Lichtenstein, *Rouen Cathedral Set 1.* 1968

Terms

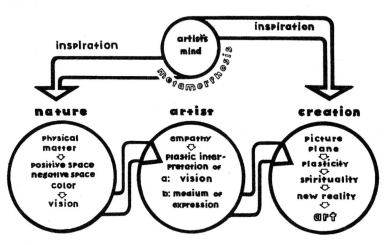

Fig. 2.27 Hofmann, Diagram of Nature-Artist-Creation. ca. 1948

Fig. 2.28 Nadar, Portrait of Gustave Flaubert. ca. 1870

ing the debate about important unresolved issues.

The Case of Flaubert and *Madame Bovary*

The case of Gustave Flaubert is relevant here (see Figure 2.28). One problem, especially at the start of modernism, is that there is little evidence in verbal form that the artists themselves were consciously aware of the influence of science on them: they were not as considerate as artists have become since: they did not feel called upon to theorize —in writing—about what they were doing and the reasons why. Influences on them were *silent* influences. Flaubert is precisely an interesting case, first, because he was very clearly influenced by the scientific mentality, second, because he talked about it, and made it absolutely clear in his work, and third, because he was himself a widely known figure in his time, known by and interested in the work of various painters. Flaubert then is useful in the presentation of the thesis, although, of course, he was not a painter, but because he was very clearly interested in the problem of the *representation* of *vision* in art—and because he demonstrates the mid-century awareness of the new scientific mentality.

Since Flaubert's *Madame Bovary*, published in 1856, is widely accepted as the first modernist novel, written in France where modernist painting was to emerge a few years later, there are thus many reasons to look at this work—a work many have seen as expressing the same spirit as Manet.

Flaubert, one-time medical student and the son of a doctor, was an enthusiastic supporter of "science." Typical of the mid-century period of European scientism, he believed that science served to counter the romanticism that had dominated the first half of the century. Flaubert asserted that the literature of his day needed to become a "scientific form." He longed for a new science in which man in his natural and social expression would be studied. His attitude has been summarized by the Flaubert scholar, B. J. Bart:

> Flaubert's hopes for the future of science were part of the Age of Scientism, and many of his expectations would be realized. Charcot and Freud, Taine, the anthropologists, and the sociologists would later arise to study man's instincts and his society. Maury, Renan, and others would shortly be laying the bases for comparative religion. But Flaubert hoped for more: he longed for answers with the precision of mathematics, and he still retained a faith that science and art would one day fuse.

"Art," writes Flaubert, "must rise above personal emotions and nervous susceptibilities. It is time to endow it with the pitiless method, with the exactness of the physical sciences." Flaubert's enthusiasm for science clearly appeared in his work: what we term the "analytic" and "reductionist" character of *Madame Bovary* was noticed from its publication. Thus, the critic Sainte-Beuve characterized Flaubert's new style as "the victory of the anatomist and physiologist in art," and stated, "Flaubert wields the pen as others wield the scalpel." Subsequent scholars have routinely commented on this preoccupation with dissective analysis of his characters' "underlying depth." A major consequence of Flaubert's scientific approach was a work that strikes even today's readers as one in which the characters are treated at a cool, detached, and even ironic distance. It is not surprising that his objective realism results in the description of people as objects, and that the moral significance and exaggerated emotional effects of earlier writers drop out as a natural result of this sort of presentation and style. The desire to reduce the moral, emotional, and story-telling nature of the novel parallels the modernist painters'

desire to escape the painted story of emotional and moral content. This impulse is expressed by Flaubert in his famous claim that he wanted to write a book about nothing: "What seems beautiful to me and what I should like to do is a book about nothing, a book with no exterior attachment . . . a book which would have almost no subject, or whose subject at least would be almost invisible, if that is possible."

This modernist ideal in literature, the abandonment of the plot and the characters, was not a major literary phenomenon before World War II, but has been very important in recent years. For example, one of the most prominent of the "New Novelists," Alain Robbe-Grillet, asserted of his work, *Jealousy* (1978), that "nothing, or almost nothing happens."

In any case, modernist painting has sought Flaubert's goal—a "work about nothing"—with greater persistance and even greater clarity. At the level of perceptual content the previously noted minimal works by Malevich, Reinhardt, Irwin, and also Klein (Fig. 7.89), Rothko (Fig. 7.90), and even Warhol (Fig. 7.93), can all be understood as paintings or works "about nothing"—perhaps more accurately stated, they are works "about themselves," for the questions raised are far more complex than the simple absence of familiar subject (See Chapters 7 and 8).

A central support for the parallelism thesis is the extent to which Flaubert's writing portrayed a major new *visual* world. This Flaubertian innovation is conceptualized convincingly in *Fiction and the Camera Eye*, by Alan Spiegel. First Spiegel gives an example from *Madame Bovary*:

One day he arrived about three o'clock. Everyone was in the fields. He went into the kitchen, and at first didn't see Emma. The shutters were closed; the sun, streaming in between the slats, patterned the floor with long thin stripes that broke off at the corners of the furniture and quivered up on the ceiling. On the table, flies were climbing up the sides of glasses that had recently been used, and buzzing as they struggled to keep from drowning in the cider at the bottom. The light coming down the chimney turned the soot on the fireback to velvet and gave a bluish cast to the cold ashes. Between the window and the hearth Emma sat sewing; her shoulders were bare, beaded with little drops of sweat.

And then points out that in this passage Flaubert

sees each object in the scene one after the other;

that is to say, one object at a time. Each object seems to emerge from its context with remarkable clarity and precision; it is seen as a thing separate and distinct, existing in and of itself and like no other thing. Flaubert is thus sparing in his use of metaphor and simile. This passage, in fact, contains none. The shutters are one thing; the light through the slats another; the table, a third; and so on. Emma, too, is a separate 'thing.'

Flaubert, then, is the first to effectively break up the traditionally integrated world found in pre-modernist novels, "reducing" it to a "cinematic" sequence of highly focussed parts within the visual field. Spiegel develops the meaning of this cinematic style in a most insightful manner:

> Visual perspective informs the reader that this is the way a specific situation allows a specific eye to view it; that any understanding of a situation is always limited by the way the eye chooses to see it, by the position of the eye in relation to its object; that truth itself now depends as much upon the angle of vision as upon the object of vision.

By introducing the changing "point of viewing," Flaubert also has implicitly introduced multiple points of view of the same person or object (see Fig. 2.29); thus he has introduced what might be called a cubist representation of objects and character. (The issue of multiple viewing in art will be treated in detail in Chapter 5.)

Curiously, what Spiegel and others have apparently failed to note is the very likely direct influence of photography on Flaubert's new style. In the period 1849–51, just prior to *Madame Bovary*, Flaubert went on a lengthy photographic tour of the Near East with his life long friend, Maxime du Camp. This friend, a writer and man-about-town, was in charge of all the photography—but the influence of the then novel scientific medium on Flaubert is probable. As the two journeyed through Egypt, Syria, and other parts of the Orient, du Camp would often stop to set up his camera. In the process there would inevitably have been a discussion of which of the many particular views should be selected—each view being an analytic slice from the complete, normal integrated view. Later, when developed, each photograph, of the Sphinx, for example, would realistically and cooly justify its particular correctness (for example, see Fig. 2.30). The absence of a single, integrating representation would, most likely, not even have been felt.

In conclusion, although the older, wholistic view of the writer as omniscient 'God' has not been eradicated, it has been definitely shattered; Flaubert has replaced the synthesizing author with the clinical, photographic, "seeing eye of man."

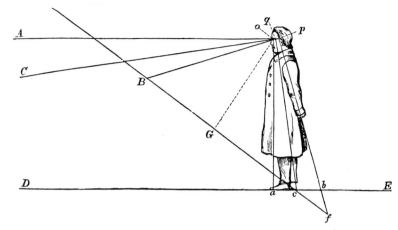

Fig. 2.29 H. Helmholtz, Analysis of angles of vision. 1867

Fig. 2.30 M. du Camp, *Thebes: Gournah, Statue of Memnon.* 1850

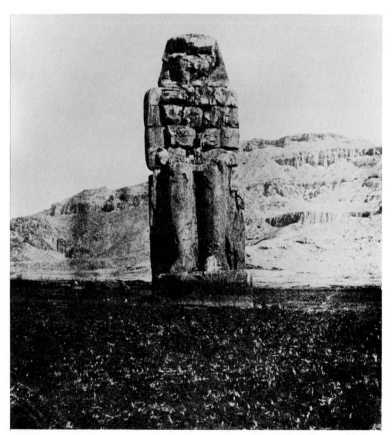

Fig. 2.31 H. Helmholtz, Eye. 1867

THREE

Light, Depth, and Photography

Helmholtz and the Perception of Light

Herman von Helmholtz was responsible for the first major modernistic theoretical treatment of perception.* Newton's earlier primarily physical observations were essential, and Thomas Young's work on color (1802–07), which Helmholtz rescued from neglect, also contributed substantially—but it was Helmholtz's classic *Physiological Optics* (1867) that established the modern understanding of the nature of visual perception. This work was first published in monographs in 1856, 1860, and 1866. Helmholtz's position, relevant aspects of which are discussed below, was recognized quickly and disseminated widely. In part this was due to his extraordinary ability to communicate his concepts to the public through his popular lectures and articles. But of greater significance was the new urban world of Europe, which enthusiastically welcomed the latest scientific wonders. After all, it was these wonders that were to a great degree bringing this new world into existence. Although Helmholtz treated the entire topic of visual perception, his work is primarily concerned with basics, such as the perception of light (brightness); depth (stereoscopic vision); distance; space; and also color. This chapter will concentrate on light and depth; color and space are discussed later.

In the mid-nineteenth century an intense preoccupation with the visual experiences of light and depth was also occurring in the related discipline of photography. Here both the scientists who were helping to develop the new field (for example, Wheatstone, Brewster) and the newly developing photographic artists (for example, Nadar), were as a practical necessity deeply involved in the study of light and also with depth, thanks to stereoscopic photography.

Helmholtz's theoretical interpretations of visual phenomena were substantially analytic and reductionist—as were those of his colleagues. In his systematic treatment he took the ordinary wholistic visual experience and broke it into separate factors. For example, depth was analyzed in terms of binocular disparity, brightness perception was separated from the experience of color and form and analyzed in terms of the relative, rather than absolute brightness of objects, while perception of color was interpreted as a consequence of the proportional stimulation of three different visual pigments in the retina. Helm-

*Goethe's work on color, especially *Zur Farbenlehre*, 1810, was certainly an important precursor to Helmholtz but for various reasons it failed to have much impact on either science or art; what influence it had came after Helmholtz. Aspects of Goethe's contributions are treated in Chapters 4 and 6.

holtz attributed much of visual experience to the result of "unconscious inference"—that is, to automatic psychic activities below awareness. Perception as a whole was reduced to the level of sensation and to the underlying sensory physiology that science had recently discovered.

The Rood-Helmholtz Insight

Early, significant evidence for major parallel concerns in science and art comes from the writings of Ogden Rood as well as of Helmholtz. Rood, a professor of physics at Columbia, was later the author of *Modern Chromatics* (1879), which directly influenced many artists—Seurat, Delaunay, and Kupka in particular. Rood and Helmholtz were contemporaries and made essentially the same observation—although Rood seems to have been the first in print by a few years. Rood (1861) starts by noting the fact "that a landscape appears more vivid in color, when viewed by the eyes brought into an abnormal position, as in looking under the arm." He explains this as follows:

> To me it seems that this effect is intimately connected with our perception or non-perception of distance . . . *if by any means the mind is prevented from dwelling on distance, it is thrown back on the remaining element, color; and the landscape appears like a mass of beautiful patches of color heaped upon each other, and situated more or less in a vertical plane.* (emphasis added)

Helmholtz had the same insight, but he gives it a lengthier, more informative expression. He writes sometime before 1867 about the perception of a landscape:

> The first thing we have *to learn is to pay heed to our individual sensations.* . . . By way of illustration . . . the instant we take an unusual position, and look at a landscape with the head under one arm, let us say, or between the legs, *it all appears like a flat picture*; partly on account of the strange position of the image of the eye, and partly because, as we shall see presently, the binocular judgement of distance becomes less accurate. It may even happen that with the head upside down the clouds have the correct perspective, whereas the objects *on the earth appear like a painting on a vertical surface,* . . . (emphasis added)

Fig. 3.1 Manet, Olympia. 1863.
(Fig. 3.2 follows Fig. 3.6)

Fig. 3.6 Braquehais, Nude. (French)
ca. 1856

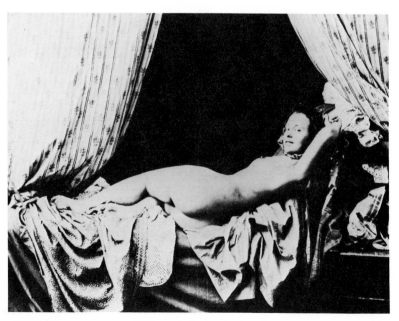

The Rood-Helmholtz passages are of historical importance, for they demonstrate that the analytic attitude toward the normal perceptual world results in the flattening of perceived space. This occurs by paying heed to our "individual sensations" and by ignoring the higher conceptual context of the objects being viewed. This flattening, as already mentioned, is a major hallmark of modernism in art. Helmholtz has substituted the seeing eye for the older, meaning-filled mind.

Manet and Modern Flatness

Edouard Manet is traditionally credited as the first artist to decisively express the modernist aesthetic in painting. Although it is difficult today to recover the sense of shock and outrage with which his works were first received, at this distance we can thoroughly grasp the pictorial qualities of Manet's work that produced the early dismay. His now classic *Olympia* (1862, Fig. 3.1), reveals Manet's cool analytical realism, compatible with that of Flaubert. The unsentimental, aggressive character of *Olympia*, staring immodestly, is obvious. Emile Zola, the writer and friend of Manet, characterized him as "a man of our age. I see in him an analytical painter. All problems have again

been put into question, science has had to have solid foundations, and it is based on exact observation of facts."

Further, the modernist, Rood-Helmholtz, flattening, or foreshortening, of the total picture space is easily observed when the Manet is compared to the corresponding Titian (Fig. 3.2) with its sculptural, voluminous space continuously moving into the distance. The Titian, which Manet copied (in an earlier drawing), is known to have influenced the *Olympia*.

Manet's work, however, is much shallower, appearing tipped up toward the picture plane, and the surface of each figure in his works is decidedly flatter than the standard of pre-modernist works. The treatment of light is quite different, for most of the traditional halftones—the gradual shading of objects suggesting a sense of volume—are missing. A modern critic, Theodore Reff, describes this well: the "tones are concentrated at the extremes of the scale, with relatively few in the middle, giving it the harshness and startling immediacy of flash-lit photograph." At the time the realist painter Courbet is quoted as saying of *Olympia*: "It's flat, it's not modeled, it's the Queen of Spades stepping out of her bath." In response Manet is reported to have said that Courbet's aesthetic ideal was a billiard ball!

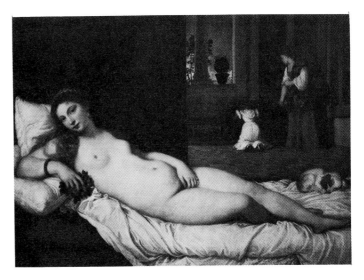

Fig. 3.2 Titian, *Venus of Urbino.* 1538

Fig. 3.3 Workshop of Velazquez, *Philip IV.* 1631–32

Manet and Photography: General Context

In addition to the prime factor of Manet's personal aesthetic perception, three influences have been suggested as contributing to the development of his modernist style: photography, Spanish painting, and Japanese prints. Of the three, the evidence now supports photography as the most decisive influence, although this claim is not, at least at present, generally accepted. It is proposed that Manet's visual sensitivity to the general analytic-reductionist mentality of his time was most strongly affected by the expression of the same logic in photography and that Spanish painting and Japanese prints had considerably less significance although they cannot be totally discounted. (It should be kept in mind that, at the time, photography was still closely tied to science.)

First, consider the Spanish artists, such as Velasquez (Fig. 3.3) and Goya (not shown). Undoubtedly they exerted an early influence on Manet, since he copied several works of Velasquez (Fig. 3.4), spoke favorably of him, and many of his paintings are filled with Spanish themes from guitar players, and reclining Spanish women, to bullfighters (Fig. 3.5). This is the influence of subject matter, general composition, and of palette, that is, the

Spanish predilection for black and white, and, especially in Velasquez, the relatively common emphasis on strong lighting. But the problem at issue is to account for something new in art history, the specifically modernist flattened style of Manet. The reductionist mentality leading to the flattening of space is not to be found in these Spanish works, which have the traditional depth and emotional content—hence Manet's modernism is not reasonably traced to them. For example, many of the Salon painters of the time—that is, the established artists working in the traditional style—were also enthusiastic admirers and adapters of the Spanish masters, yet their work remained unaffected. It is much more plausible to suppose that the factors facilitating the sudden rejection of the centuries-old Western tradition of painting, which had already been assimilated by Manet, lay outside of it in the fundamental novelties of the new modern culture.

There is, in any case, a wealth of evidence for the influence of photography on Manet—much of which has only recently been uncovered. A fundamental condition was that Manet was born at the right time—1832. Photography begins (for all practical purposes) in August 1839, when Daguerre's process was made public in Paris to a crowded joint meeting of the French Academy of Science and the Acad-

Fig. 3.4 Manet, *Philip IV* (after Velazquez). 1862

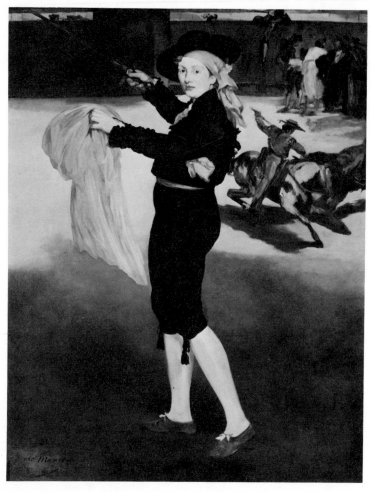

Fig. 3.5 Manet, *Mademoiselle Victorine as an Espada.* 1862

emy of Art. It was an instant success and *cause célèbre.* Aaron Scharf, in *Art and Photography,* refers to this meeting:

> The symbolic union of science and art which ushered in the daguerreotype could not have been better expressed than by the presence in the chair of Eugène Chevreul, the new President of the *Academie des Sciences,* whose famous work on the simultaneous and successive contrasts of colors was published in book form that same year.

In the early 1840s, photos were still a rarity, but by 1849, 100,000 Parisians were having their photographic portraits made each year; by the 1850s, the first modest effects of photography on paintings were being noticed by critics.

Gerald Needham has suggested a very special photographic influence on Manet: the nineteenth-century equivalent of pornographic photographs. Baudelaire describes the great popularity of such photographs in the 1850s: "the thousand hungry eyes bending over the peepholes of the stereoscopes." Figure 3.6 shows a French pornographic photo of the 1850s, strikingly like *Olympia.* Needham characterizes the women in these photographs as "more or less naked and leering at the spectator with a conscious im-

pudence." More important, Needham also describes the stylistic similarity of *Olympia* to stereoscopic pictures:

> Unfortunately this cannot be illustrated except by looking into a stereoscopic viewer. . . . The characteristic of the stereoscopic photograph is to create an illusion of actual depth, but each object in the picture appears flat—a cardboard cutout. The flattening in *Olympia*, which is such a revolutionary stylistic element (the "playing card" as Courbet called it), is thus extremely close to the effect of the main figure in the stereoscopic shots.

It is known that Delacroix studied pornographic photographs taken under his direction and claimed that they gave new knowledge of the body. Manet no doubt saw some of these as well. Needham, in line with the present argument, concludes that at least *Olympia* was much more influenced by such photographs than by Japanese prints. An impressive documentation of the many sexual aspects of *Olympia* that supports the association with pornographic photographs, can be found in Theordore Reff's recent *Manet: Olympia*.

The potential influence of photography on painting was remarked upon by many of the already established artists. Turner "believed that photography would revolutionize painting—that it would help painters to a new knowledge of light." Delacroix was well known as a champion of the new medium. He wrote in his *Journal*: "Let a man of genius make use of the daguerreotype as it should be used and he will raise himself to a height that we do not know." In 1854, he wrote, "How I regret that such a wonderful invention arrived so late. I mean as far as I am concerned! The possibility of studying such results would have had an influence on me which I can only imagine by the usefulness which they still have for me, even with the little time that I can give to serious study." The period of Manet's twenties (1852–61), when his own style was being developed, was almost perfectly synchronized with the initial impact of photography on painting.

Photography and Flatness

The new photography also fulfilled Turner's comment—that more than anything else it represented a new analysis, a new practical science, of light. To be a photographer was to be constantly analyzing, studying, and observing the effects of light. For the new medium, in spite of much literal realism, represented reality in a very distorted

Fig. 3.7 Nadar, *Catacombs*. 1861

way — the major distortion was the flattening of visual space, an effect brought about by four factors. First, black and white photographs omit the many cues to depth that are based on color differentiation. Second, the early, more primitive film did not reproduce the broad range of black and white halftones that contemporary film captures, thus reducing depth still further. Third, photographers often used unusually bright, artificially created light that led to still greater black-white contrast effects (see Fig. 3.7). And finally, it was common to use plain flat backdrops for studio portraits, in order to keep visual attention on the subject. This convention markedly reduces the depth in such photo portraits. All these transformations of the image were noticed in varying degrees by artists. An early specific discussion was published in 1871 by the English artist and critic Philip Gilbert Hamerton, who in the 1860s had travelled and painted extensively in France.

> One of the best photographs of the sea, which I have been able to procure in Paris, is a view of sea and sky, with a pier and lighthouse at the spectator's right. It is by E. Colliau, and is entitled "La Jetée." The negative has been exposed a very short time indeed, in order

to preserve the light on the clouds, and the glitter of the sunshine on the water. These two truths are accordingly obtained, the silvery touches of soft light on the clouds are all admirably rendered, too. But the gray shade of the clouds is given in deep brown; and, although the sun is high, the lighthouse, the pier, and all the people upon it *are all in silhouette, without the faintest trace of any detail whatsoever.* Of course, if Mr. Colliau had exposed his wet collodion negative a few seconds more, he would have obtained the detail in the pier at the cost of his sky, which would have been all decomposed away by the powerful action of the abundant chemical rays, and his negative on development would have exhibited a black sky over a very dark sea, which in the positive would have given us a white sky and pale water, without a glitter. But we should have had our pier in the corner quite perfect, and should have been able to see the people upon it quite distinctly. (emphasis added)

Though Hamerton was personally committed to a realistic aesthetic and saw these effects as faults, a younger, more open artist might easily value them differently. It is also interesting to note that "brown clouds," "black sky," and what Hamerton describes in a later passage as a sun like "a gray wafer on a white ground," all prefigure the coming modernist use of minimal and of nonliteral color.

Photographic Influence on Manet: Specific Evidence

Attention to *A Woman with a Parrot* (1866, Fig. 3.8) will be helpful in beginning our specific discussion of Manet's photographic tendencies. Recently Peter Gay, after noting Manet's propensity for covering large areas of his paintings with unmodulated black or dark brown, comments on the spatial ambiguity in this specific painting. He observes that the floor on which the "model stands becomes at some indeterminable point the background against which her pink shape defines itself; this is a spatial trick far more characteristic of modern photography than of nineteenth-century painting." But Hamerton points out that this was a common property of *early* photographs in the 1860s. Describing a marine photograph by Gustave le Gray, he states:

In the photograph the blaze of light upon the sea is given with perfect fidel-

Fig. 3.8 Manet, *Woman with a Parrot.* 1866

ity; but in order to get this, and the light on the edges of the clouds, all else has been sacrificed. . . . Towards the sides of the photograph, the distinction between sea and sky is wholly lost in one uniform shade of dark brown, extending from top to bottom, without any indication of a horizon; so that, if you were to cut a strip an inch and a half broad from each side of the photograph, no one looking at the strip would at all suspect that it represented either sea or sky, or anything else in nature.

A similar background effect can be seen in other well known Manet portraits. Some examples (none shown here) are *The Beggar* (1865), *The Fife Player* (1866), *Portrait of Duret* (1868), and others. This same effect can be seen in a Courbet (Fig. 3.9) painted in the 1850s when Courbet often worked from photographs.

Manet's direct links to photography are considerable. By 1860, Manet must, of course, have seen hundreds, more probably thousands, of photographs. But more important, he was himself an occasional amateur photographer and his personal album of photographs has been identified. Two of Manet's etchings were based on photographs: one an American daguerreotype of Edgar Allan Poe (Fig. 3.10), and

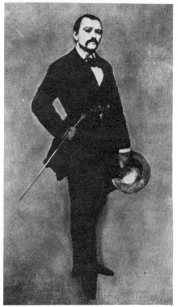

Fig. 3.9 Courbet, *Portrait of Max Buchon.* 1854

the other a Nadar photograph of Charles Baudelaire (Fig. 3.11). The two etchings (Figs. 3.12 and 3.13) employ the photographic contrast between black and white, and in fact further accentuate it. The Baudelaire photograph served as a model for four slightly different portrait etchings. Important paintings of Manet's known to be based on photographs (that is, painted from them) are *The Execution of the Emperor Maximilian* (1867) (see Aaron Scharf for a detailed presentation of several photographs involved in this famous work) and the later portraits of Mery Laurent (1882), Henri Rochefort (1881), and Clemenceau (1879).

The portraits done in 1880–81 of Isabelle Lemonnier and Jeanne de Marsy entitled *Printemps* were probably made from photographs. Alan de Leiris reports that Manet used photography when making an etching of the painting *Printemps*: "He had it photographed and printed on very thin paper. This image was then placed over a light source and the outline traced on the back of the photograph to serve as a pattern for the etching," a most inventive use of the medium and a practice that still exists in contemporary printmaking.

Many Manet family photographs have been identified from the period of the 1840s, 1850s, and 1860s, including photographs of people whom Manet painted, for ex-

Fig. **3.10** S. W. Hartshorn (attributed to), *Edgar Allan Poe.* 1848. (Fig. 3.11 follows Fig. 3.12)

Fig. **3.12** Manet, *Edgar Allan Poe.* 1856

Fig. 3.11 Nadar, *Portrait of Charles Baudelaire.* 1859

ample Madame Brunet (Fig. 3.14), Antonin Proust (now shown), Abbé Hurel (Fig. 3.15), and others. In the preceding examples, the family album photographs are not known to have been used by Manet as models, but in view of the photographic character of these portraits and in view of Manet's frequent use of photographs, it is quite possible that other missing photographs were used.

So far, Manet scholars have identified the photographs used in making seven different paintings and etchings, while strong specific photographic influence has been claimed for at least five other works. In view of the many factors that could have destroyed historical evidence for Manet's use of photographs, it is highly probable that he used them for many other paintings for which there is now no evidence. Similar material for Japanese prints is weak. It was not until the mid-1870s that there is any evidence that Manet worked from Japanese prints when they provided motifs that Manet used in illustrating Mallarmé's *Afternoon of a Faun* and his translation of Poe's *The Raven.*

The art historian John Richardson shares the opinion that photography had a major role in determining the style of Manet's portraits. He calls attention to the prevalence of frozen poses and deadpan expressions in a number of likenesses by Manet. What, he asks, "are those

models staring at so intently yet so vacantly? Not the artist, one feels, but Nadar's magic box!" Richardson also identifies the elimination of halftones as Manet's major innovation. He cites this elimination as clearly present in such early works as *Le Guitarre* (not shown), and *Portrait of the Artist's Parents* (Fig. 3.16). He goes on to say that Manet had been working toward such a style from as early as 1853 when Manet had criticized the work of his teacher Couture as being "too encumbered with half-tones." Richardson concludes, "small wonder that by the end of 1861 Manet found himself surrounded by a small authentic band of young artists . . . who looked up to him as a new master."

The great French photographer Nadar is certainly the likely candidate for some of this influence. Manet was a friend of Nadar's and was familiar with many of his photographs. The model for *The Young Woman Reclining in a Spanish Costume* (1862, not shown) is believed to be Nadar's mistress. Nadar's photograph of Manet (Fig. 3.17) is similar to the representation of Manet by the painter Fantin-Latour (Fig. 3.18), who was an enthusiastic amateur photographer, and a friend of Nadar, in addition to being an early (1857) friend of Manet. Fantin-Latour's photographic style has often been commented upon. One curious characteristic of Fantin-

Fig. 3.13 Manet, *Portrait of Charles Baudelaire.* 1865

Fig. 3.14 Manet, *Portrait of Madame Brunet.* 1862

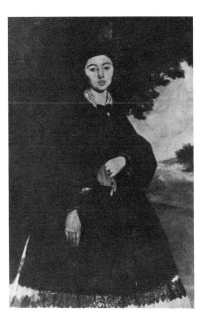

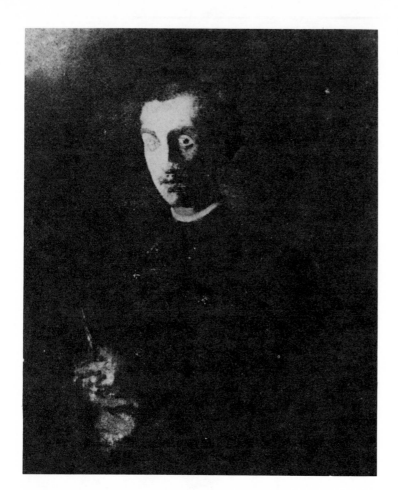

Fig. 3.15 Manet, *Portrait of the Abbé Hurel.* 1859. (Fig. 3.16 follows Fig. 3.24)

Fig. 3.17 Nadar, *Edouard Manet.* 1865

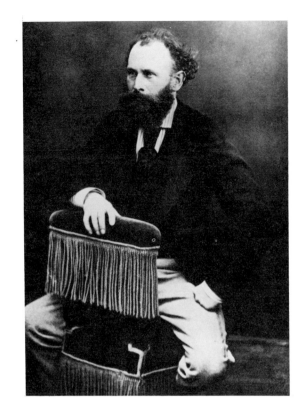

Fig. 3.18 Fantin-Latour, *Portrait of Edouard Manet.* 1867

Fig. 3.19 Fantin-Latour, *Still Life.* 1866

Latour's paintings is the difference between his still lifes—typically, flowers (Fig. 3.19)—and his portraits. The latter are reliably agreed to be quite photographic in quality, but this is not the case with his flower paintings. Their striking colors and more traditional realism contrast markedly with the somber palette, stiff poses, and photographic surface of his portraits. This difference may be attributable to his use of photographs for painting portraits, but not for still lifes. Because photographs of flowers lacked color, apparently they were rarely employed as models for paintings.

The same distinction is present in Manet's work. That is, a strong photographic quality appears retricted to his portraits—the only kind of work for which the actual photos have indeed been identified. Manet's still lifes—his flowers, asparagus, fish—like Fantin-Latour's, do not seem photographic either (Fig. 3.20). In short, it appears that the photographic quality of an artist's paintings is restricted to those subjects for which photographs served as models and that the photographic style characterized by flattened space and lack of modeling, is not easily transferable to subjects for which photographs were rarely used as models.

An especially interesting contribution of Nadar's was his early use of artificial light in photog-

raphy (he was among the first to develop this technique). His famous photographs of the Parisian catacombs, taken in 1861, piqued enough public interest that we may presume Manet saw them (Fig. 3.7). One of the most "photographic" characteristics of many of Manet's paintings is the representation of subjects' faces with one side heavily lit and the other in shadow (Fig. 3.21; see also Figs. 1.1 and 3.13.) In Figure 3.7 one can see an example of the effect of artificial light causing the face of the figure to be reduced and modernized to a remarkable degree. Next to it, Manet's portraits employ similar lighting. This aspect of Manet's painting was noted at the time by Hippolyte Babou, who described Manet as "seeing the outside world in spots and patches, as though he was looking at it with dazzled eyes."

Other important evidence for the influence of photography is shown in a painting by Charles Nègre (Fig. 3.22) made from a photograph (Fig. 3.23) taken by the artist in 1852. Eight to ten years before Manet's own innovation, one can see here in these buildings a simplified treatment of light and form that projects well past Manet to Cézanne and Cubism. Nègre was a member of the Photographic Society in Paris and often painted from photographs. Once more photography and the reductionist style

Fig. 3.20 Manet, *Still Life with Carp.* 1864

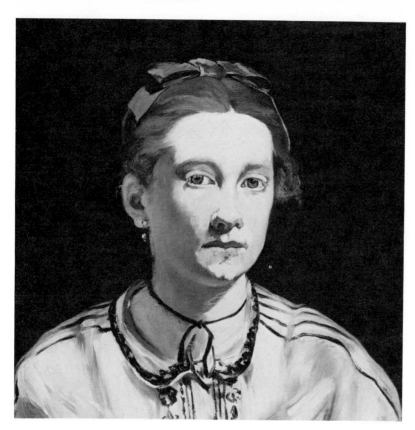

Fig. 3.21 Manet, *Victorine Meurand.* 1862

are linked—this time without any Spanish or Japanese influence. Nègre, however, never developed the modernist breakthrough as did Manet. Perhaps he lacked the aesthetic insight or perhaps was born too early for the full impact of photography to be strong enough to overcome his Salon training.

Japanese Prints: The Case against Early Influence on Manet

Now, the strongest case for the influence of Japanese prints on Manet's style has been made by Sandblad who notes that some Japanese woodcuts had been commented upon by European artists in the second half of the 1850s. The craze for things Japanese became obvious in the mid-1860s and peaked in France in the 1870s. By the mid-1860s Manet had almost certainly seen a good number of Japanese prints and probably owned a few. (For example, his painting of Zola, 1867 [not shown here], contains one in the background, but next to a photograph of *Olympia*.) There is no doubt about some influence, but the critical issues of how soon and how much remain. Sandblad claims that a small shop selling Japanese *objets d' art* and curosities, which opened in Paris in

1862, provided the earliest decisive Japanese influence on Manet—an influence that is reliably acknowledged by art historians to be evident in Manet's work by the mid-1860s.

But, weighing strongly against the early importance of Japanese prints is the photographic style apparent in Manet's works, such as the *Portrait of the Artist's Parents* (1860, Fig. 3.16), which predated any Japanese influence. This painting's photographic character was noticed at the time and it has been suggested by later art historians that it may have been directly based on a photograph—not, obviously, by Figure 3.24, but presumably by an image on the same type. A striking but little known 1859 Manet portrait of Abbé Hurel (Fig. 3.15) shows obvious photographic character; although not shown here, the atmosphere of photography seems to hover over *Portrait of a Man* (1855–56), *Portrait of a Man* (Rubini, 1860), and *Proust* (ca. 1855) as well. *Portrait of Astruc* (1863, not shown) and *The Portrait of His Mother* (1863, Fig. 3.25) have a photographic quality, as does *The Old Musician* (1862, Fig. 3.26), which, like the photograph (Fig. 3.27) paired with it, presents a haphazard organization in which each subject seems to be posed with little attention paid to overall interpretation and where figures at the edge of the canvas are just "cut

Fig. 3.22 Charles Nègre, *Market Scene*. 1852 (oil)

Fig. 3.23 Charles Nègre, *Market Scene on a Quai in Paris*. 1852 (calotype)

Fig. 3.24 Anonymous, *Miniature Photo-Painting of an Old Darby and Joan.* ca. 1840s

Fig. 3.16 Manet, *Portrait of the Artist's Parents.* 1860

Fig. 3.25 Manet, *Madame Manet.* 1863

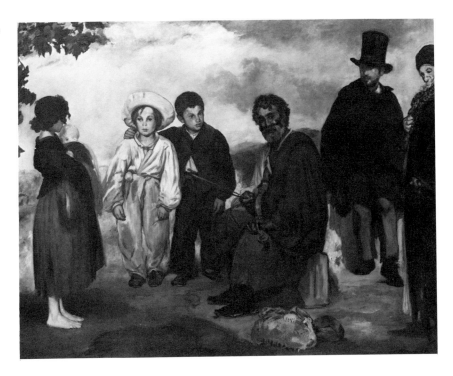

Fig. 3.26 Manet, *The Old Musician.*
1862

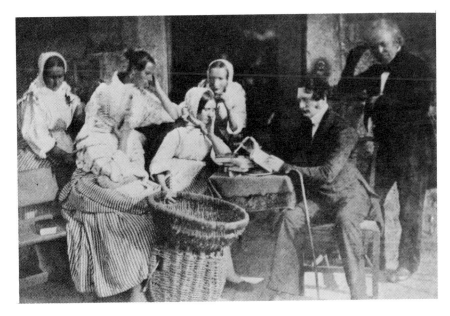

Fig. 3.27 Hill and Adamson, Calo-
type. ca. 1845

THREE: LIGHT, DEPTH, AND PHOTOGRAPHY **67**

Fig. 3.28 Manet, *Portrait of Stéphane Mallarmé.* 1876.

off", or out of the picture, as they would be in a photograph.

A further difficulty with Sandblad's case is that he cites the portrait of *Madame Brunet* (Fig. 3.14) as an example of Manet's emerging Japanese style. But he is unaware that Manet may have based this painting on a photograph; it is certainly characteristic of those paintings he is known to have made from photos. This painting's unsentimental photographic realism most likely was an important reason for its being returned to the painter as unacceptable. (Also, the date of this painting seems to be in dispute. Rewald reports 1860, which is before Sandblad's earliest claim of Japanese influence on Manet.) In general, Sandblad doesn't note Manet's frequent use of photographs, no doubt because most of the scholarship demonstrating Manet's use of them has been published since his 1954 study.

Considering Manet's total *oeuvre*, one can readily discern that his style evolves from an initial somber, rather static and quite photographic one to his later period, dominated by color and soft or quickly brushed effects. For example, see the painting of Mallarmé (Fig. 3.28). This order of development also argues for the primacy of photography in the early period followed by a later influence from Japanese prints.

It is difficult to find a strong

Japanese style about Manet's work up until the mid-1860s. Indeed, it is not until the 1870s that Manet's works display much that is obviously Japanese. Even then the resemblance can be overemphasized.

To elevate the later Japanese influence over that of the earlier, more modernist, more pervasive photograph, supports Peter Gay's claim that "art historians have too quickly assumed that a painter finds his inspiration primarily in art." Further, Manet's frequent use of large areas of dark color and his preoccupation with light are quite unoriental. The latter preoccupation he himself expressed: "Light is the principle personage of a painting." Finally, it is significant that some Japanese prints, for example, those of Hiroshige, were probably themselves influenced by photography in Japan by the rapid acceptance of the new medium from its introduction there after 1844.

Manet and Arnheim's Thesis on the Cinema

Rudolph Arnheim first published in 1933 an interpretation of the artistic significance of cinema that bears directly on the contribution of early photography to Manet's style. Arnheim proposed that the special qualities of film *as art* derive from the exploitation of the *limitations* of the medium. In particular, he suggested that the lack of color (in the early cinema with which he was concerned) and the relative lack of depth in these black and white films allowed the director to introduce many artistic effects. For example, "the purely formal qualities of the picture come into prominence only because of the lack of depth". The relative lack of depth also allows such artistic effects — as the powerful contrast between light and dark — an effect often used with great success in murder-mystery and horror films. These effects, of course, are all unrealistic distortions of natural vision. As Arnheim puts it, "Art begins where mechanical reproduction leaves off."

By extension, the claim is made here that Manet's artistic sensibility led him to introduce into his works the major distortions of the visual image which photography had created. Ironically, while the public was dazzled by the realism of the new medium, the artist, if this thesis is correct, was drawn to photography's striking new reductionist "unrealities."

Conclusion

The preceding chapter illustrated the way in which the analytical reductionist mentality common in nineteenth-century science was first decisively articulated in art — in the *Madame Bovary* of Flaubert. In

this chapter the same phenomenon is observed in the paintings of Manet. This mentality historically parallels Helmholtz's similar great modernist investigations of light, and his and Rood's remarks on depth. Both traditions now express the same assumption, namely, that one is to observe the visual world as a set of sensations devoid of higher contextual meaning. The result is a cool, objective, and analytical distancing realism. As shown by the comments of Rood and Helmholtz this new approach resulted in the flattening of perceived depth (or space), and for the artist the flattening of painted space as well. Both cool realism and reduced depth were also common novel effects in early photography—an applied visual science that strongly influenced Manet's most important initial move toward modernism.

FOUR

Color: Theorists in Science and Art

Although the primary focus of this chapter is on color, an inevitable difficulty is that the various dimensions of perceptual experience often occur together in the writing of scientific theorists. They frequently deal with several different visual phenomena: light, space, color, and so on—though usually only one aspect is investigated at a time. Similarly, the artist also had to use and be involved, simultaneously with more than one visual dimension. As a result it will often be necessary to deal with the same theorist, or the same artist, in several different chapters.*

The reason for presenting the following material around perceptual phenomena, is to put the emphasis on visual science, which is the lens through which we are looking at modernist art. This contrasts with the standard art historical treatment, which presents modernism as a series of movements or great artists in which the major influences are transmitted from within the tradition of art—from artist to artist or school to school.

*As a general rule, however, the chapter topics, for example, Light, Color, Space, Form, are in the approximate historical order in which they arose as subjects of conscious preoccupation both within science and art; also, the treatment within each chapter is typically in chronological order.

The Rood-Helmholtz Insight and Monet

The scientific approach of Rood and Helmholtz to both light and color was equally analytic and reductionist. First, recall Rood's observation that a landscape when viewed from an abnormal position "appears much more vivid in color . . . like a mass of beautiful patches of color heaped upon each other, and situated more or less in a vertical plane." Helmholtz (1867) elaborates on the same consequences for color when viewed in a manner that breaks our common preconceptions by focussing attention on the "individual sensations." Then

> it is a familiar experience that the colours of a landscape come out much more brilliantly and definitely. . . . In the usual mode of observation all we try to do is judge correctly the objects as such. We know that at a certain distance green surfaces appear a little different in hue. We get in the habit of overlooking this difference, and learn to identify the altered green of distant meadows and trees with the corresponding color of nearer objects

Observed in the analytic/reductionist way the colors lose

their association with near or far objects, and confront us now purely in their own peculiar differences. Then we have no difficulty in recognizing that the vague blue-gray of the far distance may indeed be a fairly saturated violet and that the green of vegetation blends imperceptibly through blue-green and blue into this violet, etc. This whole difference seems to me to be due to the fact that the colours have ceased to be distinctive signs of objects to us, and are considered merely as being different sensations. (emphasis added)

Of major importance is the observation by both visual scientists that such an attitude toward color changes the appearance of the colors themselves, by making them brighter, more varied, more unusual, and less associated with a particular distance. Helmholtz's discussion should be compared with a similar but much later statement of Monet:

> Try to forget what objects you have before you. . . . Merely think, here is a little square of blue, here an oblong of pink, here a streak of yellow, and paint it just as it looks to you, the exact color and shape, until it gives your naive impression of the scene.

Monet followed this axiom so regularly that even while observing the body of his dead wife he reported that he could not help but note in her face the shades of blue, gray, and yellow that death had brought.

In a similar vein is the comment, radical at the time (1890), by the symbolist critic Maurice Denis, which expresses the same sentiment:

> a picture before it is a picture of a battle horse, nude woman, or some anecdote is essentially a plane surface covered by colors arrayed in a certain order.

A translation of Denis into the language of Helmholtz would be somewhat as follows: "the visual image before it is a group of people, or a landscape or a social event, is essentially a sensory experience of colors arrayed on the retinal surface in a certain order."

The effect of Monet's reduction of paintings to areas of color is perhaps best seen in his haystack series (one of which is shown in Fig. 4.1). That such paintings are close to pure objectless abstraction is clear from their effect on Wassily Kandinsky. The "Helmholtzian" insight these haystacks provided when he first saw them in 1895 led him to observe that colors, once they cease to be associated with objects, can

be "considered merely as being different sensations."

Previously I knew only realistic art. . . . Suddenly, for the first time, I saw a "picture." That it was a haystack, the catalogue informed me. I could not recognize it. This lack of recognition was distressing to me. I had a muffled sense that the object was lacking in this picture, and was overcome with astonishment and perplexity that it not only seized, but engraved itself indelibly on the memory, and, quite unexpectedly, again and again, hovered before my eyes down to the smallest detail. All of this was unclear to me, and I could not draw the simple consequences from this experience. But what was absolutely clear to me was the unsuspected power, previously hidden from me, of the palette, which surpassed all my dreams. Painting took on a fabulous strength and splendor. And at the same time, unconsciously, the object was discredited as an indispensable element of the picture.

Although Monet may have been indirectly influenced by the emerging visual science (see below) there is no evidence for any obvious or direct link to Helmholtz. Instead, the painter's constant in-tuitive study and expression of pure visual experience "uncontaminated by the higher meanings" of objects is a strong example of a conceptual parallelism with the slightly earlier visual science. In fact Monet, due to his radically empirical attitude toward visual experience, was indifferent to theoretical science and hostile to religion, metaphysics, and theory of any kind except for limited generalizations won from hard experience. The modern critic Seitz refers to this as Monet's "ruthless devaluation of the transcendental"—a reductionist position *par excellence.*

Helmholtz further exemplifies the emerging new visual world:

Artistic painting of the highest type, however, is achieved only when an artist succeeds, not just in reproducing colors, but in imitating *the action of light upon the eyes.*

An artist cannot copy nature but he must translate it. . . . This translation can give us an impression which is in the highest degree clear and forceful, *not only of the objects themselves, but also of the different lights under which we see them.* (emphasis added)

Any reader of Helmholtz's other relevant writings such as "The Relation of Optics of Painting"

(1870) or "Recent Progress in the Theory of Vision" (1868) will be struck many times by their modernist logic.

Helmholtz's research introduced a wide audience of readers to such topics as the determinants of brightness, color after-images, data on additive mixtures of color, colored shadows, aerial perspective, and others. It is interesting that in his important 1871 essay "The Relation of Optics to Painting," Helmholtz's German terminology is translated by the word "impression" more than once each page—it is especially common in the earlier more theoretical pages. This is three years before a Monet painting titled *Impression, Sunrise* resulted in the term "Impressionism" being applied to the style of that now familiar school. For example, Helmholtz writes "the imitation of nature in a painting is more than a copy, it is an ennobling of the impression of the senses."

For many purposes the words "sensation" and "impression" are synonyms, a connection noticed by Castagnary in one of the few generally supportive reviews of the original Impressionist exhibition; in April 1874 Castagnary wrote:

If one wants to characterize them with a single word that explains their efforts, one would have to create the new term *Impressionists*. They are impressionists in the sense that they render not a landscape but the *sensation produced by a landscape.*

Helmholtz was considerably influenced by the color experiments of the famous English physicist James Clerk Maxwell, some of which are described by the Finnish psychologist von Fiendt:

in 1855 this superb research worker had already devised a method for producing the world's first color photograph. Maxwell took pictures of a given still life or landscape in an ordinary way, using achromatic negatives. But each time, he took three snapshots from exactly the same spot and with the same camera focus, masking the lens alternatively with red, green and blue filters. The exposed negatives were developed into positive black and white transparencies. Using three projectors, the three diapositives were superimposed on a screen, resulting, if the same filters as those through which the pictures had been taken were placed before their respective diapositives, in a *projected color photograph*. It had not only the three filter colors but contained all the colors of the originally photographed scene.

It was at almost the same time as these experiments that Flaubert was describing (in *Madame Bovary*) Emma's strolling at dawn in the park and her long contemplation of the countryside through a window with different colored panes. Although Flaubert later eliminated this description—this study in vision—its significance is interpreted by Jean Rousset as follows:

> Flaubert still attached importance to these pages, and this we can understand. It is a perfect illustration of subjective vision; seen through panes of different colors, the same landscape does not change only in color, but also in form, dimensions, relationships between objects at different distances.

"A Psychophysical Aesthetic"

With the exception of Pissarro, the Impressionists were not very inclined to theoretical statement, but the similarity of Impressionism to the new psychophysics was clear by the early 1880s to the critic Huysmans and to Jules LaForgue, a young poet and critic with a serious interest in art and science. Huysmans, who often showed great insight in his appreciation of Impressionism, nevertheless was "moved to say" that the study of these works (Impressionism) "belongs principally to the domain of physiology and medicine," while LaForgue commented in 1882:

> I'm doing . . . an article explaining Impressionism to these people [the Germans] who will then say that Impressionism—with all its madness—was born in Germany of Fechner's law.

Fechner's now classic *Elements of Psychophysics* (1860) had established experimental psychology by providing methods for the measurement of sensations, plus a mathematical law of how our subjective sensations are related to the objective physical stimulus. Even earlier than Helmholtz, Fechner helped to focus attention on the careful observation of sensory impressions. This new science of sense experience and its associated consciousness expressed the fundamental intellectual shift from the study of the external object to the analysis of an internal activity.

In 1883, LaForgue went on to use the ideas of Helmholtz, Fechner, Hartmann, and others freely to emphasize the grounding of the new art in the new visual science. Jose Argüelles, in a stimulating book on this period, very aptly terms this innovation the "psychophysical aesthetic." Argüelles summarizes La-

Forgue's position in terms strongly supportive of the parallelism thesis:

> By indicating the basically scientific nature of the impressionist vision, La-Forgue emphasizes the break with traditional art, which is the victim of its own creation, the academic studio. LaForgue understands *that there can be no truly visual art that does not take into account the properties and function of vision*: this can be taken as a fundamental assumption of the psychophysical aesthetic.

Modern Color: Chevreul and Impressionism

The unusually great (and justified) prestige of Helmholtz has tended to overshadow others who worked on problems in closely related areas. One of these is the French scientist M. E. Chevreul whose early, monumental studies of color are once more coming to be appreciated.

His initial and most famous work on color, which went through many subsequent editions (and translations), is *De la loi du Contraste Simultané des Couleurs* (*The Law of the Simultaneous Contrast of Colors*), published in Paris in 1839. Recall that in 1824 he had been appointed dye master of the great Gobelin tapestry works. Shortly after accepting this post he received complaints about some of the tapestry colors. He found that certain colors produced unacceptable visual effects when they were combined or placed close to other colors. He thereupon began lengthy, systematic research on the perceptual effects that adjacent colors have. His first discoveries, succinctly described by Birren, were the laws of simultaneous, successive, and mixed contrast. By *simultaneous contrast* Chevreul meant the change in appearance of a given color due to the effects of colors next to it. For example, complementary colors such as red and green tend to enhance the redness and greenness of each other, especially if they are of the same brightness and purity of color (see the border of the top portion of Fig. 4.2). Conversely, it is possible for two neighboring colors to diminish each other's brilliance. If yellow is put next to orange, the contrast is less, and yellow's blue afterimage makes the orange seem purplish, while orange's complement gives the yellow a greenish cast (Fig. 4.3): each seems duller.

By *successive contrast* Chevreul meant those phenomena observed when the eye, having looked at a given color for some time, is turned away to view a blank or neutral surface. For example, after

staring at a large red dot and then looking at a white surface, one sees a paler green dot. Today these effects would be called complementary afterimages. *Mixed contrast* involves the effect of a complementary afterimage of one color on the appearance of a second color not next to the first color. (This combines the properties of the preceding two effects.)

For example, if after staring at a large red dot the eye is shifted not to a neutral area but to a blue area, the green afterimage will change the blue toward greenish blue. Chevreul did not just deal with the simplest and most obvious cases but systematically described these effects for scores of pairs of colors. For example, he goes on to discuss contrast effects as influenced by white, black, and gray backgrounds (Fig. 4.4).

In his book, Chevreul treats the problems of color vocabulary, the construction of the color circle, the colors that he theorized as complementary, the primary colors, the structure of the color solid, color progressions, and so on. In the final sections he discusses the application of his findings to colors in painting, tapestries, carpets, mosaics, architecture, cloth, maps, wallpaper, and clothing. The persistent, underlying novelty in all of Chevreul's work, however, is a thoroughgoing shift from the study of the physical nature of color to the investigation of its psychological nature — a shift to the perceiver's point of view.

The Impressionist Camille Pissarro greatly admired Chevreul. In the 1880s, partly under the influence of Seurat, he attempted to convert Monet, Renoir, Cézanne, Van Gogh, and others to perceptual theories including Chevreul's. Although his enthusiasm was not contagious, Pissarro did successfully transmit Chevreul's principles to these seminal modernists. Earlier, in the 1840s and 1850s, Chevreul had already been accepted by many of the Salon painters. Couture, Manet's teacher, apparently introduced his pupils to Chevreul's principles.

Chevreul's emphasis on enhancement effects led him to the glorification of color with such comments as "It almost always happens that *true*, but exaggerated, coloring is more agreeable than absolute coloring." Throughout his book Chevreul suggests that it is often preferable not to mix pigments on the palette or on the canvas but to keep the colors separate and allow them to combine in the viewer's eye; he also posited that elaborate palettes were not needed to achieve color variety since a few colors combined with his simultaneous contrast principles would suffice. In short, he recommended painting by dots or stripes using relatively few strong colors, a technique shown in Figures 4.5 and

Fig. 4.1 Monet, *Haystacks at Giverny.* 1884

Fig. 4.2 Chevreul, Contrast of primary and secondary colors. 1860 (first published 1839)

Fig. 4.3 Chevreul, Color contrast effects of surrounding color on center dot and of center dot on surrounding color. 1860

Fig. 4.4 Chevreul, Dots of primary colors enhanced by proximity to gray dots. 1860

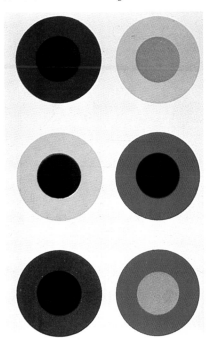

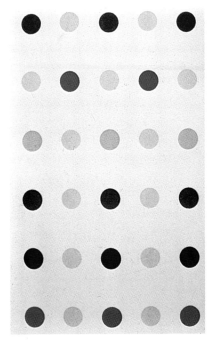

Fig. 4.5 Chevreul, Color contrast effects determined by relative width of stripes. 1860 (first published 1839)

Fig. 4.6 Monet, *La Grenouillère*. 1869

Fig. 4.9 Seurat, *Evening, Honfleur*. 1886

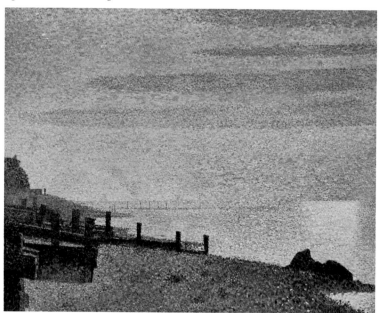

Fig. 4.10 Stilling, Early color-blindness test plate. 1878

4.4. Such a procedure involves the use of areas of solid color that Chevreul called "painting in flat tints" (see, for example, Fig. 4.2), in contrast to the other system of painting that portrayed objects in chiaroscuro. With this distinction between these two styles of painting Chevreul isolated the basis of the coming clash between modern flatness and the older "depth" styles of chiaroscuro. At the time he was writing, the first modern "flat" style was years in the future and "depth" painting still dominated, yet Chevreul was most sympathetic to painting with flat areas of color. He mentioned his admiration for the flat color in Gothic stained glass windows and noted that Chinese paintings were examples of flat tints. Chevreul remarked that even though such a style of flat tints preceded chiaroscuro in art history, it would still be an error "to renounce the first to practice the second exclusively."

The visual scientist Jacob Beck has commented that the charm of many Impressionist paintings lies in the "dematerialization" of the objects in them (for example Fig. 4.1). This effect is created by the use of very strong colors with little or no use of black for modulation. Such a procedure follows Chevreul's advice to avoid chiaroscuro with its modeling of depth through shading. That is, the use of bright, flat colors with little or no differences among them in darkness creates a dematerialized or atmospheric effect.

Although it is doubtful that Monet was directly influenced by Chevreul, there is no doubt about the parallelism that is obvious in such works as *La Grenouillère* (Fig. 4.6), where various effects of strips of flat tints can be seen.

Modern Color: Chevreul, Delacroix, and Baudelaire

Although Chevreul's direct links to Impressionism are modest, he was widely known by artists in France. Delacroix, the great Romantic colorist of the period just prior to Modernism, enthusiastically read Chevreul and often used simultaneous contrast principles. For example, he claimed, "Give me mud and I will make the skin of Venus out of it, if you will allow me to surround it as I please."

In his journal entry of October 11, 1852, Delacroix observed:

> One thing is certain and that is that by making the flesh red or purplish and by using highlights of the same type there is no longer any contrast and you therefore get the same tone everywhere. . . . Therefore one must put more green into the half-tints.

When green highlights were used with red flesh "the flesh immediately became luminous."

Delacroix's interest in color contrast problems led him to write Chevreul to arrange a visit but due to a persistent illness of Delacroix the meeting never took place.

Chevreul had a particular interest in red/green contrasts and referred to them often: he frequently starts his discussion of various contrast effects with these two strong complementary primaries. Delacroix was also partial to the same two colors, as is shown by Baudelaire's comments in his famous reviews of the Salons of 1845, 1846, and 1859. Enthusiastically identifying Delacroix as a great colorist, he picks out the painter's reds and greens for comments more than any other pair.

> Its color is incomparably scientific; it does not contain a single fault. . . . And far from losing its cruel originality in this new and completer science, the color remains sanguinary and terrible. The equilibrium of green and red delights our heart.

> Modelling with color . . . means first discovering a logic of light and shade, and then truth and harmony of tone, all in one

sudden, spontaneous and complex working. Put in another way, if the light is red and the shadow green, it means discovering at the first attempt a harmony of red and green, one luminous, the other dark.

Baudelaire seems equally preoccupied with red and green in his discussion of "modern color." No other pair receives such attention.

> Let us suppose a beautiful expanse of nature, where there is full license for everything to be green, red, dusty, or iridescent as it wishes.

> The trees are green, the grass and the moss are green; the tree trunks are snaked with green, and the unripe stalks are green; green is nature's ground bass, because green marries easily with all the other colors. What strikes me first of all is that everywhere—whether it be poppies in the grass, pimpernels, parrots, etc.—red sings the glory of green

And finally

> For a long time I lived opposite a drinking shop which was crudely striped

in red and green; it afforded my eyes a delicious pain.

Baudelaire anticipated so much in modernist art—certainly the "delicious pain" of contrasting complementary red and green is an uncanny intimation of such hard edge artists as Elsworth Kelly and Jack Youngerman. He is also acknowledging the stripe pattern or grating motif that would become so popular in the mid-twentieth century—a motif already focused upon by Charles Blanc (Fig. 4.7; see Chapter 7 section on grating paintings).

Fig. 4.7 Blanc, Diagrams illustrating heightened contrast at border of red and green in two large areas compared to the same colors in narrow bands. 1867

Seurat and Stilling: Pointillism and Elementism

However unconscious the parallel was between visual science and modernist painting in the 1860s and 1870s, by the 1880s the similarity of the latter to science, in fact the direct causal influence of visual research, was acknowledged. At this time, the crucial artist was Georges Seurat, and the movement in question is the Pointillist or Neo-impressionist movement, which he initiated and led. The major connection between perceptual science and art is well known, thanks particularly to William I. Homer's in-depth study, *Seurat and the Science of Painting* (1964).

Fig. 4.8 Blanc, Diagram illustrating optical mixing of color, that is, for mixing color in the eye. 1867

In 1879, at the age of twenty, Seurat had already begun the serious study of contemporary visual science. Initially, he studied both Chevreul and Charles Blanc's *The Grammar of Painting and Engraving*. In this popular book Seurat read such observations as: "When the Orientals, who are excellent colorists, have to tint a surface which is smooth in appearance, they make the color vibrate by putting tone upon tone."

Here Blanc, following Chevreul, is advocating optical mixture —the placing of small overlapping areas of different colors on the canvas and obtaining the resulting color by standing back far enough for the colors to be mixed in the eye (optically) in contrast to mixing the pigments directly on the canvas. This technique, first introduced in Western painting as a major style of the Impressionists, was developed almost into a science by Seurat whose adaptation involved the use of many small dots of unmixed pigment used to cover the entire canvas: a technique known as pointillism or divisionism. Pointillism is not only suggested in the statement above of Blanc, and in the writings of Chevreul, but the idea is visually portrayed in a Blanc diagram (Fig. 4.8). (See Homer for a thorough discussion of this point.)

The influence of Charles Blanc, professor at the Ecole des Beaux Arts and founder of the *Gazette des*

Beaux Arts, has been somewhat overlooked. For example, years before the Denis remark cited earlier with reference to Monet and Helmholtz, Blanc penned the following "formalist" analysis: "Painting is the art of expressing all the conceptions of the soul by means of all the realities of nature *represented on a simple surface in their form and colors*." (emphasis added)

The major scientific influence on Seurat was Rood's *Modern Chromatics*, published in the United States (1879) and quickly translated into French (1881). In it he expounded Helmholtz's color theory and many other scientists' work with special reference to painting, including a very precise description of the Pointillist technique. Rood was quite often specific in his instructions to artists about the handling of color and on how the new physics of light "could—and should—be applied to art."

An important work on color translated from the German into French at the time Seurat was steeping himself in scientific color theory was a book by Brücke, *Scientific Principles of Art* (French translation, 1878). This work by a prominent scientist and colleague of Helmholtz had an especially clear description of Pointillist theory and method. All these publications preceded Seurat's Pointillist paintings, the earliest of which was done around 1883 (Fig. 4.9). Seurat's *Evening, Honfleur* demonstrates the technique of painstakingly constructing a painting from small dots of carefully selected colors. Signac, the younger colleague of Seurat, described the method as being based on "the methodical separation of elements—light, shade, local color, and the interaction of colors." Seurat's Neoimpressionist Pointillism, or Divisionism, analyzed color to the extreme of dividing it down into small visual elements carefully chosen as to hue, brightness, and purity. Meaning, object, form, line, all were rejected in favor of detailed exclusive analysis of color sensations.

There is an important and previously unnoted pictorial parallel between Seurat's Pointillism (for example, his work *Evening, Honfleur*) and the first color blindness test plates, which were originally constructed and published in Germany in the 1870s by Jakob Stilling. These plates were also constructed of carefully controlled dots of color (Fig. 4.10). In Figure 4.10 the red and green dots are of matched brightness and size, so that the only cue enabling the viewer to identify the correct number is the color. Like the early Pointillist paintings by Seurat, the plates involve the complete rejection of lines. The subject can perceive the number only by optically mixing the color. This color plate, the first in the test set, uses red and green in order to

Fig. 4.11 Contrast diagram from O. N. Rood. 1881. (upper diagram); Copy of Rood's diagram by Seurat (lower diagram).

test for the most common form of color deficiency—the inability to distinguish red and green. Seurat's *Evening, Honfleur,* especially in the area where the sea meets the sky, is constructed of dots of greenish and orangeish-red color of such equal brightness that an individual who is red-green color blind will be unable to distinguish the horizon line present in it.

Seurat conceived of the surface of *Sunday Afternoon on the Isle of La Grand Jatte* as an abstract screen composed of tiny molecular units that transmit colored light—very much like today's color TV screen. According to W. I. Homer, it is possible that the artist was influenced by primitive color photographs of the day. The three-color process of constructing all halftones of color from dots of three primaries was invented in France in 1869—based in part on the research of James Clerk Maxwell (for a contemporary artist's response to the three-color photographic process see Chapter 8 on Chuck Close.) Such photographs were exhibited at the 1878 Exposition Universelle Internationale in Paris. In addition, Charles Gros, one of the inventors and also a poet, was in close touch with Charles Henry and his circle.

Figure 4.11 presents a copy of a color circle (contrast diagram) found in Rood, made by Seurat in one of his notebooks. According to Homer, a circle something like this

Fig. 4.20 Goethe, Diagrams illustrating various color phenomena. 1810

Fig. 4.23 Kupka, *Disks of Newton*. 1911–12

Fig. 4.19 Delaunay, *Homage to Bleriot*. 1914

Fig. 4.27 Chevreul, Color scales. 1856 (first published 1839)

4.25 Kelly, *Series of Five Paintings* (only three shown).

Fig. 4.26 After an Ostwald color plate in *Die Farbenfibel.* 1917

Fig. 4.29 Klee, *Resonance of the Southern Flora*. 1927

Fig. 4.30 Ostwald, from scientific color chart (*Die Farbenfibel*). 1917

Fig. 4.28 Klee, *Greeting–Diametrical Gradation Blue-Violet and Yellow-Orange with Blue and Red Accents (Arrows)*. 1922

strongly influenced Seurat in selecting the palette of colors used in his *Sunday Afternoon on the Isle of La Grand Jatte.*

However, in artists of this period other than Seurat and Signac the presence of scientific influence is often a difficult thing to document—even when it almost certainly exists. For example, by 1900 the logic of the new color theory can be found in the writings of Cézanne—even though there is no obvious evidence of a source in science. Cézanne wrote:

> To read nature is to see it . . . in terms of an interpretation in patches of color following one another according to a law of harmony. . . . the contrast and connection of colors— there you have the secret of drawing and modeling.

The Elementist Theory of Perception: Wilhelm Wundt and Ernst Mach

Stilling's plates can be seen as a visual expression of a dominant scientific theory during 1860 to 1900—an interpretation that has been labeled the "elementist," or "punktät" theory of perception. This theory is of interest since it is a major example of a conceptual similarity between visual science and Impressionism and Neoimpressionism—that is, a parallel with those painters who were preoccupied with sensory reality and represented visual experience with dots, dashes, strips of paint—the painterly equivalent to sensory elements. The elementist theory of psychology was a conceptualization of the external world, as we perceive it in any case, as consisting of a mosaic of sensory elements characterized by color and brightness. The elements themselves were sometimes called "just noticeable differences" (JNDs). For example, moving around the extreme edge of the color circle there might be 150 just noticeably—just perceptually—different degrees or units of color. (Of course, the many less pure colors mixed with white, gray, or black make for many thousands of additional discrete colors.) Experimental psychologists attempted to identify the actual number of these JNDs existing in each of the major sensory domains. For example, in 1896 the experimental psychologist Titchener summarized research on vision and audition by proposing that there are 32,820 visual sensations and 11,600 auditory sensory elements. He concludes that each of these over 40,000 sensory elements is distinct from the rest, altogether simple and unanalyzable, and each capable of being known consciously. These elements, plus those from the other sensory di-

mensions, represent what he calls "The full resources of the human mind."

For most scientists at the time the "elementist theory" was more of a general attitude or mind-set established by the nineteenth century preoccupation with studies analyzing and measuring sensation than a consciously articulated theory. This mind-set was suggested by the experimental approach to perception exemplified by Helmholtz, Fechner, and Wundt with their descriptions, categorizations, and measuring of sensations. However, none of these men was a pure elementist since all of them accepted a view of psychology that in addition included other autonomous mental processes, often of a dynamic nature, involving higher levels than simple sensory elements: such levels as perception, cognition, and volition.

The most powerful theoretical expression of elementism was proposed by Ernst Mach, the Austrian physicist (1838–1916) who also made major contributions to visual science. Mach based his philosophy of science upon his interpretation of sensory elements—a redefined form of the earlier units of "ideas," and "impressions." Mach's psychological theory is best expressed in his classic book, *The Analysis of Sensations* (1886). (What better summary of the method of Pointillism than "Analysis of Sensations"?) According to Mach, sensory impressions are ultimate in that nothing else exists but our sensations although he preferred to use the term "elements" rather than sensations. (Mach's philosophy also accepts the laws of logic and reason, but these are "invisible" operations of the mind and not the content of experience.) Thus sensations are what scientists should investigate, since even the ego, even objects, are best understood as complexes of the true elements—sensations. These complexes or clusters of sensations representing the self or an object often either "disintegrate into elements" or slowly change over time into very different clusters. Regardless, the sensations themselves, fundamental psychological atoms, do not change. In summary, Mach expresses his philosophy as "the world consists only of our sensations," a statement worthy of Monet.

Mach's reductionist hostility to higher theoretical concepts was also very much like Monet's mentality: for Mach rejected all metaphysical elements and assumptions "as superfluous and as destructive of the economy of science."

One major perceptual effect discovered by Mach is now known as the Mach band effect. The effect, which is a kind of sensory illusion, involves the enhancement of contours. For example, whenever there is a sudden change from an area of white to an area of black,

the edge between the two is accentuated. This accentuation comes from the presence of a subjective narrow band of brighter white in the white area just before the change to black and another narrow band of darker black just inside the black area.

This effect, which has received considerable attention in the field of physiological psychology, was noticed by Signac and quite consciously used by him, for example, in his painting, especially *Le Petit Dejeuner*, 1886–87 (not shown). For an informative discussion of the Mach band effect in this work and in other art, see Ratliff, 1971.

Ratliff points out the Mach band effect was used long ago in certain oriental ceramics. However, it apparently took a perceptually and scientifically oriented artist like Seurat to first notice it within traditional Western painting.

Charles Henry: A Scientific Theory of Aesthetics

Charles Henry (1859–1926), an unusual, multifaceted Frenchman with competence in fields ranging from mathematics to physiology, proposed a set of ideas about visual art that provoked great interest. His ideas were innovative interpretations and extensions of the earlier work by Chevreul, Blanc, Helm-holtz, and others. He was a theoretician of the new science, not an experimentalist—hence his theories were unsupported by carefully collected evidence. Though Henry's writings are often obscure, the particular concepts that can be reliably distilled from his work identify him as the first to develop systematically a scientific theory of art based on the new visual science. He is of special interest not just because he proposed these ideas but also because his ideas paralleled and directly affected the work of many artists in the period 1885 to 1915. For the present let us put aside Henry's romantic, mystical philosophy, which was part of the Symbolist movement, and attend to his general approach (again, we are heavily indebted to Jose Argüelles). Henry wrote:

> Art pursues the expression of the physiognomy of things, and [that] aesthetics studies the conditions in which these things are satisfying; that is, when they are represented gay or sad, agreeable or disagreeable, beautiful or ugly . . . aesthetic things for us are *reduced to forms, to colors, and to sounds.* (emphasis added)

In a related vein Henry writes of a future applied aesthetics:

> That which science can

and must do is to expand the agreeable within us and outside of us, and from this point of view its social function is immense in this time of oppression and blind conflicts. It ought to spare the artist hesitations and useless attempts in assigning or indicating the way in which he can find ever more rich aesthetic elements; it ought to furnish the critic a rapid means of discerning the ugly, so often informulable, however much it is felt.

Speaking at a more concrete level, Henry claims that colors and lines have specific intrinsic emotional significances derived from our biological nature.

Although the biological or physiological rationale remained an uninvestigated underpinning in Henry's aesthetics the idea of a scientific basis for aesthetic responses to simple perceptual elements appealed to Seurat's scientific predilections. Henry and Seurat met during 1885 and 1886; and the impact of Henry's ideas from that time until Seurat's early death in 1891 was considerable. The basic elements of Henry's aesthetic theory are *tone* (brightness), *tint* (color or hue), and *line* (straight or curved lines). Seurat, in a well known 1890 letter to a friend, pro-

vided the following short characterization of his own approach—one heavily influenced by Henry (and to some extent by Charles Blanc):

> Art is harmony. Harmony is in the analogy of contraries and in the analogy of similar elements of *tone, tint,* and *line,* considered according to their dominants and under the influence of light, in gay, calm, or sad combinations. . . .
>
> For *tint,* the complementaries, that is to say a certain red opposed to its complementary, and so on (red-green; orange-blue; yellow-violet).
>
> Gayety of *tone* is given by the luminous-dominant, of *tint* by the warm-dominant.

To expand and clarify this passage, Seurat is saying that positive or happy emotions are caused by bright light (luminous-dominant), warm colors (red, yellow, orange). And that harmony is the integration of both contrary and similar elements. He goes on:

> Calm of *tone* is the equality of dark and light; of tint, equality of warm and cold; . . . Sadness of *tone* is given by the dark-dominant; of *tint* by the cold-dominant.

Henry's influence was, if anything, greater on Signac, who in a more mechanical, or less inspired, way, applied Henry's theories. This influence is expressed in Signac's Pointillist Théâtre-Liberté (T-L) print (Fig. 4.12) and in *Portrait of M. Félix Fénéon* (not shown), both of which are based on Henry's particular theory of color and lines applied to art. (See Argüelles for a detailed discussion of the connection between Signac and Henry.)

In addition to its scientific character, Henry's theory contained a heavy emphasis on a general, mystical, vaguely religious harmony as the higher aim of his scientific aesthetic. This concern is part of a widespread reaction against science, especially against scientism—that is, extreme materialism and analytic-reductionist thought—which began in Europe in the latter part of the nineteenth century. The strongest artistic expression of this tendency was in the Symbolist works of such painters as Redon, Ensor, Moreau, Munch, and Klimt.

These artists, although of great intrinsic interest, are not part of the modernist movement, as the various religious, romantic, decadent, and mythological contents of their paintings make clear. Their art, though original in style, was inspired by earlier, synthetic, hierarchical pre-modern preoccupations. This is not a denigration of such

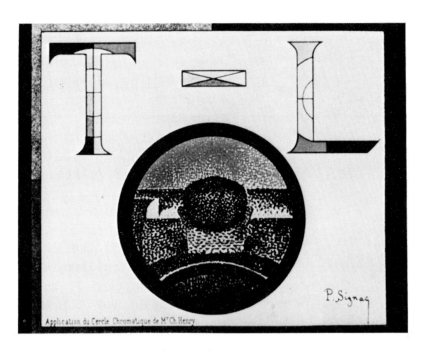

Fig. **4.12** Signac, *Théâtre-Liberté*. (print illustrating color circle of Charles Henry). 1888

movements — for they may in fact be of special importance to our increasingly "post-modernist" and expressionist times. However, they lie outside the present thesis.

In spite of Henry's obvious personal involvement in the higher synthetic meanings of his theory — an involvement that came to dominate his later years — it was the early, more scientific ideas that were to have the greater influence on artists. After Seurat's death a new generation of painters in the early twentieth century was to be affected by Henry and still newer theories of the emotional significance of color and simple forms.

Delaunay: The Disks of Visual Science

Robert Delaunay's contact with the new color science began very early, when he was 20 years old. This period, 1905–07, called his Neoimpressionist period, was seminal for Delaunay's career — a career that was internationally significant by the time he was 30 in 1915. He became aware of the color theory of Seurat's Neoimpressionist style through Cross, an artist who belonged to Seurat's original circle and who, along with Signac, was the leader of the Pointillist movement in the early twentieth century.

Delaunay's work of this time uses considerably larger patches of color than Seurat's small dots, but the influence is clear. More important still was Delaunay's friendship with Metzinger — an artist who later produced minor Cubist paintings and had a reputation as a Cubist theorist. (Along with Albert Gleizes, he published *Du Cubisme;* see Chapter 5.) After they met in 1905, Delaunay and Metzinger wrote letters and had many discussions about the scientific color research of both Rood and Chevreul.

In Rood's book Delaunay must have read the following claim first made more than 25 years earlier — a claim that even then was an extension of Chevreul. Rood wrote:

for example, where the design is worked out solely in flat tints. . . . We have here colours arranged in harmonious masses, bounded by sharp outlines, often definitely traced in black, and are pleased with them and with the beautiful, correct outlines. All graduation and blending of colours is abolished, and this fact alone announces to us, in an emphatic way, that the design makes no pretension to realistic representation; we are pleased with the colours and outlines, and are rather surprised to find how much

can be accomplished by them.

Delaunay was quite aware of his debt to Chevreul:

> It was the genius Chevreul whose theoretical studies called attention to the laws of simultaneous colors. Seurat had adopted them, but lacked the daring to forge ahead to the point of breaking with conventional methods.

Indeed, Delaunay's writing is filled with key words that show the influence of scientific terminology and the particular vocabulary of Chevreul and also, most probably, that of Charles Henry as well. Recall the title of Chevreul's primary work, *De la loi du Contraste Simultané des Couleurs*. This work had important sections on the harmony of colors. The complete title of Henry's most relevant work is, with key words italicized: "*Cercle chromatique*, presentant tous les *complements* et toutes les *harmonies des couleurs* avec une introduction sur la *théorie générale* du *contraste, du rhythme* et de la *mesure*." As we will see, these words all occur in Delaunay. Henry, like Delaunay, was preoccupied not only with simultaneous contrast and the emotional and dynamic significance of color, but also with color harmony and rhythms. Henry's ideas could have come to Delaunay's attention via two routes: through the Neoimpressionists, for example, Signac, who was active as a painter and as a theorist at about this time, and was strongly influenced by Henry. The other quite possible link would have been through Metzinger, a close friend of Gleizes, since Gleizes, according to Argüelles, became closely acquainted with Henry. In any case, an extensive color science vocabulary can be found in Delaunay's theoretical writings — for example, note the words italicized in the following passage by Delaunay:

> The *function of light* . . . remains the problem of modern painting. Seurat evolved the *contrasts of complementary colors from light*. He was one of the first to develop a *theory of light*. This *contrast* became his means of expression. Seurat's early death put a stop to his discoveries, . . . he was the one who pursued *research* into the methods of painting furthest.
>
> *Light* reaches us through our perception. Without *visual perception, no light, no movement.* Light in nature creates *movement of colors. The movement* is provided by the relationships of uneven

measures of *color contrasts* among themselves and [it] constitutes *Reality . . . Simultaneity* in light is *the harmony, the rhythms of colors* which creates *Men's Sight. . . . The Eye* is our highest sense, the one that communicates most closely with our *brain*, our *consciousness*, the idea of the vital *movement* of the world, and *its movement* is simultaneity. Our *comprehension* is correlative with our *perception. . . .* Clarity will be color, *proportions*; these *proportions* are composed of *simultaneous measures.*

Even more important than Delaunay's words are his powerful new abstract forms, which were apparently taken from the diagrams of color science. His famous disks —sometimes considered the first completely nonobjective paintings —are adaptations of many similar disks found throughout the writings of Rood and other color scientists. Indeed, they are not fully nonobjective, since the circular, spherical, and disk patterns taken from visual science still remain, and these shapes within visual science represent theory or stimuli used in studies of color mixing and are not without meaning and associative significance. The evidence for this striking parallel, taken from Rood's

Modern Chromatics (and other works), is shown in Figures 4.13 to 4.15 and 4.16 to 4.18. Such a source of imagery should not be surprising since disks, circles, spheres, all names for Delaunay's distinctive forms, (Fig. 4.19) are part of the common "iconography" of the new color science—an iconography and general aesthetic mentality already apparent 100 years earlier in Goethe's great work (Fig. 4.20); and also present in the early studies of Maxwell (Figs. 4.21 and 4.22). Indeed, Delaunay's writings make a strong case for parallelism—for viewing these pioneering abstractions as an explicit homage to visual science.

Delaunay, however, was not simply painting some quasi-literal expression of scientific color diagrams. There is certainly no reason to think that he had any real substantive knowledge of the new color science. Instead he admired and delighted in the spirit of the new theory and was drawn to the novelty of its iconography. His achievement was to take this material and portray its meaning in such a way that it could be visually appreciated by viewers without the slightest knowledge of or interest in perceptual science. One consequence would be that the new industrial environment with its circles, arcs, straight lines, and flat patches of color—all derived from science and technology—would be made not

Fig. 4.13 Rood, Color circle. 1879

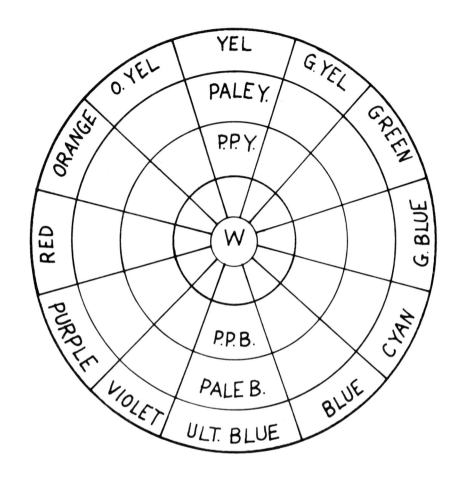

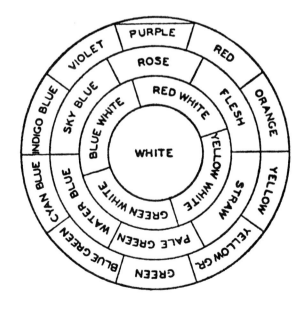

Fig. 4.14 Helmholtz, Color circle. 1867

Fig. 4.15 Delaunay, *Disk, First Nonobjective Painting.* 1912

Fig. 4.16 Rood, Disk for mixing colors. 1879

Fig. 4.17 Rood, Disk for mixing colors. 1879

Fig. 4.18 Delaunay, *Rhythms.* 1934

Fig. 4.21 James Clerk Maxwell at Cambridge, holding color top. 1855

Fig. 4.22 Maxwell's color top. When the top is spun the colors mix in the eye. The observer adjusts either or both sets of papers until they match. A color equation is then formed in terms of the exposed angles of each color.

just bearable, but even aesthetically desirable.

The work of scientists such as Chevreul, Helmholtz, Rood, and Henry very quickly fed into the rich stream of modernist artistic creativity in France. Johann Wolfgang Goethe's impact on art was much less and came later, since it was not until the early twentieth century that modernism strongly affected German artists. Goethe's writings on color were also ignored because they were very extensive, very complex, and were seldom translated. These factors plus Goethe's intemperate attacks on Newton resulted in a neglect of Goethe's contributions in the nineteenth century. Nevertheless, Goethe's theory of the primary colors had some influence, and his work as compared to Newton, was much more modernist in character since he was concerned with color as it depended on the condition of the eye. Newton was primarily concerned with light as a physical phenomenon. Goethe also developed many interesting patterns and visual stimuli in the course of his investigations (see Chapter 6).

Kupka: Major Similarities to Delaunay

The most powerful evidence that color science was the necessary catalyst for the development of nonobjective painting is the un-canny similarity between the role of color science in Delaunay's work and that of Frantisek Kupka. This Czechoslovakian artist also initiated abstract painting, independently of Delaunay. The scholar, Margit Rowell, describes the artist's experiment:

> The function of color, as Kupka began to conceive of it, was to structure space. He devised a system of large colored planes which cannot be mixed by the eye, which are not equivalent to shading or modelling and which indicate the rhythmic structure of the composition. . . . Kupka admittedly derived this solution from Neo-Impressionist example. He even referred to the planes as an enlarged Pointillism.

This brief stage of Kupka's is very similar to Delaunay's encounter with Pointillism—during the same years both used large lozenges of shingle-sized areas of color instead of dots. Like Delaunay, Kupka also accomplished his breakthrough in Paris—though there is no evidence that the two men had any significant interaction.

Kupka was drawn to scientific color theory. In his student diary he specifically noted Ernest Brücke's *Die Psychologie der Farben* (Leip-

zig, 1866). The German Brücke was a great physiologist (and a colleague of Helmholtz) who also made some important contributions to vision. Further,

> Kupka never ceased to be interested in the psychology of color, eventually devoting a great part of his research to it. In his book *Tvoření v Umění Výtvarném (Creation in Plastic Art)*, published in 1923 in Prague, he developed a theory very similar to that of Brücke in a chapter entitled "Meaning and Feeling of Color."

Kupka was quite familiar with Chevreul's work. His painting *The Yellow Scale (La Gamme Jaune,* 1908, not shown), for example, not obviously connected to color science, nevertheless was strongly affected by it, for this painting "shows all the variations of orange and yellow in Chevreul's 'Yellow-Orange Chromatic Scale'." In his writing, Kupka "referred to the theories of Newton and Herschel, Helmholtz, and Ogden Rood, and Charles Blanc indiscriminately." His experiments in color finally broke through to pure nonobjective color studies in his *Disks of Newton* 1911–12 (Fig. 4.23), which is obviously very similar in expression to Delaunay's work of the same period. In this painting the direct influence of and homage to scientific color circles is especially clear. For example, Rowell comments:

> The largest disk configuration consists of concentric bands of color laid out according to Herschel and Young's color table. This table was published in Ogden Rood's *Modern Chromatics* of 1879. Kupka copied and referred to it frequently, preferring it to Newton's theories which he found outdated. The Herschel-Young table calculated the relative length, density, and velocity of the wave lengths of color, from red . . . to purple. This analysis of color became fundamental to Kupka's thinking. He even devised a theory of the shapes of color which he illustrated in a series of paintings after World War I.

The connections here are so strong, and Kupka so aware of the inspirational power of science, that he comes very close to explicitly acknowledging this book's central thesis when he says: "I always had a great urge to learn. Psychophysical problems, for instance, always interested me, the parallelism of it."

Kandinsky: A Color Theorist

Wassily Kandinsky both strongly rejected and enthusiasti-

cally accepted science as it related to art. He rejected harsh, cold, materialist, and positivist science with its emphasis on physical reality. This rejection stemmed from his religious commitment and spiritual interests. (Kandinsky was a lifelong Russian Orthodox Christian of the Tolstoyan, mystical variety; he was also much influenced by Eastern religious notions, especially theosophy.) However, he was strongly drawn to psychophysical, perceptual, associative, and symbolic interpretations of color and form. At first, his involvement with the psychology of perception was modest, but as he continued to develop his nonobjective style he grew correspondingly more interested in perceptual science.

Kandinsky's thoughts at the start of his period of nonobjective painting are best characterized by his well known essay *Concerning the Spiritual in Art* (1912). In this theoretical statement, Kandinsky develops a position in some ways similar to that of Charles Henry. After briefly noting that the first reaction to color is "a purely physical effect," he goes on to a lengthy discussion of what was to him the major effect of looking at colors, the "psychological effect."

In his early years, Kandinsky's attitudes were much like Henry's. Both men were concerned with psychological responses to color, both thought this response could be systematically, indeed scientifically

characterized, and both proposed a close connection between color and music—an interest in the harmony of colors and in connections between painting and music (synesthesia). Finally, both Kandinsky and Henry wrote about the emotional, symbolic, and spiritual meanings of color.

Their specific color interpretations do not seem to have much agreement—in part because they picked different subjective dimensions to emphasize—for example, warm vs. cold (Kandinsky), happiness vs. sadness (Henry), but also because the scientific color theorists that influenced them were in disagreement.

It is questionable whether Kandinsky was directly influenced by an acquaintance with Henry; but influence of some kind is not improbable, since they were both active during the first part of the twentieth century, and Kandinsky was familiar with artists who knew Henry and who's influence they acknowledged. Kandinsky lived in Paris for the year of 1906–07 and probably Signac is a link between them, since Kandinsky refers to Signac's *D'Eugène Delacroix au Neo-Impressionisme*. This work (first published in 1899, and well known among artists) contained Signac's theories of Neoimpressionism, which were much affected by his close personal association with Henry.

Theodore Lipps—a German

psychologist and aesthetician—is a more certain influence on Kandinsky. (His ideas also have much in common with Henry's). Marianne Teuber writes in her article "Blue Night by Paul Klee" that the influence of pre-Gestalt theories (that includes Lipps) and experiments on both Kandinsky and Klee "cannot be overrated." As Teuber notes, Lipps lectured to large audiences at the University of Munich between 1894 and 1913—the period when both Kandinsky and Klee began their artistic careers in the Bavarian capital. Lipps was widely known for his theory of empathy—in which he describes how by "'feeling ourselves into' forms and colors, we can experience how they expand and contract."

In a related passage Kandinsky writes

> If two circles are drawn and painted respectively yellow and blue, a brief contemplation will reveal in the yellow a spreading movement out from the center, and a noticeable approach to the spectator. The blue, on the other hand, moves into itself, like a snail retreating into its shell, and draws away from the spectator.

Kandinsky's initial scientific attitude toward art is clearly expressed:

The starting-point is the study of color and its effects on men. There is no need to deal with the profound and refined complexities of color; consider at first only the direct use of simple colors. Let us test the effect upon ourselves of *individual* colors, and make a chart, which will simplify the whole question.

It is evident that certain colors can be emphasized or dulled in value by certain forms. Generally speaking sharp colors are well suited to sharp forms (e.g., yellow in the triangle), and soft, deep colors by round forms (e.g., blue in the circle).

The final abstract expression of every art is number. (emphasis in original)

A few years later, in the heavily scientific and technological atmosphere of the Bauhaus, Kandinsky came under the influence of the color theory of the scientist Hering and his own theory became still more explicit.

Hering, a German scientist influenced by Goethe, criticized the generally accepted Young-Helmholtz theory of color perception, which was based on three primary colors: red, green, and blue. Hering proposed a theory based on two pairs of primary colors—blue-yel-

low and red-green—plus another pair, black-white. (The emphasis on black-white is also more in the German tradition of Goethe-Hering.) Kandinsky's emphasis on blue and yellow, plus his concern with light and dark and his neglect of green, place him the Goethe-Hering tradition; in contrast, a preoccupation with the red-green opposition is part of the Chevreul, Helmholtz, Rood tradition—one that seems to have dominated French color thinking, for example, as with Delacroix. For artists responding to the theory about the color primaries see the Kandinsky color scale Fig. 4.24 and to the iconography of color theory, if not the theory itself, see the Ellsworth Kelly works (for example, Fig. 4.25). On a much smaller scale, these large paintings by Kelly are "anticipated" by the color research of the prominent German scientist Wilhelm Ostwald (Fig. 4.26).

It is not surprising that the understanding of color theory should have been debated for so long a time, since color is not by any means a simple phenomenon. There are in fact different sets of primary colors: red, green, and blue are the standard primaries for *mixing light*, and they are governed by additive principles. A second set of primaries is red, blue, and yellow—the primaries for *mixing pigments* governed by subtractive rules. A third set of primaries is *psychologi-*

cal or perceptual and consists of red, green, blue, and yellow (four basic colors that are perceptual categories even in human infants). The concept of a primary color is further complicated by the fact that at the physiological level there are three types of cones on the retina: those sensitive primarily to "red," "green," and "blue" light respectively, while above the retina (at a small structure lying between the retina and the visual cortex called the lateral geniculate nucleus, and at the visual cortex itself) the physiological structures support four primaries, as in our perceptual experience, that is, red-green and blue-yellow.

At the Bauhaus, Kandinsky continued using diagrams especially as aids for his frequent lectures on color. His "Germanic" color theory, with its emphasis on a limited number of pigment primaries—blue, yellow, and red, plus black and white—developed a wide influence. The early Bauhaus approach to color encompassed different, and inevitably somewhat conflicting, theoretical systems, but all approaches were systematic and

Color Scale, after Kandinsky

Fig. 4.24 Kandinsky, Color scale (in the Goethe tradition). 1926

scientific to a significant degree. The art historian Clark Poling describes the situation as follows in his monograph "Bauhaus Color."

> The teaching encompassed established color theories from Goethe to the scientist Wilhelm Ostwald and empirical investigations of color characteristics in laboratory-like courses. These studies were to provide objective, universal standards for the use of color in art and design. The emphasis, therefore, was on the physical properties and perceptual effects of color rather than on its potential for subjective or symbolic expression.

Mondrian and Science: Schoenmaekers's Color Theory

During a visit to Holland in 1914, Mondrian was caught there by the outbreak of World War I. While there, he met a number of Dutch artists, who together founded *De Stijl*. Although many of the ideas for *De Stijl* came from fellow artists, there was one important outside influence, that of a man named Schoenmaekers (see Jaffe, 1960).

The influence of Schoenmaekers's color theory on Mondrian has not been recognized. For example,

in *Het Nieuwe Wereldbeeld* (*The New World Image*, 1915), Schoenmaekers proposed that there are only three major colors: red, blue, and yellow, — each significantly like Kandinsky's formulation of a few years earlier:

> The three basic colors are yellow, blue, and red: essentially they are the only colors because all other colors can be reduced to these three. These three colors are symptoms of the movements of radius, line and the movement of the plastic center point. In these three colors we see the disintegration and reshaping of the perfect form.

> Yellow is the movement of the radius. The pure yellow color is a radiant color; of all the colors yellow is the brightest or most light-giving; it spreads out in space, it flares and leaps out and wants to be the center of all movement in space.

> Blue is the opposite color of yellow. As light, blue is of course space movement, but as color it is opposite to the taut yellow; the color blue is soft, pliant, it gives the impression of receding concentrically behind the yellow. As color it is the blue heavens, line and horizontally.

Red is the fusion of yellow and blue. The mixture of yellow and blue gives green. But a living, profound fusion of yellow and blue gives red. Red, not blue-red or yellow-red but pure red, it is radiant, the principle of complete formation. It does not jut out like yellow, it does not recede like blue, but it is in suspension (floats) in front of blue horizontal space.

Although unaware of any direct influence, Schoenmaekers acknowledged that his theory was closely related to Goethe's color theory, first published 100 years earlier. It is not clear exactly how Schoenmaekers picked up his theory of red, blue, and yellow, but the Goethe tradition and its variants had become an intellectual standard by that time. Regardless, it is extremely important to note that Mondrian, after making the acquaintance of Schoenmaekers in 1914—restricted his palette to these primary colors. In several paintings Mondrian only uses yellow and blue; in particular, he studiously avoided green.

Further, Mondrian explicitly acknowledges this influence:

Reducing natural color to primary color changes the most outward manifestation of color back to the most inward, if red (the union of blue and yellow —see Dr. H. Schoenmaekers, *The New World Image*) is more outward; then a painting in yellow and blue alone would be more inward than one in the three primary colors.

Klee: Progressions and Charts

Klee, like so many others, came under the influence of color science at the Bauhaus. He studied the various theories, gave lectures on them, and incorporated their principles into his work. He was particularly interested in gradations of color—more so than in contrasts and complementaries. The principles of contrast and gradation were defined first by Chevreul, who proposed two types of color harmony —analogous (graded) colors and contrast. As a result, Klee's special contributions to Bauhaus concepts were his conclusions on the nature of color progression, obtained by investigating and painting color sequences more systematically than his colleagues. A typical scientific color progression is a series of step-like increases or decreases in the purity of strength of a particular color. The concern is usually with understanding how to use the physical basis of the color so as to get steps of equal perceptual distance. (Occasionally other bases for progressions were also of interest.)

Such color progressions are frequent in Klee's work. Significantly, the first appearance of this kind of imagery is in scientific color theory, for example, Chevreul, (Fig. 4.27) and from there it has made its way into modern painting. Klee's graded scales were achieved by progressively adding layers of watercolor washes (Fig. 4.28) a method derived from Chevreul. This procedure does not, in fact, produce a series whose steps are all seen as equal. If a constant number of new layers is added for each step, the degree of difference gradually diminishes. In order to maintain the appearance of equal steps, it is necessary to multiply the number of layers and thus follow a geometric progression instead of the arithmetic one of addition. This principle is known as the Weber-Fechner Law: it was established by Weber (1839) and Fechner (1860). In an intuitive way this principle was used by artists many years before its scientific formulation. For example, Vermeer rendered tones proportionally (see Pope, 1949).

Joseph Albers's now familiar series, *Homage to the Square,* is to a great degree based on this principle, which he acknowledges in his theoretical opus on color theory, *Interaction of Color* (1963), and the interaction of color is the investigation to which all of his work is dedicated. The book summarizes Albers's lifetime of color study, which began in the Bauhaus and which was thoroughly influenced by visual science—from Chevreul to Fechner to Gestalt psychology. There are many other paintings of Klee's (Fig. 4.29) that express the spirit of color science: he frequently worked with color progressions and relationships using squares or rectangular shapes—adaptations of color charts. The Ostwald color charts (Fig. 4.30) consist of two columns: the column on the left is a random arrangement of strong colors; the column on the right is a natural or spectral ordering of the same colors.

More recently, Ellsworth Kelly has expressed his own adaptation of both the achromatic series (Fig. 4.31) and of color progressions, often in very large scale works. Kelly's achromatic series is obviously in the scientific tradition of Chevreul (Fig. 4.32). Some of Kelly's most powerful progressions are simply series of pairs of complements (Fig. 4.25). In a strictly scientific context, and on a much smaller scale, this kind of "imagery" makes its first appearance in the treatises of the color scientists (Fig. 4.26) and also in the science-like treatment of Kandinsky (Fig. 4.24).

Conclusion

Even from this chapter's relatively brief statement of modern

color it should be clear that not just the spirit but often the concepts and the very images of the new scientific study had a profound impact on modernist painting. Sometimes, as with Seurat, the effect was direct and commonly acknowledged, but more frequently the scientific approach provided an unconscious attitude toward the "problems" of color, as with Delaunay and Kupka. This attitude led many artists to adopt the role of visual scientist and to work out on their own many of the applied principles of color, as was done by Klee and Albers. Although at times the artists may have failed to understand fully many aspects of the new science—still, Pissarro's reflection on the earlier connection between visual science and Impressionism seems equally appropriate for the effect of color science throughout the modernist period:

But surely it is clear that we could not pursue our studies of light with much assurance if we did not have as a guide the discoveries of Chevreul and other scientists. I would not have distinguished between local color and light if science had not given us the hint; the same thing holds true for complementary colors, contrasting colors, etc.

Fig. 4.31 Kelly, *Spectrum III.* 1967

Fig. 4.32 Chevreul, Scale of grays. 1839

FIVE

Space and Time

For centuries European artists used a fixed, deep, and Euclidean space. This idealized container of visual experience routinely provided a framework within which the painting was constructed. People and objects might be moved as the artist searched for his final composition—occasionally even unusual angles of vision were used—but the space itself remained constant, and unaffected by the objects placed within it. It is now of course a commonplace that modernist art has shattered and distorted this previously sacrosanct space. What is not so commonly known is that visual scientists began the experimental and theoretical breaking up of this same space at approximately the same time; and in fact some years earlier.

The Stereoscope

Ordinary visual experience is of a single homogenous visual world similar to that portrayed in traditional painting. At least this is usually true when our gaze is fixed on the scene in front of us. It had long been known that this single or cyclopean visual field was somehow constructed from two visual images—the slightly different views of the two eyes (see Boring, 1942; Held, 1976; Kaufman, 1974). The question of how the underlying right and left eye views were put together

to make one view suddenly became a major issue in visual science in 1838. In that year, this long-dormant problem came into prominence when Charles Wheatstone invented what is known as the "stereoscope." This instrument (Fig. 5.1) using mirrors or prisms, enabled the viewer to fuse two slightly different two-dimensional drawings of an object into a single, strikingly three-dimensional view. A major point of Wheatstone's original 1838 paper held that each eye has a different image projected on it from the scene or object in view, due to the slightly different perspectives of the left and right eyes. The disparity between the two images in normal vision, when combined into a single image, gives a strong, three-dimensional effect. For example, Figure 5.2 shows a drawing from Wheatstone's original paper. The views are carefully drawn from slightly different angles of regard as would be the vision. Figure 5.1 shows an early stereoscope; a schematic diagram of how the images are presented to the viewer in a prism stereoscope is shown in Figure 5.3.

In 1839, a year after the invention of the stereoscope, it became obvious with the first public presentation of the daguerreotype that instead of tediously made drawings, two photographs taken at slightly different angles would be far more efficient. By the mid-1850s stereoscopes were widely available to a

Fig. 5.1 A typical hand-held early stereoscope designed to present disparate images to each eye. This type was first designed in 1861 by Oliver Wendell Holmes.

Fig. 5.2 Wheatstone, stereoscopic drawing. 1838

a *b*

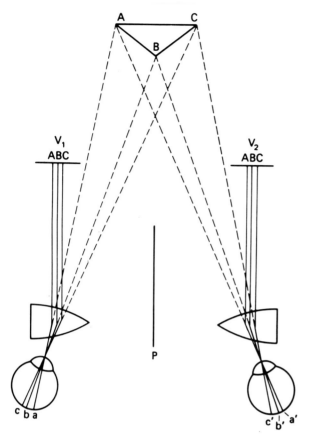

Fig. 5.3 Overhead schematic of stereoscopic viewing of a wedge (ABC).

fascinated public and millions of stereoscopic photographs were being purchased. The importance of this is commented upon by Gerald Needham:

> No nineteenth century home of any pretensions was complete without a viewer and a collection of photographs. The stereopticon was one of the major optical devices of the century, which was so widespread, and which played such an important part in the changed vision of the latter part of the century.

The combination of the still-fresh fascination with photography plus the remarkable three-dimension effect of stereoscopic photographs gave them a truly great impact.

During the period 1839 to 1860 scientists and early photographers were busily investigating ways to take stereoscopic photographs. Initially, at least three procedures were used. In one procedure, two cameras with identical optical properties were placed side by side, with the two lenses about eye distance apart. The object or scene would then be photographed simultaneously with each camera; a slightly different procedure involved taking the first picture and then moving the camera a few inches to the side and taking the second picture. This procedure is a conceptual

forerunner of cinematography, since the two different views represent the scene at time 1 and time 2. The two photographs could be fused stereoscopically, of course, only if the object did not move in the short interval between the two shots. Yet a third technique involved a stereoscopic camera, constructed with two lenses, in the same enclosed box: the film behind each lens was thereby exposed at the same time. This special stereoscopic camera was to become a common piece of equipment.

The stereoscope and its associated techniques fractured the existing visual space in various ways. First and most important for the general public, stereoscopic photographs literally broke the visual space by presenting the viewer with *two* images taken from slightly different viewpoints. That is, the viewer prior to fusing the two images could see and inspect the two distinct images that would "disappear" in his subsequent single three-dimensional experience. Therefore the apparatus held by the viewer demonstrated, in very concrete terms, that the cyclopean, homogeneous visual world was a construct that could be analyzed as two underlying, separate "flat" views.

As described above, the breaking of space was represented in even more specific detail to any scientist or photographer engaged in making stereoscopic photographs, for ex-

ample, if two cameras were used, each one very clearly represented a different view of space.

As an example of an even more complex fracturing of space, Wheatstone in 1852 reports taking a whole series of photographs of the same portrait bust, all from systematically different distances and angles (described in Brewster, 1856). The resulting set of photographs represents the same object from multiple points of view. Considered as a *set*, these multiple view photographs plus the conceptual framework that generated them contain the kernel of Cubism, and can be considered the first visual expression of one central aspect of the Cubist idea. This set also suggests the first cinematic multiple views developed later by the photographer Muybridge.

Some of Wheatstone's photographs violated a correct mathematical understanding of stereoscopic vision and were criticized by the more knowledgeable Brewster, as representing "binocular and multiocular monstrosities." (The expression "multiocular monstrosity" is worthy of early naive critics of Cubism.) Whatever the fine points of the complex analysis behind the theoretical debate, Wheatstone's experiments show that not just two but multiple points of view follow naturally from the study of stereoscopic vision. It is probable that other scien-

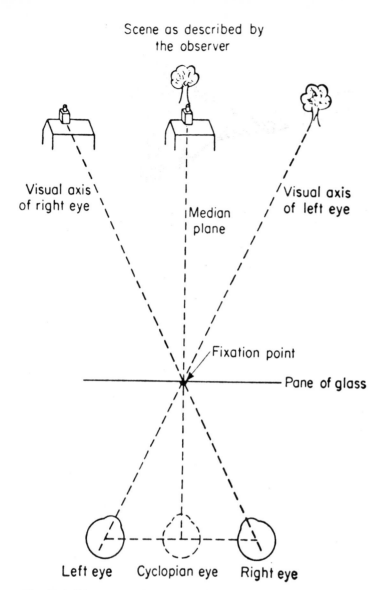

Scene as described by
the observer

Visual axis
of right eye

Median
plane

Visual axis
of left eye

Fixation point

Pane of glass

Left eye Cyclopian eye Right eye

Fig. 5.4 Diagrammatic representation of Hering's theory of binocular perception (1861). It shows the view of the left eye, the right eye, and the scene as described by the observer—the normal integrated view of the "cyclopean" eye.

tists and photographers besides Wheatstone engaged in similar experimental activities.

Finally, traditional space was broken conceptually by the scientists attempting to interpret the now-lively theoretical problem of stereoscopic vision. Diagrams published in the writings of prominent mid-nineteenth-century visual scientists express in pictorial form this theoretical breaking down of ordinary space into two quite distinct points of view. In particular, the important early theory of space perception proposed by the scientist Hering (1861) involves not only the separate view for each eye, but the normal, resultant view described by him as the "cyclopean eye" (Fig. 5.4). As Spiegel put it, speaking of Flaubert, it is now clear that visual truth "depends as much on the angle of vision as upon the object of vision."

The concept of the cyclopean eye has remained a useful one in the study of perception. The most recent case in point is Julesz's *Foundations of Cyclopean Perception* (1971), a masterful treatment of binocular vision. The cyclopean notion suggests that Picasso's representation of the artist as having three eyes in the painting *The Studio* (not shown) is an example of an intuitive and humorous expression of the same understanding. If so, it represents another link between Cubism and the stereoscopic

investigations of vision. Robert Rosenblum in *Cubism and the Twentieth Century* lends some support to this interpretation by commenting: "the inventive potentialities of Cubism permit Picasso to describe the artist's superior visual perception by the addition of a third eye."

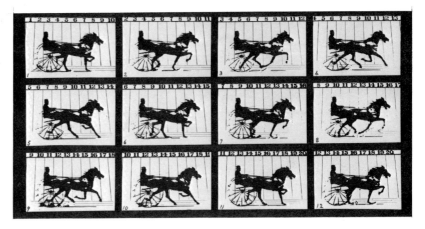

Fig. 5.5 Muybridge, *The Horse in Motion.* 1878

Eadweard Muybridge: His Studies of Vision

In their studies of animal movement, Eadweard Muybridge and E. J. Marey are generally acknowledged—separately—as the founders of the cinema. The approach of both involved primarily the analysis of movement in time, but in the case of Muybridge, space was also broken into different points of view.

In Muybridge's early photographs of the horse in motion (Fig. 5.5) taken in 1878–79, he used 24 high-speed cameras placed in a series (Fig. 5.6). (There was a camera under each number painted on a stable building.) Muybridge's accomplishment was an analytic-reductionist one, for his sequences of images broke down the natural perception of animal movement into a series of discrete stills, each existing at a level beneath normal perceptual experience. At the time this aspect of Muybridge's photographs drew criticism from those

Fig. 5.6 Muybridge, general view of the experiment track. The camera shed is at the right, the background wall at the left, and four diagonal cameras on stands at four corners of the track area. 1881

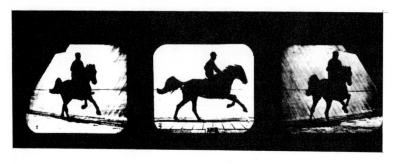

Fig. 5.7 Muybridge, Horse and rider at same moment from three viewpoints. 1881

who rightfully argued that the discrete, frozen images of moving animals were not correct in terms of natural vision, because they show the animal as the human eye could never see it. Such photographs ignore the natural blurred image of movement, mostly due to the persistence of the image on the retina.

For our purposes, of still greater interest are the four diagonally oriented cameras placed at the corners of the special track area (there are four cameras, but only the one in the right foreground is easily seen). This installation unambiguously presents very different points of view for photographing the horse. An example of a horse and rider taken from three positions can be seen in Figure 5.7. The use of additional cameras, whether in a series or a different angles, is a natural extension of the procedure for obtaining stereoscopic photographs. It is not by accident that Muybridge himself was well-grounded in steoscopic technique, having first come to prominence for his outstanding stereographic photographs of California scences. In addition each of the twenty-four cameras in the series was a stereoscopic camera, that is, it had two lenses, thus directly linking Muybridge to Wheatstone.

For the purpose of demonstrating Muybridge's significance to visual science, a number of aspects of his career need to be em-

phasized. First, Muybridge is best understood as even more of a photographic engineer than as a photographic artist. To a large extent, he belongs to that group of applied scientists, often American, who brilliantly pioneered concrete applications of existing theoretical accomplishments—much like Thomas Edison and Samuel B. Morse. For example, the construction of the complex apparatus for getting high-speed (1/2,000th of a second or faster) photographs of a rapidly moving horse took the skills of a team ranging from mechanics to practical electricians. In a recent scholarly summary of Muybridge's work, this technical solution was described as follows: "In a manner comparable to scientific experimentation today, Muybridge's idea was worked out on a practical level through the cooperation of a group of specialists." There is other evidence that places Muybridge more in the history of applied visual science than in the history of artistic photography. Much of the early interest in his photographic accomplishment came from the scientific community: for example, his horse photographs were first published in *The Scientific American* and in the French *La Nature*; the immediate response to these photographs by Marey, a prominent French scientist, also indicates Muybridge's scientific importance. According to

one scholar, Mr. Leland Stanford—Muybridge's patron and sponsor—at times thought of Muybridge as a "mere technician." This is far too extreme a position—but we do wish to emphasize that Muybridge's scientific and technical innovations were very great and absolutely essential to his photography. There is no other early photographer who competes with Muybridge in technical significance.

At least partly at the instigation of Marey, Muybridge later placed the sequence of horse photographs on a circular glass, which was then rapidly rotated across a narrow opening (Fig. 5.8). This set-up, with a light and lens, was used to project the series of animal stills on a screen. When presented rapidly, the result was an early form of cinema—one reported to be much smoother than the first jerky movies. Muybridge called his apparatus, a prototype of the movie projector, by the awkward name of "Zoopraxiscope"; the first attempt to devise his Zoopraxiscope was based on Wheatstone's reflecting stereoscope (establishing yet another link between Muybridge and Wheatstone). Later, he abandoned this approach and developed his own instrument, more closely related to the strobascope or phenakistoscope (Fig. 5.9), invented in 1830 by the French scientist, Joseph Plateau. Muybridge himself claimed

Fig. 5.8 Muybridge's Zoopraxi-scope. Note the disk with the sequence of horse and rider. 1879

Fig. 5.9 Plateau, Phenakistoscope. 1832

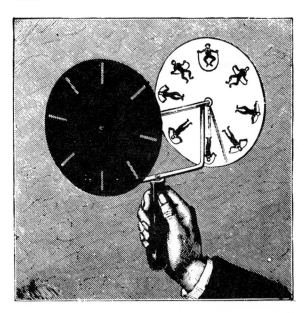

his Zoopraxiscope to be the prototype for "synthetically demonstrating movement analytically photographed from life."

Marey: French Developments

E. J. Marey was a French scientist and professor of natural history at the College de France, as well as a member of the French Academy of Medicine. He was especially interested in the nature of animal movement and published a classic early work on the nature of animal locomotion in 1873. Marey learned about Muybridge and Stanford's investigations into animal locomotion in 1878. He grasped immediately their relevance for his own research, which loosely paralleled Muybridge's studies. Marey welcomed Muybridge's accomplishments and from that time on the two were in friendly communication. By 1881, Muybridge's photographs were well-known in France. In November 1881, the then prominent French painter Meissonier gave Muybridge a spectacular reception in Paris, attended by a large number of prominent artists and scientists. Here and at other public events, Muybridge's work was customarily presented to large numbers of European artists and scientists.

From the early 1880s, Marey systematically applied photography to record movement in its various phases (Fig. 5.10). His research, like that of Muybridge, had been influenced by the earlier visual studies (Fig. 5.9). In 1882 Marey designed the "photographic gun," which very rapidly took twelve exposures on one photographic plate (one exposure for every pull of the camera's trigger: hence, to "shoot" a movie). Marey continued and in 1888 he began using movable film first using rolls of paper, and then introducing the use of celluloid paper; thus, he developed the first movie camera.

Throughout this period and into the present the public, although superficially fascinated with the new scientific technique, was (and still is) primarily drawn to the normal, synthetic experience. The public's interest was in the full three-dimensional stereoscopic image, rather than the analysis that brought it about. Later the interest moved to the "movie," but even then not to the discrete series of underlying images. The general public wanted its art presented in the familiar space and time and filled with traditional meaning—stories, plots, and so on. For example, the Muybridge scholar, Françoise Forster-Hahn, comments on the French public's reaction: "the overwhelming response which

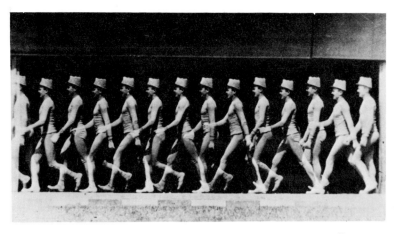

Fig. 5.10 Marey, *Man Walking.* ca. 1882

Muybridge received in Paris . . . however, was perhaps less due to the photographs themselves than to their demonstration with the Zoopraxiscope. While the individual still (image) tended to 'freeze' simple attitudes in isolation, the Zoopraxiscope offered the possibility of creating an illusion of coherent motion." In marked contrast to the public, however, the scientists and avant-garde artists were strongly drawn to the novelty and conceptual power of the new analysis of space and time.

Manet: a Specific Example of Fractured Space

Fractured space refers here to two or more discrete lines of view present at the same time in a given portrayal of space: these separate but simultaneous views break or fracture what was once (seen as) homogeneous.

The compositional character of Manet's paintings has from the beginning drawn criticism not only from his detractors but also from staunch supporters such as Zola, who once said that "for Manet, composition has disappeared . . . one or two figures, sometimes a crowd seized at random . . . composition does not exist for him." Other critics have commented on Manet's "compositional difficul-

ties." Thus, John Richardson notes that Manet's works were frequently "badly composed, out of scale, incoherent, especially if the composition involves a degree of recession or indicates two or more figures or groups." In the context of the parallelism thesis it is not necessary to take sides in the evaluative character of this debate. However, it will be demonstrated that Manet's intuitive exploration of the new perceptual world with its various points of view inevitably leads to compositions that would be judged as unsatisfactory by traditional criteria. His well-known *Bar at the Folies Bergère* (1881) is just such an example (Fig. 5.11). In this painting, the viewer is placed in a spatially or temporally ambiguous situation. The problem is that from the normal point of view it is impossible for the figures reflected in the mirror to be consistent with the viewer's position in front of the woman. We suggest that this painting represents two moments in time or viewpoints in space, as shown in Figure 5.12. The simplest solution—interpretation A—is that the painting is an integration of two slightly different points of view, each also at a different point in time. The first view at "location one and time one" is six or eight feet directly in front of the young woman. At "location two and time two" the observer has moved a few feet to the left, allowing the top-

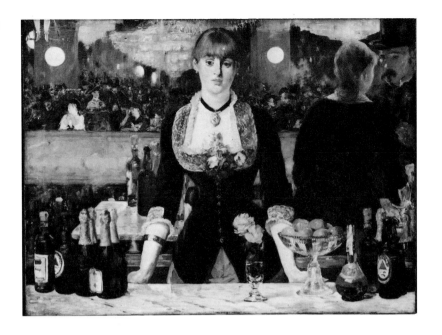

Fig. 5.11 Manet, *Bar at the Folies Bergère.* 1881

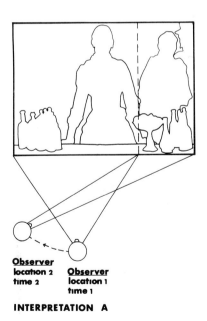

Observer
location 2
time 2

Observer
location 1
time 1

INTERPRETATION A

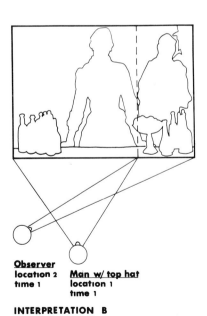

Observer
location 2
time 1

Man w/ top hat
location 1
time 1

INTERPRETATION B

Fig. 5.12 Two interpretations of *Bar at the Folies Bergère.*

1

2

A B

3

A B

hatted man to approach the bar. The observer then turns his gaze to view the reflection of the two figures in the mirror. This analysis argues then that the left two-thirds of the painting and the right one-third are the viewer's two brief glances, which Manet has integrated.

Another interpretation (B) is that there are two observers (or cameras)—one, the man with the top hat who is standing directly in front of the barmaid, and the other, an observer standing at the left looking at their reflections in the mirror. In this case the two viewpoints are of the same moment in time but from different spatial locations—as in the taking of a stereoscopic photograph. (This argument assumes that the top-hatted man standing in front cannot see his own reflection in the mirror since it is presumed to be hidden by the young woman.) In either interpretation, Manet has in-

Fig. 5.13 Two interpretations of *Bar at the Folies Bergère* based on a "Muybridge" analysis. The top photograph (1) *Getting into Bed* shows a woman from three different perspectives. The pairs of photographs in the middle section (2) show two stills each from a different perspective: Pair A from slightly different times, Pair B from the same time. The bottom two photographs (3) show combinations of the two views in the same image.

tegrated two points of view in the same painting.

The conceptual significance of Manet's integration can be seen by noting how multiple points of view are shown in the various Muybridge photographs, for example, the sequences of a woman getting into bed (Fig. 5.13). Each vertical column shows the same time from three different locations, while a diagonal grouping of images represents different points of view at slightly different times; each horizontal series, taken from a different location, is of course, the familiar analysis of time. The first interpretation of the Manet painting (Fig. 5.13, lower left side) is that of two "digaonal" images—that is, the integration of two views from different locations and at slightly different times. The second interpretation (bottom right) represents the integration of two images from a vertical column—two different locations at the same time. In any case, the Manet composition can be understood as an artistic analogue to the space-time analysis of the Wheatstone, Brewster, Hering, and Muybridge tradition.

An earlier example of Manet's uncertain space can be found in his *The Absinthe Drinker* (1862, not shown) in which critics have noted that the shadows of the figures and the objects are not consistent. In this work the two different light sources, through their inconsistent shadows, implicitly fracture the space of the painting, and imply different points of view.

Another different perceptual intuition is expressed in Manet's paintings *On the Beach at Boulogne* (1869, not shown) and *View of the Universal Exhibition of 1867* (1867, Fig. 5.14).

In such works the group of figures seem isolated and unconnected to each other, and the space between the groups seems "dead." The picture is organized by the eye fixating on a group, then moving to the next, until the complete painting has thus been loosely tied together. Anne Coffin Hanson summarizes prior descriptions by Leiris and others by noting that these paintings consist of "successive components," or a "series of discoveries," that their "elements are observed and understood sequentially." Such a viewing procedure breaks up space with a series of temporally discrete fixations with the intervening space between being ignored as of little visual significance.

In some ways this type of perceptual organization can be understood as cinematic, for it has an obvious sequential character. Much later, of course, cinema would commonly present visual experience as a series of focal points with the intervening space omitted or sometimes rapidly panned. Although Muybridge and Marey were developing cinema in the 1870s and

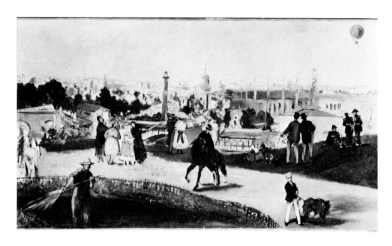

Fig. 5.14 Manet, *View of the Universal Exhibition of 1867*. 1867

Fig. 5.15 Eye movement pattern of one subject on Manet's *View of the Universal Exhibition*. Shows fixation points with large saccadic jumps over the dead space between centers of visual fixation.

1880s, no sequences of scenes yet existed that were especially close to Manet's anticipatory "series of discoveries."

Another interesting parallel between these paintings and the visual science of the time exists. The most important single fact about the way in which humans move their eyes is that they are not moved "in a steady sweep but in a series of little jumps with intervening fixation pauses," which was discovered by a French scientist, Javal, in 1878. He observed that the eye moved "par saccades" (by flicks or jumps) from one point in a scene to the next. As a result, these movements are now commonly known as saccadic eye movements or saccades. Javal's discovery was made while observing the eyes of school children as they read, but the phenomenon applies to visual scanning of any environment. Figure 5.15 shows the pattern of the first few seconds of eye movements of one subject whom we had scan Manet's *Universal Exhibition*. The subject pointed with a long marker to the exact places to which he attended. The spaces between the areas of fixation are poorly seen or not seen at all since the eye is moving over them rapidly, giving only a blurred impression. Only a fixated area is seen clearly. Obviously in this Manet there are large areas that receive very little or no fixation. Although this pattern is not based on systematically gath-

ered data it corresponds very closely to the results of two other subjects and it is almost certainly a plausible approximation of what would be found for most viewers. The eye movement summary very nicely captures the "organization" of the work as a series of discrete points of interest commonly separated by large distances of little interest. There is, of course, no reason to think Manet was conscious of such an interpretation. Nevertheless, his intuition about the nature of perceptual scanning seems clear. Since these works were completed a few years before Javal's discovery, in this instance, Manet's parallel insight is in advance of the visual scientists.

Cézanne: More Fractured Yet

A broken space combining aspects of two or more points of view is a familiar characteristic of many of Cézanne's paintings. Excepting Manet's still rather tentative treatment it is Cézanne who pioneered this type of special organization. Cézanne did it with such frequency and success that it is one of his greatest contributions to modernist painting and it proved to be essential to the later development of Cubism. Erle Loran has identified this property of Cézanne's work with a now familiar clarity. His analysis of the *Still Life with Fruit Basket* (Fig. 5.16) is particularly informative. He comments (in reference to Fig. 5.17), "The first eye level, marked I, takes in, roughly, the front plane of the fruit basket, the sugar bowl, and the smaller pitcher. . . . The second eye level, much higher, marked II, looks down on the ginger jar, and the top of the basket." The eyes at Ia and IIb represent still two other points of view on the right side of the picture, as though the observer had stepped to this new location. All of this increases the illusion of "seeing around" the objects. It is unlikely that Cézanne arrived at these effects through a particularly conscious, theoretical approach, but the parallel with Muybridge's multiple views is obvious. The short step from Cézanne's and Muybridge's analyses to Cubism, especially in later Cubism, is succinctly represented by the 1952 sketch of André Lhote (Fig. 5.18), which shows the combination in one single image, of several different views of the object. (See also Picasso's *Grand Nu de Femme*, 1962, not shown).

Except for some late Cubist examples, Leo Steinberg (1972) has rejected the claim that Cubism can be understood as involved in the portrayal of multiple points of view, especially as this notion was advanced by theorists at the time, for example, Metzinger in 1911. Since we do not generally agree

Fig. 5.16 Cézanne, *Still Life with Fruit Basket.* 1888–90

with Steinberg's position in this matter, and since the topic is important we will take it up in some detail.

First, Steinberg acknowledges Cézanne's use of multiple perspectives, but in light of the accepted influence of Cézanne on the development of Cubism it is difficult to understand how this important aspect of Cézanne's style was not transmitted to Picasso and Braque. Steinberg's position is also made problematic by his acceptance of the multiple point of view as informing Picasso's late synthetic Cubist paintings done in the 1960s. Picasso's late paintings, although more expressionistic in technique are built on the logic of his earlier Cubist works.

Steinberg bases his rejection of multiple perspectives in classic Cubism on three interesting arguments. First, he writes that Cubist objects "are episodic, they lurk here and there, without sustaining the general program. The pictorial space and its fill remain squarely confronted from one position, like a relief." Even if this observation is accepted, the fact that the different points of view are not systematically expressed throughout the painting, à la Lohte, but only in an episodic manner, is irrelevant. The points of view are there even if the general program of all the rationally possible views is not. Certainly an artist is not expected to produce a literal

scientific exercise. Once the need for a systematic expression of multiple views is understood as unnecessary, then it is not surprising that the convenient view of an observer squarely in front of the painting is selected as the predominant, but not exclusive, perspective.

Steinberg continues with his second criticism: "the few doubling facets that do occur belong to objects of the most predictable familiarity. Instead of specific shapes fetched from around top or corner, we get schematic tokens, so that the information delivered invariably is such as the viewer already has." Here Steinberg raises two issues. The first, concerning the predictable and familiar objects, seems mistaken, since common objects are just as good as any others for the purpose of showing different views. Indeed, they are superior for their very familiarity accentuates the shock of strange juxtapositions — there is no distraction from trying to figure out what the object is and what the viewpoints represented are. (The use of common objects was also part of the new aesthetic with its shift from distinctive and historically given subject matter.)

Steinberg's comment about the schematic character of the objects is a helpful one. It is quite true that Cubism does not provide realistic images of the different perspectives. One reason for this is that

Fig. 5.17 Loran, Diagram showing how parts of the Cézanne are in correct perspective for eyes situated at different heights (I and II) and at different angles of observation (Ia and IIb).

Fig. 5.18 Lhote, *Cubist Drinking Glass.* 1952

specific, detailed realistic views would have softened the contrast between the perspectives by drawing attention to the realism itself. Still more relevant is the fact that Cubism is far from a unidimensional style. It was not solely an expression of multiple view, but was part of the common reductionist move toward abstraction. In particular, the use of simplified pictorial fragments is a major device for flattening the picture plane—an omnipresent modernist concern.

In addition, multiple viewpoints were one of the stylistic vehicles that facilitated the development of a flattened space. Each view by contradicting the other prohibits the observer from establishing any fixed interpretation of depth. As a result each perceptual contradiction emphasizes the surface of the canvas.

The third criticism by Steinberg is that Cubist works never portray an object as a summation of disparate views, instead Picasso and Braque convey parts and discontinuity rather than fragments capable of being integrated into one object once the pieces are put together. Again accepting this observation as valid and stimulating, it is difficult to see how it undercuts the multiple points of view position. The whole emphasis of the multiple views, at least conceptually, was that there was no single correct viewpoint. Any attempt to suggest that some ideal Platonic form lay behind the different perspectives would simply be a "regression" to the earlier one perspective tradition. Such a visual implication would not only be at odds with the philosophical point of this framework, it would also work against the striking novelty of the concern with expressing perceptual subjectivity and relativity.

Although issue is taken with Steinberg's position as just noted, the multiple point of view was not the most important perceptual aspect of Cubism. Steinberg, in developing his positive interpretation of what Cubism was primarily about, zeroes in on crucial perceptual ambiguities relating to spatial location and depth. The character of these ambiguities will be taken up in the next chapter.

Herbert Read writes that although Cézanne never showed any particular interest in science itself (unlike Seurat, for example), nevertheless his "whole attitude toward nature . . . [was] analytical, experimental, essentially scientific." Cézanne's new perceptual understanding is essential. As Gowing has recently put it, Cézanne's work was so guided by both perception and reason that his approach can be pithily summarized as "the logic of organized sensations." Cézanne himself consistently spoke

of his preoccupation with the sensory and perceptual experience of nature:

> One must make a vision for oneself . . . one must make an optic. One must see nature as no one has seen it before you — being a painter I attach myself first of all to visual sensation.

> Literature expresses itself by abstraction, whereas painting, by means of drawings and color, gives concrete shape to sensations and perceptions.

The French philosopher Merleau-Ponty interpreted the distortions as the rejection of fixed, static perspectives; thus he wrote that Cézanne gave the impression of an object "in the act of appearing." An object "in the act of appearing" — what better description of the Muybridge-Marey photographs?

Futurism and Duchamp

The strong influence of the cinematic images of Muybridge and Marey on painters in the period 1885 and 1915 is now well known.

The writings of Aaron Scharf and of Van Deren Coke, are especially good in this connection. For now it is enough to briefly note this influence to underline the impact of the new analytic science and visual technology on modernist art.

Degas, an enthusiastic amateur photographer, occasionally copied quite directly from Muybridge's photographs. Degas's concern with sequences of body movements and of movement seen from different viewpoints can also be attributed to Muybridge's influence (see Scharf and Coke for detailed evidence). Seurat's attempt to portray movement, as in *La Chahut* (not shown), came from his interest in science. He was also a close friend of Henry, who was especially concerned with movement and who was well acquainted with the photographs of the by-now prominent Marey. It is thus almost certain that Seurat was influenced by photos of movement.

The new cinematic images of both Muybridge (Fig. 5.19) and Marey (Figs. 5.10 and 5.20) were given wide publicity. And their impact was by no means shortlived. More than 20 years later they were still considered novel and artistically significant for Duchamp's *Nude Descending a Staircase* (Fig. 5.21) and the Italian futurist paintings were strongly affected by these photographs. Duchamp describes this influence on his modernist classic:

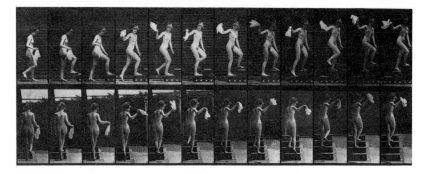

Fig. 5.19 Muybridge, *Woman Climbing Stairs, Waving Handkerchief.* 1887

I was working quite by myself at the time—or rather with my brothers. And I was not a café frequenter. Chronophotography was at the time in vogue. Studies of horses in movement and of fencers in different positions as in Muybridge's albums were well known to me.

In 1910, just a year earlier, the Futurists had startled the artistic world with claims long familiar to those studying animal motion:

> A profile is never motionless before our eyes, but it constantly appears and disappears. On account of the persistency of an image upon the retina, moving objects constantly multiply themselves; their form changes like rapid vibrations, in their mad career. Thus a running horse has not four legs, but twenty, and their movements are triangular. [see Fig. 5.20]

Fig. 5.20 Marey, *Walking Horse.* ca. 1880s

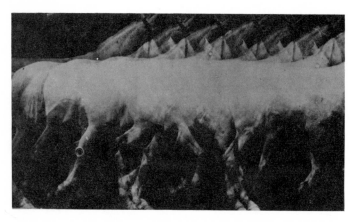

An excellent example of this is the Italian Futurist Balla's *Dynamism of a Dog on a Leash* (Fig. 5.22). The profound reductionist motivation of this kind of art—the drive to reduce images and phenomena to something simpler—is stated quite starkly by Duchamp:

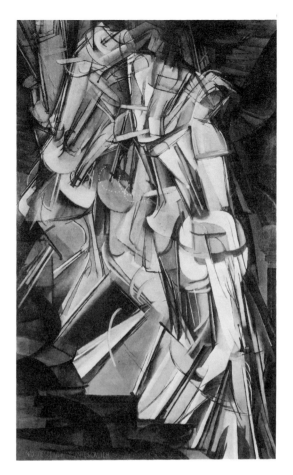

Fig. 5.21 Duchamp, *Nude Descending a Staircase, No. 2.* 1912

Fig. 5.22 Balla, *Dynamism of a Dog on a Leash.* 1912

Fig. 5.23 Muybridge, *Daisy Jumping a Hurdle.* 1883–87

The reduction of a head in movement to a bare line seemed to me defensible. A form passing through space would traverse a line; and as the form moved the line it traversed would be replaced by another line — and another and another. Therefore I felt justified in reducing a figure in movement to a line rather than to a skeleton. Reduce, reduce, reduce was my thought — but at the same time my aim was turning inward, rather than toward externals.

Fig. 5.24 Kupka, *Horsemen.* 1901–02

To Kupka, however, belongs the honor of the first breakthrough into direct multiple image painting. With him, as with Duchamp, the catalyst was the new scientific photography. As early as 1901 he worked in this new style (Figs. 5.23 and 5.24); in 1909–10 he clearly painted the same concept (Fig. 5.25) that Duchamp would express more publicly a year later in *Nude Descending.* Duchamp does not acknowledge Kupka's influence, which is however very probable since Kupka was a friend of Duchamp's brothers, both of whom were painters; Kupka lived nearby and often visited the Duchamp residence during this period. It is doubtful that an innovation as novel as his would not have been discussed.

Another interesting precursor to Futurism and Cubism is photographic error. Specifically, in the first decade of photography subjects occasionally failed to remain still long enough, and hence the print would show multiple images of the subject. For example, the dog and his master in the Civil War photograph (Fig. 5.26) and in Figure 5.27. A common error somewhat later was the double exposure (Fig. 5.28) à la Picasso (Fig. 5.29). Such mistakes are obviously similar to the deliberate scientific analysis of chronophotography and to Futurism (Fig. 5.22). That many of these photographs survived—and were not discarded—shows that they often were found interesting. Once again, science, and photography and art are in parallel. Both kinds of image are the visual essence of simultaneity. As suggested in the discussion of Manet's *Bar,* a "Cubist" painting can be easily constructed from a Muybridge multiple view by combining parts of the figure as they existed at the same time but from different viewpoints.

Distorted Space

The term distorted space is used here to mean a space that is warped or continuously curved, rather than discretely broken.

In the first half of the nine-

Fig. 5.25 Kupka, *Woman Picking Flowers I.* 1909–10

Fig. 5.26 George N. Barnard and Gibson, Detail of *Fortifications on Heights of Centerville, Virginia.* 1861–65

Fig. **5.27** Bragaglia, *Fotodynamic Portrait.* 1911

Fig. **5.28** Amateur snapshot. ca. 1924

teenth century space was routinely conceptualized both in science and art as linear, fixed, and Euclidean. The first theoretical challenges to this position were proposed by mathematicians in the second quarter of the century. These contributions are now known as non-Euclidean geometry, and these new geometries represented space as curved—a space in which parallel straight lines do not occur. The first non-Euclidean geometry was that of Bolyai, who in 1833, published his contribution in an appendix to an article by his father. Apparently 1833 was too early for such a radical idea, and it was ignored. A few years later Lobatchevsky, a Russian, published remarkably similar ideas but they were received with such hostility that it cost Lobatchevsky his job at the University of Kasan. The great mathematician Karl Friedrich Gauss was the third to independently describe non-Euclidean geometry at about this time. He however, did not publish his work, believing that it would be received most negatively. Instead, his geometry was published posthumously along with other works in 1854. Partly because of the great reputation of Gauss and partly because the mathematical Zeitgeist seems to have changed, the idea of non-Euclidean geometry from that time on began to be given serious consideration. By the 1870s and

Fig. 5.29 Picasso, *Untitled*. 1937

1880s, Western thought had begun to seriously absorb the impact of these new concepts of space. The primary consequence of the non-Euclidean ideas was to pose the nature of space as an empirical question. That is, the question of whether space was Euclidean or in some way curved — non-Euclidean — was something that could be empirically investigated. From the mathematical point of view a geometry was now seen as an abstract set of axioms that must satisfy certain mathematical properties such as consistency but that had no necessary connection to actual physical or perceived space. Thus, at the highest conceptual level, the *a priori* fixed, premodernist space of Euclid was dethroned from its position as descriptive of the physical world: it was now only one theory, however important, among others.

A consequence of this was that visual scientists began to propose theories of how space was in fact perceived — including whether perceived space was or was not Euclidean. By the early 1890s the *subjective* notion of space had become a standard interpretation within science. In *The Grammar of Science* (1892), Karl Pearson shows just how far the new concept of space had moved toward a relativistic internal subjective perception. Pearson's work, heavily influenced by the writings of Ernst Mach, is a major statement of the philosophy of science at that time. Pearson defines space not as an external reality but as a "mode of perception." That is, space is an expression of the "perceptive faculty." As such, Pearson argues that we should never talk about space as something "out there" but as something intrinsically *in* the individual. For example, he says we should not ask "why space seems the same to you and me"; instead, we should ask "why your space and my space are alike." Finally, Pearson claims that "space and time are not realities of the phenomenal world but the modes under which we perceive things." Space and time are "not infinitely large nor infinitely divisible but are essentially limited by the contents of our perception."

Given that mathematics and both theoretical and experimental science had arrived at a subjectivist notion of space (and also of time), and in particular at a powerful new mathematical representation of space as curved, it should not be surprising that modernist painters as well had started to introduce distortions of space.

In *Boats*, (Fig. 5.30), *On the Beach at Boulogne* (not shown), and other seascapes, Manet shows a curved horizon line. This curvature, though slight, is a pictorial representation of a common perceptual

experience and shows Manet's concern with personal perception and withdrawal from the authority of the older notion of space. Manet's sensitivity in this regard is further evidence of his innovative ability to directly observe visual experience without allowing familiar higher order concepts to get in the way. For, as the visual scientist Beck has noted, "To see straight lines as bowed in the periphery of the visual field requires fixation (straight ahead) and an analytical observational attitude (directed at the periphery)," where the curvature occurs.

Cézanne also introduced spatial distortions into his compositions. Loran, for example, notes this aspect of Cézanne's work. In *Landscape at La Roche-Guyon* (Fig. 5.31) a looming and "disturbing" expansion of the road is easily observed (see Fig. 5.32, a photograph of the original scene). Areas of tilted and looming perspective can be found in many other of Cézanne's works. It is not just that he presents different points of view, but his manner of combining them also involves the introduction of local areas of warped space—distortions that his commentators have often incorrectly classed as mere changes in perspective.

In summary, it is important to observe the close similarity between Cézanne's work—and its implica-

Fig. 5.30 Manet, *Boats.* 1873

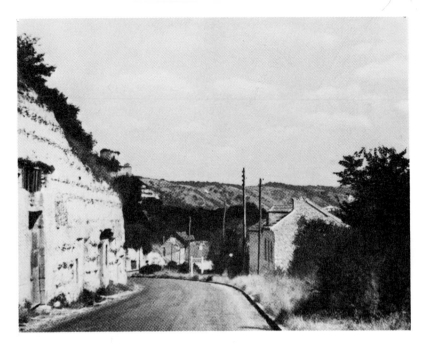

Fig. 5.32 Rewald, Photograph of the motif (above).

Fig. 5.31 Cézanne, *Landscape at La Roche-Guyon. ca. 1885*

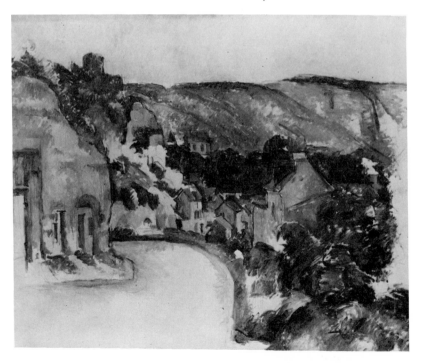

tions — and the Pearson-Mach position, both formulated in the years between 1880 and 1900. Art historian Judith Wechsler writes:

> Cézanne rendered the interface of the process of perception and object of perception. . . . Cézanne above all makes us conscious of the way he sees and in the process dramatically extends *our* field of vision, our possibility of seeing. The perceptual process was primary for Cézanne. He did not, even more, he could not accept a preconceived set of rules for painting his vision of nature. Once we understand Cézanne's art in this light, we can no longer accept the notion that our seeing an object is only a function of that object itself.

This interpretation by Wechsler is not a recent or post hoc reading. Albert Gleizes and Jean Metzinger, two of the first Cubists, in their articulate defense of that movement in 1912, argued much of the case for Cubism in pure Machian and Pearsonian language. The influence of the new perceptual theory of space is strong — the direct influence of visual science is clear.

There is nothing real outside ourselves; there is

nothing real except the coincidence of a sensation and an individual mental tendency. Be it far from us to throw any doubts upon the existence of the objects which impress our senses; but, rationally speaking, we can only experience certitude in respect of the images which they produce in the mind. It therefore amazes us when well meaning critics explain the remarkable difference between the forms attributed to nature and those of modern painting, by a desire to represent things not as they appear, but as they are. As they are! How are they, what are they? According to them, the object possesses an absolute form, an essential form.

What Simplicity! An object has not one absolute form: it has many, it has as many as there are planes in the region of perception.

Van Gogh's subjective spaces are well-known and in Figure 5.33 we see a schematic summary made by Roland Fischer that clearly shows the curved-space character of a van Gogh and its contrast with the Euclidean space shown in the lower picture.

Meyer Schapiro comments on

Fig. 5.33 Schematic representation of van Gogh's *Bedroom at Arles,* 1888. Note the excited painter's distorted space perspective (upper half of figure). Schematic representation of van Gogh's *Bedroom at Arles* in reconstructed Euclidean space perspective (lower half of figure). From R. Fischer 1968.

Van Gogh's space with special force in *Bedroom at Arles*.

The perspective vision of the walls and bed is as exciting as one of his deep landscapes, where we are carried headlong into the horizon.

As we follow the converging lines of the floor and bed to an unmarked point, we come to a rival perspective system in the dark lines of the casements.

In Renaissance pictures it [geometric perspective] was a means of constructing an objective space, complete in itself and distinct from the beholder, even though organized with respect to his eye, like the space of a stage, in many of Van Gogh's last landscape drawings, the world seems to emanate from his eye in a gigantic discharge with a continuous motion of rapidly converging lines.

Note in the upper drawing how nearby objects loom large and curve; note too the curved floorboards in the foreground and the curved lower edge of the footboard. Fischer attributes the representation of this non-Euclidean space to van Gogh's extremely agitated emotional state—a manic phase that began just before he painted this work in October 1888. This kind of warped or excited space is, according to Fischer, frequently characteristic of schizophrenics, children, and normal subjects "under the excitatory influence of a psychotomimetic drug." But as noted earlier a curved space is apparent to all of us after very careful perceptual observation, such as fixation plus analysis of peripheral vision. Helmholtz, in 1867, was apparently the first to make this observation.

Patrick Heelan, in analyzing *The Bedroom at Arles* in great detail, concluded that van Gogh painted a non-Euclidean space "based on a strictly binocular visual comparison of depth and distance when all other clues to size, depth, and distance . . . are inoperative," This space, according to Heelan, is one in which near space is a kind of looming bulge while far space drops off rapidly. Heelan further claims that van Gogh's particular space is very close to the space Luneburg and other visual scientists have proposed on the basis of their studies, using trained observers in experiments carefully measuring the nature of the space of binocular vision, If so, van Gogh's intuitive grasp of this space, although not strictly in advance of scientific speculation and early studies,

nevertheless predates any systematic demonstration of a non-Euclidean perceptual space, especially one based on binocular cues. (There is, as far as could be discovered, no evidence of van Gogh's having been affected by the relevant science of his day.)

Heelan's thesis has been criticized on several points by John Ward. He asks how it was possible for van Gogh to use only binocular cues to depth and to make inoperative other relevant depth information. Ward posits that van Gogh's curved space resulted from the artist's smoothing over on the canvas the different representations of the room, each painted from a somewhat different point of view. This alternative remains consistent with the parallelism thesis since it can be interpreted as the result of integrating more or less smoothly a set of images, each from different points of view, as in the analysis of Cézanne—the only difference would be that the expressionistic continuity results in space that is more warped than fractured.

Perhaps the simplest way to understand van Gogh's space is to note that it is not really an abstract, consciously planned space. Instead, as Fischer implies and Beck states, van Gogh's space "represents the sensation of space accompanying observation under unusual and restricted conditions"—that is, the artist's psychopathology plus the cramped physical space. In any case, van Gogh's dramatic, warped space is characteristic, the precise way in which he concocted it can only be hypothetical, and may not in fact matter.

There is one final important distortion of space that was influential at this time. Rather early, it was noticed that the camera often distorted objects that were photographed. The most common distortion was foreshortening; an example of this may be seen in Picasso's *By the Sea* (Fig. 5.34). Common examples of similar distortions in photography pointed out by Scharf and Coke make interesting comparisons (Fig. 5.35). The similarity and possible causal relationship are obvious. It is as though the camera were an example of applied non-Euclidean space—again, a kind of parallel within science itself—if we take the mechanism and physical theory of photography as part of science. There is no evidence to suggest that Manet, Cézanne, and van Gogh were directly influenced by the new mathematical and scientific theories of space. In the case of Picasso, however, there is the probable effect of Gleizes and Metzinger to be considered, as well as reason to believe that the distorted space of many photographs was influential. (For this evidence see Scharf 1968 and Coke 1972). In any case,

Fig. 5.34 Picasso, *By the Sea.* 1920

Fig. 5.35 Anonymous, *Man with Big Shoes.* ca. 1890

140 MODERN ART AND MODERN SCIENCE

these similar distortions of space were occurring in both the scientific and artistic worlds.

Throughout this chapter we have shown that the scientific analysis of the perception of space and time developed quite consistently from Wheatstone's stereoscope to Marey's cinema. Each step of this development involved the breaking up of "space" into more points of view and the breaking up of "time" into more and smaller discrete underlying parts. Starting some decades after Wheatstone, artists such as Manet and Cézanne initiated the parallel breaking up of painted space into multiple points of view. Although these two painters seem to have intuitively investigated the new perception, painters such as Degas consciously took up the new images and approach of Muybridge, and Seurat at least began to do the same with Henry and Marey. This type of influence culminated in the work of Kupka, Duchamp, the Futurists, and the Cubists, all of which were directly and deeply influenced by the Wheatstone, Muybridge, Marey tradition and by the new Machian perceptual theory of space.

A secondary theme accompanying this analysis has been the distortion of space introduced by non-Euclidean geometry, by empirical theories of space perception, by distorted photographs, and by the new philosophy of science. This important change in visual science was independently paralleled by the distorted spaces of Manet, van Gogh, Cézanne, and Picasso.

Form and the Elements of Form

Serious scientific and artistic preoccupations with abstract form as a *separate* aspect of visual experience emerged in both disciplines around the turn of the century. This strikingly similar preoccupation is a prime demonstration of parallelism. By the term "form" we mean visual configuration considered as distinct from such things as color and pictorial content and from the representation of objects. For present purposes the words "form," "figure," "pattern," and "shape" can all be considered essentially equivalent.

Figure and Ground

The fundamental distinction between figure and ground was first made by the Danish psychologist Edgar Rubin in a series of investigations begun in 1912. The results were initially published in Danish in 1915, but they had little impact until they were republished in German in 1921. Rubin established that ordinary visual experience has two primary parts—the figure and the ground. The figure is the focus of attention, is seen as an object, is surrounded by a contour (boundary), and is seen as a whole against the ground or background. The ground, however, is typically seen as an undifferentiated field, lying farther away and hence behind the figure; it does not look like an ob-

ject. This distinction between figure and ground is of special interest when the two perceptual categories are ambiguous (Figs. 6.1, 6.2, and 6.3). Such ambiguity has been attractive to artists since it flattens perceived depth and adds visual tension by breaking down the hierarchy between figure and ground. These figures are Rubin's original plates and in each the part seen as figure or ground is perceptually unstable. Thus, Figure 6.1 can be seen as small white "nonsense" shapes (that is, essentially random shapes), on a black background. Or the white can be seen as a background sheet lying behind a closer black sheet that has had the nonsense shapes cut out of it. Next to this Rubin plate is a remarkably similar Arp (Fig. 6.4) in which first the black and then the white can be seen as the figure. A much earlier Arp constructed in 1925 titled *Mountain, Table, Anchors, Navel* (Fig. 6.5) is a very conscious expression of figure-ground ambiguity. As reproduced, it looks like a pattern on a single flat surface, however, the anchors and table are shapes cut out from the blue and brown areas, allowing the white ground situated several inches behind to show through. As early as 1925 it was obvious that Arp was directly exploring the figure-ground distinction. Although Rubin and Arp were contemporaries, no connection between them could be

Fig. 6.1 Rubin, Ambiguous figure-ground. 1915 (see text for discussion). (Fig. 6.2 follows Fig. 6.5)

Fig. 6.4 Arp, *Constellation of Six Black Forms on White Ground.* 1957

Fig. 6.5 Arp, *Mountain, Table, Anchors, Navel.* 1925

found. (Apparently, Arnheim, in his classic *Art and Visual Perception*, was the first to clarify this very effective use of figure-ground ambiguity by Arp.)

Figure 6.2 presents the famous Rubin "claw" (1915) which can be seen as either a black claw on a white ground or as white finger-shaped objects on a black ground. Next to it is a Matisse (Fig. 6.6) and a Miró (Fig. 6.7); in both works this kind of figure-ground ambiguity is also prominent. Such figure-ground ambiguity became a distinctive, almost definitive, characteristic of the later Matisse cutouts.

Perhaps the best known Rubin figure-ground example is the vase or two faces in profile presented in Figure 6.3. The Salvador Dali (Fig. 6.8) is a complex, rather humorous elaboration on Rubin's theme;* the recent Jasper Johns print using Picasso's profile (Fig. 6.9) has the same source.

Turning to Cubism, John Richardson provides a useful discussion of figure-ground. About Cubist works Richardson writes that: "Their fascination with continuities and discontinuities makes it very difficult for us to separate figures from their background." A

Fig. 6.2 Rubin, Ambiguous figure-ground: claw. 1915. (Fig. 6.3 follows Fig. 6.8)

*There are many other works of Dali that demonstrate his frequent use of figure-ground ambiguities—especially as they involved the hidden forms of recognizable objects.

Fig. 6.6 Matisse, *The Cowboy.* 1947

Fig. 6.7 Miró, *Hand Catching Bird.* 1926

Fig. 6.8 Dali, *Apparition of a Face and a Fruit Dish on a Beach.* 1938

Fig. 6.3 Rubin, Ambigous figure-ground: vase-face. 1915

Fig. 6.9 Johns, *Cups 4 Picasso.* 1972

very early intuitive use of this ambiguity can be observed in *Ma Jolie* (Fig. 6.10) by Picasso (1911). Richardson goes on to develop his analysis in a pictorial scheme (Figs. 6.11 and 6.12). In the first diagram (Fig. 6.11), the three planes are unambiguous as to their locations in space, it being clear that the area marked **O** is the closest to us, then **P**, then **Q**. When **O** is focused upon, the areas **P** and **O** and white surround all function as what he calls background. Figure 6.12 reproduces Richardson's analysis of "cubistic" relationships in which ambiguous, that is shifting, figure-ground properties are clearly present. For example, the gray area to the upper right of **P** is ambiguous where it protrudes into the black of **O**. This area can either be seen as a figure in its own right or as the ground behind **O**: this part of the figure being similar to Rubin's claw. These areas of ambiguous depth, of figure-ground ambiguity, constitute much of the Cubist style, and are particularly prominent in Picasso's *Card Player* (Fig. 6.13) and in Braque's *Musical Forms* (Fig. 6.14). Richardson does not discuss his cubistic relationships in terms of Rubin's work and indeed even his reference to figure and ground are rather informal but he notes the "ambiguous space" and comments that in *Musical Forms* "we can't settle upon the true relationships of the paper to the card-

Fig. 6.10 Picasso, *Ma Jolie.* 1911–12

Fig. 6.11 Richardson, Planes arranged to show normal overlapping unambiguous figure-ground. 1971

Fig. 6.12 Richardson, Planes arranged to show "cubistic" ambiguous figure-ground. 1971

Fig. 6.13 Picasso, *Card Player.* 1913–14

board. Are the forms cut from the paper or are they the result of the cardboard overlaying it?"

In Chapter 5 we mentioned that Steinberg, somewhat like Richardson, identified the expression of ambiguous depth as probably the most fundamental aspect of Cubism. Steinberg's analysis (as abbreviated) is as follows:

human figures and implements, having crystalized into angular planes, began to break up; the facets disengaged, tipped and quivered in the thickening ground. . . . Pictorial space became a vibrating shallow of uncertain density, the equal footing of solid and void. The perceptual possessiveness which demands the illusion of solids was mocked. . . . [In *Woman with Mandolin*, Fig. 6.15] the space behind, smooth at the upper left, is subtly mystified. Stacked rectangles nest in each other and cascade down the left margin. . . . Incomplete as they are, and never concretely localized, these prisms are the exchange medium between segments of body and geometric right angles. All pictorial action, all rhythmic movement depends upon transience and convertibility—back and forth between

Fig. 6.15 Picasso, *Girl with a Mandolin (Fanny Tellier)*. 1910

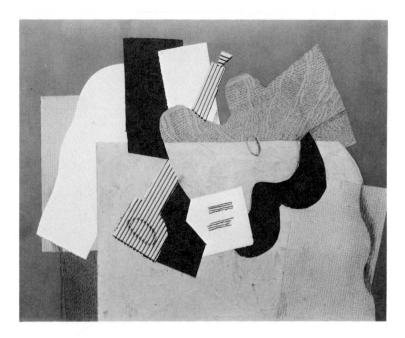

Fig. 6.14 Braque, *Musical Forms.*
1918

the modeled rotundities of the nude and the flats of the "background."

More simply—the abstracted, simplified features of the objects are painted so that many parts of the image are ambiguous as to whether they are the figure or the ground. These areas of figure-ground ambiguity create an intriguing, constantly shifting tension that is perceptual in nature.

Commonly overlooked are Rubin's starkly simple figure-ground-stimuli (Fig. 6.16), for example, which show how a simple contour divides an area in *Musical Forms* so that either half can be viewed as figure.

As in the case of Arp, no causal link could be found between the spatial ambiguity of Cubist surfaces and figure-ground as expressed in visual science. For Cubism a direct link is most unlikely since the early Cubist paintings predate the figure-ground distinction by three or four years—Rubin first published in 1915. An independent parallelism in art and science is thus almost certain, in which Picasso and Braque had an early intuitive insight; however, Rubin was the first to demonstrate the effect consciously with great clarity.

Figures 6.17 and 6.18 show figure-ground patterns taken from Koffka's *Gestalt Psychology* (1935), originally published by

Bahnsen (1928). Figure 6.19 shows a similar expression by the American painter Burchfield.

From the above analysis of figure-ground ambiguity, and from the earlier discussion of multiple points of view, we can conclude that these two perceptual phenomena, along with a focus on simple abstract forms are the major characteristics of the Cubist style.

Form-Quality:
The Neglected Early Gestalt Movement

More than 20 years before figure and ground were conceptually and pictorially distinguished by Rubin, psychologists had already begun to treat the perception of form as a fundamental issue. In 1890, Christian von Ehrenfels published an article introducing the notion of form-quality (Gestaltqualität). Ehrenfels proposed that form was an important new visual quality—a quality not given by the simpler elements making up the form. He took the square as an example in which he claimed that the four lines of a square are separate sensations that underlie, but are not the same as, the perception of the square as a whole. The "squareness," the form as a *whole*, is not in the separate elements but instead comes into existence only when the

Fig. 6.16 Rubin, Ambiguous figure-ground. 1915

Fig. 6.17 Koffka, Ambiguous figure-ground partially resolved in favor of seeing the symmetric shapes as figure. 1935

Fig. 6.18 Koffka, Ambiguous figure-ground. 1935

Fig. 6.19 Burchfield, *Crystalline Composition*. ca. 1920

elements are combined into the square—thus *form quality* is an important and distinct kind of perceptual experience. It is not necessary to get involved in the theoretical debate that Ehrenfels's proposition set in motion; the important point, for our purposes, is to note that the question of how form was perceived was put on the agenda of visual science between 1890 and 1900. This problem remained an avantgarde issue in perceptual studies for many years. Thus, as Wertheimer acknowledges, Ehrenfels was the father of Gestalt psychology. It is also interesting to note that the issue was initially argued with reference to the square.

In the 1890s, Theodore Lipps, another proto-Gestalt psychologist, wrote extensively on the perception of simple forms and on how forms and configurations of forms were related to their parts. His diagrams, which he used in discussions of the square and rectangle, are shown in Figure 6.20; others of Lipps's diagrams appear later in connection with his influence on Klee and Kandinsky. This influence established Lipps as especially important for artists of this period.

Frederick Schumann was the first, in 1904, to investigate empirically Ehrenfels's position, using a variety of different figures. He was especially concerned with evidence for Gestalt qualität and with any changes in perceived form occur-

ring with a change in a figure's orientation (for example, square vs. diamond; Fig. 6.21).

Fechner (1876) appears to be the first scientist to do research on the pleasingness of forms—in his case the square and rectangle. The issue of preference for simple form remained dormant until the 1890s, when the proto-Gestalt theorists awakened a widespread interest in the problem. At this time many psychologists began to investigate the "aesthetics" of simple form. These investigators isolated preferences for squares, rectangles, ellipses, and triangles. Others tested preferences for how to divide a line, or the expressiveness of different lines.

In this research literature—which was published a decade or so prior to cubism, abstraction, and formalist art criticism we have such formalist sentiments as: "Any form that . . . suggests a general tendency which is satisfied by the elements it contains, apperceived as a whole, may be beautiful" (Pierce, 1896). Witmer (1894) concluded that a square, a circle, or a rectangle could please the viewer.

Given that visual scientists had begun to find the study of the perception of abstract forms richly significant, it is not surprising that artists also had—at largely the same time—broken through to the idea that a painting could consist solely of simple form—indeed of *a* simple form.

Fig. 6.20 Lipps, Square as balance of vertical and horizontal (left figure); balance reduced by changes (two figures on right). 1897

Fig. 6.21 Schumann, Change in appearance of a form (square) when orientation is changed. 1904

Fig. 6.22 Malevich, *Black Square.*
1920 (after *The Basic Suprematist
Element: The Square.* 1913)

Malevich

The most important early pure form painter is the Russian suprematist Kasimir Malevich, who introduced simple geometric form as the only "content" of a painting. Malevich's enthusiasm for the modern, urban, technological world was at the center of his conception of Suprematism. Much like the Futurists, he was deeply impressed with the new visual world created by technology and science. In *The Non-Objective World,* his aesthetic manifesto, he wrote:

> I call the additional element of Suprematism "the suprematist straight line" (dynamic in character). The environment corresponding to this new culture has been produced by the latest achievements of technology . . . one has only to remove the artist from the center of energy of the city so that he no longer sees machine, motors, and power lines and can devote himself to 'the agreeable sight of hills, meadows, cows, farmers and geese in order to heal his cubist or futurist illness.

Throughout his important book, Malevich consistently identifies science, technology, and machines with the spirit of Cézanne,

Cubism, Futurism, and of course, his own position. He elaborates, however, that the Suprematist "should by no means portray the machine, he should create new abstract forms." The fundamental form for Malevich was the square—as shown in Figure 6.22. Paintings of this type, initiated in 1913, are the first to bluntly present a simple Gestalt as *the* message.

Malevich's most famous work is his 1918 *White on White* (Fig. 6.23) with its strong anticipation of minimal art. In any case, the general preoccupation of both these works with the visual significance of elementary geometric form marks Malevich as the first painter of Gestalt-qualität. Additional Malevich compositions are shown in Figure 6.24; these can be considered as obvious parallels to the proto-Gestalt stimuli in Figures 6.25 to 6.28.

Starting with Schumann (1900), the experimental literature on the perception of form developed rapidly, and the use of simple geometric forms as stimuli presented to subjects in order to investigate their perceptual responses becomes widespread. A. Kirschmann (Fig. 6.29), in a 1908 study of perception of form (Gestalt) and orientation (Lage), used the Kandinsky-esque geometric figures shown in Figure 6.30.

It was not just the perceptual characteristics of simple shapes that

Fig. 6.23 Malevich, *Suprematist Composition: White on White.* 1918

Fig. 6.24 Installation view of Malevich paintings. 1915–16

Fig. 6.25 Lipps, Center rectangle as affected by rectangles on either side. 1897

Fig. 6.26 Lipps, Rectangles of fixed height as changed by reduced length. 1897

Fig. 6.27 Kirschmann, Recognition of geometrical figures as affected by form (Gestalt) and orientation: stimulus examples. 1908

Fig. 6.28 Kirschmann, Recognition of geometrical figures as affected by form (Gestalt) and orientation: stimulus examples. 1908

Fig. 6.29 Kirschmann, Stimuli used to investigate recognition of different geometric figures on black or white backgrounds. 1908

Fig. 6.30 Kandinsky, *In the Black Square.* 1923

were being studied at this time. Scientists, starting with Fechner in 1876, had also begun the first empirical investigations of the aesthetic significance of simple form, that is, preferences for rectangles (including the square). By the early part of this century a good number of studies on aesthetic preferences for simple forms, especially the square and rectangles of different proportions, had been published.

Gestalt Psychology and "Gestalt" Artists

As an active, coherent movement, Gestalt psychology began in Germany shortly before 1920; it reached its peak influence in the 1930s. This important theory of visual perception emphasized the perception of form: the term Gestalt means not only form, configuration, or shape but also implies good—significant or living—form. The movement was dominated by a trio of brilliant, energetic scientists—Max Wertheimer, Wolfgang Kohler, and Kurt Koffka—whose writings have unfortunately overshadowed the earlier proto-Gestalt contributions of Ehrenfels, Lipps, and others.

Since visual perception involves the processing of a large area of complex stimuli, mechanical association theories of processing, for example, those that simply link sen-

sory elements like dots of color, are clearly inferior to those that can establish general laws of organization that summarize and integrate large amounts of sensory experience. Such principles were put forward by the Gestalt psychologists. In his well known 1923 essay, Wertheimer outlined seven major factors by which organization of the stimulus field might take place. Some of these principles are 1) *the factor of proximity* (defined as the tendency for elements located close to one another in the perceptual field to be seen as a group); 2) *similarity* (elements with similar characteristics may be seen in a group); 3) *objective set* (grouping of elements will be affected by a preceding sequence of sensory events); 4) *good continuation* (the perceptual field will be organized along lines of uninterrupted flow); and 5) *closure* (elements will, if possible, be grouped to appear as self-enclosed units). The basic tenet under which these principles are subsumed is the Law of Pragnanz, which holds that, within the limitations of the sensory field, organization of elements will be as "good," "simple," and "economical" as possible. This organization is supposedly achieved by superimposing perceptual processes on the stimulus. Kohler claimed that sensory organization is a primary fact that arises from the elementary dynamics of the nervous system. The outcomes of these organizational operations are Gestalten, defined as dynamically structured forms, configurations, or wholes. In contrast, then, to simple summation theories, the Gestalt psychologists maintained that perception entails a "spontaneous arrangement" of elements in the sensory field into segregated units that are "separate from and related to one another." From this it follows that the organized whole is different from the sum of its individual parts: the appearance of any part depends on the structure of the whole and the whole, in turn, is influenced by the nature of its parts.

In the Gestalt system, vision is not taken as a process of learning shapes or of associating arbitrary meanings to them, as was held by earlier learning or association theories—and is still held by behavioristically inclined psychologists. Rather, as Arnheim points out, the Gestalt theory infers an active interplay between the observer and properties supplied by the observed object. The fact that figural units, grouped according to Gestalt or other perceptual laws of organization, are perceived to be the same shape by all observers in spite of cultural or personal associations, strongly implies that these shapes have a common universal significance. That is, that everyone's nervous system supplies the same organization to their perceptual experiences. This line of reasoning

lends itself to a psychology of art founded on perceptual processes, one that addresses the objective effect that a work of art would have on the observer. The Gestalt approach to such a theory is founded on the principle of isomorphism, that is, there is a close similarity (in theory a one-to-one mapping) between the structure of the physiological response (brain activity) and perception—the experience. Thus, it was postulated that a kinship exists between the brain activity and the configuration of the experience in the observer.

Picasso

The connection between Picasso and Gestalt principles seems especially noteworthy. Evidence of this connection is reported by Fritz Heider, a prominent Gestalt psychologist, in an article in which he reminisces about his student days in the 1920s in Berlin with Wertheimer and Kohler. Heider comments:

> Wertheimer published his paper in 1923, but he said in it that he had already developed its main points in the years 1911 to 1914. It was exactly during the same years that Picasso, one year younger than Wertheimer, developed his style of breaking up

the visual appearance of objects, as was shown to perfection a few years later in pictures like the "Three Musicians," which he painted in 1921. If one looks at these pictures after having read Wertheimer's paper, one realizes immediately that Picasso's new technique consisted partly in destroying the natural units of familiar objects by opposing one unit forming factor to another. One specific part of the picture may make a good unit with a table according to one factor, but according to another factor it belongs to the wall. True enough, unit-forming factors were used in older pictures, but more often they were used to help in a redundant way to segregate one object unit from others, e.g., a person from the landscape. One has the feeling that Picasso's introduction of these strange visual contradictions implies a more conscious use of these factors.

Heider goes on to say that he doubts that the two men knew each other and he notes that

> when Gertrude Stein and Picasso walked down a boulevard in Paris during World War I, they came

across camouflaged cannon. Picasso was spellbound and said: "It is we who have created that". ... The Gestalt psychologists, on their side, were of course conscious of the fact that camouflage makes use of unit-forming factors, and there was a rumor that Wertheimer or Koffka helped in improving it.

Heider thinks it hardly possible that these two similar approaches to perception occurred by chance; instead he posits two independent disciplines — science and art — coming to the same understanding at the same time.

Similarly, the paintings of Klee, Kandinsky, and others can be interpreted as investigations of form that parallel the studies of the Gestalt psychologists or their immediate precursors.

Klee

Perhaps the first influence of visual science on Klee came in 1905, early in his career, when he writes in his diary of the impression made on him by Ernst Mach's *The Analysis of Sensations*. Marianne Teuber, in a 1976 paper, to which this section on Klee is greatly indebted, notes this and suggests that Mach's theories about economy of form, his analyses of visual and musical patterns, and his reversible diagrams contributed to Klee's first abstract compositions of the war years.

Klee's ideas were also based in part on Wilhelm Worringer's aesthetic concepts, expressed in *Abstraction and Empathy* (1918), a book that was adopted by members of the *Blaue Reiter* (a group of modernist artists centered in Germany established about 1907; Kandinsky was their spiritual leader). Among other important observations, Worringer said that space is the major enemy of abstraction.

Worringer, heavily influenced by Lipps, also developed an aesthetic based on empathy — the notion that there is a strong association between the physical forces or shapes in the observed object and psychological responses in the observer. This principle is, as Rudolf Arnheim notes, very close to the central Gestalt principle of isomorphism.

In 1908, while painting *The Balcony* (not shown), Klee transposed accidental qualities of nature into flat, ordered patterns. His method was quite interesting. First drawing from nature, he then turned the paper upside down to choose the abstract forms needed to convey the impression he wanted. This procedure is a simple adaptation of the one recommended by Rood and Helmholtz 50 years earlier; recall

that both had suggested that if viewers want to see a landscape as a flat, colorful, abstract pattern without familiar meaningful objects, they should look at the scene upside down.

The contemporary German painter George Baselitz has taken this Helmholtzian logic still further. Not only does Baselitz paint his works upside down, but exhibits them upside down as well, thus placing the viewer in the position to appreciate the distinctive perceptual effects of such an orientation.

In 1921, Klee joined the Bauhaus, which began to feel the influence of Gestalt psychology over the next few years. The close connection between the Bauhaus theory of architecture and design and the Gestalt theories of good configuration led Hannes Beckmann, a student in the Dessau years, to comment that the Bauhaus was "a school in Gestalt psychology itself."

In 1920 Klee's "Creative Credo" makes a strong statement that his aesthetic was aimed at expressing the nature of underlying perceptual processes: "Art does not reproduce the visible, rather it makes visible. Formerly we used to represent things visible on earth. . . . Today we reveal the reality behind visible things."

Klee's teaching position at the Bauhaus required that he develop and elaborate a theoretical position

"to be clear about what I — unconsciously for the most part — did." His theories have been preserved in lecture notes and illustrations prepared for the Bauhaus classes. These notes are ample evidence of Klee's concern with achieving the utmost simplicity and economy of form. He instructed his students to "reduce the whole to a very few steps, let the general impression rest on this principle of economy"; and toward production of the whole, "all the sections must fall into a definite structure . . . join into an articulated whole. The interaction between the general structure of the whole and the natural structure of the parts forms the core of an elementary theory of proportion." In his search for "the crucial images of creation," Klee discovered patterns and principles that reflect with remarkable similarity the Gestalt theories of perceptual form. Indeed, Gestalt psychology had a profound effect on Klee's theory of form: he distinguished between "Theories of form and formation," emphasizing formation or good form, which means something alive — a form with an undercurrent of living functions.

Klee's extensive adoption of Gestalt principles and figures can be seen in a 1928 work, *Old Town and Bridge* (Fig. 6.31). Figure 6.32 depicts the Gestalt shapes or principles found in this work. For example, repeating arches or V-shapes

Fig. 6.31 Klee, *Old Town and Bridge.* 1928

Fig. 6.32 Examples of patterns and diagrams from various Gestalt publications found in Klee (Fig. 6.31). 1922–35

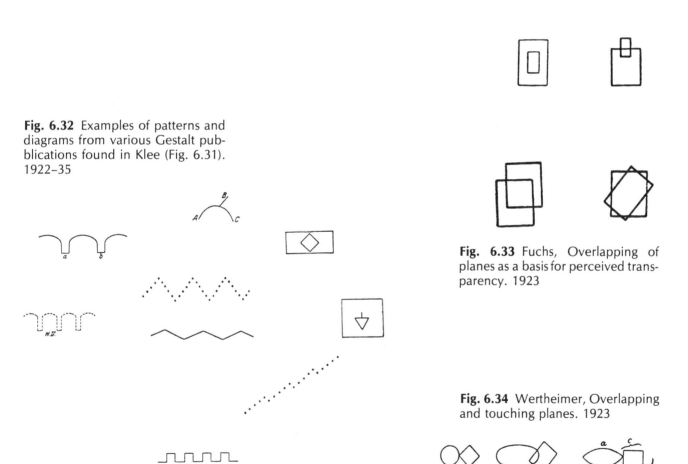

Fig. 6.33 Fuchs, Overlapping of planes as a basis for perceived transparency. 1923

Fig. 6.34 Wertheimer, Overlapping and touching planes. 1923

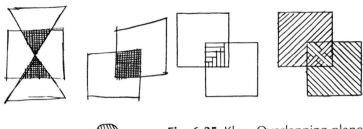

Fig. 6.35 Klee, Overlapping planes (Bauhaus notebooks). 1921–30

Fig. 6.36 Klee, *Dancing Master.* 1930

show the principle of "good continuation" representing the repeated elements found throughout *Old Town and Bridge.* (For different examples of Klee's use of Gestalt patterns and elements see Teuber.)

Teuber very thoroughly identifies Klee's interest in the Gestalt work on transparency and overlapping figures. Diagrams appearing in Fuchs's (1923) article "On Transparency" (Fig. 6.33) and in Wertheimer's writings (Fig. 6.34) appear to have been assimilated into Klee's teaching notes, and the principles of transparency delineated by Fuchs and Wertheimer found articulation in Klee's notebooks (Fig. 6.35). Fuchs stated in his article that "transparency of a smaller figure can be achieved, if it is moved so as to fall partly upon and partly outside of the large rectangle." Wertheimer stressed that partially overlapping figures maintained independent "inner coherence" and good continuation of each figure was maintained to achieve transparency. Transfer of these theories can be easily observed in a number of Klee's works (Figs. 6.36, 6.37, and 6.38).

Kandinsky, at the Bauhaus at this time, was also influenced by the Gestalt studies on transparency and he painted many transparencies, for example, *Yellow Circle* and *Green Collection*, both painted in 1926 (not shown). This Gestalt-Bauhaus interest in transparency is shown in

the work of Lazlo Moholy-Nagy (Fig. 6.39), and in Figure 6.40, another Gestalt representation of this interesting phenomenon. Josef Albers and Hannes Beckman also often experimented with transparency as a consequence of the same Gestalt influence.

Teuber concludes her important study with a direct statement of the parallelism thesis, but applied only to Klee and to one period of visual research.

Much more could be said about Klee's contacts with experimental work on vision; but even the few instances given here suggest that Klee's teaching at the Bauhaus and his picture making can be better understood if seen as paralleling the developments in psychology and laboratory studies of visual perception (from the late nineteenth century to 1933).

The Elements of Form: The Nineteenth Century

Closely related, of course, to the perceptual and aesthetic meaning of a simple complete form (Gestalt) are the elements of which the form is composed, such as straight lines. Theories of the perceptual and psychological significance of lines, especially ver-

Fig. 6.37 Klee, *Laced into a Group.* 1930

Fig. 6.38 Klee, *Rich Land.* 1931

Fig. 6.39 Moholy-Nagy, *Colored Segments*. 1922–23

Fig. 6.40 Overlapping planes showing transparency (first described in Fuchs, 1923).

tical and horizontal, were first proposed in the elementist framework of the nineteenth century and are an important part of the influence of science on art. Initially, ideas of this kind affected modernist painting through Seurat, and influence coming via Charles Blanc, who presented a theory of the intrinsic psychological significance of vertical, horizontal, and oblique lines. Blanc argued that the straight line is a "symbol of unity" and the curved line of "variety." Of the straight lines, the most important is the vertical—since man stands perpendicular to the horizon and since he is bilaterally symmetric. The horizontal line is next in importance and then the two obliques. Blanc discusses three types of human faces characterized by the three orientations and by the associated effects of happiness, rest, and sadness (Fig. 6.41). Blanc's treatment is primarily a popularization of an earlier position (Fig. 6.42) by Humbert de Superville (published in 1827–32), a Dutch painter and theorist who claimed that these lines conveyed emotion not only through their association with the acts of smiling or weeping but also from the evocative value inherent in the physiological response. It was, however, Blanc's writings that were widely known among French artists of the later nineteenth century. Seurat's use of the Superville-Blanc ideas on line organization in the

Fig. 6.41 Blanc, Drawing of human face (from deSuperville). 1876

Fig. 6.42 deSuperville, *Synoptic Table.* 1827–32

VICTOR JOZE
La
Ménagerie Sociale
L'HOMME À FEMMES.

Fig. 6.43 Seurat, *L'Homme à Femmes.* 1889

human face are directly applied in *L'Homme à Femmes* (Fig. 6.43), *Le Cirque* (Fig. 6.44), and *La Chahut* (not shown).

Charles Henry went much further in his theorizing than Blanc, whose position remained rather sketchy and limited. Henry, starting with the ideas of Blanc, Chevreul, Rood, and others, developed in the 1880s his dynamic interpretation of color and lines, a theory that was applicable in some detail to all line orientations and colors. His aesthetic protractor (Fig. 6.45) allows one to measure theoretically rhythmical angles — that is, to determine whether the angles between lines radiating in different directions from a single point are harmonious. Seurat's theories of line orientation, color, and emotion were based on Chevreul, Blanc, Henry (Fig. 6.46), and others, as well as his own experience. A diagram of Seurat's theory, also from Homer, is shown in Figure 6.47. In his previously cited letter to Beauburg (August 20, 1880), Seurat described the aesthetics of lines: "Gaiety . . . of line, lines above the horizontal; calmness . . . the horizontal. . . . Sadness . . . of line, downwards directions." This is illustrated in part in a diagram from the same letter (Fig. 6.48), a diagram whose properties are found in the lights of *La Parade* (Fig. 6.49). This painting, besides having a somber palette to represent and in-

Fig. 6.44 Seurat, *Le Cirque.* (detail) 1890–91

Fig. 6.46 Diagram illustrating Charles Henry's Theory of Expression (from Homer).

GAIETY
ABOVE THE HORIZONTAL

WARM COLORS
LIGHT VALUES
ASCENDING LINES

DESCENDING LINES
DARK VALUES
COOL COLORS

SADNESS
BELOW THE HORIZONTAL

Fig. 6.47 Diagram illustrating Seurat's Theory of Expression (from Homer).

RAPPORTEUR ESTHÉTIQUE
DE M. CHARLES HENRY

Fig. 6.45 Henry, Esthetic protractor (Rapporteur Esthétique). 1888

duce sadness, uses a harmonious mixture of horizontal and vertical lines, though the horizontal lines are dominant as would be consistent with the blue mood of the colors. W. I. Homer, in a detailed analysis of *La Chahut*, shows how the orientation of the work's many lines and curves, and its dynamic properties conform to Henry's theories.

Even Gauguin, normally hostile to anything scientific, wrote in 1885 as if paraphrasing the current scientific aesthetics:

> All our five senses reach the brain directly, affected by a multiplicity of things, and which no education can destroy. Whence I conclude there are lines that are noble and lines that are false. The straight line reaches to infinity, the curve limits creation . . . the equilateral triangle is the most firmly based and the perfect triangle. A long triangle is more elegant. We say lines to the right advance, those to the left retreat.

The Elements of Form: The Early Twentieth Century

The analysis of lines in scientific aesthetics moved in the twentieth century from France to Ger-

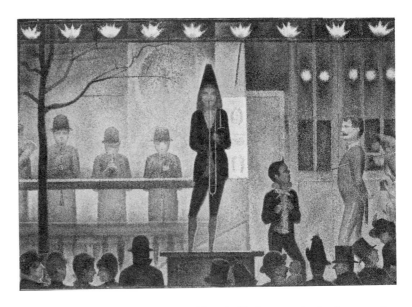

Fig. 6.49 Seurat, *Invitation to the Side Show (La Parade)*. 1887–88

Fig. 6.48 Drawings from a letter by Seurat illustrating some of his Theory of Expression. 1890

many. There, in the late 1890s, Lipps seems to have been the first to write on the topic, when in *The Aesthetics of Space and Geometric-Optical Illusion* he treats vertical and horizontal lines as having their own internal energy—as the embodiment of abstract principles (Fig. 6.50). He had little to say about them in terms of the human face and emotions related to it, but he commented on the abstract, dynamic significance of vertical and horizontal lines:

> We always have to distinguish two kinds of movement in a direction, especially in the vertical direction. The form that arises does so because of a single vertical impulse which is the form's origin. The impulse is not generated by something else but just exists. The form frees the impulse.

Much earlier (1876) Blanc had written in a similar spirit:

> If we look at the "stage" [or: scene] of the world, we see in it the straight line appear and dominate in all the sublime spectacles: the rays of the sun, of the stars.

> But the most striking aspect of the straight line, is that it is a symbol of unity, for there is only one straight line, whereas curved lines are innumerable, which makes us consider the curved line as an image of variety.

Mondrian also expressed himself in the same fashion:

> More and more I excluded from my painting all curved lines, until finally my compositions consisted only of vertical and horizontal lines, which formed crosses, each one separate and detached from the other. Observing sea, sky, and stars, I sought to indicate their plastic [gestalt] function through a multiplicity of crossing verticals and horizontals.

> Impressed by the vastness of nature, I was trying to express its expansion, rest, and unity. At the same time, I was fully aware that the visible expansion of nature is at the same time its limitation; vertical and horizontal lines are the expression of two opposing forces.

It is with Kandinsky, however that the most important, detailed, and clearest aesthetic of the elements of form, including the vertical and horizontal, is expressed.

By the time Kandinsky published *Point and Line to Plane* (1926), a theoretical continuation of "On the Spiritual in Art," his scientific approach to art had greatly matured. The second major statement presents an introduction to what Kandinsky called "The Science of Art"—essentially, to the elements of form. In this theoretical treatise Kandinsky presents an examination of the individual art elements, an examination heavily analytic and dissective in character. He believes that unless such a science of art is developed—one based on meticulously exact research—further advancement in painting will be impossible. He attributes the early research to the Impressionists, who not only destroyed the older academic theories but "immediately—though unconsciously—laid the first foundation stone of a new science of art, despite their contention that nature is the only theory of art."

Although Kandinsky remains interested in the higher spiritual meanings of art, which he implies will come out of the synthesis of the new elements of art, he admits that the expression of these higher values lies far in the future. For the present, his problem is to start the "microscopic" analysis by proposing three basic elements: points, lines, and planes. He then describes various simple configurations of these three elements and the emo-

tions or other psychological responses that he believes are associated with them. For example, in Figure 6.51 Kandinsky presents the basic types of straight lines with their psychological meanings: vertical lines = warm movement, horizontal lines = cold movement, and diagonal lines, which are a mixture. This subjective interpretation is obviously similar to Blanc's treatment portrayed in (Figure 6.52); to Henry's and Seurat's "restful" horizontal lines, and as mentioned, it is prefigured by Lipps (Fig. 6.50) in his discussion of the basic meanings of vertical and horizontal lines.

Kandinsky's claim that there are reliable emotional responses to visual configurations puts him both in the Gestalt and in the empathy tradition. In the Lipps empathy system the perceivers project themselves into the object of perception: in Figure 6.53 the observer is interpreted as perceiving "huge object as pressing down, the bridge span as straining or in tension, the arrow as moving or striving forward." (The whole process is more easily understood in light of Gestalt pschology's more systematic perceptual principles, which were developed after Lipps.) The Lippsian (empathic) quality of different types of lines was often noted by Kandinsky with the use of arrows, as in Figure 6.54. (Teuber appears to have been the first to observe this in Kandinsky.) Examples of very similar arrows are

Fig. 6.50 Lipps, line orientations discussed in terms of their proposed dynamic psychological principles. 1897

Fig. 6.51 Kandinsky, Basic types of geometric straight lines. 1926

Fig. 6.52 Blanc, Diagram of the three basic types of lines—each with its own associated feeling. 1876

Fig. 6.53 Lipps, Diagram. 1897

common in Klee as well (Fig. 6.55; see also Fig. 4.25).

Additional Kandinsky diagrams, remarkably similar to those published about 30 years earlier by Lipps, can be seen in Figures 6.56 and 6.57; diagrams 6.58, 6.59 (Figs. 6.57 and 6.59) are from Lipps. Despite the 30-year difference in publication dates, Teuber emphasizes that Lipps lectured to large audiences at the University of Munich from 1894–1915, when both Klee and Kandinsky were starting their artistic careers; furthermore, she mentions that Kandinsky's *Point and Line to Plane* was planned in 1914, many years before its eventual publication. In any case, it is obvious that Kandinsky both responded and contributed to the new investigations of form.

The point of comparing these diagrams by Lipps and Kandinsky is not to claim that Kandinsky's theoretical interpretations were the same as those of Lipps. What is made clear by the comparison is that the drawings and the spirit of the analysis were very close even if the specifics were not. Thus both discussed simple forms such as squares and even simpler elements such as vertical and horizontal lines and the types of angles and curves. Both postulated intrinsic forces or tensions to each of the different lines, and shapes and combinations

thereof. The particular forces, and associations with particular colors or sounds might be slightly different—or sometimes contradictory—still, all these theorists from Blanc and Seurat to Lipps and Kandinsky and to Schoenmaekers and Mondrian, were part of the same abstract and analytical mentality.

Schoenmaekers's color theory, treated in Chapter 4, was not his only scientific influence on Mondrian. Although primarily a Dutch esoteric philosopher with strong Gnostic and Christian elements, Schoenmaekers had great sympathy for science and his approach to form and shape can be considered proto-Gestalt. He often used the word "Gestalt" (or its variants) to refer to shape and form and he writes about art much like a Gestalt psychologist: "Plastic art is completely form [Gestalt] or shape" and he claims that "form (gestalt) is created by the process of perception."

The way in which Schoenmaekers discusses the significance of vertical and horizontal lines is similar to both Blanc and Lipps and one suspects that the earlier aesthetic thought, in particular the early Gestalt thinking in Germany in the preceding 20–25 years, must have seeped across the Dutch border—even though Schoenmaekers makes no references to such positions in *The New World Image*

Fig. 6.54 Kandinsky, Curve with uniform alternation of positive and negative pressure. 1926

Fig. 6.55 Klee, *Burden*. 1939

 Fig. 6.56 Lipps, Diagram. 1897

Fig. 6.58 Kandinsky. Vertically oriented shapes with the empathetic quality of "warm rest." 1926

Fig. 6.57 Lipps, Diagrams with reference to perceptual effects of neighboring angles on the center angle. 1897

 Fig. 6.59 Kandinsky, Angle made from the two forces of each line; acute angles are tensest and warmest. 1926

(1915) or in *The Foundations of Plastic (Beelding) Mathematics* (1916). (These two are the only works for which there is evidence of influence on Mondrian.) The Dutch word *beelding* (often translated as "plastic") occurs often in Schoenmaekers's writings and equally often in the aesthetic writings of the painters of *De Stijl,* especially those of Mondrian. "Beelding" is frequently translated into German as "Gestaltung"—it carries not only the meaning "form" but also a dynamic, that is, formative, emphasis. (Many English translations have rendered Beelding as "plastic", a translation that we believe is often misleading.)

Schoenmaekers puts the vertical ray (Fig. 6.60) and horizontal line and the cross that they form (Figs. 6.61 and 6.62) at the very center of his philosophy. He writes, in words resonating with Malevich's "Suprematist straight line":

> The straight line is the absolute line, it is an absolute, and its radius, the infinite radius, is an absolute too. The line and the radius (in a straight angle of 90°) form a pair of absolutes. The figure of the cross is the image of the absolute right angle. The cross is the shape that reduces the line and the radius to the original absolute and characterizes the relationship of ab-

solutes of the first order. This shape is essentially open. All the lines can be extended endlessly and the figure will retain its open character. . . . The cross precludes all limits. The cross characterizes the image of the absolute opposites of the first order as an image of the essentially "open," of the real "unlimited."

From these two orientations Schoenmaekers goes on to develop a highly personal mathematical grid or coordinate system of straight lines, usually with an ellipse (Fig. 6.63) or diamond (Fig. 6.64) to represent the border or shape of the entire cosmos. Representative Mondrians—Figures 6.65, 6.66, and 6.67—painted at this time identify Schoenmaekers's influence as iconographic as well as conceptual. That is, the paintings are full not merely of horizontal and vertical lines but with clearly identifiable cross shapes, with diamonds, and ellipses. (The ellipse shape occurs in Mondrian's paintings one or two years before he meets Schoenmaekers. Thus, in this case, the influence was supportive rather than initiative.)

Post-Gestalt Visual Elements

Within the experimental psychology of perception, the Ge-

a

b

Fig. 6.60 Schoenmaekers, Diagram of opposed straight lines. 1915

Fig. 6.63 Schoenmaekers, Cross at center of elliptical representation of the universe. 1915

a

b　c　b

a

Fig. 6.61 Schoenmaekers, Diagram of cross: both a cosmic "Gestalt" mathematical coordinate system for the universe and a religious symbol. 1915

a

b　c　b

a

Fig. 6.64. Schoenmaekers, Cross at center of diamond-shaped representation of the universe. 1915

Fig. 6.62 Schoenmaekers, Cross figure. 1916

stalt movement emphasized the integrated wholistic nature of perception, as in their motto "The whole is more than the sum of its parts." However, in spite of this synthetic emphasis *relative* to the preceding scientific interpretations of visual perception (that is, the elementists of the nineteenth century), Gestalt psychology was still of a general analytic and reductionist character. For example, its major analytic contribution was to separate out for study the perception of form from the rest of the normal perceptual field.

Likewise, within the development of art, the new Gestalt emphasis represented a major acceleration of the analytic-reductionist movement since the art of simple form was the first to remove completely the recognizable object. In some cases, for example, the work of Malevich, color was removed as well; it was often an artistic concern with form, as distinct from, even opposed to, everything else.

In time, however, even Gestalt psychology's modest synthetic emphasis lost out to the increasingly analytic nature of the subsequent scientific interpretations of form perception. D. O. Hebb in 1949 proposed that the perception of a form, such as a triangle, began with detecting, scanning, and fixating the figure's separate sides (lines). The movements associated with these activities would set up in the

Fig. 6.65. Mondrian, *Composition 1916.* 1916

Fig. 6.66 Mondrian, *Lozenge.* 1919

Fig. 6.67 Mondrian, *Church at Domburg.* ca. 1914

brain a group of associated or connected neurons. These connected neurons would be the brain activity elicited by the presence of a line and would constitute the neural basis of "seeing" a line. In time all the neural units triggered by each line would themselves get connected into a higher order structure that would represent the neural basis of a complete triangle. That is, the neural units associated with the lines would get hooked up to form the neural basis of a triangle. The important point is that Hebb's theory proposed no special wholistic property of a form. Subsequent experiments on the effects of fixing a stimulus image so that it fell continuously on exactly the same retinal receptors were influenced by Hebbs's theory. These experiments showed that figures such as a square consisted of underlying elements, primarily straight lines. Thus, the image of a square projected continuously on the same part of the retina would sometimes disappear all at once or, more often, one or two of the lines would suddenly disappear. Frequently, pairs of parallel lines or other lines related by meaning or physical properties would disappear together (Fig. 6.68).

The conclusion of these and other research efforts was that, although a whole figure sometimes did act as a single unit, more often it was the parts of the figure, such

as lines, angles, planes, that established the units, and that were seen in an all-or-nothing-at-all fashion.

Roughly a decade later, the now well known studies by Hubel and Wiesel began to appear. These two scientists investigated the neural structure of the visual cortex of cats and monkeys. They discovered the presence of single neurons that responded only to straight line stimuli. These "line feature" detectors were sometimes sensitive only to lines in particular parts of the visual field, and were always sensitive only to a straight line of a particular orientation (Fig. 6.69), as well as to lines moving in only certain directions (Fig. 6.70). It is important to add that the Hubel and Wiesel experiments (for which they received the Nobel Prize) established an entire field of research aimed at discovering the abstract properties of stimuli that underly our perception of ordinary visual experience.

Another representative experiment, by the perceptual psychologists Olson and Attneave (Fig. 6.71), involved visual stimuli made of short vertical and horizontal lines, in order to investigate the speed with which groups of lines of the same orientation could be discriminated from a field of lines of varied orientation. In short, over the last 20 years, visual scientists have been especially interested in properties of straight lines; their

location, length, or orientation as fundamental visual elements that are first detected by special line-sensitive neurons in the initial layers of the visual cortex. In order to investigate these lines, a large number of line stimuli similar to those shown have been used in thousands of visual experiments.

In appreciating the straight line as a fundamental visual element, it is proposed that the *De Stijl* artists — and possibly others, such as Kandinsky — were in advance of scientists. There are several kinds of evidence indicating that Mondrian, in addition to paralleling the science of his own time, had an intuitive understanding of what scientists would later verify. Recall also Delacroix's speculation (ca. 1840) "It would be interesting to work out the question of whether regular lines do not exist only in the brain of man."

Although Mondrian's general philosophy was often, as noted, a somewhat vague blend of philosophy, mysticism, and religion, many of his more particular comments and, of course, many of his paintings show his natural sympathies with simple abstract aspects of science. He is especially close to Gestalt psychology in passages such as: "The appearance of natural forms changes but reality remains constant. To create pure reality . . . it is necessary to reduce natural forms to the constant ele-

Fig. 6.68. Pritchard, Lines act independently in stabilized vision with breakage in the fading figure at an intersection of lines. Adjacent or parallel lines may operate as units. 1961

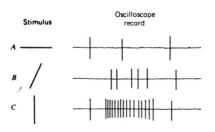

Fig. 6.69 Oscilloscope record of a cortical cell whose maximal response is to a vertically oriented straight line stimulus. At (A) the line produces no response; slight tilt at (B) produces a weak response; vertical stimulus at (C) produces a strong response.

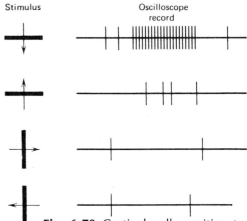

Fig. 6.70 Cortical cell sensitive to the direction of motion of a straight line stimulus. The cell responds strongly only to downward movement. The oscilloscope record shows a weak response when the stimulus is moved up and no response to sideways motion.

ments of form." For Mondrian, the equilibrium of the "elements of form" was "established through contrasts or opposites." As already described, this meant that the vertical, the horizontal, and the right angle were for him the only relations resulting in equilibrium and stasis. (Fig. 6.72).

The same emphasis on vertical and horizontal lines initially characterized the work of Theo van Doesburg and Bart Van der Leck (Fig. 6.73), two other members of the group *De Stijl*. It is interesting that one of the important causes of *De Stijl's* break-up was Mondrian's belief that the vertical and horizontal were so fundamental that he parted company with van Doesburg in 1925 and refused to continue as a member of the group because van Doesburg advocated the use of diagonals. Mondrian proposed lifetime commitment to the static equilibrium of the vertical and horizontal. Mondrian's break was permanent and seems indeed to have marked the end of the group. The *De Stijl* examples show a clear similarity to line stimuli used much later by scientists (Fig. 6.74).

Mondrian's intuition of the greater psychological significance of vertical and horizontal lines is confirmed by research that has shown that humans can perform a great number of perceptual tasks more readily in respect to the vertical or horizontal than to oblique

Fig. 6.71 Olson and Attneave, Straight line stimuli perceptually segregated by orientation. 1970

Fig. 6.72 Mondrian, *Composition of Lines.* 1917

Fig. 6.73 Van der Leck, *Composition #5, 1917 (Donkey Riders)*. 1917

Fig. 6.75 LeWitt, Examples from *Location of Lines*. 1974

Fig. 6.74 Olson and Attneave, Straight line stimuli perceptually segregated by orientation. 1970

orientations. For example, they can detect vertical and horizontal lines easier than oblique lines. This phenomenon, known as the "oblique effect," has also been demonstrated in animals from the octopus to the monkey. Of course, the greater perceptual utility and stability of vertical and horizontal lines does not mean that the other orientations have no aesthetic meaning. It was part of Mondrian's personal vision, however, that only horizontal and vertical should be allowed in the expression of his aesthetic.

Van Doesburg's commitment to science was expressed directly when he wrote "In place of the dream, the future will put art on a scientific and technical basis," and "We are the painters who dare to think and to measure." The entire *De Stijl* movement's emphasis on the abstract nature of form is an example of the same mentality that emerged simultaneously in Russia, as represented by Suprematism and Constructivism and the artists Malevich and Gabo. Certainly the Bauhaus reductionist cry of "less is more" is applicable to Mondrian. The basic similarity was not missed and much like the influence of the Russian groups, the ideas of *De Stijl* became part of the Bauhaus position.

Sol LeWitt's treatment of the straight line, as in *The Location of Lines* (Fig. 6.75), published as a series of straight lines of different orientation, location, and length in a small white booklet, is also relevant here. LeWitt's minimal-conceptual approach has close affinities with a scientist's systematic manipulation of line orientation, line length, and location in experiments designed to investigate the relevant stimulus properties for different cortical feature detectors (Figs. 6.69 and 6.70). Kandinsky's (Fig. 6.51) much earlier expression of the same general idea in his search for the scientific elements of art provides additional evidence of the perceptual-conceptual analysis implicit in LeWitt's series.

At the simplest level, what these artists LeWitt and Kandinsky are focusing on is the short straight line and its possible systematic changes in orientation and location. The line and its properties are identified and are brought to our attention as a basic element by Kandinsky; the lines are organized in an apparently haphazard but nevertheless interesting order of locations by Mondrian, Van der Leck, and LeWitt. At a higher level, beyond whatever visual interest the works have, the artists are treating the line as a basic conceptual entity. They are exploring the *idea* of the line.

Some years before the discovery of straight line feature detectors, an even more elementary detector was found — the neurons in the retina that respond only to dots

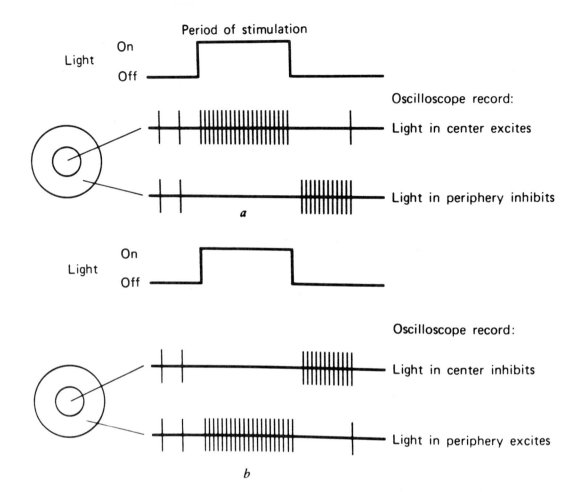

Fig. 6.76 Hubel, At top an oscilloscope recording shows strong firing by an "on"-center type of cell when a spot of light strikes the field center; if the spot hits an "off" area, the firing is suppressed until the light goes off. At bottom are responses of another cell of the "off"-center type. 1963

or points of light (Figs. 6.76 and 6.77). These "dot" feature detectors, first reported by Kuffler, have been found in the retina and in the lateral geniculate nucleus. The latter structure is a rather small group of neurons (a nucleus) in the brain, which functions as a kind of relay station between the retina and the visual cortex. A large proportion of its neural elements appear to respond only to dots of light. Later investigations, especially those of De Valois and his colleagues, found spot detectors in the lateral geniculate nucleus that were especially responsive to a certain color, and inhibited by the complementary color. There now appear to be six kinds of spot detectors—those especially sensitive to white or black; to red or green; or to blue or yellow—and each type is inhibited by light of the complementary color. Although the shape of the receptive field, that is, the shape of the stimulus field that stimulates a given neuron, is usually a small circle or spot, sometimes an oval field is found.

As shown in Figures 6.76 and 6.77, stimulation of the area just outside of the small center spot has the opposite effect. That is, the neuron responds to a small spot of light located in a particular part of the visual field. Then, if the light is moved away from this small sensitive spot-shaped area, the neuron will be inhibited by neighboring elements, again demonstrating the oppositional or opponent process nature of the feature detectors. If the light is moved still farther away, it has no effect whatever.

The early work of the artist Larry Poons most thoroughly suggests the visual properties of these spot detectors (Fig. 6.78). Poons's large paintings express not only a preoccupation with fields of small dots or ovals, but they also typically consist of complementary primary colors. These paintings can be interpreted as representations of the perceptual world of spot-detectors. Again, there is no evidence of a conscious awareness of spot detectors by Poons; instead, a reductionist intuition about interesting perceptual effects of aesthetic significance presumably led him to his distinctive imagery. A similar understanding of the sensory interest and conceptual significance of spots is implied in the later work of Miró (Fig. 6.79).

In contrast, Richard Anuszkiewicz, arrived at his subtle perceptual explorations after serious study of perceptual psychology, especially Gestalt and color interactions. He was a student of Albers at Yale. His *All Things Do Live in the Three* (not shown) presents a solid field of dots—blue, green, or yellow on a red ground. As is true of Poons's work, such a spot-field suggests that it can be understood as a representation of the phenomenology of

Fig. 6.77 Kuffler, "Spot"-shaped receptive field of a ganglion cell located at the tip of electrode. In the central region "on" discharges (+) are found, while in the dark area only "off" discharges occur (0). In the intermediate zone discharges are "on-off". Note shape of receptive field, especially the "off" field is closer to an oval than a circle. 1953

Fig. 6.78 Poons, *Northeast Grave.* 1964

the lateral geniculated nucleus, that is, of the spot detector. Many other artists, including Vasarely, Bridget Riley, and Robert Irwin, have also explored the visual world of the spot field, if not of spot detectors. In certain respects this concern with spots can be traced all the way back to Pointillism (Seurat) and the elementist theory of perception (Mach, Stilling, and Blanc).

Corners and Angles

There is evidence that corners and angles also constitute a special visual feature detected by specialized neurons existing in the visual cortex at levels higher up in the cortex than line detectors. Hubel and Wiesel first found these detectors to be neurons that respond to shapes like those in Figure 6.80. Although there is still only limited neuronal data from studies of the visual cortex, corners or angles certainly often function as abstract properties of form. Interest in the dynamic aspects of the angle was first voiced in psychological studies investigating perceptual responses to angles by Lipps (Fig. 6.81). Recent "angle" stimuli used in relevant visual studies are those of Beck (Fig. 6.82), and Olson and Attneave (Fig. 6.83). Such angle configurations are also briefly treated by Kandinsky (Fig. 6.84), who was clearly interested in their abstract artistic

Fig. 6.79 Miró, *The Wing of the Lark Encircled by Blue and Gold Rejoins the Heart of the Poppy Which Is Sleeping on the Prairie Adorned with Diamonds.* 1967

Angle detector

Stimulus Response

Fig. 6.80 Hubel and Wiesel, Angle-shaped stimuli to which certain cortical neurons respond. 1965

(b)

Fig. 6.83 Olson and Attneave, Angle stimuli used in study of perceptual grouping. 1970

Fig. 6.84 Kandinsky, Complex of lines; repetition of an angular line. 1926

Fig. 6.85 Noland, *Drive.* 1964

Fig. 6.81 Lipps, Repeated angle pattern with dynamic properties. 1897

Fig. 6.82 Beck, L- and T-shaped stimuli used to study factors in perceptual grouping. 1966

significance. Artists who have concentrated on the same dynamic chevron pattern are Noland (Fig. 6.85) and Stella (Fig. 6.86), while angles of various types also have figured notably in the sculpture of David Smith (Fig. 6.87).

In these visual elements there is no clear case of a scientist directly influencing an artist. Instead, there seems to have been an independent parallel preoccupation. The notion of a parallel analysis of form arriving at similar elements should not be considered surprising. After all, once forms are reduced to underlying elements, it is inevitable that points (dots) and lines and angles (corners) should be "discovered." The major break was the earlier proto-Gestalt decision to isolate simple form as the subject of study. Kandinsky's *Point and Line to Plane*, by encapsulating the entire gamut of form analysis, makes the case for parallel analysis with great power. The book outlines "the beginning of the Science of Art"; hence, Kandinsky operates more as a scientist than as an artist. He sets out to scientifically reduce form to its "basic elements": the point (really the dot); the basic types of straight lines (vertical, horizontal, oblique); the angle (right, acute, obtuse); the single component; curved line (arc); and planes. Certainly the discovery of the recent neurophysiological evidence for visual feature detectors

Fig. 6.86 Stella, *Quathlamba.* 1964

Fig. 6.87 David Smith, *Cubi XXVI.* 1965

has amply supported Kandinsky's (and Lipps's) much earlier intuitive analysis. Artists, moving in synchrony with visual science, have provided over the past few decades almost an explosion of works equally preoccupied with exploring the nature and significance of the elements of form.

Conclusion

The conscious scientific investigation of visual forms began with Ehrenfels (1890), develops with Lipps (1897) and Rubin (1915), and culminates in the Gestalt psychology of the 1920s. Within modernist art, the concern with pure form is hinted at by Cézanne with his proto-Cubist works and his famous advice to "treat nature by the cylinder, the sphere, and the cone." Cubism (1909–13) comes close to a pure emphasis on form or fractured form but it is not until Malevich, Kandinsky, Klee, and Mondrian (ca. 1915–1930), that abstract form and the elements of form emerge as a central focus of painting. The early artistic investigation of form up through Cubism appears to have developed as an independent parallel to the scientific studies, but with the Bauhaus artists the direct impact of visual science became extensive.

Aside from the scientist, scientific aesthetician, and the artist, a fourth party was also on the scene — the formalist art critic whose concept of "significant form" (Clive Bell, 1913) can also be viewed as an expression of a Gestalt analysis. Another early formalist Roger Fry (1912) wrote that the new art had created "a purely abstract language of form — a visual music". Obviously, in the first quarter of this century, the concept of form and of its analysis was surfacing throughout much of Western culture.

Finally, closely related to the study of form was the analysis and aesthetic interpretation of the elements of form. Here again artists and researchers in experimental aesthetics worked along similar paths — with the latter often directly influencing art. In the last few decades such underlying elements as dots, lines, and angles have become a standard visual preoccupation. Thus, the search for an understanding of the "alphabet" involved in perceiving a pattern has received as much attention in art as in science.

SEVEN

New Varieties of
Visual Experience

Fig. 7.1 Plateau, Spiral. 1850

Fig. 7.2 Musatti, Stimulus circles which when rotated cause stereo-kinetic effect. 1924

Twentieth-century visual scientists and artists have investigated a rapidly increasing number of visual effects. As these varied effects are not easily placed in one or two basic perceptual categories, they are presented below under a number of different headings.

Illusion: Movement Effects

In the nineteenth century, scientists first studied illusions of movement using standard stimulus patterns. In Plateau's spiral (1850, Fig. 7.1) the disk can be seen as expanding when rotated clockwise; when rotated counter-clockwise the disk seems to contract; movement in the reverse direction is seen whenever the disk is stopped. (Rotating Plateau's disk may also induce faint colored rings, known as subjective colors, even though the pattern is only black and white.) A variant of this spiral with its associated illusions of expansion and contraction was discussed by Helmholtz (1867) and investigated in further studies by scientists in the latter part of the nineteenth century.

In the 1920s, two Italian visual scientists, Benussi and his student Musatti, seriously considered the much earlier suggestion of Helmholtz about the connection between motion and depth perception. Musatti, using patterns of circles or

ellipses on rotating disks (Fig. 7.2) demonstrated in 1924 what he named the stereokinetic effect. The slowly rotated stimulus disk causes the observer to see cone-shaped solids as well as illusionary movement of the cones relative to each other. These investigations were close both in concept and in expression to Marcel Duchamp's Roto-reliefs and his similar rotating disks, which were part of a film (Fig. 7.3). The Roto-reliefs, constructed some-what later in 1935, were meant to be rotated (originally on a record turn-table at 33⅓ RPM). Almost all of these patterns give rise to similar three-dimensional movement and illusions. Duchamp's exploration with new visual technology ex-pressed itself even earlier when he used spirals in a brief experiment in stereophotography. The two special patterns (Fig. 7.4)—one black on red, the other black on green, were meant to be fused in a single stereo-scopic presentation—but apparently the pattern was never completed. Here Duchamp's work is very simi-lar to research on binocular rivalry, for example, Breese's (Fig. 7.5); this binocular problem goes back to Helmholtz. Most likely Duchamp was also interested in the resulting stereo color—would it be a fused darkish yellow-orange or an alter-nating red and green? The latter is the common finding.

Musatti's discovery of stereo-kinetic movement fell into obscurity

Fig. 7.3 Duchamp, Optical disk from Anémic Cinema. 1925–26

Fig. 7.4 Duchamp, Frames from uncompleted stereofilm; left frame green, the right red. 1920

Fig. 7.5 Breese, Green and red stimuli with oblique lines to study binocular rivalry. 1899

Fig. 7.6 Helmholtz, Concentric circle stimulus. 1867

until rediscovered in the United States by Wallach (1954). A similar fate befell much of Duchamp's work, including the Roto-reliefs, which were generally forgotten. The Duchamp retrospectives of the late 1950s and 1960s reintroduced these accomplishments to art and to art historians.

A yet simpler circular pattern has been of persistent visual interest since Purkinje's initial descriptions in 1823 and 1825. Helmholtz (Fig. 7.6) was apparently the first to publish the concentric circle pattern and he attributed the optical effect of the rotating sections to failure in accommodation or to astigmatism. Ninety years later, and after relatively little interest since Helmholtz, D. H. MacKay published the same pattern. MacKay's concern centered on more complex determinants of the effect. Around the time of MacKay's publication, various contemporary artists were using this pattern as the major message of their works, for example, Tadasky (Fig. 7.7). Again, however, it was Duchamp who pioneered artistic involvement when in 1920 he developed a motor-driven form of these concentric circles (Fig. 7.8).

In 1957, MacKay introduced a pattern now known by his name (Fig. 7.9) (although Pierce, 1911, is credited for it by MacKay). This highly redundant stimulus, when stared at for ten seconds or so,

Fig. 7.7 Tadasky, *A-101*. 1964

Fig. 7.8 Duchamp, *Revolving glass.* 1920 (reconstruction 1961)

Fig. 7.9 McKay, Ray pattern: moving image produced by a regular stationary pattern. 1957

Fig. 7.10 Schouten, Stimuli for investigating visual movement detectors. 1967

creates the afterimpression of wavy lines moving in circular orbits at right angles to the stimulus lines. This pattern is closely related to the concentric circle pattern seen in Figure 7.6. This stimulus was adapted by Schouten to investigate the nature of human visual movement detectors—see the stimulus disks in Figure 7.10. When rotated, the subjects reported complex perceived movement effects that varied with the rotation speed. The MacKay pattern has figured in various artists' work—most strikingly in Ludwig's *Cinematic Painting* (Fig. 7.11), which captures it with considerable simplicity and elegance.

Illusion: Miscellaneous

Many artists, especially those labeled optical ("op") artists, have explored visual illusions and perceptual effects. In some cases, this exploration was influenced by knowledge of visual science, but more often, the artists worked independently, rediscovering the effects on their own. The English scientist N. J. Wade has recently documented many visual effects found in the work of optical artists, and the relevance of this kind of painting to the present thesis is self-evident.

The phenomenon of "subjective contour" first published by Schumann (1900, Fig. 7.12), and of

considerable recent interest (Coren; Kanizsa, Fig. 7.13) has often been a central emphasis in works by Vasarely (Fig. 7.14).

A subjective or illusionary contour is created by certain combinations of incomplete figures. These clearly visible contours or edges of figures don't actually exist and are supplied by the visual system. (The explanation of the effect is still being investigated.)

Wade discusses the case of the Hermann grid, a typical example of which is a grid of thick white lines on a black background. The illusion is to see dark gray "phantom" dots at nonfixated intersections—an effect nicely captured in prints by Vasarely (not shown). Wade goes on to document the presence of afterimages, Moiré effects, Gestalt principles of grouping, and other effects in the art of Riley, Neal, Morellet, Soto, Gabo, Kelly, and others.

Optical art, however derided by modern critics, has its roots in the classic modernist tradition, for example, in the work of Seurat and Signac. Duchamp has also contributed extensively to it, as many of his works already cited demonstrate. But his *Fluttering Hearts* (not shown) has been called his "most spectacular optical work." Wade comments on the fluttering heart phenomenon—often called "jitter" or "vibration" by artists—which

Fig. 7.11 Ludwig, *Cinematic Painting.* 1964

Fig. 7.12 Schumann, First published subjective contour pattern: note the appearance of a vertical white stripe bounded by straight lines at the right and left where it is separated from the semi-circular figures. 1900

Fig. 7.13 Kanizsa, Subjective contour pattern: note the enhanced whiteness of square in center (after Coren, 1972). 1976

Fig. 7.14 Vasarely, *Betelgeuse II*. 1958

was first reported by Wheatstone (1844), who observed it in a carpet with a dominant red and green design—the colored parts appeared to be moving. He found the effect occurred best with red and green, and that dim lighting was necessary for its observation. According to Helmholtz (1867, 1924), the effect was most pronounced with juxtaposed, saturated reds and blues; if a card bearing red and blue figures was moved to and fro "the figures themselves seemed to shift their positions with respect to the paper, and dance about on it. . . ." Presumably with stationary figures, the movement is provided by the eyes. The effect has been exploited on a large scale by Ellsworth Kelly (see Seitz, 1965), and more recently, in some of Vasarely's colored paintings (see Vasarely, 1973). However, it is Marcel Duchamp's delightful visual pun, called *The Fluttering Hearts*, which provides the best example: this consists of a blue heart surrounded by a red one, with this sequence repeated.

Even Duchamp's *Bicycle Wheel* (1913, not shown) has an optical quality when rotated, the spokes giving rise to a kind of sequence of multiple images. Certainly

multiple image photographs (Fig. 5.27) have an optical effect, one commonly found in Futurist paintings (Fig. 5.22), which contain various optical effects.

The final examples of op art are visual conundrums known as "impossible figures." Some of these forms, first published in the scientific literature by Penrose and Penrose in 1958, are shown in Fig. 7.15. About the same time, Joseph Albers produced his drawings and constructions on laminated plastic, treating the same visual problem (Fig. 7.16). Marianne L. Teuber (1974) writes that Albers's constructions of this kind can be traced to ambiguous forms, especially to reversible Necker cubes (Fig. 7.17) found in the psychological literature. Albers, both as a student and then a teacher at the Bauhaus, was fascinated with reversible perspectives. The cube in Figure 7.18 shows the close connection between the Necker cube and ambiguous shapes.

Certainly the best known artist to study such figures and base his work on them is Maurits Escher. Escher, as Teuber (1974) makes clear, was very deeply involved in figure-ground ambiguities as well, and he "not only uses reversible perspective but also introduces perceptual impossibility." These impossible architectural constructions resemble the Penrose diagrams, which were acknowledged

Fig. 7.15 Penrose and Penrose, Impossible figures. 1958

Fig. 7.17 Necker cube from German psychology text, ca. 1910.

Fig. 7.16 Albers, *Structural Constellations.* 1953–58

Fig. 7.18 Impossible Necker cube, note how the treatment of the vertical "back" line with the horizontal "front" line creates the perceptual impossibility.

by Escher as a source for the lithograph *Ascending and Descending* (not shown).

Grids

The simple grid—sometimes a checkerboard grid—has a long history within visual science. For example, Goethe (Fig. 7.19) and Helmholtz (Fig. 7.20) both used it. It is the basis of the Herman grid (not shown) and has been used in various forms in countless visual studies. Scientists initially used the grid primarily because it provides an easily constructed simple stimulus of repeating elements. With the exception of the closely related and still simpler grating of parallel lines, it is probably the visually simplest *pattern* available for use in the study of perception. Because of this utility, the grid appeared frequently in the scientific literature, both technical and popular, which discussed aspects of vision that were of interest to artists. In time the grid, and even more-so the grating, became standard visual stimuli in experiments. Muybridge's photographs involved a grid format, and not just the grid created by the rows and columns of the photos themselves; note how there is a grid on the wall behind the subject in Figure 7.21.

Recent important explorations of the grid include the various

modular or systematic series of Sol LeWitt (Fig. 7.22). The example shown should be compared with Muybridge (Fig. 7.21)—not just because both use the grid but because LeWitt acknowledges Muybridge as a conceptual influence in his work. Muybridge's scientific attitude led him to his numbered sequences of movement portrayed against a grid. It is this highly rational serial approach that provides the link to LeWitt—obviously not the images themselves.

In view of the modernist move to the simple and abstract as well as the use of such scientific iconography as color circles and disks, the introduction of grids and gratings was to be expected. Two early paintings that contain these motifs are Matisse's *The Moroccans* (Fig. 7.23) and Picabia's *Venus and Adonis* (Fig. 7.24). Much more explicit are Mondrian's later works, such as *New York City, New York* (Fig. 7.25). However, the simplest, most abstract and purest expression is Francois Morellet's 1953 painting, *16 Squares* (Fig. 7.26). Here the expression of the grid culminates and is stated with total frankness.

Other important explorations of the grid in the last several years include the works of Warhol (Fig. 7.27), Alfred Jensen (Fig. 7.28), and Carl André (Fig. 7.29). The Jasper Johns grids of numbers (Fig. 2.7) and alphabets fit this category, as do many by Ellsworth Kelly (see

Fig. 7.19 Goethe, Checkerboard grid. 1810

Fig. 7.20 Helmholtz, Grid stimulus for study of stereoscopic vision. 1867

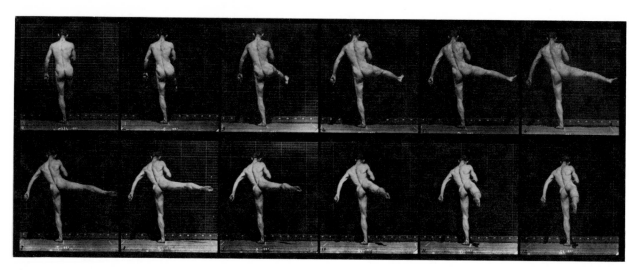

Fig. 7.21 Muybridge, First ballet action. 1884–87.

Fig. 7.22 LeWitt, *Modular Drawings.* 1976

Fig. 7.23 Matisse, *The Moroccans.* ca. 1916

Fig. 7.24 Picabia, *Venus and Adonis.* 1924–27

Fig. 7.25 Mondrian, *New York City, New York.* ca. 1942

Fig. 7.26 Morellet, *16 Squares*. 1953

Fig. 7.27 Warhol, *Dollar Bills*. 1962

Fig. 7.28 Jensen, *The Reciprocal Relation of Unity 20-40-60-80 that Forms the Beginning of the Vigesimal System*. 1969

Fig. 7.29 André, *Aluminum-Steel Plain*. 1969

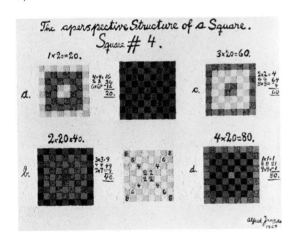

the section on randomness that follows). Klee's checkerboard-like grids of colors should also be recalled (Fig. 4.29), as well as Kandinsky's paintings of the 1920s, in which he was an early user of the grid.

The modernist meaning of the now-common grid is succinctly summarized by Rosalind Krauss in her introduction to the catalogue of a recent exhibition (Pace Gallery, New York) and it can serve to conclude this section.

> In the spatial sense, the grid states the absolute autonomy of art. Flattened, geometricized, ordered, it is anti-natural, anti-mimetic, anti-real. . . . In the flatness that results from its coordinates, the grid is the means of crowding out the dimensions of the real and replacing them with the lateral spread of a single surface . . . the grid is a way of abrogating the claim of natural objects to have an order particular to themselves.

Gratings

The grating, a pattern of parallel lines, is still simpler than the grid: with no intersections of lines and no resulting angles, it has but one linear orientation. Expressions of this pattern occurred in Helmholtz (1867), in Chevreul (Fig. 4.5), and in Blanc (Fig. 4.7). Visual scientists' early interest in the perceptual properties of the grating appear to have occurred first in the proto-Gestalt work of Hans Cornelius (Figs. 7.30 and 7.31). Both Kandinsky (Fig. 7.32) and Klee discussed gratings in their theoretical works, the former having made what appears to be the first straightforward paintings of gratings (Fig. 7.33).* Still earlier, Monet's *The Four Poplars* (Fig. 7.34), one of several with this motif, hinted at the grating structure.

The grating pattern was scattered throughout the Gestalt literature and began to become a familiar research stimulus when Gibson used it in demonstrating many of his examples of texture gradients (Fig. 7.35). In the mid-1950s the grating stimulus was introduced widely via a cathode ray tube (CRTs as in television). This

*Kandinsky appears to be one of the last of the great modernists to express real enthusiasm for science. Although his own theorizing in *Point and Line to Plane* (1926) was quite analytical Kandinsky saw this only as a necessary early stage. He himself was much more interested in synthesis and integration than in analysis; he was especially hostile to materialistic and positivistic science. His favorable view toward science in the 1920s and 1930s was primarily because he thought science was moving into a new synthetic stage. Science was moving away from the old materialism, but no real synthesis or "harmony of the spheres" as Kandinsky hoped has made itself known in the subsequent 50 years. Science is even more specialized and fragmented now than then.

Fig. 7.31 Cornelius, Strong and weak lines on vertical surfaces. (Clarity of the surface as affected by line orientation and shape.) 1908

Fig. 7.30 Cornelius, Drawings characterizing a vertical surface. 1908

Fig. 7.32 Kandinsky, Repetition of a straight line at equal intervals—the primitive rhythm; in uniformly increasing intervals; in unequal intervals. 1926

Fig. 7.33 Kandinsky, Decor for
Mussorgsky's *Pictures at an Exhibi-
tion*. 1928

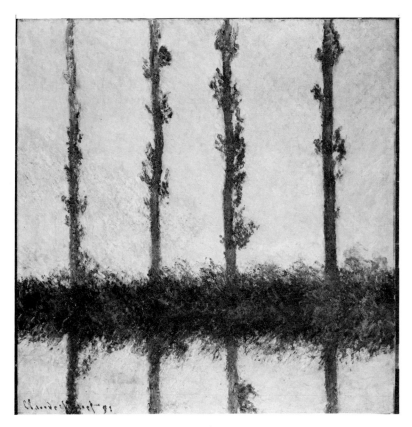

Fig. 7.34 Monet, *The Four Poplars.* 1891

Fig. 7.35 J. J. Gibson, Gradients of vertical spacing corresponding to three types of surfaces. 1950

Fig. 7.36 Experimental arrangement for recording electrical potentials evoked in the brain by grating stimulus flashed on screen. Electrodes are on back of head; with animals microelectrodes are surgically implanted into the visual cortex (from Campbell and Maffei, 1974)

methodology grew out of the earlier use of such displays in physics for the study and systematic characterization of the optical properties of lenses, and lens systems. By natural extension, these procedures were carried over into the study of human vision. The CRT displays allowed the investigator to carefully control such things as the brightness, brightness difference, and exposure time of the stimulus. An example of such a procedure and a display is shown in Figure 7.36. With the discovery in the early 1960s of neural elements in the perceptual cortex that were sensitive to straight lines the use of CRT gratings increased dramatically, for if the visual cortex is to be a significant organized system of straightline feature detectors, then an easily quantified grating of straight lines is an obvious fundamental stimulus with which to search for how these detectors work. In the subsequent two decades the utility of the grating stimulus has been amply demonstrated by the large numbers of important experiments that have used it.

More recently the use of the grating pattern has received still more support. The parallel bars on the screen are normally carefully controlled waves of light and dark. Sometimes the brightness of the bars changes gradually, as with sine waves (Figs. 7.36; 7.37), and

and sometimes it is abrupt, as with square waves (Fig. 7.38). New theories suggest that the visual system analyzes visual experience by breaking the light pattern into its sine wave components (as shown in Fig. 7.37). This powerful theory, called "spatial frequency analysis," develops further the rationale for the utility of the grating stimulus, although this newest emphasis is less on feature detectors than on the general process of pattern perception.

Other important examples of the grating stimulus should be mentioned. In 1966, what is now called the McCullough effect was reported. This effect is set up by presenting a sequence of a vertical black and red grating followed by a horizontal black and green grating. After several minutes of alternating 20- to 30-second exposures of these gratings, the observer is shown a test grating containing both vertical and horizontal black and *white* gratings. The alternation of the first two gratings results in a long-lasting color after-effect, sometimes lasting a week, in which the observer sees green bars or stripes when looking at the vertical test grating and red when viewing the horizontal test grating. These findings are typically interpreted as a kind of cortical (not retinal) afterimage in which red vertical line feature detectors in the brain are so satiated from their prolonged stimulation

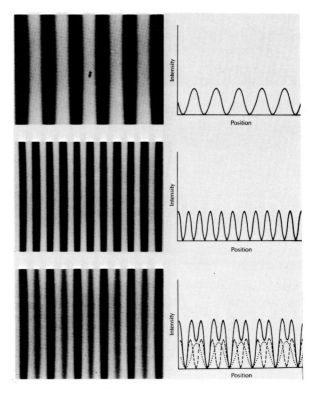

Fig. 7.37 The sine-wave grating in (b) has twice the spacial frequency in (a). When the two light distributions are added together, the distribution in (c) results. The intensity of each point in (c) is simply the sum of the intensities in the corresponding points in (a) and (b). (From T. Cornsweet, 1970).

Fig. 7.38 Simple square wave grating (left) with the shape of the light intensity (right).

Fig. 7.39 Goldstein, The visual world of a kitten raised in an environment of vertical stripes. Other kittens saw only horizontal stripes. 1980.

Fig. 7.40 Horizontal grating image —from malfunctioning television set.

that afterward the complementary color green is seen on the white bars whenever the vertical test grating is viewed (and vice versa for the other orientation). This effect, of great interest, introduced colored gratings into the study of vision.

Animal studies also used the grating stimulus in many ingenious ways. In one experiment kittens were raised during a critical period of days in a visual world made up only of vertical grating stripes (Fig. 7.39); other kittens saw only horizontal stripes. It turned out that if the kitten only saw vertical stripes that later the animal was almost insensitive or "blind" to horizontal stripes, and vice versa. The natural structure of the visual system with 'line detectors' needs specific environmental stimulation in order to develop.

However familiar television has become, it is most important to recall that it was only in the late 1940s that television came into the culture. For most viewers an experience all too common was the horizontal grating pattern—different forms of which were so often seen before the picture was brought into focus (Fig. 7.40). Just as photography provided an earlier parallel to visual science and an influence on art, so has television in recent decades. For millions of people, the first experience with the grating stimulus was provided by their TVs. Artists also might have been

prompted to paint the "grating" from this source.

The 1950s and 1960s were the years in which the "grating painting" came into its own. Variations on the grating theme characterized many of the most important artists of the time. The works of such painters as Barnett Newman (Fig. 7.41), Kenneth Noland (Fig. 7.42), Gene Davis, Brice Marden, Victor Vasarely, and Agnes Martin (Fig. 7.43) are typical examples. The Jasper Johns *Flag* of the late 1950s (Fig. 7.44) represents another form of the grating painting, one to which he returned much later in works like *Scent* (Fig. 7.45). Dubuffet (Fig. 7.46) provides another distinctive example of the pervasive grating motif in recent painting. For none of these examples is there any evidence of direct influence by visual science. Instead, it could be argued that the artists' perceptual intuition of basic perceptual structures, combined with the generally accepted reductionist logic of modernism, brought them to a preoccupation with images paralleling those coming into prominence in visual experiments. Otherwise, how is the remarkable iconographic similarity between the two fields — the sudden mutual growth of grating images in both fields between 1950 and 1970 — accounted for?

One final piece of evidence on visual science's preoccupation with gratings (and grids) is shown in Figure 7.47. Here, in 1810, 100 years before Malevich and Mondrian and about 150 years before minimal art and op art, in some of the earliest stimuli used by Goethe to study perceptual experience, it is already apparent that much of the imagery of modernist painting lies waiting to be tapped.

Depth — Texture Gradients

Scientific studies of depth were first preoccupied with the stereoscopic or binocular cues to depth perception. But in fact, the binocular cue, however useful for accurate depth perception, is only one of many enabling us to see depth. Monocular cues to depth, requiring the use of only one eye, provide most of our depth information. (Some commentators have implied that binocular cues are the only cues of real importance. The reader can easily ascertain that they are not, by viewing the world with only one eye and noticing that depth scarcely disappears.)

The systematic investigation of monocular cues began at least as early as Helmholtz, with his comments about aerial perspective. However, the most important and striking analyses of these cues are due to the work in 1950 of James J. Gibson, who first conceptualized and dramatically illustrated the texture gradient as a monocular cue to

Fig. 7.41 Newman, *Vir heroicus sublimis.* 1950–51

Fig. 7.42 Noland, *Wild Indigo.* 1967

Fig. 7.43 Martin, *On a Clear Day #16.* 1973

Fig. 7.44 Johns, *Flag.* 1954–55

Fig. 7.45 Johns, *Scent*. 1973–74

Fig. 7.46 Dubuffet, Compagnie Fallacieuse. 1963

depth. Gibson, however, interested in simple cues, theorized that the significance of cues for perception depends on the brain's ability to extract higher order in variant relations among the cues. Early examples of checkerboard texture gradients (although not called that at the time) are shown in Figures 7.48 and 7.49, which demonstrate the simple but important idea that as the density of visual elements increases, our perception of increased depth does as well. The visual elements may be of any type as long as density can be regularly varied. The common elements, however, are dots, lines (gratings), and squares (grids). Gibson's texture gradients were first introduced in 1950 and immediately became a major contribution to perceptual knowledge. One particular texture gradient is the checkerboard in which density changes with the number of squares per area. The changes in the density give rise to changes in perceived depth.

The psychologist Eleanor Gibson used the checkerboard gradient to construct a now well known test situation, the visual cliff, shown in Figures 7.50 and 7.51. The visual cliff consists of a narrow center-board on which an animal or baby is placed. On one side, the drop-off is shallow and on the other, much greater. The cue to the shallow side is the large checkerboard square; on the deep side, the squares are much

smaller. In fact, there is a strong clear pane of glass under the center-board and covering both the right and left sides, and thus there is no real drop-off or cliff, but only the visual cues to a cliff. The situation was originally designed to test whether very young animals had good depth perception and would avoid the deep side by stepping off onto the visually shallow side (they generally do) (Fig. 7.52).

At about the same time, various artists began to use texture gradients to obtain interesting perceptual effects in their art. Bridget Riley, in *Movement in Squares* (Fig. 7.53), can be inter-preted as investigating the visual cliff depth experience with the checkerboard grating. Vasarely, beginning earlier in the 1930s, varied the density of a checker-board gradient in order to create perceptual tensions in his works. In both cases the artists' visual intui-tions were independent of contem-porary perceptual studies. In *Static 3* (Fig. 7.54), Riley has presented the viewer with a work that is close to the simplest texture gradient, one with no change in density and hence no depth, as in Gibson's stimulus (Fig. 7.55).

Anuszkiewicz, who acknowl-edges his debt to perceptual studies, is, in a painting like *Progression: In and Out* (Fig. 7.56) exploring the Gibson texture gradients shown in

Fig. 7.47 Goethe, Screens with black and white patterns used for prismatic experiments. At left is a meter scale to give an idea of the size. 1810

Fig. 7.49 Wundt, Depth in "warped" checkerboard pattern. 1898

Fig. 7.48 Helmholtz, Slightly dis-torted checkerboard pattern for stereoscopic vision experiment. 1867

Fig. 7.50 E. J. Gibson and R. W. Walk, The visual cliff. The apparatus consists of a board laid across a sheet of heavy glass, with a patterned material directly beneath the glass on one side and several feet below it on the other. 1960

Fig. 7.51 E. J. Gibson and R. W. Walk, Child called from the "deep" side, pats the glass, but refuses to cross over to the mother. 1960

Fig. 7.52 E. J. Gibson and R. W. Walk, Kitten on visual cliff. 1960

Fig. 7.53 Riley, *Movement in Squares.* 1961

Fig. 7.54 Riley, *Static 3*. 1960

Fig. 7.55 J. J. Gibson, Spot distributions based on perfectly regular spacing of the elements. Change in density (left) causes perception of depth; constant density (right) does not. 1950

Figure 7.57. Here direct influence is apparent.

Depth: — Drawings of Cubes and Other Two-Dimensional Forms

For many years, the fact that two-dimensional drawings can portray three dimensional objects (Fig. 7.58) has represented an intriguing problem for scientists in visual perception. The Necker cube is just one example of such drawings. The question is, what are the cues in the two-dimensional representation that allow the viewer to construct a three-dimensional shape? Recent systematic work on this problem has been done primarily by Julian Hochberg. In his studies, he demonstrated that a corner represented by the intersection of three or more lines was an important and necessary cue for the viewer to see the shape in three dimensions. This principle is illustrated in Figure 7.59, which shows the figure when cut into strips. The upper and lower figures are identical, except the strip boundaries occur at different places. Thus, the upper strip keeps the corner intact, giving rise to a strong three-dimensional experience. The lower figure, where the corner is cut, is seen as flat. In later studies (Fig. 7.60) Hochberg used a circular aperture behind which a se-

Fig. 7.56 Anuszkiewicz, *Progression: In and Out.* 1965

Fig. 7.57 J. J. Gibson, Reversal of shape due to reversed gradients of density. 1950

(a)

Fig. 7.58 Vitz and Todd, Families of reversible-perspective figures (adapted from Hochberg and Brooks, 1960). 1971

(c)

Fig. 7.59 Hochberg, Reversible-perspective figure presented in single vertical slices. (top) Slice 2 (of above) showing intact corner as factor in creating perceived three dimensionality. 1968

Fig. 7.60 Hochberg, Views of a 3-D drawing behind a circular aperture. 1968

quence of corners was presented with the viewers' task being to construct, as best they could, the three-dimensional object presented in this manner. Another example of visual research on perceptual characteristics of such figures is that of Ohrbach and his students. Ohrbach was especially interested in the fact that these cubes reverse their perspective when they are stared at for some time. The stimulus shown in Figure 7.61 contains fixation points (small dots) on which the subject's gaze was fixated while Ohrbach recorded the rate at which the cubes fluctuated from one perspective to the other.

Compare the stimulus shapes and the concepts behind the above research to paintings of the prominent contemporary artist, Al Held. In the first Held painting (Fig. 7.62), we see that the artist has selected a group of the same kinds of cubes and related shapes. They are obviously of visual interest, and as an artist he has presented an aesthetic organization of a variety of these shapes.

Two years later Held apparently arrived at the conclusion that the most interesting parts of these shapes are the corners, which were often accentuated by being placed in a circle, suggestive of Hochberg's circular aperture. In any case, for Held, as for Hochberg, the sides or straight lines of these figures by their omissions are

Fig. 7.61 Orbach, Ehrlich, Vainstein, Reversibility of the Necker Cube. 1963

Fig. 7.62 Held, *Southeast.* 1972

Fig. 7.63 Held, *Solar Wind V.* 1974

interpreted as being less visually interesting. Finally, in Figure 7.63, Held presents a field of these figures. Again he emphasizes the three-dimensional dynamic corners, but in this painting he has placed tiny circles, squares, and triangles at various places in the canvas. It is not clear whether Held conceives of these as fixation points, but they certainly function as such and allow the viewer to focus on the painting at these different points. In any case, this is another example of the preoccupation of both scientist and artist with the same phenomena, both apparently identifying the same perceptually salient properties. It is especially interesting that an artist should intuitively arrive at a similar grasp of the cues to depth in these figures, particularly since Held was concerned with other aspects of his imagery besides these perceptual ones.

Randomness

The concept of randomness, which includes such related ideas as chance, uncertainty, and entropy, has become a rich and pervasive one in the twentieth century. Within science, the steady erosion of simple causality (determinism) was brought on in large part by the expanding success of statistical theories, which incorporate ran-

domness or uncertainty as intrinsic to the basic nature of many important phenomena. Outside of science, in the culture at large, these ideas were paralleled by the growth of philosophies and attitudes emphasizing the meaningless, nonsensical, and absurd aspects of human life—interpretations greatly reinforced by major historical experiences such as the two world wars but also "supported" by the scientific theories themselves. That is, the scientific concepts provided both a rationale for randomness and a procedure for expressing it. Within visual science, the use of meaningless or nonsense shapes was prefigured by Ebbinghaus (1885), who first developed the now-famous nonsense syllable, for example, ZEV, in order to study memory. Judd and Cowling appear to have constructed and published the first nonsense (or random) visual shapes (Fig. 7.64). Certainly the spirit of Duchamp's random string painting (Fig. 7.65), which represents the outline of strings dropped from one meter, captures the same spirit. This interest in randomness both in visual science and art has come in two waves—the first early in this century, and the second in the 1950s and 1960s. Random line patterns show up again in both disciplines in this latter period, for example, the Vitz short random walks (Fig. 7.66) and the very similar Carl André random pieces (Fig. 7.67).

Fig. 7.64 Judd and Cowling, Nonsense figures used to study memory for shapes. 1907

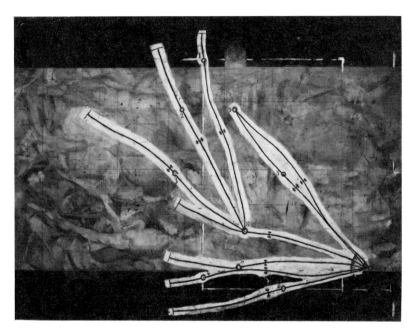

Fig. 7.65 Duchamp, *Network Stoppages*. 1914

Fig. 7.66 Vitz, Short random walks: stimuli for experiment on preference as a function of stimulus complexity. 1966

Fig. 7.67 André, Artist's studio. 1970

Fig. 7.68 Vanderplas and Garvin, Twenty-four point random polygons (after Attneave and Arnoult, 1954). 1959

The second period of preoccupation with randomness in visual science was influenced by information theory, which enabled perceptual psychologists to systematically use random (statistical) procedures for the construction of visual stimuli. The leader in this innovation was Fred Attneave, who introduced the use of random shapes in perceptual studies. He constructed polygons where the length and direction of the sides in each shape are determined by random selection procedures. Such shapes are shown in Figure 7.68, the sides of which are prefigured by Rubin (Fig. 7.69) and later in Kandinsky (Fig. 7.70). Similar shapes are often found in Matisse (Fig. 7.71).

Simple random polygons with four to six sides (Fig. 7.72) provide much the same visual effect as do certain abstract works of the early 1950s, for example, those of Kline (Fig. 7.73) and Kelly (Fig. 7.74). The contemporary artist Mel Bochner (Fig. 7.75) has used similar forms for some of his distinctive works. Within psychology, the Attneave technique was adapted to enable the construction of random shapes with curved sides as well (not shown). These shapes are often suggestive of those used by Youngerman (not shown). Once again, there is a preoccupation with similar visual forms at about the same time.

Jackson Pollock's technique of painting using a large brush while

Fig. 7.69 Rubin, Ambiguous figure-ground. 1915

Fig. 7.71 Matisse, *Green Chasuble.* 1950–52

Fig. 7.70 Kandinsky, Many-angled (zig-zag) line of diverse parts. 1926

Fig. 7.72 Vanderplas and Garvin, Random polygons with six points (after Attneave and Arnoult, 1954). 1959

Fig. 7.73 Kline, *Untitled*. 1952

Fig. 7.75 Bochner, *Three Shapes*. 1976

Fig. 7.74 Kelly, *Cowboy*. 1958

moving rhythmically and spontane-
ously over a large canvas inevitably
produced many chance-like effects.
The random character of Pollock's
"all-over" paintings* was first no-
ticed by Arnheim, who compared
Pollock's effects (Fig. 7.76) to Att-
neave's random "dot" matrix (Fig.
7.77). However, this comparison is
even more appropriate when a
Pollock is placed next to a "random
walk" pattern (Fig. 7.78). This pat-
tern was constructed with a short
straight line as the basic element.
For each step in the walk, the line
could be extended a unit length in
one of eight directions chosen at
random. Figure 7.78 has over 1,000
such steps representing a long ran-
dom walk; it would have been even
more Pollock-like if the not uncom-
mon procedure of using an outside
boundry to reflect the line back had
been used, since Pollock's lines
often turn back near the edge. Con-
structing the pattern so as to allow
curves instead of just the straight
line would have further enhanced
the Pollock effect. In any case, as
Arnheim observes, the use of acci-
dent as a compositional principle is
often powerfully expressed in much
of abstract expressionism. Curiously
enough, the results of *repeated*

*Pollock's technique was an important
impetus to the development of the all-over
picture, that is, a painting that has no
center or hierarchy of interest but instead
gives all areas of the picture equal impor-
tance.

Fig. 7.76 Pollock, *One (Number
31, 1950).* 1950. (Fig. 7.77 follows
Fig. 7.78)

Fig. 7.78 Vitz, Long random walk:
stimulus for experiment on prefer-
ence as function of stimulus com-
plexity. 1966

Fig. 7.77 Attneave, A "random field" consisting of 19,600 cells. The state of each cell (black vs. white) was determined independently with a probability of .50. 1955.

Fig. 7.79 Morellet, *Chance Distribution of 40,000 Squares 50% White, 50% Black.* 1961

chance elements is a rather homogeneous field or texture which doesn't appear especially unpredictable or chance-like. Attneave also commented on the visual monotony of his random dot matrix. As Arnheim puts it, "piles of accidents add up to very little."

The earliest use of chance techniques in the visual arts was informal and limited. Such composition techniques were advocated by Dada artists, but actual works expressing this idea were not common; an example, however, is Hans Arp's *Collage with Squares Arranged According to the Laws of Chance* (not shown). This work anticipates Kelly and Morellet and is well in advance of the first scientific random square patterns (see Figs. 7.79 and 7.80).

Attneave (1955) first constructed and published the well known random "dot" or random squares pattern (Fig. 7.77). A table of random numbers was used to fill in the squares: an odd number for one color, even for the other. This tedious procedure was used by two research assistants to fill in all 19,600 squares. Just a few years later in France, François Morellet, constructed an essentially identical work of art. His pattern (Fig. 7.79) was made in 1961, using the odd or evenness of the last digit of telephone numbers in a French phone book to determine black or white. By this time, in the United States,

Fig. 7.80 Julesz, Random-dot stereogram. 1971

Fig. 7.81 Dorfman and McKenna, Stimuli varying in complexity constructed by chance procedures. For experiment on pattern preference as determined by pattern uncertainty. 1966

Attneave's technique had been refined and adapted to the computer by Béla Julesz (Fig. 7.80) for his important works on stereoscopic vision—but Morellet was completely unaware of this research, and his painting is thus a fine example of similar conceptual concerns resulting in an almost identical pictorial parallelism. Morellet did know Ellsworth Kelly and was influenced somewhat by Kelly's earlier chance works and perhaps also by the general existential tone of French intellectual life in the 1950s, with its preoccupation with the absurd, the meaningless, and the chance aspects of life. In any case, Morellet was also exploring an approach to painting that reduced a work to two simple strategies—complete determinism on the one hand and complete randomness on the other. The first principle rigidly restricted all elements to equal-sized small squares that could be only one of two colors, and the second principle allowed the square to be black or white via a totally random procedure. His aesthetic was motivated by a deep antipathy to the romantic theory of painting, with its emphasis on unconscious and intuitive creativity—a kind of aesthetic Morellet sees as fraudulent, since it allows the artist to take credit for all kinds of meanings and significance that were only accidents and in no sense were truly expressive of the artist. Morellet's work, then, is a strong statement of

an antiromantic or rationalist's theory of art. Almost all is simple and controlled, the rest is chance.

Some years earlier, Ellsworth Kelly had partially anticipated Morellet's work. Kelly's *Seine* (Fig. 7.82) was constructed using a modified random technique. The squares were filled in black or white by chance but with an initial bias, first toward more black squares, and then, around the painting's midpoint, toward white. Kelly's original visual inspiration came from shadow patterns on water. The stimuli (Fig. 7.79) next to it are from a set of random checkerboard patterns constructed in the 1960s to investigate preferences for abstract patterns as determined by the amount of randomness in them. A blow-up of a part of the Attneave random dot pattern (Fig. 7.77) would have served as well.

Kelly also expressed his use of chance in a multicolored checkerboard grid or random squares matrix (Fig. 7.83). In this case as above, he again modified the original chance procedure so as to give some weight to his own artistic judgment. Nevertheless, the chance effect is easily seen when the work is compared to the similar four-color random squares matrix by Julesz (Fig. 7.80), a stimulus in which the colors, visible here as shades of gray, were assigned entirely at random.

Still other types of elements for

Fig. 7.82 Kelly, *Seine.* 1951

Fig. 7.83 Kelly, *Spectrum Colors Arranged by Chance.* 1952–53

Fig. 7.84 Vitz, Random lines in a square: Stimulus for experiment on preference as a function of stimulus complexity. 1966

Fig. 7.85 Morellet, *50 random lines.* 1967

constructing random patterns have been used, resulting in additional types of parallel images in the two fields. Several years ago, Vitz (Fig. 7.84) constructed a sequence of six squares (one is shown), each containing more randomly placed lines than the other. These "random line" squares are remarkably close to some of Morellet's prints (Fig. 7.85), although neither knew of the other's work. This type of pattern can be found much earlier in Kandinsky's discussion of the scientific elements of art (Fig. 7.86), as well as in stimuli used in early studies of visual memory.

That there is a randomness—an essential unpredictableness—in much of abstract expressionism has often been noticed: this quality is apparent, for example, in the bold black lines in many paintings by Franz Kline. Leo Steinberg, commenting on Kline's paintings, proposed that for all their appearance of "spontaneity" they were made with considerable deliberateness. Just as with the carefully calculated random polygon of Attneave, the casual, accidental impression is the opposite of the procedure used to produce it.

Finally, it is important to mention that the new visual technology of television had already introduced the same random "dot" image as a common, albeit often ignored, image to millions of viewers (Fig. 7.87). Like the grating patterns of

TV, the "noise" image was an unavoidably frequent percept for millions some years before it became a physically realized pattern for either the scientists or the artists.

Redundancy

There is, in all random patterns, a close connection with redundancy. Redundancy refers to any extremely predictable (that is, repetitive), phenomena, especially when the predictability is high and of a very simple type. In an important sense, therefore, redundancy is the opposite, indeed it can be expressed as the precise mathematical opposite of randomness. Thus, randomness and redundancy go together like many opposites, such as black and white, vertical and horizontal, or left and right. However, the link between these two notions is much deeper and more interesting. In fact randomness cannot be understood, defined, or expressed except with reference to a pre-existing system or structure. That is, randomness is always a kind of deviation from an expectation and can only be defined within highly constricted conditions. For example, consider the random square pattern (Fig. 7.77), which was compared to the Pollock (Fig. 7.76). Here as we noted with the Morellet (Fig. 7.81), only small squares may be used as elements

Fig. 7.86 Kandinsky, Unbalanced lines, acentric. 1926

Fig. 7.87 Black and white visual noise on television screen.

and these only within a rigidly organized grid. The constraints that are a form of redundancy are as visible as the randomness and are a major reason why these constructions appear rather homogeneous and not truly unpredictable as the concept of randomness might lead one to expect.

Further, in scientific practice so-called random stimuli are often selected from several examples so that only those that are close to the average or expected random pattern are ever actually used. Should the random construction process ever generate an "atypical" pattern that, for example, suggested a recognizable shape or object it would be rejected by the scientist as not representative. The use of an "expected" or typical random pattern again shows that randomness is only understandable within a highly developed framework.

The notion of randomness that is so pervasive today has picked up a significance far beyond what it can actually sustain on rational grounds. Historically the idea of randomness arose from the mathematical study and representation of games of chance and it is still true that chance can only be represented within a framework in which all possible outcomes can be identified and the probability of each outcome specified. The concept of randomness makes little sense when these *a priori* conditions are not

known. The narrow rigid pre-existing framework strongly conditions the kind of image that can be produced and also means that the construction of a chance work is in fact a highly deliberate and often tediously compulsive activity. A chance technique is therefore the opposite of a spontaneous or unplanned procedure.

Such chance images do have conceptual significance but visually they verge on the banal.

Returning to the random dot patterns (Figs. 7.77, 7.81, and 7.80) and Pollock (Fig. 7.76), it is more accurate to say that the randomness of the works is a relatively superficial aspect, at least from the point of view of their visual character. Instead, as noted, the Attneave pattern gives an impression of a homogeneous or redundant texture and the random aspects seem less important than the overall impression of organization, thanks to the restraints (redundancy) actually used in making it. Likewise more careful observation of the Pollock shows that this painting is indeed far from a haphazard work, and that it shows a redundant texture of interwoven, rythmic effects.

Because of the previously noted close connection between randomness and redundancy, it is not surprising to find interest in these two ideas being expressed at the same time. Scientific study of redundant visual stimulation began

with an investigation by a Gestalt psychologist of the effects of a completely homogeneous field of light. In 1930, Metzger had seated observers stare at a "carefully whitewashed 4 x 4 meter square surface from which wings extended toward the observer on three sides." The homogeneous wall-field, called a Ganzfeld by Metzger, was illuminated with neutral light and the observer reported his experience.

Following Metzger's first Ganzfeld study, interest lay dormant until a revival began in the early 1950s, continuing into the 1960s. Although the precise results vary somewhat with experimental conditions, certain general effects are commonly reported. The typical reaction is for the observer to feel "himself swimming in a mist of light which becomes more condensed at an indefinite distance." When a Ganzfeld is illuminated with color, the result is first a vast color field followed by rather rapid adaptation. For example, Hochberg and his students reported that a "red-colored surfaceless field" reduced to a colorless field of gray or black (in one case the field reduced to a very dark, brownish magenta). These color fields and their changes quickly bring to mind such minimal art as Robert Ryman's white painting from the period 1965-75 (not shown), Ad Reinhardt's black paintings (Fig. 7.88), Yves Klein's *Blue Monochrome* (Fig. 7.89),

Fig. 7.88 Reinhardt, Untitled. 1956

Fig. 7.89 Klein, *Blue Monochrome.* 1961

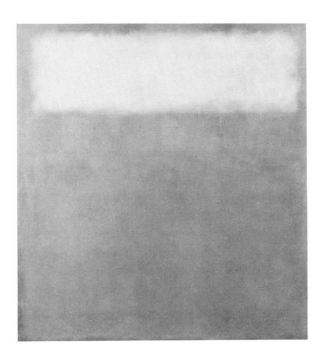

Fig. 7.90 Rothko, *White Cloud.* 1956

Fig. 7.91 Irwin, Untitled wall (installation). 1973

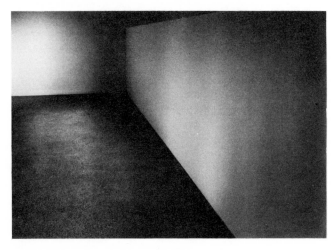

and Rothko's almost homogeneous works (Fig. 7.90) or his dark magenta and black paintings (not shown). Research by other scientists has reported the visual field is occasionally reduced to a much less intense form of the original color; uncommonly a typical cessation of vision, or black-out, has been reported. As for a true homogeneous light field (Ganzfeld), that is closely approximated by Irwin's wall (Fig. 7.91) or his scrim pieces, and by many other minimal artists.

The most important investigations of redundant perceptual experience are known as studies on the effects of sensory deprivation. These experiments involve putting the subject in an environment with a minimum of sensory-perceptual experience. The first such investigation carried out at McGill University in the mid-1950s called for college student volunteers to spend days in a small cubicle. The subject wore translucent goggles, which sets up a decent approximation to a visual Ganzfeld; earplugs that combined with background noise to reduce hearing to a constant low background noise (auditory Ganzfeld); and cardboard cuffs over hands to reduce tactile experience (Fig. 7.92). Such minimal sensory-perceptual environments typically resulted in boredom, restlessness, strong desires for stimulation, and for many brought on visual hallucinations as well. The effect of these

Fig. 7.92 Heron, Experimental cubicle constructed to study the effects of perceptual isolation. The subject lies on a bed 24 hours a day, with time out for meals and going to bathroom. The room is always lighted. The visual perception of the subject is restricted by a translucent plastic visor; his auditory perception, by a U-shaped pillow covering his ears and by the noise of an air conditioner and a fan. The subject's sense of touch is restricted by cotton gloves and long cardboard cuffs. 1954–57

Fig. 7.93 Warhol, *Sleep* (movie). 1963

studies was to emphasize the need of the nervous system for perceptual experience and to demonstrate that such minimum environments had profound effects on those in them. The scientist, following Flaubert, had finally conducted an experiment in which nothing occurs. The result was that nothing was a rather dramatic something: nothing stimulates not just a need for stimulation but it also stimulates a complex intellectual understanding of the disturbing and in some cases positive effects of nothing. (Under some conditions, such as a brief stay in a darkened, warm chamber, "nothing" can be accepted and even enjoyed as bringing a kind of psychological rest.)

At this same time, minimal art was also an active school. Originating with Suprematism, it had many expressions by important artists of the 1950s, 1960s, and 1970s (including Reinhardt, André, and Agnes Martin). An interesting parallel here would be the redundant movies of Andy Warhol, for example, *Sleep,* a 24-hour film of a young man sleeping in bed with only occasional movements (Fig. 7.93). This film places the viewer in two sensory deprivation or minimal experience positions. First, like the experimenter in the McGill studies who viewed the subject resting on a cot (Fig. 7.92), the viewer watches the sleeping subject in the film. Second, since the visual experience is

itself so redundant, the viewer is also placed in a minimal sensory environment, thus being forced via boredom to a greater awareness of the needs of the perceptual system; and to become aware of the perceptual impact of "nada" and of the idea of nothing.

In looking back on the topics of randomness and redundancy, we can note that in spite of the obvious parallelism, in some cases resulting in physically indistinguishable works, there do not appear to be any direct links between the two expressions. Nevertheless, both random and extremely redundant perceptual works were being produced and diligently looked at in both traditions during the same period. The studies of sensory deprivation, for example, the McGill studies, were precipitated by the occurrence of certain new environments and their associated experiences, environments resulting from the new technology. For example, radar operators in isolated northern stations had to monitor screens for any new "blip"—but of course, like watching a Ryman, an Irwin "wall," or a Warhol movie—very little ever happened. In the end, the operators' ability to see the screen tended to deteriorate. Pilots of planes, especially high altitude jets, were exposed to an unchanging blue or white misty world—a visual Ganzfeld; occasionally, this resulted in a "black out." These new perceptual worlds inevitably attracted the visual scientist and suggested new experiments. But, the artist was rarely far behind—and in one major case, was far ahead. Kasimir Malevich, the primary source of the minimal movement, intuited all of this before any Ganzfeld or sensory deprivation experiment was conducted.

In 1919 Malevich wrote:

I have broken the blue boundary of color limits, come out into the white, beside me comrade—pilots swim in this infinity. I have established the semaphore of Suprematism. I have beaten the lining of the colored sky, torn it away and in the sack that formed itself, I have put color and knotted it. Swim! The free white sea, infinity, lies before you.

EIGHT

The Thesis Reviewed

Modernism: Why So Theoretical?

There is one new—and final—piece of supporting evidence for the theory of parallelism. We have stated that an essential, and often commented upon, characteristic of modernist painting has been the enormous amount of theoretical interpretation that it has prompted—in short, its "wordiness." Such theory begins with Baudelaire and the list is long and filled with important figures: Zola and the many French critics of the 1860s and 1870s; LaForgue, Signac, Cézanne's letters; the manifestos of Cubism, Futurism, Suprematism; the articles and books of Mondrian, Kandinsky, Klee, Albers; the Formalist writings of Bell and Fry, and finally the many commentators, both artists and critics, of the last three decades. Indeed the traditional distinction between critic and visual artist has now become so blurred that Ad Reinhardt and Robert Motherwell, for example, could fit into both categories. Why this overwhelming need for theory, for a verbal interpretation of what in the past had been considered a primarily visual experience? If the modernist artist has become an investigator of perception in a manner paralleling that of visual science, then the answer is obvious. Science intrinsically requires the expression of its knowledge in a theoretical, and necessarily verbal, form. Scientific experiments, even for those that witness them, don't explain themselves. Likewise, modernist paintings—representing investigations of visual phenomenon, have required theoretical explanation.

The Relation of Parallelism to Other Theories of Modernist Art

The parallelism thesis can be further clarified in many ways by relating it to other theories of modernist art. The three major contemporary interpretations of modernist art are the formalist position, the social-cultural-historical viewpoint, and the more recent emphasis on the perceptual or optical factors exemplified in modern painting.

Formalism

Formalism is an analytic approach dealing primarily with a work's forms or structure rather than its content. The origin of this approach is traceable to Immanuel Kant's *Critique of Judgment* (1790) in which he distinguished between the realm of pure aesthetic values and the identity or content of that which was being represented. Also important to early formalist theory are the contributions of Hegel who argued that the role of the artist

was to express an ideal, especially Hegel's concept of a historically developing Absolute Spirit. One consequence of this point of view was that the imitation of nature became an increasingly superfluous artistic goal. For example, Hegel's proposition of a history that unfolds in response to an imminent Spirit or Will influenced the formalist critics by suggesting to them that the development of increasingly abstract structures in art was a kind of "will to abstraction." Hegel also influenced the historical descriptive school with its emphasis on developing social forces, usually within a Marxist interpretation.

With the rise of abstract art at the beginning of this century, formalist criticism received a major impetus. Roger Fry (1912) looked back at earlier art with a sensitivity to abstract elements that had been clarified by his familiarity with the new Cubist painters:

> Now, these artists . . . do not seek to imitate form, but to create form; nor to imitate life, but to find an equivalent for life. . . . The logical extreme of such a method would undoubtedly be the attempt to give up all resemblance to natural form, and to create a purely abstract language of form — a visual music; and the . . . works of Picasso show this clearly enough.

At the same time, Clive Bell introduced the expression "significant form" in his major formalist theory:

> If the forms of a work are significant its provenance is irrelevant. Before the grandeur of those Sumerian figures in the Louvre one is carried away on the same flood of emotion to the same aesthetic ecstasy as, more than four thousand years ago, the Chaldean lover was carried. . . . Significant form stands charged with the power to provoke aesthetic emotion in anyone capable of feeling it. The ideas of men go buzz and die like gnats; men change their institutions and their customs as they change their coats; the intellectual triumphs of one age are the follies of another: only great art remains stable and unobscure.

This formalist concentration on "pure form" allows an objectivity, or at least the appearance of it, on the part of the critic, which is based on the assumption of a universal accessibility of stylistic qualities.

Finally, in the work of recent formalists there are extensions of this interpretation in the attempt to deal with the art of the last 30 years: This art is seen as one of the few ex-

pressions of our time uninflated by illegitimate content — no religion or mysticism or political certainties. . . . Integral efficiency they propose is as lofty an ideal as any other.

In summary, the hallmarks of formalist criticisms are: a distinction between form and content, and the placing of critical emphasis on the former; the assumption that artistic quality is imminent and self-contained within the forms themselves or in their compositions; the assumption that this quality is objective and universally recognizable by the trained eye; and the assumption that changes in artistic production are caused by logical developments or evolution within the structures of the forms themselves, rather than by idiosyncratic artistic decisions or by influence from the surrounding social milieu.

A major weakness of this theory is its failure to develop any articulated connection between the nature of the individual's aesthetic experience — particularly the nature of his visual perception — and the proposed universally appreciated forms. Presumably it is the universal character of the human mind, particularly of the visual system, which accounts for the basis of the aesthetic significance of forms and their arrangement, but this critical link has in fact remained fundamentally untreated. The parallelism thesis, however, provides this connection, and in the process con- siderably expands the concept of what is involved in the perception of form and also of color.

An additional difficulty stems from the historical question: why does this emphasis on pure form oc- cur in Western art of the last 100 years or so? The possibility that modernist art was deeply influenced by the powerful system of modern science has been suggested by many, since science has been the dominant ideology of recent Western culture and a close connection, in other periods, between art and the domi- nant ideology has been a common observation. But, formalist theory has largely ignored science and other outside historical factors as well. For example, Clement Green- berg — although he acknowledges that modern art belongs to the same general "cultural tendency as modern science," nevertheless claims that: "From the point of view of art in itself, its convergence with science happens to be a mere accident, and neither art nor sci- ence really gives or assures the other of anything more than it ever did."

Obviously, the position that the convergence of modern art and science is a mere accident has been consistently challenged here. For, in spite of the brilliant and varied contributions of the formalists, their analysis has failed to raise the issue of the nature of the perceiver, and of the pervasive scientific society in which modern art has developed.

Again the parallelism thesis handles this problem directly, especially with its emphasis on the emergence of a dominant analytic and reductionist mentality in modern science.

Social-Cultural-Historical Determinants

The social, cultural, and historical interpretation of art is well represented by Arnold Hauser's work. For Hauser the formalist position that takes art out of its social and historical context so reifies art that it loses its human significance for those contemplating it. The interpretation of art as "mere play of lines and tones" is a serious impoverishment of our understanding of art, according to Hauser. By contrast he interprets art as the expression, often as essentially a rationalization, of the "material interests, desires for power, considerations of prestige and social aims" of the dominant class or the ascending group of a given period.

According to this view, one heavily influenced by Marxism, art is no longer a transcultural appreciation of forms; instead "art stands in the very closest connection with social reality and farthest from the region of what are commonly regarded as timelessly valid ideas" (for example, mathematical concepts).

Hauser's position, based on a materialistic philosophy of history and on its related doctrine of the ideological character of thought, exemplifies "the thesis that spiritual attitudes are from the outset anchored in *conditions of production*." Hauser also claims "that the social tendencies art serves can scarcely ever be seen unconcealed and unsublimated—that is the essence of the ideological mode of expression, which if it is to achieve its aims, cannot afford to call a child by its proper name."

The difficulties with this kind of theory are substantial. The social and economic forces that it identifies are of so general a character that they rarely apply with any useful specificity to individual artists, much less to particular paintings. If the art of 1850-1900 may be interpreted as the art of the rising new capitalist class, how does that then clarify, or account for, the stylistic differences of Manet, Monet, Dégas, Seurat, or Cézanne? Somehow the large cultural forces—the macro level—have difficulty being translated into concepts that make effective contact with individual paintings—the micro level. Besides, how does the economic interpretation account for the fact that most of these artists were quite consciously rejecting bourgeois capitalist society and being rejected in return? (though it is ironic that the capitalists are now avidly collecting the works of these same artists).

The one major aspect of the

dominant society, however, which many of these artists did not reject but actively sought out was science —especially any science dealing with visual experience—as well as the new technology of vision, such as photography.

Hauser does argue effectively that the new technology of modern economic production is an underlying condition of modernist art but he largely ignores science itself. This fundamental neglect of science is clearly present when in his comment above he claims that art is very close to everchanging social realities, and far from mathematics, far from the regions of abstract timeless ideas, and by implication far from the natural sciences as well.

In spite of his theoretical rejection of science, some of Hauser's most convincing interpretation comes when he discusses Impressionism as an expression of the new industrial technological environment that developed so rapidly in the mid-nineteenth-century cities. Though Hauser can accept economic systems or religious and political beliefs as major social forces somehow the possibility of science as a primary autonomous force consistently affecting society and forcing it to change seems not to occur to him. Science is always seen as the servant to other powers, in particular economic ones. Such an everpresent and indispensable ser-

vant, however, should make any student of Hegel or Marx pause and wonder whether, beneath external appearances, this is not another example of the slave controlling the master.

Perceptual Interpretation

The third and much looser approach to all of art, including the modern period, is what might be called the perceptual interpretation. The first to systematically pioneer this view was Rudolph Arnheim, who discussed art in terms of its optical and perceptual qualities, usually from the position of Gestalt psychology, that is, a particular theory of perception. Thus Arnheim gives the perceiver and visual science a primary interpretive role. More specifically, he argues that the mind has certain innate organizing principles such as a tendency toward "simplicity," or "good form," which successful art takes advantage of. This principle, and others drawn from Gestalt psychology, are illustrated by examples taken from many periods with a special emphasis on twentieth-century art. Arnheim argues most persuasively that art has not been concerned with the literal likeness of a painting to external reality but instead with a property of art that he calls "aliveness," which is different from literal life in that it is in many ways even more alive or "real"

than actual reality. The perceiver senses this vitality when the artist successfully captures and accentuates some of the mind's perceptual principles more effectively than would ordinary visual experience. These principles operating in all perception are often shown by Arnheim to be functioning in both abstract and realistic art.

E. H. Gombrich has also provided a perceptual understanding of art. His theory emphasizes empirical experience and learned perceptual schemata in opposition to Arnheim's assumption of innate principles. Gombrich thereby provides an interesting dialectic with Arnheim. However, Gombrich is somewhat limited by the empiricist approach, which has never fared quite as well as the nativist (or innate) position when treating organized perception. Nevertheless, like Arnheim, he very effectively interprets much in painting as an expression of human perceptual schemata or expectancies.

One difficulty with the perceptual approach has been its failure to bring the historical development of science itself into an understanding of the perceptual nature of modern painting. That is, while perceptual theory is used to interpret visual effects found in art of all periods, the logic of modern visual science has not been considered especially similar to that of modern art, nor has it been considered a major systematic

influence on this art. Once again, the present thesis resolves this weakness by focusing on the historical expression of perceptual science. Nevertheless, of all the preceding interpretations the present thesis is closest to the perceptual approach, especially Arnheim's.

Eclectic Theory

Some of the best criticism has come from an intelligent, sensitive merging of the preceding three interpretations. Eclectic theory is typified by Meyer Schapiro, whose largely cultural approach to art history incorporates formalist and perceptual observations, as well as a strong emphasis on content in terms of the artist's own personal history. In comparing the arts of the present with those of 100 years ago he notes:

we observe that the arts have become more deeply personal, more intimate, more concerned with experience of a subtle kind.

One of the charges brought most frequently against art in our time is that because of the loss of the standards, it has become chaotic, having no rule or direction. Precisely this criticism was often made between 1830 and 1850, especially in France, where one ob-

served side by side works of Neo-Classic, Romantic and Realistic art—all of them committed to representation. The lack of a single necessary style of art reminded many people of the lack of clear purpose or common ideals in social life. What seemed to be the anarchic character of art was regarded as a symptom of a more pervasive anarchy or crisis in society as a whole.

In his social-historical overview of modernism, Schapiro sees this crisis as progressively responsible for the emergence of a new vocabulary in the arts that has progressively expanded to include less idealized experience and to embrace that which was not previously considered suitable, as in African and Oceanic art. Schapiro comments that to us these varieties are less "signs of weakness in the culture than they are examples of freedom, individuality, and sincerity of expression," all values emerging in the modernist period. Thus, Schapiro is rich in his treatment of the personality and intentions of the artist. In any case, Schapiro reserves almost all of his scholarship for other aspects of and influences on modern art, and he only occasionally notes affinities between modern art and science.

In summary, the thesis presented in the preceding chapters is not offered in opposition to the above theoretical approaches, but primarily as a principle of integration among them. Essentially, it has been suggested that—to a very significant degree—modern science has been the muse of modern art. It is claimed that the conceptual framework of modern science, most especially of the science of vision, is a rich link that connects the perceptual to the formal properties of modernist art, and both of these to personal, cultural, and historical factors.

We turn now to other more varied issues and to important qualifications of the theory.

Mimesis: The Problem of What Is Painted

Leo Steinberg, in his essay "The Eye Is Part of the Mind," (1953) describes one of the strongest and most frequently found interpretations of modern art by quoting the French art theorist André Malraux, who wrote: "Modern art has liberated painting which is now triumphantly a law unto itself." Steinberg then notes that "Malraux speaks the mind of his generation when he declares that the representation of external nature has nothing to do with art." Other critics quoted by Steinberg even more starkly reject the notion that modern art is imitation. He

concludes the introduction of his essay by saying that the position of Malraux and others like him

> presents a serious quandary, for the first glance of art through the ages shows unmistakenly that most of it is dedicated precisely to the imitation of nature . . . to representation. Now there are three possible formulas by which this introduction between evidence and creed may be resolved.

The first "formula," given by the formalists, is that representation has always been an impure concession by art to the concern with content by its historic patrons—the state, the church, or the public. The second solution is that although representation was once an artistic necessity it no longer is and this move to abstraction away away from mimetic preoccupation constitutes the radical innovative essence of modern art (this is Malraux's position.) The third possibility, and the one brilliantly developed by Steinberg is that in fact modern art is still deeply involved in representation of a new kind.

Rather than restating Steinberg's convincing discussions of what modern art is a representation of, it is enough to say that the parallelism thesis supports much of the Steinbergian third view. For in spite of the formalist cast to much of the preceding preoccupation with perception, an underlying assumption has been that these artists have been engaged in representation. Very simply, they have been representing perceptual "experience." For example, Impressionism, Pointillism, Cézanne—indeed all nineteenth-century art—makes this clear to the point of being obvious. In view of the continuity between modernism in the nineteenth and twentieth centuries there is every *a priori* reason to assume the situation has not been fundamentally changed in recent modernist expression. The argument of a parallel analysis of vision claims that in this century the artist has been representing either more specialized aspects of perception, such as figure-ground, illusions, cues to depth perception, color contrasts, or that the artist has been representing the nature of the elements, structures, and processes in the visual system with which we construct the perceptual world—such as the spot—and other "feature" detectors.

Steinberg identifies science as the origin of this new kind of representation. For example, he suggests that the new images coming from "telescopic vistas, submarine scenery, X-ray photography . . . cloud chambers," and so on, are the initial source for the new representation. Here for the most part, the

present analysis parts company with Steinberg but there is obviously no disagreement with his claim that there is a very basic affinity between modern art and science, and that this affinity points to a modern kind of mimesis.

Higher Meaning: The Problem of Religious Mysticism and Romantic Symbolism

One of the recurring characteristics of many of the artists cited here has been a frequent recourse by them to interpretations of their work in terms of various vague references to higher meanings, usually religious, romantic, or mystic. These meanings have been irrelevant to the thesis and they have been put aside; nevertheless the artists' statements raise an interesting issue since they cannot be reconciled with the parallelism argument, nor by any of the other interpretations of modern art discussed in this chapter. First, recall some of the artists who show this tendency toward "higher meaning." Good examples are Kandinsky, Mondrian, and to some extent Klee and even Malevich. Aesthetic theorists like Blanc, Henry, and Schoenmaekers, and the empathy theorists, such as Lipps, at times exemplify this concern as well.

What is one to make of this?

The phenomenon can be comfortably placed within the recent theory of Robert Rosenblum (1976) who provides a stimulating interpretation in which he shows that modern painting has involved a systematic evolution of a tradition of religious concern—a position he presents in *Modern Painting and the Northern Romantic Tradition.* For the artist in need of higher meaning, whose work paralleled science, the issue was apt to be acute unless he seriously mastered the scientific material. This rarely happened; perhaps Seurat is the only example. Rosenblum's thesis provides an interpretive framework for understanding the higher meaning attributed to many modern works. The scientist derives plenty of highly significant meaning from the theoretical and mathematical nature of his work. But for the artist the higher scientific understanding was usually not there, no matter how involved he may have become with the perceptual power and artistic utility of the new visual material. Therefore it is reasonable to expect the artist to fill this vacuum with his particular religious and romantic philosophy, which could be applied to abstract visual properties. Rosenblum documents that this higher meaning was often a preoccupying force in the artist's life and a fundamental part of his aesthetic vision. In this way, one can account for those artists who combined a scientific re-

ductionist concern with "simple" perceptual elements with a higher symbolic interpretation, and as a consequence allow the parallelism thesis to make some contact with Rosenblum's "Northern Romantic Tradition."

Surrealism: The Problem of the Image

The modern school most noticeable by its absence from consideration here has been Surrealism. It was pointed out earlier that although some characteristics of Dali and Miró are captured by perceptual concepts, the body of their work remains outside of visual analysis. This is even more so for such artists as Magritte, Ernst, and Tanguy. The problem is that most Surrealism maintained a strong commitment to the image, especially to detailed realism of individual objects (however unrelated to each other in the work as a whole), and also to illusionary depth. As a consequence, most of the movement is not interpretable within the modernist theoretical framework; Surrealism thus also falls outside of the parallelism thesis, and hence represents a significant limitation of it.

Although often in remnant form, the recognizable image has, of course, appeared in most art of the twentieth century, including the work of artists commonly consid-

ered modernists. Picasso, Matisse, Klee, and de Kooning, for example, all have major commitments to recognizable images, themes, and meanings. This commitment to imagery along with such painterly qualities as a work's texture and surface also remain outside of the present thesis. Many elements of the artists' backgrounds — their friends and teachers, personal histories, and philosophies — are irrelevant to the case for parallelism. But this material is of great overall significance; and certainly much of the better art criticism is a sensitive response to these dimensions as well as to a painting's modernist significance.

The possibility of *including* a discussion of Surrealism in the present thesis was seriously explored, for there is a parallelism between modern psychology's interpretation of dreams and fantasies and much of the imagery and interpretative framework of Surrealism. After all, dream images are a visual experience and psychology's explanation of them could conceivably be construed as part of visual science. Given this assumption, it would be relatively easy to explore and document the already well known links between Freud and such surrealists as André Breton. In any case, there was a remarkable, mutual preoccupation with dream images in psychology and in painting in the first half of this century. The case for in-

cluding Freud, Jung, and other psychologists as representative of "visual scientists" is not, however, very sound. First, they were not centrally concerned with vision (an "image"—especially a dream-image as recalled and expressed through words—is not the same thing as a visual experience or stimulus). Second, these thinkers, in spite of their great influence, are no longer categorizable as "scientists" in the normal and still useful sense of the word. Whatever these psychologists are, they certainly do not belong in the same tradition as Helmholtz and Gestalt psychology.

False Parallels

The case of Surrealism highlights some significant issues raised by the notion of parallelism (see Chapter Two). There are all manner of similarities and simultaneities among historical phenomena that could be called "parallelism," such as psychoanalysis and Surrealism. What is intended by this term here, however, is something more specific—clear evidence for the similar mental process or attitude of analytical reductionism expressing itself in conceptually and physically similar forms. When both such conceptual and pictorial parallelism are present, the thesis receives its strongest support. Surrealism, however, did not really involve the analysis or reduction of *images,* nor did most of the psychology that influenced it. The relationship between Surrealism and psychoanalysis is therefore an example of a parallelism of another kind: partly a general cultural interest in dreams, and partly a clear but limited influence of a major thinker on art, for example, Freud on Breton.

However, even granting that some of the evidence in the previous chapters involves accidental parallelisms, the cumulative effect of so much conceptual and pictorial similarity substantially supports the claim that a great deal of modernist painting can be understood as the artist's exploration of perception; that the two fields—art and science —have been involved in a parallel analysis of vision.

Weak Evidence for Recent Years

Strong support for the thesis has not always been present,—particularly in the last 30 years, in spite of sometimes striking examples of pictorial parallelism. In recent years, then, with the exception of optical art and the work of some of the minimalists, the evidence for conceptual parallelism is less persuasive. The art of this recent period, dominated by Americans, does not show major direct influence by visual science. This can

be partly accounted for by the fact that many artists have forgotten — or have never known — the scientific roots of the modernist aesthetic. Nevertheless they are still in fact heirs to this tradition; they are playing out the trajectory of scientific modernism that began in Europe in the nineteenth century and remained strongly acknowledged by artists into the 1920s.

But it is not surprising that the thesis is weaker with respect to recent decades, for the prestige and the moral standing of science have greatly declined. Certainly by the 1950s the Scientism of a Flaubert, a Seurat, a Malevich — or even of the later Kandinsky — would have appeared dated and rather unappealing. Today, at the most pluralistic moment in recent art history, most artists would find it irrelevant or decidedly offensive.

Future Possibilities

The possible future relationship between art and science is problematic, primarily because the analytical-reductionist strategy no longer convinces or satisfies very many either in art or in science. Much of the growing critique of science has centered on its tendency to treat things and people as isolated objects — that is, on science's dominant analytic tendency. Likewise, modernism's habit of reduc-

ing our understanding to a lower level is starting to receive criticism. Those sciences such as ecology, which emphasize the hierarchical interconnections of life, are received with enthusiasm — in marked contrast to the now aging expressions of reductionistic science.

Meanwhile, the calls for an art with more moral meaning, for example, an architecture as if people counted, are part of a rising tide of antimodernist sentiment. If science does move back to a concern with synthesis and hierarchy, then art might continue to find science a rich source of support. If science does not, then art appears to be moving in a different direction in response to the only vaguely articulated but growing hunger for meaning. Such a possibility is suggested by Chuck Close (Fig. 8.1). In this figure, *Robert*, in spite of — or in fact because of — the grid of small squares, the artist has been able to develop an innovative way to return to the image. Each square is one constant shade of brightness, with the complete image constructed from the mosaic. Likewise, scientists' recent explorations of how people recognize faces (Fig. 8.2) have used stimuli constructed from squares of constant brightness, that is, white or black or some degree of gray. In another portrait (not shown), Close's procedure is used in an especially distinctive way. The squares out of which the face is

Fig. 8.1 Close, *Robert/Square Fin-gerprint II.* 1978

Fig. 8.2 L. D. Harmon and B. Julesz, Computer-processed block por-traits used to study visual recogni-tion of portraits. 1973

Fig. 8.3 Close, *Self-Portrait.* 1976–77

constructed are fingerprints obtained by pressing the finger, with different pressures, on an inked stamp pad. A square is thus a particular shade of impersonal black or gray—yet as fingerprints, they are also personal with their unique microstructure of swirls. If visual science can return to the image in a synthetic way perhaps the link between science and art will continue to be fruitful.

As a concluding example consider Close's *Self-Portrait* (Fig. 8.3). The method of constructing this work can be seen in Figure 8.4; here on the left we see each small square of the color photograph is marked off by the grid and each square must be painstakingly replicated on a larger scale for the actual portrait. This process involves three distinct stages. In addition to the natural color photograph, shown in Figure 8.4, Close uses the three color separations, red, blue, and yellow, used in printing the final complete color representation. That is, he has a red, blue, and yellow photograph of the same head. Each square on the canvas is first painted with an air brush to match the red photograph (color separation), then the blue, and finally the yellow.

Each of the areas, painted by itself and considered by itself, is a "meaningless" abstract expressionist painting or a color field canvas—or in some cases an all-white minimal work. But this now familiar implicit

Fig. 8.4 Chuck Close working on *Self-Portrait.* 1980

reductionist message of the parts—and of the grid—all disappear when the parts are integrated in a hierarchy that returns the painting to that most archetypical meaning—the human face (Fig. 8.3). Such a new art no longer uses analysis for its own sake; instead it points in a new direction for it has put analysis in the service of synthesis. □

Notes

CHAPTER 1

Abstraction

Other examples of Mondrian's move toward abstraction can be seen in Michel Seuphor's *Piet Mondrian — Life and Work* (New York: Abrams, 1956).

The Robert Irwin white nylon scrim piece could have been seen, for example, at The Pace Gallery, New York, in the last three weeks of December 1974.

Flattening of the Picture Plane

Barbara Rose, "Wolfeburg," *The New York Review of Books,* June 26, 1975, p. 26. Frances Bradshaw Blanshard, *Retreat from Likeness in the Theory of Painting.* (New York: Columbia University Press, 1949). Katherine Kuh, *Break-up: The Core of Modern Art.* (Greenwich, Connecticut: New York Graphics Society, 1965). Quote from New York Graphics Society Art Library Paperback, p. 11

Theorizing Tendencies

The practice in which artists use their own work to make explicit reference to important earlier accomplishments was the subject of an exhibition at the Whitney Museum in New York, July 19–September 24, 1978. See Jean Lipman and Richard Marshall, *Art About Art* (New York: E. P. Dutton with the Whitney Museum, 1978). Hilton Kramer, *New York Times,* April 28, 1974, Section 2, p. 19; quoted by John Russell in the *New York Times Book Review,* June 15, 1975, p. 4.

Perceptual Character

Probably the first to forcefully draw attention to the perceptual aspects of modern painting was Rudolf Arnheim in the now

classic *Art and Visual Perception* (Berkeley: University of California Press, 1954).

The present thesis and evidence for it, in a shorter form, was first published as "Visual Science and Modernist Art: Historical Parallels" by Paul C. Vitz in *Perception and Pictorial Representation*, C. F. Nodine and D. F. Fisher, eds. (New York: Praeger, 1979), pp. 134–66.

CHAPTER TWO

Synthetic-Hierarchical Thought

Arthur O. Lovejoy, *The Great Chain of Being* (New York: Harper & Row, 1960), originally published by Harvard University Press, 1936. Quotes from H. & R. Torchbook edition, p. 63, p. 60. *French Painting 1774–1830: The Age of Revolution* (New York: Metropolitan Museum of Art, 1975). For the Pierre Rosenberg quote, see p. 12. The Scheffer painting is probably of St. Thomas of Villanova, although some sources (e.g. *Ibid*) specify St. Thomas Aquinas. For Delacroix and his modernist interest in color see *The Journal of Eugène Delacroix,* Walter Pach, trans. (New York: Viking, 1972), p. 278.

Analytical-Reductionism as the Basis for Abstraction and Flatness in Modernist Art

The Appollinaire quote is from "*Les Peintres Cubistes,*" partially reprinted and translated in Hirschel B. Chipp, *Theories of Modern Art: A Source Book by Artists and Critics* (Berkeley: University of California Press, 1968), p. 222.

The Duchamp quote is found in Chipp, *op. cit.*, p. 393.

The Harold Rosenberg quote is from his book *Artworks and Packages* (New York: Dell, 1969), p. 32.

Examples: Biology,
Chemistry, and Physics

See especially Erik Nordenskiold, *The History of Biology* (New York: Knopf, 1928); additional historical information about chemistry and physics is taken from Aaron J. Ihde, *The Development of Modern Chemistry* (New York: Harper & Row, 1964); J. R. Partington, *A History of Chemistry*, Vol. 4 (London: MacMillan, 1964); Max van Laue, *History of Physics*, Ralph Oesper, trans. (New York: Academic Press, 1950), chapter on "Atomistics." Quote from Aaron J. Ihde, *op. cit.*, p. 109.

For Baudelaire's discussion of "modern color" see Charles Baudelaire, *Art in Paris: 1845-1862. Salons and Other Exhibitions*, Jonathan Mayne, trans. and ed. (London: Phaidon, 1965), pp. 48–50.

Mid-Nineteenth Century:
A Special Situation

Harvey's discovery of the circulation of the blood in the early seventeenth century was also primarily synthetic. No new level of biological reality nor any new set of biological elements was involved. Instead, the circulation theory represented the harmonious cooperation of various parts of one body in order to account for the movement of a familiar fluid. Like Newton, his approach was mechanical, for example, the heart was interpreted as a pump, and in this sense his work was obviously modern, but it is not primarily analytical and reductionist (modernist).

For Newton's religious thought, see Eugene M. Klaaren, *Religious Origins of Modern Science* (Grand Rapids, Mich.: Eerdmans, 1977). See Frank E. Manuel, *Isaac Newton, Historian* (Cambridge, Mass.: Harvard University Press, 1963); Aaron Bunsen Lerner, *Einstein and Newton* (Minneapolis, Minn.: Lerner, 1973); and Newton's own book *Observations upon the Prophecies of Daniel and the Apocalypse of John* (London: Darby and Browne, 1733). Also see Herbert MacLachlan, *The Religious Opinions of Milton, Locke, and Newton*, Publication of the University of Manchester, Manchester, England, CCLXXVI, Theological Series, no. VI. (Folcroft: Folcroft Press, 1970).

For Chevreul's contributions to chemistry, see Aaron J. Ihde, *op. cit.*, pp. 168–70; and J. R. Partington, *op. cit.*, pp. 246–49. Michel Eugène Chevreul, *De la loi du Contraste Simultané des Couleurs* (Paris: Pitois-Levrault, 1839). This book went through several later editions, plus several translations into English.

Alfred North Whitehead, *Science and the Modern World* (New York: Macmillan, 1925). Chapter VI discusses professionalism.

Mid-Nineteenth Century Psychology

Lancelot Law Whyte, *The Unconscious Before Freud* (New York: Doubleday, 1962), original publication by Basic Books, 1960. Quotes from Doubleday-Anchor edition: Whyte, p. 145; for Carus, *Psyche: Zur Entwicklungsgeschichte der Seele* (1846), p. 141; Carpenter, pp. 146–47; E. S. Dallas, p. 153; H. A. Taine, p. 165; Hartmann, pp. 154–55; Helmholtz, pp. 149–50; Fechner, pp.151–52; Wundt, p. 152; Whyte's summary statement, p. 161.

The Specific Thesis— Pictorial Parallelism

Roger Fry, *Vision and Design* (London: Chatto and Windus, 1920), p. 14.

Clement Greenberg, "Modernist Painting" in *Art and Literature,* Hilton Kramer, ed., 1965. For quote, see G. Battcock, *The New Art* (New York: Dutton, 1973), pp. 73–4.

Christopher Finch, introductory essay in *Concepts of Modern Art,* Tony Richardson and Nikos Stangos, eds. (New York: Harper & Row, 1974), p. 1.

Flaubert and Madame Bovary

See Benjamin F. Bart, *Flaubert* (Syracuse, N.Y.: Syracuse University Press, 1967) for a discussion of Flaubert's life and attitudes. The quote is from p. 326; see also p. 324.

Flaubert's quote is from Alan Spiegel, *Fiction and the Camera Eye* (Charlottesville: University of Virginia Press, 1976), p. 18. The original quote is from an 1857 letter of Flaubert to Mademoiselle Leroyer de Chantepie.

Charles-Augustin de Sainte Beuve quotes are in *Moniteur-Universal*, May 4, 1857 (reprinted in many subsequent sources). The Flaubert quote is from Jean Rousset, "*Madame Bovary* or The Book about Nothing," in *Flaubert: A Collection of Critical Essays*, R. Giraud, ed. (Englewood Cliffs, N.J.: Prentice Hall, 1964). Original from Flaubert's *Correspondence*, (Paris: L. Conard, 1926–1933) II, p. 345. *Jealousy* can be found in *Two Novels by Robbe-Grillet*, Richard Howard, trans. (New York: Grove, 1965). Quote from Jean Rousset, *op. cit.*, p. 112. Original from Preteste, Nouvelle serie, no. 1, January 1958, p. 100.

Gustave Flaubert, *Madame Bovary*, Francis Steegmuller, trans. (New York: Random House, 1957), p. 25. Alan Spiegel, *Camera Eye*, pp. 29, 31. See Chapters 1 and 2 for Spiegel's presentation of Flaubert's camera or cinematic style.

For Flaubert's travels to the Orient with du Camp see Francis Steegmuller, *Flaubert in Egypt* (London: Bodley Head, 1972); Antoine Youssef Naaman, *Les Lettres d'Egypte de Gustave Flaubert* (Paris: Nizet, 1963).

The quote "seeing eye of man" is from Spiegel, *op. cit.*, p. 30.

CHAPTER 3

Helmholtz and the
Perception of Light

Hermann von Helmholtz, *Handbuch der physiologischen Optik*, (Leipzig, 1867). This work was first published in three monographs in 1856, 1860, and 1866. It was published in English as *Helmholtz's Treatise on Physiological Optics*, 3 vols., J.P.C. Southall, ed. (Rochester, New York: Optical Society of America, 1924). See Edwin G. Boring, *A History of Experimental Psychology* 2nd ed. (New York: Appleton-Century-Crofts, 1950) pp. 300-01.

O. N. Rood, "On the Relation between Our Perception of Distance and Color," *American Journal of Science*, Second Series, Vol. 32, no. 95 (September 1861), p. 184. Ogden N. Rood was also an amateur painter who studied painting in Germany in the 1850s. His research career had a heavy emphasis on optics and visual effects and he produced three early papers involving contributions to photography. Although he was quite unsympathetic to the new art, his *Modern Chromatics* was referred to as "The Impressionist's Bible" and some "hailed" him as the "father of Impressionism." His book certainly had an extensive period of influence from its publication in 1879 well into the twentieth century. See, for example, our section on Delaunay. Biographical information on Rood can be found in Edward L. Nichols, "Biographical Memoir of Ogden Nicholas Rood (1831–1902)," *National Academy of Science Biographical Memoirs* 6 (1909), pp. 447–72.

Helmholtz, *op. cit.*, pp. 8–9. The quote is taken from the English translation of the third German edition (1909–11). However, the passages quoted are unchanged from the first edition (see the preface to the third edition). In the first German edition, the quotes are from pages 432–34. Since these pages are at the start of the third section (Dritter Abschnitt), it is probable that the quote first appeared in the 1866 monograph just before the book was published. However, the earlier monographs, which preceded the *Physiologischen Optik*, are very rare and could not be located.

For the quote by Emile Zola, see *Mes Haines* (Paris: F. Bernouard, 1928), p. 260. Quoted from Anne Coffin Hanson, *Manet and the Modern Tradition* (New Haven: Yale University Press, 1977), p. 26.

For the influences of Titian and Giorgione see George Bataille, *Manet: Biographical and Critical Study,* A. Wainhouse and J. Emmons, trans. (New York: Skira, 1955); Pierre Schneider,

The World of Manet 1832-1883 (New York: Time-Life, 1968); John Rewald, *The History of Impressionism* (New York: Museum of Modern Art, 1961); Theodore Reff, *Manet: Olympia* (New York: Viking, 1976). The Reff quote is from *Olympia, op. cit.*, p. 81. For the Courbet and Manet exchange see Reff, *op. cit.*, p. 30 and A. Wolff in *Le Figaro*, May 1, 1883.

Manet and Photography: General Context

Important aspects of the material presented in support of photography are taken from Aaron Scharf's *Art and Photography* (Baltimore, Maryland: Penguin Press, 1969; Pelican Books Edition, 1974, with revisions). All quotes from 1974 edition and from Van Deren Coke's *The Painter and the Photograph* (Albuquerque: University of New Mexico Press, first published in 1964; revised and enlarged edition, 1972). All quotes from 1972 edition. We are indebted to these two important books. The present discussion differs from them by focusing on different issues—the origins of Manet's modernist "flattening" and the parallel between the Rood-Helmholtz insight and Manet's analytical realism. It also introduces new evidence and interpretation as well as relevant information that has come to light since the contributions of Scharf and Coke were published.

The three sources (Spanish paintings, photography, Japanese prints) are now routinely suggested as influences; see Hanson, *op. cit.*; and Schneider, *op. cit.* Photography seems to be the most recently acknowledged.

For Spanish influence see Hanson, *op. cit.,* and Peter Gay, *Art and Act* (New York: Harper & Row, 1976); and John Richardson, *Edouard Manet, Paintings and Drawings* (London: Phaidon, 1958). George Mauner, *Manet: A Study of the Painter's Themes* (University Park: Penn State University Press, 1975) is good on Manet and Velasquez. Manet's early knowledge of Goya is not clear. Baudelaire asserted in 1864 that Manet had never seen a Goya (letter to Thoré, June 20, 1864), see G. M. Hamilton, *Manet and His Critics* (New Haven: Yale University Press, 1954), pp. 62–63. However, it is believed he had seen the *Clothed Maja*, perhaps in a photograph by Nadar. See Reff, *op. cit.,* pp. 64–65.

Examples of Salon painters influenced by Spanish painting include Carolus-Duran whose rather slick Salon style adaptations of Velasquez made him highly successful. Manet and he were friends. See Schneider, *op. cit.*, p. 135. Also, Henri Regnault, a fine academic painter, greatly admired Velasquez. (See Gay, *op. cit.*, p. 74 and note 38).

For the Scharf quotation see Scharf, *op. cit.*, p. 37. The popularity of photography with Parisians in 1849 is noted in Schneider, *op. cit.*, p. 96.

Gerald Needham, "Manet, *Olympia*, and Pornographic Photography," in *Woman as Sex Object*, Thomas Hess and Linda Nochlin eds. (New York: Newsweek, 1972), pp. 81–89. Charles Baudelaire, *Art in Paris: 1845–1862*, Jonathan Mayne, trans. and ed. (London: Phaidon, 1965), p. 153. Gerald Needham, *op. cit.*, pp. 81–82 and p. 82 for the Needham quotes. For discussion of Delacroix and photography with special reference to pornographic photographs see F. A. Trapp, "The Art of Delacroix and the Camera's Eye," *Apollo* 83, (1966), pp. 278–88. Also Scharf, *op. cit.*, p. 8, and Hanson, *op. cit.*, p. 100. Reff, *op. cit.*, is a sustained comment on Manet and the influence of pornographic photographs.

The Turner position is quoted in Coke, *op. cit.*, p. 12. The Delacroix quote is from his *Journal*, May 21, 1853; the second quote is from an 1854 letter; both taken from Coke, *op. cit.*, p. 9.

Photography and Flatness

Philip Gilbert Hamerton, *Thoughts on Art* (Boston: Roberts Brothers, 1871), pp. 118–19, p. 121.

Photographic Influence on Manet: Specific Evidence

Gay, *op. cit.*, p. 49. Courbet's use of photographs in the 1850s is reported by Scharf, *op. cit.*, pp. 130–38.

Coke, *op. cit.*, p. 9 claims Manet was an amateur photographer. Hanson, *op. cit.*, p. 195, in spite of noting several photographs attributed to Manet and other evidence, concludes that whether Manet was an amateur photographer or not is still

undecided. She does, however, refer to his photograph album and some of the pictures in it (p. 196).

The connection of these two etchings to photographs is well known. See Coke, *op. cit.*, p. 9 and Scharf, *op. cit.*, p. 64. The four versions of the Baudelaire etching can be seen in Nils Gosta Sandblad, *Manet: Three Studies in Artistic Conception*, Walter Nash, trans. (Lund, Sweden: New Society of Letters at Lund, 1954), plates 15–18.

Scharf, *op. cit.*, pp. 66–75 gives a thorough summary of the photographs involved in the *Emperor Maximilian*. For reference to the photographs involved in the four portraits see Scharf, *op. cit.*, pp. 65–66; and Hanson, *op. cit.*, pp. 193–96; De Leiris is quoted by Coke, *op. cit.*, p. 308.

Rewald, *op. cit.*, p. 32 mentions that the sitter's family rejected the Madame Brunet painting and comments that Manet was "more interested in lights and shadows, and in fluid brushstrokes, than in flattering his model."

The seven works of Manet in which relevant photographs have been identified are: The Poe and Baudelaire etchings, *Printemps* and *The Execution of the Emperor Maximilian*; the portraits of *Mery Laurent*, *Henri Rochefort*, and *Clemenceau*. Paintings for which specific photographic influences have been claimed are *Angelina*, *Emilie Ambre as Carmen*, *The Escape of Rochefort*, and *Spring*. (See, for example, Hanson, *op. cit.*, p. 195); also *Olympia* (see discussion on pornographic photographs). Hanson, *op. cit.*, Chapter 5 presents a good recent treatment of Manet's use of Japanese prints as models. For the connection between Manet and Nadar see Hanson, *op. cit.*, p. 30. The Richardson quote is from *Edouard Manet: Paintings and Drawings* (London: Phaidon, 1958), p. 20. Richardson's quotes (and general discussion) on Manet's elimination of halftones are on pp. 11–12.

For photographs of Manet that are similar to paintings of him, see Rewald, *op. cit.*, pp. 125, 404. Fantin-Latour apparently often used photographs in his paintings of people; see Coke, *op. cit.*, p. 106. For the contrast between his photographic portraits and his floral studies peruse any book covering his work with reasonable thoroughness. Likewise, any book providing good coverage of Manet will provide comparisons of his portraits with his still lifes.

The Nadar photographs using artificial light can be seen in

Jean Prinet and Antoinette Dilassser, *Nadar* (Paris: Librarie Armand Colin, 1966), Italian edition by Lamberto Vitali (Torino: Guilio Einaudi, 1973), pp. 340-47. This effect is also noted by Hanson, *op. cit.*, p. 196; and Scharf, *op. cit.*, pp. 111-13. The Hippolyte Babou quote is on p. 12 in Pierre Courthion, *Edouard Manet* (New York: Abrams, 1962). This book also contains some of the photographs from the Manet family album; photographs of people whom Manet painted can be seen in Henri Perruchet, *Manet,* W. Hare, trans. (Cleveland: World, 1962). For example, Abbé Hurel, Suzanne Leeuhoff (his wife), Manet himself. Photographs from other sources, but similar to Manet's paintings, are those of Antonin Proust, Isabelle Lemonnier (see reference to Pierre Courthion, above, also).

Daumier's paintings from about the mid-1850s also show clear reductionist qualities. These have been attributed to his contact with Nadar—both were interested in artificial lighting. Jean Adhemar, reported in Scharf, *op. cit.*, pp. 61-62, shows that one of Daumier's portraits has exactly the same features as a Nadar photograph of the same person. As with Nègre, photography is linked very early with the new "flat" style, and without Japanese influence.

Japanese Prints:
The Case Against Early
Influence on Manet

Sandblad's case for the year 1862 can be found in Sandblad, *op. cit.*, pp. 69-87. The small Japanese shop was Madame de Soye's La Porte Chinoise. The date of 1860 for *Madame Brunet* is given by John Rewald, *op. cit.*, p. 33; Sandblad, *op. cit.*, pp. 82-83, implies that the date is 1862 both citing its other title *La Parisienne de 1862* and by placing it in the same period as *La Chanteuse des rues* and other paintings of 1862. The 1862 date is also given on p. 91 in *L'opera pittorica di Edouard Manet* (*The Pictorial Works of Edouard Manet*) (Milano: Rizzoli, 1967). Presentazione by Marcello Venturi; Apparati critici e filologici by Sandra Orienti.

The unsentimental description of *Madame Brunet* is made by Rewald, *op. cit.*, p. 34.

The photographic character of the portrait of Manet's parents

is mentioned, for example, by Hanson, *op. cit.*, pp. 76, 195–96. A description of the presumed similarity between *The Railroad* and a Japanese print is an example of the tendency to overread the Japanese influence, as in Hanson, *op. cit.,* p. 190.

Peter Gay's reservation is not in a context supporting photography but we believe it represents a bias on the part of art historians that needs correction. For the quote see Gay, *op. cit.*, p. 55.

See Schneider, *op cit.,* p. 104, for Manet's reference to light.

Scharf, *op. cit.*, p. 357, discusses the early introduction of photography into Japan and its possible influence on Japanese artists such as Hiroshige.

Manet and Arnheim's
Thesis on the Cinema

Rudolf Arnheim, *Film as Art* (Berkeley: University of California Press, 1957), p. 57. See also pp. 49 and 58. The original publication of these ideas was 1933.

CHAPTER 4

The Rood-Helmholtz
Insight and Monet

Hermann von Helmholtz, *Handbuch der physiologischen Optik* (Leipzig: Leopold Voss, 1867). Quotes are taken from the 1924 English translation *Treatise on Physiological Optics,* Vol. 3, by J. P. C. Southall, (Rochester, N.Y.: Optical Society of America, 1925), pp. 8–9.

William C. Seitz, *Claude Monet* (New York: The Museum of Modern Art, 1960), p. 8 also reports that Monet wanted to see the world "as a pattern of nameless color patches." The Monet quote is from Lilla Cabot Perry's "Reminiscences of Claude Monet from 1889 to 1901," *The American Magazine of Art* 18, no. 3 (March, 1927): p. 120. The reference by Monet to his wife is reported in Jean Leymaire, *Impressonism: A Biographical and Critical Study,* James Emmons, trans. (Paris: Skira, 1955), p. 36; and Seitz, *op. cit.,* p. 10.

Maurice Denis, "Definition of Neo-traditionalism," in *Theories of Modern Art,* Chipp, ed. (Berkeley: University of California Press, 1968), p. 94.

Kandinsky is quoted from Seitz, *op. cit.*, p. 25 (fold-out). Original source: Wassily Kandinsky, *Rückblick 1901–1913* (Berlin: Der Sturm, 1913). See also Kandinsky, "Reminiscences" in *Modern Artists on Art*, Robert L. Herbert, ed. (Englewood Cliffs, N.J.: Prentice-Hall, 1964), p. 26. The Seitz quote is from Seitz, *op. cit.*, p. 30.

The Helmholtz quotes are from Helmholtz, *op. cit.*, pp. 328, 313, and 144. Also recall Helmholtz's quotes from Chapter 3. There are 37 usages of the word "impression" in the 33 pages of the English translation of "The Relation of Optics to Painting" published in *Selected Writings of Hermann von Helmholtz*, Russell Kahn, ed. (Middletown, Conn.: Wesleyan University Press, 1971). For a discussion of Helmholtz's empirical philosophy and his experimental and theoretical contributions see Edwin G. Boring, *A History of Experimental Psychology*, 2nd ed. (New York: Appleton-Century-Crofts, 1950), Chapter 15.

Jules Antoine Castagnary, "Exposition du Boulevard des Capucines — Les Impressionistes." *Le Siècle,* April 29, 1874. Cited in John Rewald, *The History of Impressionism* (New York: Museum of Modern Art, 1961), p. 330.

Kai von Fieandt, *The World of Perception.* (Homewood, Ill.: Dorsey, 1960.), p. 96. Jean Rousset, "*Madame Bovary*, or the Book about Nothing," in *Flaubert: A Collection of Essays*, R. Giraud, ed. (Englewood Cliffs, N.J.: Prentice-Hall, 1964), p. 126n.

"A Psychophysical Aesthetic"

J. K. Huysmans, "L'exposition des independents en 1880," in Huysmans, *L'Art Moderne*, (Paris: G. Charpentier, 1883), pp. 99–139. Quoted from Rewald, *op. cit.*, p. 441.

Jules LaForgue. Quoted from Jose Argüelles, *Charles Henry and The Formation of a Psychophysical Aesthetic.* (Chicago: University of Chicago Press, 1972), p. 70n. From LaForgue's *Oeuvres Complètes,* Vol. 4, G. Jean-Aubry, ed. (Paris: Mercure de France, 1922), p. 212.

Gustav Theodor Fechner, *Elemente der Psychophysik*, two vols. (Leipzig: Breitkopf und Härtel, 1860). English translation (Vol. 1) by Helmut E. Adler (New York: Holt, Rinehart, and Winston 1966). For a discussion of Fechner's work, especially the issue of the measurement of JNDs, see Boring, *op. cit.*, Chapter 14. Fechner also developed the first experimental psychology of aesthetics. His important *Introduction to Aesthetics* was published in 1876 at the start of Impressionism. See Allen (1876) for another early scientific approach to aesthetics. A contemporary aesthetician who fits the general thesis advocated here is Hippolyte Taine (1828–93) whose approach has been described as "empirical, analytical and mechanistic," p. 280 in Peyton E. Richter ed., *Perspective in Aesthetics* (New York: Odyssey, 1967). The art critics and aesthetic theorists Taine, LaForgue, and Fechner roughly are to Impressionism what the Formalists (Bell, Fry, etc.) are to Cubism. Argüelles, *op. cit.*, pp. 70–71 for the Argüelles quotes.

Modern Color: Chevreul and Impressionism

Faber Birren has been instrumental in rescuing Chevreul from his relative neglect. Birren has republished Chevreul's work under the title *The Principles of Harmony and Contrast of Colors and Their Applications to the Arts* (New York: Reinhold, 1967). This book is a mine of information about Chevreul and this section owes much to Birren.

The expression "modern color" is a natural extension of Baudelaire's preoccupation with "Modern Life" (for example, "Modern Beauty") to one of his prime interests—color. Some might prefer Johann Wolfgang Goethe's *Zur Farbenlehre* (Tübingen: J. G. Cotta, 1808–10) as the first great example of modern color theory. There is much merit in this suggestion; I have concentrated on Chevreul, however, because his approach was more concerned with artistic problems and quickly fed into the rich stream of French artistic creativity. Goethe's position suffered from his emotionally biased attack on Newton's color theory; it was also more theoretical and less practical than Chevreul's, and somewhat more concerned with the physical nature of light than Chevreul. Even today Goethe's very extensive writings on color

are daunting to all but the most highly motivated. For the best coverage of Goethe's understanding of color see R. Matthaei, ed., *Goethe's Color Theory* (New York: Van Nostrand, 1971). Still, as noted in this chapter and in Chapter 6, Goethe's work was important and far in advance of his time.

The analysis by Beck was in a personal communication (1980) in which he went on to elaborate on the basis for dematerialization in Impressionism:

> In his book An Introduction to Color (New York: Wiley, 1948), Ralph M. Evans has a plate in which a normal colored woman is reproduced (a) without hue but keeping the brightness variations, and (b) in full color but eliminating the brightness variations. The picture without color gives an immediate visual sense of the material composition of objects. The picture *without brightness variations* gives an impression of a film color. There is no sense of the material properties of the skin, hair and clothes of the woman or of the other objects portrayed.

Beck, thus, clearly identifies the loss of brightness variations with their cues to depth and solidity as crucial to the impressionist style.

Goethe fairly often described color from a psychological point of view, that is, color as it depended on the condition of the eye. Later this tradition of color theory settled on red, blue, and yellow as primary. This important alternative system was represented by Hering and much later surfaced in the color theory of Mondrian, Kandinsky, and Klee, at the Bauhaus (see later sections of this chapter).

Michel-Eugène Chevreul, *De la Loi du Contraste Simultane des Couleurs* (Paris: Pitois-Levrault 1839). The first English translation by Charles Martel (London: Longman, Brown) was in 1854. Shortly after, in 1857, John Spanton also translated another edition titled *The Laws of Contrast of Colour* (London: Routledge). The translator's preface to the 1857 edition makes it clear that at that time in England Chevreul was viewed as the first to scientifically investigate the aesthetic significance of color.

Faber Birren, ed., *The Principles of Harmony and Contrast and Their Applications to the Arts by M. E. Chevreul* (based on the first English edition of *De la Loi du Contraste Simultane des*

Couleurs, 1854, as translated from the first French edition of 1839; with a special introduction and explanatory notes). (New York: Reinhold, 1967.)

Pissarro's relationship to color science is discussed in Birren, *op. cit.,* p. 20; the painter's position in the 1880s is well captured in his comment quoted at the end of this chapter.

The Chevreul quotes about exaggerated color are in Birren, *op. cit.,* p. 139. Other positions and comments of Chevreul are in *Ibid.,* Birren, *op. cit.,* pp. 127, 179, 136, 137, 147. Also in the 1859 London edition of Chevreul's *The Principle of Harmony and Contrast of Colours and Their Application to the Arts,* p. 104.

Modern Color: Chevreul, Delacroix, Baudelaire

Delacroix is quoted in Birren, *op. cit.,* p. 81 and in *The Journal of Eugène Delacroix,* Walter Pach, trans. (New York: Viking Press, 1972), p. 278.

Concerning the missed meeting see John Rewald, *Georges Seurat* (New York: Wittenborn, 1946), p. 16; original reference Paul Signac, *Le Neo-Impressionisme, documents* (Introduction to the catalogue of the exhibition "Seurat et ses amis," reprinted in the *Gazette des Beaux-Arts,* 1934).

For Chevreul's preoccupation with red and green see Birren, *op. cit.,* Plates I, II, IV, V.

For the Charles Baudelaire quotes see Charles Baudelaire, *Art in Paris: 1845–1862.* Jonathan Mayne, ed. and trans. (London: Phaidon, 1965), pp. 4–5, 48, 51.

Seurat and Stilling: Pointillism and Elementism

Charles Blanc, *Grammaire des arts du dessein* (Paris: Renouard, 1867.) *The Grammar of Painting and Engraving* (New York: Hurd and Houghton, 1874), p. 164. Second Blanc quote from Blanc, *op. cit.* (French ed.), p. 509. Quoted from Chipp, *op. cit.,* p. 94n.
Ogden Rood, *Modern Chromatics* or *The Student's Handbook of Color.* (New York: Appleton, 1879).
William I. Homer, *Seurat and the Science of Painting,* (Cam-

bridge, Mass.: MIT Press, 1964), pp. 146–53. This scholarly book is an indispensable source for the impact of science on Seurat.

E. Brücke, *Bruchstücke aus der Theorie der bildenden Kunste* (Leipzig: Brockhaus, 1877); E. Brücke, *Princepes scientifiques des beaux-arts; essais et fragments de théorie* (Paris: Baillère, 1878). The translation of Brücke was published with H. Helmholtz, *L'optique et la peinture* (translation of Helmholtz, 1871–73). Information taken from M. H. Pirenne, *Optics, Painting, and Philosophy* (Cambridge, Mass.: Cambridge University Press, 1970), pp. 166n and 184.

Paul Signac, *Le Neo-Impressionisme, documents*, Chapter IV; quoted in Rewald, *op. cit.*, p. 14.

E. Hertel, ed., *Stilling's pseudoisochromatische Tafeln zur Prüfung des Farbensinnes* seventeenth ed., (Leipzig: Georg Thieme Verlag, 1926). The first edition is reported to have been published in 1878. The reproduction is taken from Plate I in the 17th edition. Stilling published a variety of different articles and tests containing color blindness test plates — starting in the 1870s. Prior to Stilling's work, color blindness tests were rather haphazard — the best used colored yarns. That Stilling is the author of the first plates is not generally known, for example, we sampled four American authorities on vision, including two on color vision, before finding one who knew who had constructed the first color-blindness test plates. Related works by Stilling are: *Die Prüfung des Farbensinnes beim Eisenbahn und Marinepersonal*, with 3 plates. Zweite Auflage (German and English), (Cassel: T. Fischer, 1877); *Uber das Sehen der Farbenblinden* (Cassel: T. Fischer, 1880). *Tafeln zur Bestimmung der Blau-Geilb-Blindheit.* (Cassel: T. Fischer, 1878).

W. I. Homer, *op. cit.*, p. 292.

The Cézanne quotes are from Lawrence Gowing "The Logic of Organized Sensations" in *Cezanne — The Last Work*, W. Rubin, ed. (New York: Museum of Modern Art, 1977), pp. 57, 59.

The Elementist Theory of Perception: Wilhelm Wundt and Ernest Mach

Edward B. Titchener, *An Outline of Psychology* (New York: Macmillan, 1896), pp. 74–75.

Wilhelm Wundt has been classified as an elementist by some authors, such as Edwin G. Boring, *A History of Experimental Psychology, 2nd ed.* (New York: Appelton-Century-Crofts, 1950), and R. J. Herrnstein and E. G. Boring, *Source Book in the History of Psychology* (Cambridge, Mass.: Harvard University Press, 1965). Wundt's work clearly shows he was concerned with sensory elements but he was also equally, if not more preoccupied, with higher level concepts such as the "apperceptive mass" and with volition. Wundt was often closer to a proto-Gestalt position in his emphasis on the dynamic higher organizational nature of much of perception and thought. This misunderstanding about Wundt has been identified and corrected by the Wundt scholar Arthur L. Blumenthal: "A Reappraisal of Wilhelm Wundt," *American Psychologist* 30 (1975): 1081–88; "Wilhelm Wundt and Early American Psychology: A Clash of Two Cultures," *New York Academy of Science Annals*, in press. Also pointed out in a personal communication from Blumenthal.

Ernest Mach, *Beiträge zur Analyze der Empfindungen.* (Jena: T. Fischer, 1886). English version, *Contributions to the Analysis of Sensations*, C. M. Williams and S. Waterloo, trans. (Chicago: Open Court, 1897). Benjamin Rand, compiler, *The Classical Psychologists* (Boston: Houghton-Mifflin, 1912), p. 559, and pages 597–610 of Mach were also used for summarizing his position. Also see Peter Alexander on Ernest Mach in the *Encyclopedia of Philosophy,* Vol. 5, Paul Edwards, ed. (New York: Macmillan, 1967), pp. 115–19. Quote is from p. 116 of this article, originally in *The Analysis of Sensations,* p. 12. In addition, Mach believed in the fundamental importance of mathematics and logic. His philosophy, which was an important source of the positivist school, consisted of logical thought applied to describing and organizing sensations, that is, scientific principles applied to sensory experience. The use of principles is, of course, equally true of Seurat.

For some recent discussions of Mach and his relevance for visual phenomena (for example, Mach bands) see the papers of Floyd Ratliff, especially "Contour and Contrast," *Proceedings of the American Philosophical Society* 115 (1971), pp. 150–63. This has an excellent treatment of Signac's use of Mach bands—and of Mach bands in oriental art.

Ratliff, "On Mach's Contribution to the Analysis of Sensations" in *Ernst Mach Physicist and Philosopher*, Boston Studies in the Philosophy of Science, VI (1970), pp. 23–41. Also see the en-

tire volume. Ratliff's *Mach Bands: Quantitative Studies on Neural Networks in the Retina* (San Francisco: Holden-Day, 1965) is also relevant. One thing made clear by the scholarship on Mach is that he was a man of very diverse interests and contributions to science. His general antimetaphysical philosophy of science was consistent, and as Ratliff (1970) points out, this was heavily conditioned by his persistent interest in the analysis of sensory experience and his concern with the role of the observer and his senses in investigating the nature of physical phenomena. But ultimately he fell back on sensations as the only indubitably given reality.

Charles Henry:
A Scientific Theory
of Aesthetics

Much of this treatment of Henry is taken from José Argüelles's *Charles Henry and the Formation of a Psychophysical Aesthetic* (Chicago: University of Chicago Press, 1972). Argüelles appears to be the only biographer of the remarkable Mr. Henry. Argüelles identifies the connection between Chevreul and Henry by writing that "In many ways, Henry's work is a further and more expanded realization of Chevreul's idea." p. 164n.

Charles Henry quoted in Argüelles, *op. cit.*, pp. 83–84.

Argüelles, *op. cit.*, p. 79. Evidence for the impact of Henry on Seurat, Signac, and others can be found throughout Argüelles's book. See also William I. Homer, *op. cit.*

Seurat's letter is in Rewald, *op. cit.*, pp. 60–62.

William I. Homer, *op. cit.*

See Edward Lucie-Smith's *Symbolist Art* (New York: Praeger, 1972) for the Symbolist's generally synthetic accomplishments as well as the various "contents" of the movement. Argüelles also discusses the connection of Henry to Symbolism. Henry's links to Delaunay, Kupka, and Gleizes are noted on pages 146–49. Henry has interesting affinities with Theodore Lipps and M. H. J. Schoenmaekers, all three of whom developed science-influenced theories of aesthetics in different countries at about the same time—presumably independently of each other.

Information about Delaunay's career, his contacts with Neoimpressionism, color theory, Metzinger, Rood, Chevreul, and others, was taken from the very informative *Robert Delaunay: Light and Color* (New York: Abrams, 1967), by Gustav Vriesen and Max Imdahl. For quotes see pp. 17, 18, 44, and 49. See also Michael Hoog, *Robert Delaunay* (New York: Crown, 1976). Hoog makes the following claim, which we will quote extensively because of its relevance:

> The example of the Neo-Impressionists and their writings, which Delaunay probably read, must have led him to their common source, that is to Chevreul. When one speaks of Delaunay, inevitably, one has to refer to Chevreul. Delaunay owes him his surname of "simultaneous" and, in his own writings, somewhat belatedly it is true, claimed that he had learned from Chevreul. Who and what was he?

> Henri Chevreul (1786–1889), whose exceptional longevity had enhanced his fame, was a chemist who was always fascinated by the problems posed by color. He systematically devoted himself to studying them and, when he became head of the dying studio at the Gobelin tapestry works, was able to further his research. He is responsible for a large number of books and articles, of which the best known is the work entitled: The Law of Simultaneously Contrasting Colors, which was first issued in 1839 and reissued in a deluxe edition by the Government Printing Office in 1889. This volume attracted Delaunay's attention even before it was read by Seurat and Signac.

This last sentence by Hoog is incorrect and misleading. If Seurat read the deluxe edition (1889) of Chevreul's work it was very probably shortly after it was published, for Seurat died in 1891 when Delaunay was only six years old. Obviously, Seurat read it before Delaunay, if he read it at all. Furthermore emphasizing this deluxe edition is beside the point. Seurat was quite familiar

with Chevreul's work in its earlier editions, and as it was presented in Rood's *Modern Chromatics* and very probably through popular articles (for example, Sutter) and finally through personal contact with Charles Henry. (See Homer's book on Seurat). As for Signac, he, like Seurat with whom he was closely associated, would have become familiar with Chevreul in the 1880s and 1890s. He also very probably read the particular deluxe edition before 1900 and hence before Delaunay who was only 15 years old in that year. Again, however, all this is beside the point for Signac as for Seurat, since there were other editions of Chevreul plus the solid clear exposition of his work by Rood, and his close personal association with Charles Henry. Hoog continues:

> Should one therefore draw the conclusion that De-launay was so strongly influenced by Chevreul? There is no evidence of it. First, it must be said that Chevreul's book was a heavy quarto volume and that much of its contents were not of a nature likely to interest Delaunay. The theoretical and scientific parts did not make for easy reading; the practical parts concerned themselves with examples such as the combinations of colors in flower beds or military uniforms. It is hard to imagine the mischievously inclined Delaunay being fascinated by such an exploration.

The whole question of the heavy quarto deluxe edition of Chevreul is, as previously mentioned, beside the point. Smaller standard editions of Chevreul's had been readily available in France for years. Also, to imply that Chevreul's practical significance was primarily or exclusively with "flower beds or military uniforms" is simply false. The problems of painting and design were most prominently discussed by Chevreul. Unfortunately, Hoog seems unaware of and hostile to any possible effect of the new color science on art. Regardless, on the basis of the work of Homer, Argüelles, Vriesen, and Indahl and the evidence cited here, we conclude that there were three major influences on Delaunay:

1. Scientific color theory, such as that of Rood and Chevreul.
2. Neoimpressionism, which would not have existed without scientific color theory.

3. Cubism, with its multiple points of view. In some cases, for example, Duchamp, Futurism, and Kupka, the tendency derived from the photographic science of Muybridge and Marey. In the other cases it was an autonomous parallel to what was going on in science.

Thus, visual science was a necessary but not sufficient determinant of Delaunay's art.

Arthur A. Cohen, ed., *The New Art of Color: The Writings of Robert and Sonia Delaunay* (New York: Viking, 1978) writes that he "suspects that Chevreul gave the Delaunays simultaneity" (p. xvi). Cohen notes the significance of color science for Delaunay as follows:

Paul Signac's theories of Neo-impressionism, first published in 1899, were highly influential on later artists. Signac was convinced by his own study of Chevreul and other theoreticians that the element of color in painting could be controlled by the mind, and could be employed to correspond with the character of the lines in order to fortify the mood evoked by the subject. It was in an attempt to control the chaotic multiplicity of colors and the uncontrolled sensations of Impressionism that he proposed the four principles of Divisionism. These provide that the various aspects of color in a painting, that is, color of the object, of the light, and of the reflections, should be analyzed separately, and that they may be brought into equilibrium according to the laws of contrast as set forth by Chevreul and other scientists. Thus, color was considered apart from a descriptive function and was thought of as an independent expressive means. Finally, Signac would subordinate the role of color, traditionally conceived of as the more emotional element, to the linear composition, or the more intellectual element. Thus color was to be brought under conscious control as one of the elements of the painting.

Henry was well known to artists, having discussed his theories with Signac, Seurat, and others, and Signac had made diagrams to illustrate the theories in his books. He had written extensively on the theories of art and music, on mathematics, and on techniques of painting, and was himself a poet in the circle of the Symbolists. His major works dealt with the physiology of aesthetic sensations, and they analyzed experiments by

which he attempted to reduce the effects of color and line to simple nervous reactions.

Charles Henry's *Cercle Chromatique* was published in Paris by Charles Verdin in 1888. For Henry's aesthetic theory of line orientation, see his *Rapporteur esthétique* (1888) and Homer, *op. cit.* Argüelles, *op. cit.*, p. 149, mentions the link between Gleizes and Henry, as well as suggesting a connection to Orphism and the Section d'Or.

Kupka: The Same Story as Delaunay

The importance of Kupka has been acknowledged only recently. The writings of Meda Mladek and Margit Rowell are especially important in this respect. See their articles in *Frantisek Kupka: A Retrospective* (New York: Solomon R. Guggenheim Museum, 1975). (Biographical information is taken from this book.) The first five quotes are from pp. 69, 19, 68, 69, and 73.

Herschel B. Chipp in "Orphism and color theory," *The Art Bulletin* 40 (1958) pp. 55–63, concludes on the basis of his knowledge and of an article by Lillian Longren that Kupka's precedence in arriving at nonfiguration seems to be demonstrated. See also Alfred H. Barr, quoted by J. P. Dupin, in *Frank Kupka*, by Ludmila Vachtova (New York: McGraw-Hill, 1965), p. 8.

The last quote is from J. P. Dupin, "Introduction" in Vachtova, *op. cit.*, p. 10.

Kandinsky: A Color Theorist

Biographical information is taken from Paul Overy's *Kandinsky: The Language of the Eye* (New York: Praeger, 1969); also from Richard Stratton's preface and M. T. H. Sadler's introduction to *Concerning the Spiritual in Art* (New York: Dover, 1977); original publication *Über das Geistige in der Kunst* (Munich: Piper-Verlag, 1912). Quotes are from *Concerning the Spiritual in Art* (New York: Wittenborn, 1947). Quotes, in order, are from pages 43–44 and p. 57.

The idea of a connection between art (especially color) and music was apparently a popular one at the turn of the century. Very early, Chevreul used musical vocabulary, such as harmony, to discuss color combinations. Henry was thoroughly involved in developing a scientific theory that integrated those two sensory worlds. For example, his *"Eléments d'une Théories Générale de la Dynamogénie autrement dit du Contraste, du Rythme et de la Mesure avec application spéciales aux sensations visuelle et auditive* (Paris: Charles Verdin, 1889). This large folio contains a serious but flawed attempt to quantify and integrate the properties of color, line, and music. In it Henry frequently refers to Marey, Helmholtz, Fechner, Rood, Wundt, and other scientists.

Somewhat earlier the Frenchman David Sutter, in a series of six articles, "Les phénomènes de la vision", *L'Art*. I (1880) wrote "The laws of the aesthetic harmony of colors can be taught as the rules of musical harmony are taught" (p. 219). Sutter was one of the earliest to explicitly argue for the application of the new visual science to art; he was part of the science-art environment that influenced Seurat.

Kandinsky was probably influenced by Lipps, whose writings were more often concerned with music than painting. Also, a theory of empathy would naturally suggest cross-sense comparisons. (See, for example, Lipps's "Aesthetik" in *Systematische Philosphie*, by W. Dilthey et al. (Berlin: Teubner, 1907). Kandinsky *(Concerning the Spiritual in Art)* cites Freudenberg, p. 44n, Madame A. Sacharjin, Unkowsky, and Scriabin, pp. 45–46n on this topic. In most cases an interest in synesthesia seems to be associated with religious, spiritual, and symbolist thought. Klee was involved with music as well. This entire topic needs further research. Kandinsky refers to Signac's book on page 46n.

Marianne L. Teuber in her article "Blue Night by Paul Klee", in *Vision and Artifact*, Mary Henle, ed. (New York: Springer, 1976), pp. 131–51, has been the first to detect Lipps's significance. The quotes from and about Lipps are from Teuber, p. 143.

The last Kandinsky quotes are from *Concerning the Spiritual in Art, op. cit.* pp. 54, 47, and 73.

The Bauhaus, founded in Weimar 1919 by Walter Gropius, moved to Dessau in 1925 and then to Berlin in 1932. It was closed in 1933 by the National Socialists. A center of new ideas for architecture and design, it was characterized by a modernist aesthetic

emphasizing formal simplicity and functional logic. For more about the effect of the Bauhaus on Kandinsky, Klee, Albers, and other artists see Clark V. Poling, *Bauhaus Color* (Atlanta, Ga.: The High Museum of Art, 1975).

There are many interesting similarities between the Gestalt and Bauhaus schools. Both officially began in Germany at about the same time (1919-20), both were brought to an end in Germany about 1933 by the Nazi movement. The leaders of both schools subsequently moved to the west, mostly to the United States, from which their ideas spread throughout the post-war world. Both schools, as noted, were preoccupied with simple good form and were sympathetic to a mixture of science and art and to modernist ideas in general. In view of the similarity of their basic approaches as well as their German origin, it was inevitable that the two would get together and in a sense merge conceptually. It is also interesting that Malevich, whose concern with simple forms would place him in the same tradition, was invited to the Bauhaus in Munich in 1927, thus linking Suprematism with Gestalt. Malevich's work, in the German translation, was titled: "Die Gegenstanslose Welt" (Bauhaus Bucher-II). See Donald Karshan, *op. cit.*

Hering's theory, published in 1878, derived from the phenomenology of color experience that strongly suggests the basic opposition between blue-yellow, red-green, and black-white. The Young-Helmholtz theory has no significant place for yellow— and tends to relegate the black-white dimensions to a less prominent place. Hering's theory is in the tradition of introspection and nativism, a tradition that began with Goethe (1810) and Purkinjie, and continues up to Gestalt psychology; this tradition predominated at the Bauhaus. Today, Hurvich and Jameson are the modern proponents of Hering's views (see L. M. Hurvich and D. Jameson, "Opponent Processes as a Model of Visual Organization," *American Psychologist* 64 [1957], pp. 384–404).

The conflict between the Young-Helmholtz theory, which posits only three pigments, and the Hering position, which uses three pairs of binary oppositions, is resolved today by viewing Young-Helmholtz as consistent with the data at the receptor level, that is, three pigments: red, green, and blue on the retina. In contrast, the Hering theory accounts for color phenomena occurring at the level of the optic nerve, the lateral geniculate nucleus, and beyond. For discussions of the Hering and Young-Helmholtz con-

flict see Boring, *A History of Experimental Psychology*, *op. cit.*, pp. 352 ff; H. R. Schiffman, *Sensation and Perception* (New York: Wiley, 1976) pp. 216–21. L. Kaufman, *Sight and Mind* (New York: Oxford, 1974), pp. 174–76.

Chevreul placed his emphasis on the red-green contrast. In his notebooks and paintings recall that Delacroix was also preoccupied with red and green. Red and green figured strongly in Blanc's work (*Grammaire des Arts du Dessin*). His discussion of Pointillism and optical mixing uses red and green as *the* example. Rood also gives emphasis to red and green, less to yellow.

For evidence that human infants see four colors—red, green, yellow, and blue—as categories, see: M. H. Bornstein, W. Kessen, and S. Weiskopf, "The Categories of Hue in Infancy," *Science* 191 (1976) pp. 201–02. Another relevant source is "On the psychophysiological bases of universal color terms", by Floyd Ratliff, *Proceedings of the American Philosophical Society*, 120 (1976), pp. 331–30. A general discussion of contemporary scientific color knowledge can be found in most good recent perception textbooks.

For an informative discussion of color theory at the Bauhaus see Clark V. Poling, *Bauhaus Color* (Atlanta, Ga.: The High Museum of Art, 1975). Quote is from p. 9; see also pp. 10, 13, 18, and 22.

*Mondrian and Science:
Schoenmaekers's
Color Theory*

For general biographical evidence on Mondrian and for the importance of Schoenmaekers, see *Piet Mondrian: Life and Work* (New York: Abrams, 1956) by Michel Seuphor (Ferdinand Louis Buckelaers); and especially *De Stijl* (London: Thames and Hudson, 1970) by Hans L. C. Jaffe.

Dr. M. H. J. Schoenmaekers, *Het Nieuwe Wereldbeeld* (Bussum: van Dishoek, 1915). The book was written in Laren— and completed—in July 1914 (see the preface). Mondrian apparently arrived in Laren in 1916 or slightly earlier. See Seuphor, *op. cit.*, pp. 129, 132. The quote is taken from pp. 224–25. In note 1, p. 225, Schoenmaekers acknowledges Goethe.

The Mondrian quote is from his "Neoplasticism in Painting," in Jaffe, *op. cit.*, p. 55.

Mondrian's reductionist aesthetic and its inevitable connection to abstraction is obvious in the following, which immediately precedes the above quote: "To determine colour involves: first, *reducing naturalistic colour to primary colour*; second, *reducing colour to plane*; third, *delimiting colour—so that it appears* as a *unity of rectangular planes.*" (emphasis added)

Klee:
Progressions and Charts

Klee's color theories are also treated in Poling, *op. cit.*, pp. 22, 24.

Joseph Albers, *Interaction of Color* (New Haven: Yale University Press paperback, 1971). (Hardcover, 1963). For the influence of scientists see pp. 33, 54–58, and 70.

Probably the most important scientific color theorist at the Bauhaus was Wilhelm Ostwald—a great German scientist and Nobel laureate in chemistry who was also known for his important work on color. His best known color work was *Die Farbenfibel* (Color Primer), which was first published in 1916 and went through 15 editions. This work was reprinted with comments as *The Color Primer: A Basic Treatise on the Color System of Wilhelm Ostwald*, Faber Birren, ed. (New York: Van Nostrand, 1969).

However, we recommend that one look at the earlier edition to get a more thorough understanding of Ostwald and especially to look at the beautiful and more impressive original color plates. For example, *Die Farbenfibel* (Leipzig: Verlag Unesma, 1917).

One of the odd things about the adaptation of color science by Albers was that it included a number of serious errors. The mistakes in Albers's understanding of color science have been noted and discussed by Alan Lee, "A Critical Account of Some of Joseph Albers' Concepts of Color," *Leonardo* 14 (1981), pp. 99–105; see also the letter by Arnheim and one by Lee in *Leonardo* 15 (1982), pp. 174–75, which further elaborates on Albers's errors and the influence of color science at the Bauhaus.

Conclusion

The Pissarro quote is from *Camille Pissarro: Letters to His Son*, edited by John Rewald with the assistance of Lucian Pissarro. Translated by Lional Abel (New York: Pantheon, 1943).

CHAPTER FIVE

The Stereoscope

Charles Wheatstone, "Contributions to the Physiology of Vision. Part the First. On some remarkable, and hitherto unobserved, Phenomena of Binocular Vision." *Philosophical Transactions*, Royal Society of London, 1838 (128), pp. 371–94. Reprinted, in part, in Dember, *Visual Perception: The Nineteenth Century* (New York: Wiley, 1964). In fact, Helioth had constructed a similar instrument four years earlier but his work, for a number of reasons, never received much attention. See L. P. Dudley, *Stereoptics: An Introduction* (London: MacDonald, 1951). For another informative discussion of the invention of the stereoscope see Edward G. Boring, *Sensation and Perception in the History of Experimental Psychology* (New York: Appleton-Century-Crofts, 1942), pp. 282–88.

Wheatstone believed that earlier investigators thought the view to each eye to be exactly the same and that he was the first to note that the two views were in fact slightly different. (It is this slight difference that is crucial to the stereodepth effect.) Sir David Brewster, in *The Stereoscope, Its History, Theory and Construction*, (London: Murray, 1856), points out that Wheatstone was wrong in his belief—earlier investigators had very definitely known about binocular disparity. Wheatstone was the first to seriously ponder the implications of this difference and by investigating it to develop an apparatus to capitalize on it. Wheatstone's error, however, shows how neglected the question was up to his investigations. For a brief history of the investigation of the physiological basis of this question see Richard Held's "Single Vision with Double Images: An Historic Problem" in Mary Henle, ed., *Vision and Artifact* (New York: Springer, 1976).

For a short technical discussion of stereoscopic vision see Julian Hochberg, "Perception II. Space and Movement," p. 480 in J. W. Kling and L. A. Riggs, (eds.) *Woodworth and Schlosberg's Experimental Psychology*, 3rd ed. (New York: Holt, Rinehart and Winston, 1971). For a more detailed discussion see Chapter 8 of Lloyd Kaufman's *Sight and Mind* (New York: Oxford University Press, 1974).

The schematic stereoscopic view of a wedge (Fig. 5.3) is interpreted as follows: "Slightly different pictures of the wedge are presented to the two eyes separately, at V_1 and V_2. The light rays from these pictures are deflected by the prisms so as to appear reflected from the wedge, ABC. The distances between A, B, and C differ slightly in V_1 and V_2, as would the retinal images if the observer were actually looking at a wedge. A partition at P, serves to restrict each picture to its own eye. The retinal projections of the surfaces of the wedge, AB and BC, are at ab, a'b', and bc, b'c', respectively. Notice the difference in the retinal projections on each retina owing to the fact that each eye gets a slightly different view. The combination and fusion of these disparate views in the brain produces stereopsis." From Harvey Richard Schiffman, *Sensation and Perception*, 2nd ed. (New York: Wiley, 1982), p. 334.

Evidence of the cultural impact of the stereoscope can be found in Brewster, *op. cit.* He lists or notes well over 500 stereophotographs in the catalogue at the end of his book. Recall also Baudelaire's comment (Salon of 1859) about the "thousand hungry eyes peering" at endless pornographic stereoscopic photographs. See also Aaron Scharf, *Art and Photography* (Baltimore, Md.: Penguin Press, 1969; Pelican edition, 1974), pp. 181 and 354, who reports that one company between 1854 and 1856 sold over half a million stereoscopic *viewers* and offered 10,000 different stereoscopic slides.

For the Needham quote see Gerald Needham, "Manet, *Olympia*, and Pornographic Photography," in T. B. Hess and L. Nochlin, eds., *Woman as Sex Object* (New York: Newsweek, 1972), p. 82.

The three techniques of stereo photography are mentioned in Brewster, *op. cit.*: p. 155, two cameras; p. 153, one camera moved; p. 150, stereo camera with two lenses.

The implicit cubistic kernel is described in Brewster, *op. cit.*, p. 151. Wheatstone's original report is apparently in the

Philosophical Transaction, 1852. The multiocular monstrosities are referred to in Brewster, *op. cit.*, p. 152.

The Hering diagram is taken from I. P. Howard and W. B. Templeton, *Human Spatial Orientation* (New York: Wiley, 1966), p. 17. Their figure is a diagrammatic representation of Hering's law of identical binocular directions—a basic part of Hering's theoretical analysis of space perception. Hering's theory was originally published in 1861. Howard and Templeton's treatment is based on the English translation of Hering, *Spatial Sense and Movements of the Eye*, A. Radde, trans. (Baltimore: American Academy of Optomology, 1942). Béla Julesz, *Foundations of Cyclopean Perception* (Chicago: University of Chicago Press, 1971). Robert Rosenblum, *Cubism and Twentieth Century Art* (Englewood Cliffs, N.J.: Prentice-Hall, 1976), p. 290–91.

Eadweard Muybridge: His Studies of Vision

The case for considering Eadweard Muybridge to be father of the cinema is made in Gordon Hendricks, *Eadweard Muybridge: The Father of the Motion Picture* (New York: Grossman/Viking, 1975); and in Scharf, *op. cit.*, Chapter 9; Van Deren Coke, *The Painter and the Photograph*, rev. ed. (Albuquerque: University of New Mexico Press, 1972), Chapter 5. The case against Edison is made in Gordon Hendricks, *The Edison Motion Picture Myth* (Berkeley: University of California Press, 1961). Evidence for the great importance of Marey, especially as the inventor of the first motion picture camera, can be found in the following pieces by E. J. Marey: "Photography of Moving Objects and the Study of Animal Movement by Chronophotography" in *Scientific American Supplement*, February 5, and 12, 1887; "Decomposition of the Phases of a Motion by Means of Successive Photographic Images Received on a Strip of Sensitive Paper" in *Wilson's Photographic Magazine*, January 5, 1889; "Locomotion in Water Studied by Photography" in *Scientific American Supplement*, January 10, 1891; "The History of Chronophotography" in *Smithsonian Institution Annual Report*, 1901, pp. 317–41. Also see Merritt Crawford, "J. E. Marey and Eadweard Muybridge: Inventors of Chronophotography, and the Progenitors of the Modern Cinema," in *Cinema*, June 1930; Robert Sklar, *The Movie-Made*

American: A Social History of American Movies (New York: Random House, 1975). Much of this material supporting the case for Marey was brought to our attention in a student paper "The Origins of the Motion Picture," written by André Molen for a psychology of art course taught by P. C. V. The analytic-reductionist character of Muybridge's photos is routinely mentioned (usually using different vocabulary) in commentary on his work. For example, "Documents" by Anita Ventura Mozley and J. Sue Porter in *Eadweard Muybridge: The Stanford Years, 1872–1882*, (Stanford, Cal.: Stanford University, 1972), p. 120. The blurred image and natural movement issue is discussed in Françoise Forster-Hahn, "Marey, Muybridge, and Meissonier — The Study of Movement in Science and Art," in Mozley and Porter, *op. cit.*, pp. 103–05; Aaron Scharf, *op. cit.*, p. 222. Forster-Hahn argues (*op. cit.*) that in the period 1870–81 the scientific, photographic, and artistic study of movement crystallized into a single historical phenomenon. The first two groups, Marey and Muybridge, have already been treated above. We would also agree that artists such as Meissonier were part of the same movement. However, when Meissonier became serious about understanding the movement of the horse, he tended to step out of the role of artist and became an amateur scientist himself. Likewise, when Thomas Eakins absorbed the ideas of Muybridge — the two were closely associated for a few years — Eakins either simply translated Muybridge's results into paint or became a kind of amateur analytic photographer himself (see Hendricks, *Muybridge, op. cit.*, Chapter 8). Thus, although we agree with Forster-Hahn about this crystallization into one movement, the conceptual impetus for understanding movement came entirely from outside of the painting, from the scientist-photographer.

The photos of the installation of the Stanford Track appear in Hendricks, *Muybridge, op. cit.*, p. 107, Figures 91 and 92. Muybridge was a very well known early stereophotographer; see, for example, Mozley and Porter, *op. cit.*, introduction by Anita Ventura Mozley: "There was probably hardly a parlor in the West that did not have some stereo views by Muybridge," p. 8. The stereo cameras are in Robert Bartlett Haas, "Eadweard Muybridge, 1830–1904," in Mozley and Porter, *op. cit.*, p. 22. We have been unable to find an example of the stereoscopic photographs of the horse (or any other animal) in motion taken by Muybridge. It is not clear

whether any were ever published. For Muybridge as a visual engineer see Haas, *op. cit.*, p. 22; Forster-Hahn, *op. cit.*, pp. 86–87, 95; Hendricks, *Muybridge, op. cit.*, pp. 109 and 111. See Haas, *op. cit.*, p. 27, for the "mere technician" quote.

In a personal communication Anita Ventura Mozley made the following interesting observation about another way in which Muybridge's movement photographs could give rise to a Cubist image: "When you have a lot of positive glass slides of slightly different positions of movement and lay them on top of each other, slightly askew, you get a form that is visually, at least, related to Cubism, I think."

Marey:
French Developments

The connection between Muybridge and Marey is discussed in Anita Ventura Mozley, "Photographs by Muybridge, 1872–1880. Catalogue and Notes on Work." Chapter in Mozley and Porter, *op. cit.*, pp. 71–72. For the connection to Wheatstone see p. 71; to Plateau, see p. 73 and Haas, *op. cit.*, p. 25.

Plateau made a number of significant contributions to visual science. In particular, see Boring, *op. cit.*, who discusses the invention of the stroboscope on pages 588–91. Muybridge's projector, the Zoopraxiscope, is often shown along with a disc that Muybridge used to project his motion picture. It is similar to Plateau's stroboscope. Haas, *op. cit.*, p. 26, provides the Muybridge quote about "synthetically demonstrating." Etienne J. E. Marey, *Animal Mechanism* (London: Henry S. King, 1874), English translation of Marey's publication in France titled *La Machine Animale* (Paris: Baillière, 1873). Haas, *op. cit.*, pp. 24 and 26 and Forster-Hahn, *op. cit.*, pp. 85–87 and following pages provide further information about the early Muybridge-Marey relationship. Marey's pioneering contributions to early cinema are mentioned by Forster-Hahn, *op. cit.*, p. 98. For the quote see p. 93.

Manet:
A Specific Example
of Fractured Space

Emile Zola's Manet quote is in *Mes Haines,* Paris, 1928, pp. 307, 259, cited by Anne Coffin Hanson, *Manet and the Modern*

Tradition (New Haven, Conn.: Yale University Press, 1977), p. 298. For compositional difficulties: Anne Coffin Hanson, *op. cit.*, Part III, Chapters 1 and 7. John Richardson, *Edouard Manet: Paintings and Drawings* (London/New York: Phaidon, 1958), pp. 13–14. Peter Gay, *op. cit.*, p. 51 also comments that spatial ambiguity is almost a trademark of Manet.

Hanson, *op. cit.*, Part III, Chapters I and 7. Richardson, *op. cit.*, pp. 13–14.

Robert S. Woodworth, *Experimental Psychology* (New York: Holt, 1938) provides the description of saccatic eye movements on p. 577 and mentions Javal's discovery. (E. Javal, *Annales d'oculistique*, 1878.) For a short discussion on visual scanning see Woodworth, *op. cit.*, p. 591; see also Harvey Richard Schiffman, *Sensation and Perception: An Integrated Approach* (New York: Wiley, 1982), pp. 228–34. Also see Guy Buswell, *How People Look at Pictures* (Chicago: University of Chicago Press, 1935); D. L. Yarbus, *Eye Movement and Vision* (New York: Plenum, 1967).

Cézanne:
More Fractured Yet

Erle Loran, *Cézanne's Composition* (Berkeley: University of California Press, 1943). Quote on p. 76. This book is a classic treatment of Cézanne's 'fractured' compositions. Herbert Read, *The Philosophy of Modern Art* (London: Faber & Faber, 1952), p. 75. For discussion of Cézanne's subject matter see, for example, Meyer Schapiro, *Paul Cezanne* (New York: Abrams, 1952); Kurt Badt, *The Art of Cezanne*, Sheila Ann Ogilvie, trans. (Berkeley: University of California Press, 1965). Originally *Die Kunst Cézannes* (Munich: Prestel Verlag, 1956).

Leo Steinberg, *Other Criteria* (New York: Oxford, 1972), p. 154, all quotes from p. 160. Herbert Read, *The Philosophy of Art* (London: Faber and Faber, 1952), p. 75.

The Cézanne quote: "Letters of Cézanne." Chapter 1 in Herschel B. Chipp, *Theories of Modern Art: A Source Book by Artists and Critics* (Berkeley: University of California Press), pp. 12–13.

Cited in Judith Wechsler, ed., *Cézanne in Perspective* (Englewood Cliffs, N.J.: Prentice-Hall, 1975), p. 16. Merleau-Ponty.

Futurism and Duchamp

Scharf, *op. cit.*, Chapters 8 and 9. Coke, *op. cit.*, Chapter 5. Scharf, *op. cit.*, pp. 231 and 363 refer to the link between Seurat, Henry, and Marey.

Marcel Duchamp is quoted in Chipp, *op. cit.*, p. 393; originally from an interview with James Johnson Sweeney in "Eleven Europeans in America," *Bulletin of the Museum of Modern Art* (New York), XIII, no. 4–5 (1946), pp. 19–21. The Futurist quote is: F. T. Marinetti in Chipp *op. cit.*, p. 289. Duchamp's second quote is on p. 393.

For the Kupka material see Mladek and also Rowell in *Frantisek Kupka op. cit.*, also see Vachtova, *Frank Kupka* (New York: McGraw Hill, 1965).

Distorted Space

The treatment of non-Euclidean geometry is taken from Morris Kline's *Mathematics in Western Culture* (New York: Oxford University Press, 1953). For an example of the impact of non-Euclidean geometry in the 1870s see Helmholtz's "The Origin and Nature of Geometric Axioms" (1876) in Russell Kahn, ed., *Selected Writings of Herman von Helmholtz* (Middletown, Conn.: Wesleyan University Press, 1971).

Karl Pearson, *The Grammar of Science* (London: Walter Scott, 1892). Quotes from pp. 187, 186, 187, 229, and 229.

For a discussion of Manet's curved seascapes that ends with a similar conclusion see Hanson, *op. cit.*, p. 201.

Erle Loran, *op. cit.*, pp. 46–57, 51–52. Although not discussed in the text, tilted images were also common in Cézanne's work. It is interesting to note that the scientific study of the perception of tilt began in 1861 (H. Aubert, "Eine scheinbare bedeutende Drehung von Objecten bei Neigung des Kopfes nach rechts oder links," *Virchows Arch.* 20 (1861) pp. 381–93.) See I. P. Howard and W. B. Templeton, *Human Spatial Orientation* (New York: John Wiley & Sons, 1966) for further nineteenth-century references on tilt (orientation) perception. A possible stimulus to Cézanne's tilted images is the tilted image (a common mistake) in amateur photographs.

Wechsler, *op. cit.*, pp. 23–24. Gleizes and Metzinger are quoted from Chipp. *op. cit.*, p. 214.

Meyer Schapiro, *Vincent van Gogh* (New York: Abrams, 1950), pp. 29–30, 78.

Patrick A. Heelan, "Toward a New Analysis of the Pictorial Space of Vincent van Gogh," *Art Bulletin* 54 (1972), p. 478–92.

For Luneburg's scientific study of perceived space see A. A. Blank, "The Luneburg Theory of Binocular Space Perception," in *Psychology: A Study of a Science*, Vol. I, S. Koch, ed. (New York: McGraw Hill, 1959), pp. 395–426. John L. Ward, "A Reexamination of van Gogh's Pictorial Space," *Art Bulletin* 58 (1976), pp. 593–604.

Jacob Beck, personal communication, 1980.

Roland Fischer, "Space-Time Coordinates of Excited and Tranquilized States," in *Psychiatry and Art*, Proceedings of the IVth International Colloquium of Psychopathology of Expression. Washington, D.C., 1966. Irene Jakab, ed. (Basel, Switzerland: S. Karger, 1968), p. 44.

Scharf, *op. cit.*, pp. 192, 193, 232, and 272; and Coke, *op. cit.* pp. 181–87, provide many examples of distorted camera space and its significance for artists in the nineteenth and twentieth centuries.

CHAPTER SIX

Figure and Ground

Historical information is derived in large part from Edwin G. Boring, *A History of Experimental Psychology* 2nd ed. (New York: Appleton-Century-Crofts, 1950), pp. 605–06; and from Edwin G. Boring, *Sensation and Perception in the History of Experimental Psychology* (New York: Appleton-Century-Crofts, 1942). Edgar Rubin's original book is: *Synsoplevede Figurer* (Kobenhaven: Gyldendalske, 1915). The title of the Arp (Fig. 6.2) implies conscious preoccupation with figure-ground. A very good treatment of figure-ground with a nice analysis of an Arp woodcut can be found in Rudolf Arnheim's classic *Art and Visual Perception* (Berkeley and Los Angeles: University of California Press, 1954), pp. 225–28. His figures 176 and 177 very clearly show the intrinsic ambiguity of the different figure-ground interpretations of an Arp and also show that such works strongly suggest a "relief."

Gerald H. Fisher in "Ambiguous Figure Treatments in the Art

of Salvador Dali," *Perception and Psychophysics* 2 (1967), pp. 328–30, identifies many Dalis with figure-ground ambiguity; he also mentions that examples of ambiguous figure-ground involving the alternation of two recognizable objects go back in psychology at least to Jastrow (1900). The use of naturalistic "hidden forms" goes back further in painting. The present concern, however, is about the *new abstract* forms.

The original Rubin claw and his other figures were surrounded by a wide border of neutral gray. This makes the black and white areas about equal in their tendency to be seen as figure or ground. This gray, however, does not reproduce well, thus in Figure 6.4 the white is more often seen as ground. This tendency can be substantially overcome by concentrating on the center or "claw" portion of the figure. Some of Arp's work prior to 1925 suggests a still earlier intuitive concern with figure ground.

John Adkins Richardson, *Modern Art and Scientific Thought* (Urbana, Ill.: University of Chicago, 1971), Chapter 5, pp. 114–18.

Richardson's discussion of "figure-ground" makes no mention of Rubin, Gestalt psychology, or of any possible historical link between Cubism and the contemporaneous perceptual science. Richardson also argues that "Cubism had nothing to do with the Theory of Relativity and that is the end of the matter." By and large, this conclusion is correct. Concepts like time, space, and simultaneous viewpoints can, however, be viewed in the visual science tradition discussed in Chapter 5—without any connection to Einstein. Indeed, it is possible that Einstein's own breakthrough into an understanding of relativity was influenced by the multiple perspective logic of visual science. For example, the problem of simultaneity was, in important respects, first encountered in the theoretical and applied analyses of Muybridge and of Marey. These investigators often photographed the same moving object from two or three different perspectives and distances at the same time. If one considers each camera an "observer," then the structure of this representation is suggestive of a "relativistic" analysis of space and time. If this hypothesis about an important conceptual influence on Einstein is correct, then evidence for it may exist in a number of places: (a) French physics of the 1890s could easily have been influenced by Marey–Muybridge, especially H. Poincaré and associates; (b) Einstein's work in a Swiss patent office may have included camera patents.

Stuart Davis, one of America's leading modernist painters, used figure-ground ambiguity with great frequency. Gestalt theory was a major influence on Davis in the 1940s. See John R. Lane, *Stuart Davis: Art and Art Theory* (New York: The Brooklyn Museum, 1978), Chapter Six. Davis was influenced still earlier by European artists' treatments of figure-ground ambiguity.

Leo Steinberg, *Other Criteria* (New York: Oxford University Press, 1972), p. 159.

Form-Quality:
The Neglected
Early Gestalt Movement

The Gestalt psychologists recognized Ehrenfels as the father of their movement. For example, Max Wertheimer's "Über Gestalt Theorie," address given before the Kant Society, Berlin, December 17, 1924. Reprinted as "Gestalt Theory" in W. D. Ellis, ed., *A Source Book of Gestalt Psychology* (New York: Humanities Press, 1950). See also Wolfgang Kohler, *Die Physichen Gestalten in Ruhe und im Stationaren Zustand, Eine Naturphilosophische Untersuchung*, Erlangen, 1920, reprinted as "Physical Gestalten," in Ellis, *op. cit.*

The initiating article was Christian von Ehrenfels, "Über Gestaltqualitäten," *Vierteljahresschrift für Wissenschaftlich Philosophie* 14 (1890), pp. 249–92. Hans Cornelius, *Psychologie als Erfahrungswissenschaft* (Leipzig: G. Teubner, 1897) gives a good short treatment of Gestalt qualität; see pp. 70–71, 164–68; a similar treatment some years later in English is "The Apprehension of Form," in G. F. Stout's *Analytic Psychology* 2nd ed., Vol. 1 (London: Swan Sonnenschein, 1902), Chapter 3. See also Cornelius (1897; 1899); Lipps (1900); Gelb (1910). Zusne (1970) has an extensive bibliography of the early or proto-Gestalt movement, which was clearly well articulated by 1910.

For further information see Boring, *op. cit.*, 1950, Chapter 19, especially pp. 442–43. The major work of Lipps dealing with visual patterns is his "Raumaesthetik und geometrische-optische Tauschungen," in *Schriften der Gesellschaft für Psychologie Forschung* (Heft 9/10), 1897. The article (!) is over 400 pages long:

pp. 20–424. It is, however, available as a book, under the same title, published in Leipzig by Barth, 1893–97 (quite scarce). This work is the obvious source for Kandinsky's approach in *Point and Line to Plane*.

Schumann's relevant publications are "Beitrage zur Analyse der Gesichtswahrnehmungen," *Zeitschrift für Psychologie* 23 (1900), pp. 1–32; also, Vol. 23 (1900), pp. 1–33; Vol. 30 (1902), pp. 241–91, 321–39; Vol. 36 (1904), pp. 161–85. His studies are discussed at some length in Robert S. Woodworth, *Experimental Psychology* (New York: Holt, 1938).

Another publication in the same proto-Gestalt spirit is Hans Cornelius' *Elementargesetze der Bildenden Kunst* (Leipzig and Berlin: Teubner, 1908), see Chapter 7 on gratings. Cornelius, a Gestalt qualität philosopher-psychologist, was at Munich 1894–1910 during the time Kandinsky and Klee were getting their start in the same city. (See Boring, *op. cit.*, 1950). Obviously, at the turn of the century, the analysis of form was very much part of the Zeitgeist in Germany, especially in Munich. The Gestalt-qualität tradition can be traced back to Franz Brentano, since Ehrenfels and Meinong, the first to elaborate the problem of form, were students of Brentano. It seems, therefore, that Gestalt psychology can be traced to its origin in Brentano.

Gustav Fechner, *Vorschule der Aesthetik* (Leipzig: Breitkopf and Härtel, 1876).

For the references to Pierce (1890), Witmer (1894), and to get a good summary of the topic of preference for form in this period, see Robert S. Woodworth, *Experimental Psychology* (New York: Holt, 1938), pp. 384–91. Also related is Margaret Otis, "Aesthetic Unity," *American Journal of Psychology* 29 (1918), pp. 291–315.

Malevich

Quotes are from Kasimir Malevich, *The Non-Objective World* (Chicago: Paul Theobald Company, 1959). This book is a translation of the German translation published in 1927; the date of the original Russian edition is not known, but it was probably published about 1920. Quotes are from pp. 61–63; see also Donald Karshan, *Malevich, The Graphic Work, 1918–1930* (Jerusalem: The Israel Museum, 1975).

Good discussions of Gestalt psychology can be found in Boring, *op. cit.*, 1942, and Boring, *op. cit.*, 1950. An extensive bibliography and interesting treatment is Rupprecht Matthaei, *Das Gestalt Problem* (Munich: Bergmann, 1929). Matthaei touches on the presence of basic form in children's art, as in the work of Volkelt. The serious scientific study of children's art and the introduction of childlike motifs into art, as in Klee, also seem to have happened at about the same time. Likewise with primitive art. Max Wertheimer, "Untersuchen zur Lehre von der Gestalt," *Psychologische Forschung* 4 (1923), pp. 301–50. Translated as "Laws of Organization in Perceptual Forms," in W. D. Ellis, ed., *A Source Book of Gestalt Psychology* (New York: Humanities Press, 1950). The Gestalt principles are taken from the English translation. See also Wolfgang Kohler, *Gestalt Psychology* (New York: Horace Liveright, 1929); Kurt Koffka, *Principles of Gestalt Psychology* (New York: Harcourt, Brace and World, 1935); and Rudolf Arnheim, "The Gestalt Theory of Expression," *Psychological Review* 56 (1949), pp. 156–71.

Picasso

Fritz Heider, "Gestalt Theory: Early History and Reminiscences," in Mary Henle, Julian Jaynes, and John Sullivan, eds. *Historical Conceptions of Psychology* (New York: Springer, 1973), p. 71.

While this book was in press, we came across an article by R. Behrens (1980) in which he makes very much the same point as Heider and, in some ways, the same point we make: namely, that Gestalt psychology and the study of perception in the early twentieth century were very similar to the modernist paintings of the time and that there was probably a direct influence.

Klee

This section is indebted to an unpublished paper by Roxanne Lanquetot, submitted in the Psychology of Art course of Paul C. Vitz: "Paul Klee, The Bauhaus and Gestalt Psychology," (spring,

1978); also to papers by Susan Bergh and Karen Hartman. Marianne L. Teuber's important paper, *"Blue Night* by Paul Klee" is in Mary Henle, ed., *Vision and Artifact* (New York: Springer, 1976), pp. 131-51. Theodore Lipps, *op. cit.*, 1897.

Wassily Kandinsky and Franz Marc, eds., *Blaue Reiter Almanac* (New Documentary Edition by Klaus Lankheit) (New York: Viking, 1974).

Wilhelm Worringer, *Abstraction and Empathy*, Michael Bullock, trans. (London: Routledge and Kegan Paul, 1953, German edition in 1918), p. 30 for comment about abstraction.

Arnheim, *op. cit.*, 1949; reprinted as "The Gestalt Theory of Expression," in *Towards a Psychology of Art: Collected Essays* (Berkeley and Los Angeles: University of California Press, 1966), pp. 57-58.

For turning the paper upside down, see Will Grohman, *Klee* (New York: Abrams, 1955), p. 23. Klee's notebooks are so filled with Gestalt-like analysis that they constitute a sustained expression of the parallelism thesis.

For an example of a George Baselitz, see *The Pressure to Paint* (New York: Marlborough Gallery Publications, 1982); *Newsweek*, June 7, 1982, p. 69.

One of Klee's early drawings, *Tower by the Sea*, 1917, has many Gestalt forms in it. It contains figures that will later be called "Gottschaldt" figures. (See Kurt Gottschaldt, "Gestalt Factors and Repetition," in Ellis, *op. cit.*, p. 153); *Tower* also shows Koffka's unum-quality (Koffka, *op. cit.*, pp. 153-54.

For Klee and the Bauhaus, see M. L. Teuber, *op. cit.*; C. V. Poling, *op. cit.*; and Christian Geelhaar, *Paul Klee and the Bauhaus*, (Greenwich, Conn.: New York Graphic Society, 1973).

Hannes Beckman; "Formative Years," in E. Neuman, ed., *Bauhaus and Bauhaus People* (New York: Van Nostrand Reinhold, 1970), pp. 195-99. Quote from p. 199.

Klee's "Creative Credo" quote is from Paul Klee, *The Thinking Eye, Notebooks of Paul Klee I*, J. Spiller, ed., R. Manheim, trans. (New York: Wittenborn, 1964), p. 79.

Klee's other quotes are taken, in order, from Geelhaar, *op. cit.*, p. 18., and from Paul Klee, *op. cit.*, p. 451, and Geelhaar, *op. cit.*, p. 169. The last quote is from Paul Klee, *The Nature of Nature, Paul Klee Notebooks, Volume II*, J. Spiller, ed., H. Norden, trans. (New York: Wittenborn, 1972), p. 17.

Wilhelm Fuchs, "On Transparency," in Ellis, *op. cit.*, pp. 90–91. Original article, "Experimentelle Untersuchungen über das simultane Hintereinandersehen auf derselben Sehrichtung," *Zeitschrift für Psychologie*, 91 (1923), pp. 145–235. See Metelli (1974) for a recent treatment of transparency.

Max Wertheimer, in Ellis, *op. cit.* (1950), p. 83.

For Kandinsky transparencies and Bauhaus influence on Albers and Beckman, see Poling, *op. cit.,* pp. 8–13, 24, 27, 29, 30–32.

The Teuber quote is from Teuber, *op. cit.*, p. 148.

The Elements of Form: The Nineteenth Century

Blanc's treatment of lines and the face can be found in *Grammaire des Arts du Dessin* 3rd ed. (Paris: Librairie Renouard, 1876). The quote is from p. 24. See also pp. 32–35. A scholarly discussion of Blanc and Humbert de Superville is in W. I. Homer, *Seurat and the Science of Painting* (Cambridge, Mass.: MIT Press, 1964); Blanc, *op. cit.*, for the relation of Charles Henry and Seurat to Blanc. The Beauburg letter can be found in Homer, *op. cit.*, p. 185 and in Pierre Courthion, *Georges Seurat* (New York: Abrams, n.d.), p. 22.

Homer's analysis of *La Chahut* is in Homer, *op. cit.*, pp. 220–31.

The Gauguin quote is from Herschel B. Chipp, *Theories of Modern Art* (Berkeley: University of California Press, 1968) p. 59, originally in a letter of 1885 to a close friend, Emile Schuffenecker. Gauguin's expression is also close to David Sutter's articles, "Phenomena of Vision," *L'Art*, I (1880).

The Elements of Form: The Early Twentieth Century

Lipps, *op. cit.,* p. 374. Also see Chapter 20 starting on p. 104.
Blanc, *op. cit.*, (1876), pp. 32–33.
Piet Mondrian, *Plastic Art and Pure Plastic Art* (New York: Wittenborn, 1945), p. 13. Quotes are from *Point and Line to Plane*, Hilla Rebay, ed. (New York: S. R. Guggenheim, 1947), pp. 13, 19,

and 21. Other relevant pages for this general approach are 17 and 20. The original was *Punkt und Linie zur Fläche* (Munich: Langen, 1926), published about ten years after he wrote the first draft (see page 13). Kandinsky's interest in form begins early; see his "Über die Formfrage" ("Concerning the Form Question") in *Der Blaue Reiter* (Munich: Piper-Verlag, 1912). See also "On the Problem of Form" in Chipp, *op. cit.,* pp. 155–70.

The graphic description of Lipps's system, for example, the bridgespan, is taken from Boring, *op. cit.,* p. 455–56.

Schoenmaekers's two relevant books are *Het Nieuwe Wereldbeeld* (The New World Image) (Bossum: C. A. V. Van Dishoeck, 1915), written and finished in Laren in July 1914; and *Beginselen der Beeldende Wiskunde* (The Foundations of Plastic Mathematics) (Bossum: C. A. V. Van Dishoeck, 1916). (Perhaps a better title would be *The Foundations of* Gestalt *Mathematics.*)

For Schoenmaekers's Gestalt expression, see *op. cit.,* (1916), pp. 148–50; the long quote, "The straight line . . ." is from *op. cit.,* (1916), pp. 72–73.

In any case, there is little doubt about Schoenmaekers's direct influence—Hans Ludwig Jaffe, in *De Stijl: 1917–1931* (Amsterdam: J. M. Meulenhoff, 1959) writes, "Van Doesburg considers . . . Schoenmaekers as the source of Mondrian's terminology," p. 55; and "Mondrian and Schoenmaekers saw each other frequently and had long and animated discussions," p. 56. (The 1915 and 1916 books were part of the *De Stijl* library.)

Schoenmaekers has been called a theosophist (by Seuphor), but apparently this is not correct. Instead, he developed his own philosophy, which he termed "positive mysticism." He was an ex-Catholic priest and Catholic Christian thought permeates his works. No references to any theosophist or Eastern religious figure could be found in *The New World Image* (1915) or in *The Foundations of Plastic Mathematics* (1916). Christian references, however, abound. In 1911, he wrote *Christosophie,* an entirely esoteric Christian work. In the 1916 book he makes a major point to describe his approach as Catholic—in intellectual and philosophical terms—but not in the clerical or church sense. See pp. 201–05. His position is quite abstract, influenced by Hegel and other nineteenth-century philosophers, as well as by evolutionary theory. It is heretical and gnostic, rejecting Christian historical claims, but keeping much of its symbols, values, theology, and philosophy.

Thus, for Schoenmaekers, his concern with the cross has strong Christian symbolic meaning—the vertical dimension having a spiritual significance, and the horizontal symbolizing this world. Just as the cross is often thought of as symbolizing the love of God (vertical) and the love of man (horizontal). These general meanings are found throughout Schoenmaekers's 1915 and 1916 books.

Mondrian did not, of course, use any Christian terminology but his preoccupation with the vertical (as spiritual and masculine) and the horizontal (as worldly and feminine) can be interpreted as a theosophical, secularized, abstracted Christian position. In view of the influence of Schoenmaekers, Mondrian's paintings with nothing but "crosses" in them, can certainly be seen as having spiritual significance.

Rosenblum's thesis on the modern religious dilemma expressed within the romantic northern tradition of modern artists, receives support, we believe, from Schoenmaekers's relation to Mondrian. Rosenblum places Mondrian's earlier works firmly within his thesis. These works—all done prior to 1916–17—still had much recognizable imagery and are interpretable as at least a partial expression of his Theosophy. However, Rosenblum doesn't bring in Mondrian's abstract mature works as evidence for his thesis. Given the religious significance of the cross viz Schoenmaekers, this now seems possible. According to this argument, Mondrian is a pivotal figure between Caspar David Friederich, who often painted Christ on the cross, and the abstracted, romantic-spiritual sentiment reaching a Zen-like total reduction in the paintings of Rothko. Mondrian is the point of transition from Christian to Eastern religious minimal imagery. In 1917 Mondrian has the cross but without Christ (*Composition of Lines*): within a few years his works are only lines and areas of color. Rothko's purple and black last paintings represent the final expression of this content-stripping trajectory. Mondrian's 1914 paintings of church facades closely prefigure his "crosses" and support the interpretation of an underlying spiritual meaning in the later paintings.

For an example of an artist using the principle of element orientation as the basis for perceptual grouping see Bridget Riley's use of orientation in small dot-like ovals as in *Static 1* (1966) in *Bridget Riley: Works 1959–1978*, introduction by R. Kudielka (London: The British Council, 1978).

The straight line as a perceptual element by itself and related

Gestalt issues are covered in a very informative way by Paul Overy, *Kandinsky: The Language of the Eye* (London: Elek, 1969). This work strongly endorses the connection of Gestalt psychology with the Bauhaus and Kandinsky and his *Point and Line to Plane*. One important observation by Overy is that the vertical line tends to be seen as the figure and the horizontal line is more often a ground line. (See also Gibson, 1950; his most extensive treatment of the line is on pages 195-96.) As a result, not only Kandinsky's theory of the meaning of the vertical and horizontal line but earlier theorists such as Schoenmaekers and Blanc get some support from perceptual psychology.

One important critique of Gestalt psychology by Gibson, p. 196 (noted by Overy) is that Gestalt diagrams and their laws of visual organization are rather typically restricted to drawings and thus Gestalt theory is far more relevant to art than to natural perception. No wonder the artists like it! The big weakness of Gestalt theory is that it fails to account for accurate natural perception. The ultimate Kantian origins of Gestalt theory are clear since Gestalt is really a theory of perception as a product of the mind's natural organization, but it turns out these principles of natural organization are very limited, however interesting, and thus the overwhelmingly important aspect of vision—its veridicality—cannot be explained. As a result, Gestalt theorists dealt with abstract forms and avoided the natural image.

Sol LeWitt's series in *Location of Lines* is remarkably close to some of Kandinsky's diagrams of lines in square areas (*Point and Line to Plane*, 1926) and with Kandinsky's concern with the psychological effects of the line being in the center, near the edge, or touching the edge of the square.

Post-Gestalt Visual Elements

D. O. Hebb, *The Organization of Behavior* (New York: Wiley, 1949), contains the influential arguments for lines and angles as visual elements. The classic stabilized image position is R. M. Pritchard's, "Stabilized Images on the Retina," *Scientific American*, 204 (1961), pp. 72-77. The original claim that the parts of the fixed image often disappeared separately is not quite so certain today, but we are interested in the impact and significance of

the experiments during the time they were published, the 1950s–1960s—after all the story is rarely complete in science.

D. H. Hubel and T. N. Wiesel, "Receptive Fields, Binocular Interaction and Functional Architecture in the Cat's Visual Cortex," *Journal of Physiology* 160 (1962), pp. 106–54; "Receptive Fields of Cells in Striate Cortex of Very Young, Visually Inexperienced Kittens," *Journal of Neurophysiology* 26 (1963), pp. 994–1002; and "Receptive Fields and Functional Architecture in Two Nonstriate Visual Areas (18 and 19) of the Cat," *Journal of Neurophysiology* 28 (1965), pp. 229–89.

As an example of the subsequent research on straight-line detectors, see K. Albus, "A Quantitative Study of the Projection Area of the Central and Paracentral Visual Field in Area 17 of the Cat. II The Spatial Organization of the Orientation Domain," *Experimental Brain Research, 24* (1975), pp. 181–202. The portrayal of the organization of line orientation receptors is very similar to the pattern of lines in a painting or two by B. Riley.

Mondrian is quoted from his *Plastic Art and Pure Plastic Art,* 2nd ed. (New York: Wittenborn, 1947), p. 10 (written in 1942). This work portrays much of his philosophy and in it Mondrian, very much like Kandinsky, shows a persistent enthusiasm for science, for seeing art and science as related, and as guiding or leading society to a positive future—a future also infused with a kind of mystical religious or spiritual mentality as well: "Plastic art discloses what science has discovered: that time and subjective vision veil true reality," p. 15. Note that he understands both to go behind normal experience to "true reality"; by implication Mondrian saw his painting as a science of true visual perception.

That Mondrian parted company in 1925 with Van Doesburg over the oblique line is reported in L. J. F. Wijsenbeek, *Piet Mondrian* (Greenwich, Conn.: New York Graphics Society, 1968), p. 95. In view of Mondrian's deep spiritually anchored commitment to the vertical and horizontal it is not a surprising basis for a break.

The reduced capacity to detect and evaluate oblique lines as compared to the vertical and horizontal is known as the oblique effect. For a summary of this research see S. Appelle, "Perception and Discrimination as a Function of Stimulus Orientation: The 'Oblique Effect' in Man and Animals," *Psychological Bulletin* 78 (1972), pp. 266–78.

Theo Van Doesburg quotes from "Towards White Painting," Concrete Art (Paris), December 1929, and "Manifesto on Concrete Art," Paris, Jan. 1930, both in *Prisma der Kunsten,* Organ van Nederlandsche, Kunstenaus, Vereenigingen, May 1936.

The reductionist spirit of *De Stijl* is captured by Van Doesburg's referring to his approach as "Elementarism." (Shades of Mach and Wundt.) Mondrian, *op. cit.,* p. 14.

For "spot" or "dot" feature detectors, see S. W. Kuffler, "Discharge Patterns and Functional Organization of Mammalian Retina," *Journal of Neurophysiology* 16 (1953), pp. 37–68; J. Y. Lettvin, H. R. Maturana, W. S. McCulloch, and W. H. Pitts, "What the Frog's Eye Tells the Frog's Brain," *Proceedings of the Institute of Radio Engineers 47* (1959), pp. 1940–51; also R. L. DeValois, "Contributions of Different Lateral Geniculate Cell Types to Visual Behavior," *Vision Research* II (1971), pp. 383–96; R. L. DeValois and K. K. DeValois, "Neural Coding of Color," in E. C. Carterette and M. P. Friedman, eds., *Handbook of Perception*, Vol. 5 (New York: Academic Press, 1975), pp. 117–68; and T. N. Wiesel and D. H. Hubel, "Spatial and Chromatic Interactions in the Lateral Geniculate Body of the Rhesus Monkey," *Journal of Neurophysiology* 29 (1966), pp. 1115–56. For a good discussion of the above research, see W. R. Uttal, *The Psychobiology of Sensory Coding* (New York: Harper & Row, 1973).

Corners and Angles

Here see Hubel and Wiesel, *op. cit.*, (1965); Anuszkiewicz's relation to perceptual psychology is in Lunde's *Anuszkiewicz, op. cit.*

CHAPTER 7

Illusion:
Movement Effects

A discussion of Plateau's spiral (1850) can be found in Edwin G. Boring, *Sensation and Perception in the History of Experimental Psychology* (New York: Appleton-Century-Crofts, 1942), p. 391ff.

Helmholtz's spiral, similar to Plateau's but with a much thicker white line, is in his *Optik*, 1867, p. 381.

The J. Purkinje earliest references are *Beobachtungen und Versuche zur Physiologie der Sinne. Beiträge zur Kenntniss des Sehens in Subjectiver Hinsicht.* Erstes Bändchen (Prague: Calve, 1823); *Beobachtungen und Versuche zur Physiologie der Sinne. Neue Beiträge zur Kenntniss des Sehens in Subjectiver Hinsicht.* Zweites Bändchen (Berlin: Reimer, 1825).

The information on the stereokinetic effect was taken from a translation of "Sui Fenomeni Stereokinetici," by C. L. Musatti, *Archivo Italiano di Psicologia* 3 (1924), pp. 105–20. Translated by Howard R. Flock and Cecilia Bartoli, Cornell University, with preface, notes, and commentary by Howard R. Flock, Department of Psychology, 1962. (This project was under the direction of James J. Gibson.) Musatti credits Benussi (1921) as the first to observe the stereokinetic effect.

H. Wallach and D. W. O'Connell, "The Kinetic Depth Effect," *Journal of Experimental Psychology* 45 (1953), pp. 205–17. See also W. Metzger's "Beobachtungen über phänomenale Identität," *Psychologische Forschung* 19 (1934), pp. 1–60 and "Tiefenerscheinungen in optischen Bewungsfeldern," *Psychologische Forschung* 20 (1934), pp. 195–260. An interesting recent example of Duchamp's relevance to movement perception is described by Robert Sekuler and Eugene Levinson, "The Perception of Moving Targets," *Scientific American* 236 (1977), pp. 60–64, 70–73.

Duchamp's related accomplishments, for example, the Rotoreliefs, can be seen, with discussion, in Arturo Schwarz, *Marcel Duchamp* (New York: Abrams, 1975); Anne D'Harnoncourt and Kynaston McShine, eds., *Marcel Duchamp* (New York: Museum of Modern Art and Philadelphia Museum of Art, 1973).

Besides the Helmholtz image, see, as another somewhat later example, Silvanus Phillips Thomson, "Optical Illusions of Motion," *Brain* 3 (1880), pp. 289–98; reprinted in *Popular Science Monthly* 18 (1881), pp. 519–26.

Donald M. MacKay, "Moving Visual Images Produced by Regular Stationary Patterns," *Nature* 180 (1957), pp. 849–50. Both the pattern of concentric circles and the radiating rays pattern (the so-called MacKay pattern) are in this article. The stimuli of J. F. Schouten are published in "Subjective Strobascopy and a Model of Visual Movement Detectors," in Weiant Wathen-Dunn, ed.,

Models for the Perception of Speech and Visual Form (Cambridge, Mass: MIT Press, 1967), pp. 44–55 (the research was reported at a symposium in 1964).

Illusions: Miscellaneous

Nicholas Wade's extensive treatment is in "Op Art and Visual Perception," *Perception* 7 (1978), pp. 21–46.

Good recent interpretations of subjective contours are: S. Coren, "Subjective Contours and Apparent Depth," *Psychological Review* 79 (1972) pp. 359–67; G. Kanizsa, "Subjective Contours," *Scientific American* 234 (1976), pp. 48–52. Another excellent discussion of visual perception with relevance to art is R. L. Gregory, *The Intelligent Eye* (New York: McGraw-Hill, 1970); also R. L. Gregory and E. H. Gombrich, eds., *Illusion in Nature and Art* (London: Duckworth, 1973).

A plausible physiological interpretation of the Herman grid effect has been proposed by R. Jung and L. Spillman, "Receptive Field Estimation and Perceptual Integration in Human Vision," in F. A. Young and D. B. Lindsay, eds., *Early Experience and Visual Information Processing in Perceptual and Reading Disorders* (Washington, D. C.: National Academy of Sciences, 1970), pp. 181–97.

The Wade quote is from Wade, *op. cit.*, p. 44.

W. C. Seitz, *The Responsive Eye* (New York: The Museum of Modern Art, 1965).

L. S. Penrose and R. Penrose, "Impossible Objects: A Special Type of Illusion," *British Journal of Psychology* 49 (1958), p. 31.

Marianne L. Teuber, "Sources of Ambiguity in the Prints of Maurits D. Escher," *Scientific American* 231 (1974), pp. 90–104.

Grids

The grid also is often drawn on the visual field as seen by the professional photographer through a camera lens. Sol LeWitt's acknowledgment to Muybridge was in a personal communication to the auther (A. B. G.).

Rosalind Krauss, *Grids: Format and Image in 20th-Century Art* (New York: The Pace Gallery, 1979).

Grids seem to be common with Bauhaus artists. Kandinsky

often used the grid, Klee's notebooks, e.g. *The Nature of Nature,* H. Norden, trans. (New York: Wittenborn, 1970) are filled with grids and not just in color charts; *Painting of the Bauhaus* (no author) (London: Marlborough, 1962) presents early grids of Albers, dating from 1925.

Gratings

Hans Cornelius, *Elementargesetze der Bildenden Kunst* (Leipzig and Berlin: Teubner, 1908). Cornelius is a proto-Gestalt philosopher-psychologist — a student of Ehrenfels — who had much to say about art and architecture. His 1908 book is an obvious Gestalt work — some years before the Gestalt school of psychology got started. The first chapter is titled "The Problem of Artistic Form" ("Das Problem der Kunstlerischen Gestaltung"). The concepts referred to with the words "form," "Gestaltung," and "plastic" are the central preoccupation of the author.

Adolf Hildebrand, *The Problem of Form in Painting and Sculpture*, first published in 1893, is a still earlier thinker in the proto-Gestalt period. The English translation of the third edition of Hildebrand has been reprinted by Garland, New York, 1978.

The importance of the grating in visual research is so fundamental that no treatment of visual perception since 1960 can ignore experiment and theory centered around grating stimuli. More recently the conceptual framework of spatial frequency analysis has superceded the earlier emphasis on "line detectors" in the cortex. The recent interpretation that vision involves a kind of two-dimensional spatial frequency analysis is most important, for if this framework should be sustained, then visual theory will have developed a major synthetic understanding of vision — in contrast to the long history of breaking vision down into the perception of various separate elements, such as dots, lines, and angles. Spatial frequency analysis is a general procedure for analyzing an image into its sine wave components, and a mode for understanding how the components are put together so as to construct the image — hence its synthetic significance.

Kandinsky's belief that science was turning toward a synthetic expression can be found in Overy, *op. cit.*, pp. 31–32.

C. McCollough, "Color Adaptation of Edge-Detectors in the Human Visual System," *Science* 149 (1965), pp. 1115–16.

Goethe used these black and white screens for his prismatic

experiments. Later he used black and white cards rather than table tops, for example, the octagonal table top at the right is reproduced as a design in *Zur Farbenlehre* (literally, "Toward the Color Theory"). The way in which these diagrams were actually used is not made entirely clear in Rupprecht Matthaei *Goethe's Color Theory,* Herb Aach, trans. and ed. (New York: Van Nostrand, 1971). As best as we can make out large glass prisms (sometimes possibly quite large water prisms) were held just above the black and white patterns to observe color effects in the white areas that were generated by light passing through the prism. Even a quick perusal of Matthaei's book will make clear the modernist iconography present in Goethe's research. The book presents many grating-stimuli including colored gratings suggestive of works by Agnes Martin, Morellet, Gene Davis, (see pp. 41, 85); color concentric circles as in Noland's target paintings (p. 119); rectangular shaped color pairs suggestive of Ellsworth Kelly (p. 10); and even the remarkable "Picasso" shown in Fig. 2.23.

Depth-Texture Gradients

See J. J. Gibson, *op. cit.*, (1950), for the original and still extensive coverage of texture gradients. The visual cliff experiment, by E. Gibson and R. D. Walk, can be found in *Scientific American*, 1960, *202*, pp. 64–71.

Vasarely's use of checkerboard texture gradients to create depth effects can be observed in *Vega*, 1956, in Cyril Barrett, *An Introduction to Optical Art* (London: Studio Vista, 1971), p. 8. See also Carraher and Thurston's treatment in *Optical Illusions and the Visual Arts* (New York: Reinhold, 1966).

Vasarely's earlier use of the checkerboard texture gradient (1935) can be found in Gaston Diehl, *Vasarely* (New York: Crown, 1973), p. 17, *Harlequin.*

For the evidence of the effect of perceptual science on Anuskiewicz see Karl Lunde, *Anuskiewicz* (New York: Abrams, 1977).

*Depth: Drawings of
Cubes and Other
Two-Dimensional Forms*

The original observation by Necker on the reversal of two-dimensional line drawings is L. A. Necker, "Observations on . . .

an Optical Phenomenon which Occurs on Viewing a Figure of a Crystal or Geometrical Solid," *Philosophical Magazine* 1, 3rd Series (1832), pp. 329–37.

Hochberg's research is covered in his article, "In the Mind's Eye," in Ralph Haber, ed., *Contemporary Theory and Research in Visual Perception* (New York: Holt, Rinehart and Winston, 1968), pp. 309–31.

That Al Held's paintings have something to do with perception — especially of reversible figures — would appear obvious. Yet, reviews of his work do not mention it. Even the fine catalogue by Marcia Tucker, *Al Held* (New York: Whitney Museum, 1974), fails to identify this perceptual dimension.

The original work on nonsense syllables is Hermann Ebbinghaus, *Über das Gedächtnis* (Leipzig: Duncker and Humboldt, 1885). See Boring, *op. cit.*, (1950), pp. 386 cf., 431–32.

Randomness

For Fred Attneave's contributions see his *Applications of Information Theory to Psychology* (New York: Holt, 1959); "Some Informational Aspects of Visual Perception," *Psychological Review* 61 (1954), pp. 183–93; "Stochastic Composition Processes," *Journal of Aesthetics and Art Criticism* 17 (1959), pp. 503–10. Also relevant is A. M. Noll, "Human or Machine: A Subjective Comparison of Piet Mondrian's *Composition with Lines* (1917) and a Computer-Generated Picture," *Psychological Record* 16 (1966), pp. 1–10.

Brenda Richardson's *Mel Bochner: Number and Shape* (Baltimore: Baltimore Museum of Art, 1976) shows several "random polygon" works by this minimal and conceptual artist.

Random shapes with curved sides can be seen in D. E. Berlyne, "Novelty, Complexity and Hedonic Value," *Perception and Psychophysics* 8 (1970), pp. 279–86; D. E. Berlyne and L. C. C. Parham, "Determinants of Subjective Novelty," *Perception and Psychophysics* 3 (1968) pp. 415–23. The basic approach for generating random shapes can be found in F. Attneave and M. D. Arnoult, "The Quantitative Study of Shape and Pattern Perception," *Psychological Bulletin*, 1956, *53*, pp. 452–71.

For Youngerman's random curved shapes see *Youngerman at Pace* (New York: The Pace Gallery, 1971); and Barbara Rose, "In-

terview with Jack Youngerman," *Art Forum*, January 1966, pp. 27–30.

Kelly's approach is described in E. C. Goosen, *Ellsworth Kelly* (New York: The Museum of Modern Art, 1973), p. 29 ff.

Leo Steinberg, *Other Criteria*, *op. cit.*, p. 61. A general philosophical and scientific discussion of the relationship of randomness to art can be found in Arnheim's *Entropy and Art* (Berkeley: University of California Press, 1971).

Redundancy

For Ryman's wall see *Critical Perspectives in American Art*. An exhibition selected by Sam Hunter, Rosalind Krauss, and Marcia Tucker (Amherst, Mass.: Fine Arts Center Gallery, 1976), p. 11. Even earlier Rauschenberg painted a white wall, his *White Painting*, 1951.

This "Ganzfeld" tradition has had many expressions; it is difficult to identify all those who have contributed. For additional examples see *California White Walls* by George Miller, private printing, 1974; Stephen Cox, Peter Joseph, and Bob Law in *Lisson Gallery Catalog* (London and New York: Lisson Gallery, 1977); also the catalogue *Geplante Malerei* (Milan: Galleria del Milione, 1975).

For the reciprocal relationship between randomness and redundancy see Attneave (1959) *op. cit.*

A good review of the Ganzfeld or homogeneous visual field is Lloyd L. Avant, "Vision in the Ganzfeld," *Psychological Bulletin* 64 (1965), pp. 246–58. The W. Metzger study is "Optische Untersuchen und Ganzfeld: II. Zur Phänomenologie des homogeneous Ganzfelds," *Psychologische Forschung* 13 (1930), pp. 6–29; also see J. E. Hochberg, W. Triebel, and G. Seaman, "Color Adaptation under Conditions of Homogeneous Visual Stimulation." (Ganzfeld). *Journal of Experimental Psychology* 41 (1951), pp. 153–59.

The effects of minimal sensory environments are described in: W. H. Bexton, W. Heron, and T. H. Scott, "Effects of Decreased Variation in The Sensory Environment," *Canadian Journal of Psychology* 8 (1954), pp. 70–76; D. O. Hebb, "The Mammal and His Environment, *American Journal of Psychology*, 3 (1955) pp.

826–31; and W. Heron, "The Pathology of Boredom," *Scientific American* 196 (1957), pp. 52-56.

More recent evidence suggests that in dark, warm, often watery, chambers, after an initial period of restlessness, people often report pleasant experiences of restfulness and tranquility. These isolation tank experiences typically range from 30 minutes to a few hours—the above studies lasted a minimum of 12 hours and often went for 2 days.

The Malevich quote is from Barbara Rose, "ABC Art," *Art in American*, October-November 1965. Reprinted in *Minimal Art: A Critical Anthology*, G. Battcock, ed. (New York: Dutton, 1968), pp. 295-96. Malevich's quote is from his *Suprematism*, 1919.

CHAPTER 8

Modernism:
Why So Theoretical

The present interpretation of the meaning of "theory" for the modernist movement is certainly quite different than Tom Wolfe's in *The Painted Word* (New York: Farrar, Straus and Giroux, 1975). Not that Wolfe doesn't deservingly attack some of the excesses of art theory.

Evidence of Ad Reinhardt's status as a critic is *Art as Art: The Selected Writings of Ad Reinhardt*, Barbara Rose, ed. (New York: Viking, 1975).

Motherwell is not only General Editor of the Documents of 20th Century Art series, but his own writings have been influential, as well. See "Selections from the Writings of Robert Motherwell," in *Robert Motherwell*, William Berkson, ed. (New York: Museum of Modern Art, 1965), pp. 35-56.

The Relation of
Parallelism to
Other Theories of
Modernist Art

For Kant's position see *Kant's Critique of Aesthetic Judgment*, James Creed Meredith, trans. (Oxford: The Clarendon

Press, 1911). There are many sources on Hegel and aesthetics. A good place to start is the entry on Hegel by H. B. Acton in *The Encyclopedia of Philosophy*, Vol. 3, Paul Edwards, ed. (New York: Macmillan and Free Press, 1967), pp. 435–51. See also the discussion of Hegel in Lionello Venturi, *History of Art Criticism* (New York: Dutton, 1936, paperback edition, 1964).

Roger Fry, writing on new painting in 1912, is quoted in Venturi, *op. cit.*, p. 308. Clive Bell, *Art* (London: Chatto and Windus, 1913, reprinted New York: Capricorn Books, G. P. Putnam), pp. 33–34.

Clement Greenberg, "Modernist Painting" from *Art and Literature* 4 (1965), in Battcock, 1973, p. 74.

See also Harold Rosenberg, *Artworks and Packages* (New York: Dell, 1969). Quote from Delta paperback; Alfred Barr, *Cubism and Abstract Art* (New York: Museum of Modern Art, 1936).

Arnold Hauser, *The Philosophy of Art History* (London: Routledge, Keegan Paul, 1959). Quotes from pp. 21, 22, 28, and 29. Rudolph Arnheim, *Art and Visual Perception* (Berkeley: University of California Press, 1954). E. H. Gombrich, *Art and Illusion* (Princeton, N.J.: Princeton University Press, 1960); *The Sense of Order* (London: Phaidon, 1979).

For Arnheim see *Art and Visual Perception, op. cit.*; *Visual Thinking* (Berkeley: University of California Press, 1969); and *Toward a Psychology of Art, op. cit.*

Another advantage of the present approach is that it does not rely on the validity of any particular theory of perception. The theories of Gestalt psychology, of Gibson, and other newer approaches are of great interest and importance, for visual scientists, however, to select any one theory as the framework for interpreting art will always exclude many phenomena. Certainly artists have shown no special loyalty to any of the many changing interpretations of visual experience. Indeed there is no reason to think there ever will be one theory of perception. The more developed sciences are, in fact, characterized by many different theoretical systems. It is already clear that brightness and color perception, for example, are going to have quite different theoretical explanations as compared to binocular depth or movement or form perception. The historical motivation of the paral-

lelism thesis allows one to bypass the restraints inherent in the selection of a particular theory.

For examples and discussion of theoretical interpretations of perception with direct relevance to art, see C. F. Nodine and D. F. Fisher, eds., *Perception and Pictorial Representation* (New York: Praeger, 1979), particularly the chapters by J. Hochberg, N. Haber, M. Hagen, and R. L. Gregory. Another important treatment of theoretical interpretations of perception with respect to art is M. A. Hagen, ed., *The Perception of Pictures* (New York: Academic Press, 1980).

Meyer Schapiro, *Modern Art: 19th and 20th Centuries* (New York: George Braziller, 1978). Quotes on pp. 214 and 215. This book, a collection of Schapiro's papers on modern art, only occasionally refers to science or technology; it has no reference to visual science.

Mimesis: The Problem of What Is Painted

Leo Steinberg, *Other Criteria* (London: Oxford, 1972), pp. 290–91. Section 16, "The Eye Is Part of the Mind," was originally published in *Partisan Review* 20, no. 2 (March-April 1953).

Higher Meaning:
The Problem of Religious
Mysticism and Romantic
Symbolism

Robert Rosenblum, *Modern Painting and the Northern Romantic Tradition*, (New York: Harper & Row, 1975).

Surrealism: The Problem of the Image

There are major links establishing a kind of parallelism between the new psychology of Freud and Jung and Surrealism. Among these connections are Breton's direct contact with Freud; the primary focus in both movements on the importance of the dream, of fantasy and hallucination; the similarity of psychic automatism (for example, Breton) with its goal of verbal expres-

sion without any rational, aesthetic, or moral restraint and free association in psychoanalysis; and the mutual interest in the unconscious and in the insane.

Surrealism was prefigured by Giorgio de Chirico, and in some respects it is in the same tradition as such painters as Aubrey Beardsley, Gustav Klimt, the Expressionists, and to some extent the Symbolists.

Serious interest in dreams and subjective states got off the ground in 1900 with Freud's *Interpretation of Dreams*, but other nonpsychoanalytic writing about dreams was going on separately. For example, see Frederick Greenwood, *Imagination in Dreams and Their Study* (New York: Macmillan, 1894); Isador H. Coriat, *The Meaning of Dreams* (Boston: Little, Brown, 1918); and Mary Arnold Forster, *Studies in Dreams* (New York: Macmillan, 1921).

Apparently the whole intellectual tradition of dream study and its association with art remains to be studied.

Future Possibilities

For information and further discussion of the work of Chuck Close see *Chuck Close—Recent Work* (New York: The Pace Gallery, 1977); Martin Friedman and Lisa Lyons, *Close Portraits* (Exhibition Catalogue) (Minneapolis, Minn.: Walker Art Center, 1980).

Credits

1.1. Manet: *Angelina*, 1865, oil on canvas, 36¼ × 28¼", Collection Musée du Jeu de Paume, Paris.

1.2. Matisse: *Madame Matisse: Portrait with a Green Stripe*, 1905, oil on canvas, 16 × 12¾", Collection Royal Museum of Art, Copenhagen.

1.3. Léger: *Woman Holding a Vase*, 1927, oil on canvas, 57⅝ × 38⅜", Collection The Solomon R. Guggenheim Museum, New York.

1.4. Jawlensky: *Large Meditation*, 1936, oil on canvas, 9¾ × 7¼", Courtesy Leonard Hutton Galleries, New York.

1.5. Mondrian: *The Red Tree*, 1909–10, oil on canvas, 26⁹⁄₁₆ × 39", Collection Haags Gemeentemuseum, The Hague.

1.6. Mondrian: *Horizontal Tree,* 1911, oil on canvas, 29⅝ × 43⅞". Collection Munson-Williams-Proctor Institute, Utica, New York.

1.7. Mondrian: *Flowering Appletree*, 1912, oil on canvas, 30¾ × 41¾", Collection Haags Gemeentemuseum, The Hague.

2.1. Fabriano: *Madonna and Child, with Saints Lawrence and·Julian,* ca. 1423–25, tempera on panel, 35¾ × 18½", copyright The Frick Collection, New York.

2.2. Rembrandt: *Belshazzar's Feast* c. 1637, oil on canvas. Reproduced by courtesy of the Trustees, The National Gallery, London.

2.3. Scheffer: *Saint Thomas Preaching during a Storm,* 1823, oil on canvas, 139 × 116", Musée Louvre, Paris.

2.4. Ingres: *Portrait of Napoleon I on His Imperial Throne,* 1806, canvas, 102⅜ × 64⅛", Collection Musée de l'Armée, Paris.

2.5. David: *Antoine Laurent Lavoisier and his Wife,* 1788, 102½ × 76⅝", The Metropolitan Museum of Art, Purchase, Mr. and Mrs. Charles Wrightsman Gift, 1977.

2.6. David: *The Death of Socrates,* 1787, oil on canvas, 51 × 77¼", The Metropolitan Museum of Art, Wolfe Fund, 1931.

2.7. Johns: *Numbers in Color,* 1959, encaustic and collage on canvas, 66½ × 49½", Albright-Knox Art Gallery, Buffalo, New York, Gift of Seymour H. Knox, 1959.

2.8. Delacroix: *Liberty Leading the People,* 1830, canvas, 101⅞ × 127⅞", Musée Louvre, Paris.

2.9. Picasso: *Visage, Trois-quart gauche,* 1908–09, charcoal on paper, 12¾ × 17", The Pace Gallery, New York.

2.10. Matisse: *Joie de Vivre,* 1906, photograph copyright The Barnes Foundation, Merion, Pennsylvania.

2.11. Schleiden: Cellular tissue in plants (left and upper right); Schwann: Cellular tissue—tadpole (lower right) 1838–39. From P. Ritterbush, *The Art of Organic Forms,* Washington, D.C.: Smithsonian Institution Press, 1968, p. 31, Figures 7 and 8.

2.12. Fleming: Chromosomes, 1882. From W. Coleman, *Biology in the Nineteenth Century: Problems of Form, Function and Transformation,* New York: John Wiley, 1971, p. 39, Figure 3.2.

2.13. Double helix, ca. 1953–55. From R. Moore, *The Coil of Life: The Story of Great Discoveries in the Life Sciences,* drawings by Patricia M. Jackson, New York: Knopf, 1965, p. 288.

2.14. Dalton: Table of atomic elements, 1808. From J. Dalton, *A New System of Chemical Philosophy: Part I,* Manchester, England: S. Russell for R. Bickerstaff, 1808, plate 4.

2.15. Bohr and Sommerfeld: Patterns of electron motion in the atoms of various elements, 1913–15. From G. Gamow, *The Atom and Its Nucleus,* Englewood Cliffs, N.J.: Prentice-Hall, 1961, p. 59, Figure 26.

2.16. Newton splits up sunlight into the spectral colors by means of a prism, 1666. From F. S. Taylor, *An Illustrated History of Science,* London: William Heinmann, Limited, 1955, p. 75, Figure 57.

2.17. Nadar: Portrait of Michel-Eugène Chevreul, 1886. From J. Prinet and A. Dilasser, *Nadar,* Paris: Librairie Armand Colin, 1966, p. 199.

2.18. M.-E. Chevreul: Early Scientific arrangement of color "elements," 1839. From F. Birren, *History of Color in Painting,* New York: Reinhold, 1965, p. 277, Figure 11.6. Originally published in M.-E. Chevreul, *De la loi du contraste simultané* des couleurs, Paris: Pitois-Levrault, 1839.

2.19. Portrait of Hermann von Helmholtz (1821–94). The Mansell Collection.

2.20. Portrait of Gustav Theodor Fechner (1801–87). From J. M. Baldwin, *History of Psychology,* II, London: Watts & Co., 1913, p. 116.

2.21. Tischbein: *Goethe in Italy,* 1787, watercolor study for the oil painting *Goethe in the Campagna Romana.* From *Goethe's Color Theory,* edited by Rupprecht Matthaei. Copyright © 1970 by Otto Maier Verlag, 1971 by Van Nostrand Reinhold. Reprinted by permission of Van Nostrand Reinhold Company.

2.22. Warhol: *Goethe,* 1982, color serigraph, 37½ × 37½″, Courtesy The Pace Gallery, New York.

2.23. Goethe, Bust of a young girl in the reversed colors of an after-image, 1810. From *Goethe's Color Theory,* edited by Rupprecht Matthaei. Copyright © 1970 by Otto Maier Verlag, 1971 by Van Nostrand Reinhold. Reprinted by permission of Van Nostrand Reinhold Company.

2.24. Gestalt after-image of German President Paul von Hindenburg, 1935. From K. Koffka, *Principles of Gestalt Psychology,* New York, Harcourt, Brace and Company, 1935, page 172, Figure 49.

2.25. Monet: *Rouen Cathedral,* 1894, oil on canvas, 39¼ × 25⅞″, The Metropolitan Museum of Art, The Theodore M. Davis Collection, Bequest of Theodore M. Davis, 1915.

2.26. Lichtenstein: *Rouen Cathedral Set 1,* 1968. Oil and magna on canvas, 63 × 42″, In the Collection of Barbara Goldsmith.

2.27. Hofman: Diagram of Nature-Artist-Creation, ca. 1948. From H. B. Chipp, *Theories of Modern Art,* Berkeley and Los Angeles: University of California Press, 1968, p. 538.

2.28. Atelier Nadar: Portrait of Gustav Flaubert, (ca. 1870). From Nigel Gosling, *Nadar,* London: Secker & Warburg, 1976, p. 225.

2.29. H. Helmholtz: Analysis of angles of vision, 1867. From H. Helmholtz, *Handbuch der Physiologischen Optik,* Leipzig: Voss, 1867, p. 717, Figure 207.

2.30. du Camp: *Thebes: Gournah, Statue of Memnon,* 1850. From *A Book of Photographs from the Collection of Sam Wagstaff,* New York, Gray Press, 1977, p. 25.

2.31. H. Helmholtz: Eye, 1867. From H. Helmholtz, *Handbuch der Physiologischen Optik,* Leipzig: Voss, 1867, p. 110, Figure 58.

3.1. Manet: *Olympia,* 1863, oil on canvas, 51⅜ × 35½″, Collection Musée du Jeu de Paume, Paris.

3.2. Titian: *Venus of Urbino,* 1538, oil on canvas, 47 × 65″, Collection Uffizi Gallery, Florence.

3.3. Workshop of Velazquez: *Philip IV,* 1631–32, oil on canvas, 80 × 46¾″, Collection Musée Goya, Astres.

3.4. Manet: *Philip IV* (after Velazquez), 1862, etching, seventh state, 9¼ × 14″, S.P. Avery Collection, Art, Prints, and Photographs Division. The New York Public Library, Astor Lenox & Tilden Foundation.

3.5. Manet: *Mademoiselle Victorine as an Espada,* 1862, oil on canvas, 37⅜ × 44½″, The Metropolitan Museum of Art, New York, Bequest of Mrs. H. O. Havemeyer, 1929. The H. O. Havemeyer Collection.

3.6. Braquehaïs: Nude, c. 1856, Albumen print, 6¼ × 8¼″, Collection Sam Wagstaff.

3.7. Nadar: *Catacombs,* 1861, photograph, 10 × 7″, Collection National Conservatory of Arts and Letters, Paris.

3.8. Manet: *Woman with a Parrot,* 1866, oil on canvas, 72¾ × 52″, The Metropolitan Museum of Art, New York, Gift of Erwin Davis, 1889.

3.9. Courbet: *Portrait of Max Buchon,* 1854, oil on canvas, 76½ × 43¾″, Musée Genish, Vevey, Switzerland.

3.10. S. W. Hartshorn (attributed to): *Edgar Allan Poe,* 1848 daguerreotype, Harris Collection of American Poetry and Plays, John Hay Library, Brown University.

3.11. Nadar: *Portrait of Charles Baudelaire,* 1859, photograph Bibliothèque Nationale, Paris.

3.12. Manet: *Edgar Allan Poe*, 1856, etching, 7½ × 5⅞", Coke Collection.

3.13. Manet: *Portrait of Charles Baudelaire*, 1865, etching, 3¾ × 3", Bibliothèque Nationale, Paris.

3.14. Manet: *Portrait of Madame Brunet*, 1862, oil on canvas, 52 × 39¼", Private Collection, New York.

3.15. Manet: *Portrait of the Abbé Hurel*, 1859 (work lost).

3.16. Manet: *Portrait of the Artist's Parents*, 1860, oil on canvas, Collection Rouart, Paris.

3.17. Nadar: *Edouard Manet,* 1865. From J. Prinet and A. Dilasser, *Nadar,* Colin, Paris, 1966, p. 267.

3.18. Fantin-Latour: *Portrait of Edouard Manet,* 1867, oil on canvas 46 × 35½", Courtesy of The Art Institute of Chicago.

3.19. Fantin-Latour: *Still-Life,* 1866, oil on canvas, 24⅜ × 29½", Chester Dale Collection, The National Gallery, Washington.

3.20. Manet: *Still-Life with Carp,* 1864, oil on canvas, 28⅞ × 36¼", Courtesy of Mr. and Mrs. Lewis L. Coburn Memorial Collection, Courtesy of The Art Institute of Chicago.

3.21. Manet: *Victorine Meurend,* 1862, oil on canvas, 17 × 17", Courtesy, Museum of Fine Arts, Boston. Gift of Richard C. Paine in memory of his father Robert Treat Paine, 2nd.

3.22. Charles Nègre: *Market Scene,* 1852, oil on canvas, 6 × 7¾", Collection Joseph Nègre, Paris.

3.23. Charles Nègre: *Market Scene on a Quai in Paris,* 1852, calotype, Collection Joseph Nègre, Paris.

3.24. Anonymous: *Miniature Photo-painting of an Old Darby and Joan,* ca. 1840s. From Aaron Scharf, *Art and Photography* Penguin, Baltimore, 1974.

3.25. Manet: *Madame Manet,* 1863, oil on canvas, 41 × 31½", Collection, Isabella Stewart Gardner Museum, Boston.

3.26. Manet: *The Old Musician,* 1862, oil on canvas, 74 × 97½", Chester Dale Collection, The National Gallery, Washington D.C.

3.27. Hill and Adamson: Calotype, c. 1845, Courtesy The Science Museum, London.

3.28. Manet: *Portrait of Stéphane Mallarmé,* 1876, oil on canvas, 10¾ × 14¼", Collection Musée du Louvre.

4.1. Monet: *Haystacks at Giverny,* 1884, oil on canvas, 25¾ × 36¼", Private Collection.

4.2. Chevreul: Contrast of primary and secondary colors. M. E. Chevreul, *The Principles of Harmony and Contrast of Colors and Their Application to the Arts,* 3d ed. translated by Charles Martel, London: Bell, 1860, plate 4.

4.3. Chevreul: Color contrast effects of surrounding color on center dot and of center dot on surrounding color. M. E. Chevreul, *The*

Principles of Harmony and Contrast of Colors and Their Application to the Arts, 3d ed. translated by Charles Martel, London: Bell, 1860, plate 3.

4.4. Chevreul: Dots of primary colors enhanced by proximity to gray dots. M. E. Chevreul, *The Principles of Harmony and Contrast of Colors and Their Application to The Arts*, 3d ed. translated by Charles Martel, London: Bell, 1860, plate 9.

4.5. Chevreul: Color contrast effects determined by relative width of stripes. M. E. Chevreul, *The Principles of Harmony and Contrast of Colors and Their Application to the Arts*, 3d ed. translated by Charles Martel, London: Bell, 1860, plate 10.

4.6. Monet: *La Grenouillère,* 1869, oil on canvas, 29⅜ × 39¼″, The Metropolitan Museum of Art, Bequest of Mrs. H. O. Havemeyer, 1929. The H. O. Havemeyer Collection.

4.7. Blanc: Diagrams illustrating heightened contrast at border of red and green in two large areas compared to the same colors in narrow bands, 1867. Charles Blanc, *The Grammar of Painting and Drawing* translated from 1867 French edition by Kate Newell Doggett, Hurd and Houghton, New York, 1874, p. 163.

4.8. Blanc: Diagram illustrating optical mixing of color, that is, for mixing color in the eye, 1867. Charles Blanc, *The Grammar of Painting and Drawing*, translated from 1867 French edition by Kate Newell Doggett, Hurd and Houghton, New York, 1874, p. 164.

4.9. Seurat: *Evening, Honfleur,* 1886, oil on canvas, 25¾ × 32″, Collection, The Museum of Modern Art, New York. Gift of Mrs. David M. Levy.

4.10. Stilling: Early color-blindness test plate, 1878. Stilling, *Pseudoisochromatische Tafeln zur Prüfung des Farbensinnes*, 17th ed., Georg Thieme, Leipzig, 1926 (1st ed., 1878), plate 1.

4.11. Contrast diagram from O. N. Rood, *Modern Chromatics with Application to Art and Industry*. First French edition 1881 (upper diagram); Copy of Rood's diagram by Seurat (lower diagram), William I. Homer, *Seurat and the Science of Painting*, MIT Press, Cambridge, Massachussetts, 1964, page 41 Figures 15 and 16.

4.12. Signac: *Théâtre-Liberté,* 1888, colored lithograph, 6¼ × 7⅛″. Advertisement for Charles Henry's "cercle chromatique" in a program for André Antoine's Théâtre-Liberté.

4.13. Rood: Color circle, 1879. O. N. Rood *Modern Chromatics with Application to Art and Industry*, Appleton, New York, 1879, p. 241.

4.14. Helmholtz: Color circle, 1867. First reproduced in H. von Helmholtz, *Handbuch der Physiologischen Optik*, Voss, Leipzig, 1867; figure from E. G. Boring, *Sensation and Perception in the History of Experimental Psychology*, Appleton-Century-Crofts, New York, 1942, p. 145.

4.15. Delaunay: *Disk, First Nonobjective Painting*, 1912, oil on canvas, 52¾″ diameter, Collection Mr. and Mrs. Burton Tremaine.

4.16. Rood: Disk for mixing colors, 1879. O. N. Rood, *Modern Chromatics with Applications to Art and Industry*, Appleton, New York, 1879, p. 188.

4.17. Rood: Disks for mixing colors, 1879. O. N. Rood, *Modern Chromatics with Applications to Art and Industry*, Appleton, New York, 1879, p. 146.

4.18. Delaunay, *Rhythms*, 1934, oil on canvas, 57½ × 45″, Musée National d'Art Moderne, Centre Georges Pompidou, Paris.

4.19. Delaunay: *Homage to Bleriot*, 1914, collage on canvas, 98⅖ × 99″, Kunstmuseum, Basel.

4.20. Goethe: Diagrams illustrating various color phenomena, 1810, in Rupprecht Matthaei, ed., *Goethe's Color Theory*, Van Nostrand Reinhold Co., New York, 1971, illustration #78.

4.21. James Clerk Maxwell at Cambridge, holding color top, 1855. C. W. F. Everitt, *James Clerk Maxwell: Physicist and Natural Philosopher,* Charles Scribner's Sons, New York, 1975, p. 21. (Original with The Master and Fellows of Trinity College, Cambridge.)

4.22. Maxwell's color top. When the top is spun the colors mix in the eye. The observer adjusts either or both sets of papers until they match. A color equation is then formed in terms of the exposed angles of each color. C. W. F. Everitt, *James Clerk Maxwell: Physicist and Natural Philosopher*, Charles Scribner's Sons, New York, 1975, p. 20. (Original at Cavendish Laboratory.)

4.23. Kupka: *Disks of Newton, Study for Fugue in Two Colors*, 1911–12, oil on canvas, 19½ × 25⅝″, Musée National d'Art Moderne, Paris.

4.24. Kandinsky: Color Scale (in the Goethe tradition), 1926. W. Kandinsky *Point and Line to Plane*, Solomon R. Guggenheim Foundation, 1947, p. 63.

4.25. Kelly: *Series of Five Paintings* (detail), 1966, oil on canvas, in five parts, 70″ × 11′8″ each, Collection Geertjan Visser.

4.26. Ostwald: representation constructed for this text based on Color Plate VIII. Wilhelm Ostwald, *The Color Primer,* ed. Faber Birren, Van Nostrand Reinhold Co., New York, 1969, page 94. First published in *Die Farbenfibel,* 1917.

4.27. Chevreul: Color scales. M. E. Chevreul, The *Principles of Harmony and Contrast of Colors and Their Application to the Arts*, based on the first English edition of 1854 as translated from the first French edition 1839; introduction and notes by Faber Birren, Reinhold, New York, 1967, page 16.

4.28. Klee: *Greeting–Diametrical Gradation Blue-Violet and Yellow-Orange with Blue and Red Accents (Arrows),* 1922, watercolor on paper mounted on board, 8¾ × 12⅜″, Wadsworth Atheneum,

Hartford, The Ella Gallup Sumner and Mary Catlin Sumner Collection.

4.29. Klee: *Resonance of the Southern Flora,* 1927. Location unknown.

4.30. Ostwald: From Color Plate I. Wilhelm Ostwald, *The Color Primer*, ed. Faber Birren, Van Nostrand Reinhold Co., New York, 1969, page 82. First published in *Die Farbenfibel*, 1917.

4.31. Kelly: *Spectrum III,* 1967, oil on canvas, in thirteen parts, overall $33\frac{1}{4}'' \times 9'5\frac{5}{8}''$. The Sidney and Harriet Janis Collection, gift to the Museum of Modern Art, New York.

4.32. Chevreul: Scale of grays, 1839. M. E. Chevreul, *The Principles of Harmony and Contrast and Their Application to the Arts*, based on the first English edition of 1854 as translated from the first French edition of 1839; introduction and notes by Faber Birren, Reinhold, New York, 1967, p. 58.

5.1. A typical hand-held early stereoscope designed to present disparate images to each eye. This type was first designed in 1861 by Oliver Wendell Holmes. From Boring, Langfield, and Weld, *Foundations of Psychology,* Wiley & Sons, New York, 1948, p. 303.

5.2. Wheatstone: Stereoscopic drawing, 1838. From C. Wheatstone, "Contributions to the Physiology of Vision—Part the First. On Some Remarkable, and Hitherto Unobserved, Phenomena of Binocular Vision." *Philosophical Transactions,* Royal Society of London, 1838, (128), Figure 20.

5.3. Overhead schematic of stereoscopic viewing of a wedge (ABC). From H. R. Schiffman, *Sensation and Perception*, Wiley & Sons, New York, 1982, p. 334, figure 16.21.

5.4. Diagrammatic representation of Hering's Theory (1861) of binocular perception. It shows the view of the left eye, the right eye, and the scene as described by the observer—the normal integrated view of the "cyclopean" eye. From I. P. Howard and W. B. Templeton, *Human Spatial Orientation*, Wiley and Sons, New York, 1966, p. 17.

5.5. Muybridge: *The Horse in Motion*, 1878, albumen prints, $4 \times 8\frac{1}{2}''$, Collection Stanford University Museum of Art, California.

5.6. Muybridge: General view of the Experiment Track. The camera shed is at the right, the background wall at the left, and four diagonal cameras on stands at four corners of the track area, 1881. From *The Horse in Motion* (1882) in G. Hendricks, *Eadweard Muybridge: The Father of the Motion Picture*, Grossman, New York, 1975, plate 91.

5.7. Muybridge: Horse and rider at the same moment from three viewpoints, 1881, from *Attitudes of Animals in Motion* in A. V. Mozley, *Eadweard Muybridge: The Stanford Years, 1872–1882*, Stanford University Museum of Art, 1972, p. 79.

5.8. Muybridge's Zoöpraxiscope. Note the disk with the sequence of horse and rider, 1879. A. V. Mozley, *Eadweard Muybridge: The Stanford Years, 1872–1882*, Stanford University Museum of Art, 1972, p. 72.

5.9. Plateau: Phenakistoscope, 1832. A. V. Mozley, *Eadweard Muybridge: The Stanford Years, 1872–1882*, Stanford University Museum of Art, 1972, p. 73.

5.10. Marey: *Man Walking,* ca. 1882. Courtesy Cinemathèque Française, Paris.

5.11. Manet: *Bar at the Folies Bergère*, 1881, oil on canvas, 37¾ × 51⅛", Home House Society Trustees, Courtauld Institute Galleries, London.

5.12. Two interpretations of *Bar at the Folies Bergère* (see text for discussion). Drawn for this text.

5.13. Two interpretations of *Bar at the Folies Bergère* based on a "Muybridge" analysis. The top photograph (1) *Getting out of Bed* shows a woman from three different perspectives. The pairs of photographs in the middle section (2) show two stills each from a different perspective, Pair A from slightly different times, Pair B from the same time. The bottom two photographs (3) show combinations of the two views in the same image. Muybridge, *Getting out of Bed,* Coúrtesy The Museum of the Philadelphia Civic Center.

5.14. Manet: *View of the Universal Exhibition of 1867*, 1867, oil on canvas, 43 × 77⅛", Collection Oslo National Gallery, Norway.

5.15. Eye movement pattern of one subject on Manet's *View of the Universal Exhibition.* Shows fixation points with large saccatic jumps over the dead space between centers of visual fixation. Drawn for this text.

5.16. Cézanne: *Still Life with Fruit Basket*, 1888–90, oil on canvas, 25⁹⁄₁₆ × 31⅞", Musée du Louvre, Paris.

5.17. Loran: Diagram showing how parts of the Cézanne are in correct perspective for eyes situated at different heights (e.g. I and II) and at different angles of observation (e.g. Ia and IIb). From Erle Loran, *Cézanne's Composition*, University of California Press, Berkeley, 1943, plate 14.

5.18. Lhote: *Cubist Drinking Glass*, 1952, from Leo Steinberg, *Other Criteria: Confrontations with 20th Century Art*, Oxford University Press, New York, 1972, plate 98.

5.19. Muybridge: *Woman Climbing Stairs, Waving Handkerchief* from *Animal Locomotion*, 1887, plate 96. Courtesy International Museum of Photography, Rochester, N.Y.

5.20. Marey: *Walking Horse,* c. 1880s. Courtesy Cinemathèque Française, Paris.

5.21. Duchamp: *Nude Descending a Staircase, No. 2*, 1912, oil on can-

vas, 57½ × 35¹⁄₁₆″, Collection Philadelphia Museum of Art, The Louise And Walter Arensberg Collection.

.22. Balla: *Dynamism of a Dog on a Leash*, 1912, oil on canvas, 35⅜ × 43¼″, Bequest of A. Conger Goodyear to George F. Goodyear, life interest, and Albright-Knox Art Gallery, Buffalo, 1964.

.23. Muybridge, *Daisy Jumping a Hurdle,* 1883–87, albumen prints. From Eadweard Muybridge, *Animals in Motion,* Dover Publications, N.Y. plate 75.

5.24. Kupka: *Horsemen*, 1901–02, India ink on paper, 16 × 21¼″, Collection Musée National d'Art Moderne, Centre Georges Pompidou, Paris.

5.25. Kupka: *Woman Picking Flowers I*, 1909–10, pastel on paper, 17¾ × 18¾″, Musée National d'Art Moderne, Centre Georges Pompidou, Paris.

5.26. George N. Barnard and Gibson: Detail of *Fortifications on Heights of Centerville, Virginia*, 1861–65 from John Szarkowski, *The Photographer's Eye*, Museum of Modern Art, New York, 1966, p. 103.

5.27. Bragaglia: *Fotodynamic Portrait*, 1911. From B. Newhall, *The History of Photography*, Museum of Modern Art, New York, 1949, p. 172.

5.28. Amateur snapshot: ca. 1924. From L. Maholy-Nagy, *Painting, Photography, Film*, MIT Press, Cambridge, Massachusetts, 1969, p. 99.

5.29. Picasso: *Untitled,* 1937. Location unknown.

5.30. Manet: *Boats*, 1873, oil on canvas, 13⅜ × 22″, The Cleveland Museum of Art, purchase from the J. H. Wade Fund.

5.31. Cézanne: *La Route Tournante à La Roche-Guyon*, c. 1885, oil on canvas, unfinished, 25¼ × 31½″, Smith College Museum of Art, Northampton, Massachusetts, purchase 1932.

5.32. Rewald: Photograph of the motif (above). From Erle Loran, *Cézanne's Composition*, University of California Press, Berkeley, 1943, unpaged.

5.33. Schematic representation of Van Gogh's *Bedroom*, 1888. Note the excited painter's distorted space perspective (upper half of figure). Schematic representation of Van Gogh's *Bedroom* in reconstructed Euclidean space perspective (lower half of figure). From R. Fischer "Space-Time Coordinates of Excited and Tranquilized States", in *Psychiatry and Art*, Vol. I, Proceedings of the Fourth International Colloquium of Psychopathology of Expression, Washington, D.C., 1966, edited by I. Jakab, figure 3, page 43, Karger, Basel, 1968.

5.34. Picasso: *By the Sea*, 1920, oil on canvas, 32 × 41″, Collection of the late G. David Thompson, Pittsburgh, PA.

5.35. Anonymous: *Man with Big Shoes*, ca. 1890, stereophotograph Coke Collection.

6.1. Rubin: Ambiguous figure-ground. From E. Rubin, *Synoopleved figurer*, Gyldendalske, Copenhagen, 1915. Taken from plate 1 German edition, 1921.

6.2. Rubin: Ambiguous figure-ground: *Claw.* From E. Rubin *Synooplevede figurer*, Gyldendalske, Copenhagen, 1915. Taken from plate 2, German edition, 1921.

6.3. Rubin: Ambiguous figure-ground: vase-face. From E. Rubin *Synooplevede figurer*, Gyldendalske, Copenhagen, 1915. Taken from plate 3, German edition, 1921.

6.4. Arp: *Constellation of Six Black Forms on White Ground*, 1957 collage, $43\frac{1}{4} \times 13\frac{7}{8}''$, Collection Madame Marguerite Arp.

6.5. Arp: *Mountain, Table, Anchors, Navel*, 1925, oil on cardboard with cut-outs, $29\frac{5}{8} \times 23\frac{1}{2}''$, Collection The Museum of Modern Art, New York. Purchase.

6.6. Matisse: *The Cowboy*, plate 14, from *Jazz*, 1947, pochoir plate in color. Sheet: $16\frac{5}{8} \times 25\frac{5}{8}''$, Collection, The Museum of Modern Art, New York. Gift of the artist.

6.7. Miró: *Hand Catching Bird*, 1926, oil on canvas, $36\frac{1}{4} \times 28\frac{3}{4}''$, Private Collection. © by A. D. A. G. P., Paris, 1983.

6.8. Dali: *Apparition of a Face and a Fruit Dish on a Beach*, 1938, oil on canvas, $45\frac{1}{2} \times 56\frac{1}{2}''$, Collection Wadsworth Atheneum, Hartford.

6.9. Johns: *Cups 4 Picasso*, 1972, lithograph, $22 \times 32''$, Courtesy ULAE.

6.10. Picasso: *Ma Jolie*, 1911–12, oil on canvas, $39\frac{3}{8} \times 25\frac{3}{4}''$, Collection, The Museum of Modern Art, New York. Acquired through the Lillie P. Bliss Bequest.

6.11. Richardson: Planes arranged to show normal overlapping unambiguous figure-ground. From J. A. Richardson, *Modern Art and Scientific Thought*, University of Illinois Press, Urbana, 1971, p. 114, plate 38.

6.12. Richardson: Planes arranged to show "cubistic" ambiguous figure-ground. From J. A. Richardson, *Modern Art and Scientific Thought,* University of Illinois Press, Urbana, 1971, p. 115, plate 39.

6.13. Picasso: *Card Player,* 1913, oil on canvas, $42\frac{1}{2} \times 35\frac{1}{4}''$, Collection, The Museum of Modern Art, New York, Acquired through the Lillie P. Bliss Bequest.

6.14. Braque: *Musical Forms*, 1918, oil on canvas, $36\frac{1}{4} \times 23\frac{1}{2}''$, Collection Philadelphia Museum of Art, The Louise and Walter Arensberg Collection.

6.15. Picasso: *Girl with a Mandolin (Fanny Tellier)*, 1910, oil on canvas,

39½ × 29″, Collection The Museum of Modern Art, New York. Nelson A. Rockefeller Bequest.

6.16. Rubin: Ambiguous figure-ground. From E. Rubin, *Synooplevede figurer*, Gyldendalske, Copenhagen, 1915. Taken from plate 8, German edition, 1921.

6.17. Koffka: Ambiguous figure-ground partially resolved in favor of seeing the symmetric shapes as figure. From K. Koffka, *Principles of Gestalt Psychology*, Harcourt, Brace and Co., New York, 1935, p. 195, figures 66 and 67.

6.18. Koffka: Ambiguous figure-ground. From K. Koffka, *Principles of Gestalt Psychology*, Harcourt, Brace and Co., 1935, p. 186, figure 57.

6.19. Burchfield: *Crystalline Composition*, drawing on paper, 8⅝ × 11⅝″, Museum of Arts, Carnegie Institute, Pittsburgh, gift of Bernard Danenberg, 1970.

6.20. Lipps: Square as balance of vertical and horizontal (left figure); balance reduced by changes (two figures on right). From Lipps, "Raumaesthetik und Geometrische-Optische Tauschungen", in *Schriften der Gesellschaft für Psychologische Forschung* (Heft 9/10), 1897, p. 110, figure 38.

6.21. Schumann: Change in appearance of a form (square) when orientation is changed. From F. Schumann, "Beitrage zur Analyse der Gesichtswahrnehmungen", in *Zeitschrift für Psychologie,* Berlin, 1900, volume 23, p. 19, figure 15.

6.22. Malevich: *Black Square,* 1920, lithograph, 5⅜ × 5⅜″, whereabouts unknown. From D. Karshan, *Malevich: The Graphic Work*, Israel Museum, Jerusalem, 1975, p. 139.

6.23. Malevich: *Suprematist Composition: White on White,* 1918?, oil on canvas, 31¼ × 31¼″. Collection Museum of Modern Art, New York.

6.24. Installation of Malevich paintings: 1915–16. From *Artforum* December, 1978, p. 45.

6.25. Lipps: Center rectangle as affected by rectangles on either side. From Lipps, "Raumaesthetik und Geometrische-Optische Tauschungen", in *Schriften der Gesellschaft für Psychologische Forschung,* (Heft 9/10), 1897, p. 135, figure 48.

6.26. Lipps: Rectangles of fixed height as changed by reduced length. From "Raumaesthetik und Geometrische-Optische Tauschungen", in *Schriften der Gesellschaft für Psychologische Forschung* (Heft 9/10), 1897, p. 112, figure 39.

6.27. Kirschmann: Recognition of geometrical figures as affected by Form (Gestalt) and Orientation: stimulus examples. From "Über der Erkennbarkeit geometrischer Figuren und Schriftzeichen im indirecten Sehen", in *Archiv für Gesamte Psychologie*, 1908, #13, p. 358, table 1.

6.28. Kirschmann: Recognition of geometrical figures as affected by Form (Gestalt) and Orientation: stimulus examples. From "Über der Erkennbarkeit geometrischer Figuren und Schriftzeichen im indireckten Sehen", in *Archiv für die Gesamte Psychologie*, 1908, #13, p. 358, table 1.

6.29. Kirschmann: Stimuli used to investigate recognition of different geometric figures on black and white backgrounds. From "Über der Erkennbarkeit geometrische Figuren und Schriftzeichen im indireckten Sehen", in *Archiv für die Gesamte Psychologie*, 1908, #13, p. 358.

6.30. Kandinsky: *In the Black Square*, 1923, oil on canvas, 38⅜ × 36¾″, The Solomon R. Guggenheim Museum, New York. Gift of Solomon R. Guggenheim, 1937.

6.31. Klee: *Old Town and Bridge*, 1928, private collection, Berne.

6.32. Examples of patterns and diagrams from various Gestalt publications found in Klee (6–31). 1922–35. Left top: Erich Lindemann, "Beitrage zur Psychologie der Gestalt" in *Psychologische Forschung 2,* 1922, p. 40; also Friedrich Wolf, "Über die Veranderung von Vorstellungen", in *Psychologische Forschung 1,* 1922, pp. 333–73, Tafel IV. Left below: Friedrich Wolf, Ibid. Center top: Max Wertheimer, "Untersuchen zur Lehre von der Gestalt II," in *Psychologische Forschung 4,* 1923, p. 322. Center center: dot pattern; Max Wertheimer, Ibid, p. 321; line pattern from Lindemann, *op. cit.;* also from Wolf, *op. cit.,* Tafel 1. Center bottom: G. W. Hartmann, *Gestalt Psychology: A Survey of Facts and Principles*, Ronald Press, New York, 1935, p. 86 (see also Wertheimer, *op. cit.,* p. 323). Right top: K. Koffka, *Principles of Gestalt Psychology*, Harcourt, Brace, New York, 1935, p. 185. Right center: K. Gottschaldt, "Über der Einfluss der Erfahrung auf die Wahrnehmung von Figuren II", in *Psychologische Forschung 12,* 1929, p. 46, Tafel 10 II. Right lower: Max Wertheimer, "Untersuchen zur Lehre von der Gestalt II," in *Psychologische Forschung 4,* 1923, p. 321.

6.33. Fuchs: Overlapping of planes as a basis for perceived transparency. From Fuchs, "Experimentelle Untersuchen über das simultane Hintereinandersehen auf derselben Sehrichtung", in *Zeitschrift für Psychologie 91,* 1923, pp. 145–235.

6.34. Wertheimer: Overlapping and touching planes. From M. Wertheimer, "Untersuchungeng zur Lehre von der Gestalt II", in *Psychologische Forschung 4,* 1923, pp. 301–50.

6.35. Klee: Overlapping planes (Bauhaus notebooks). 1921–30. From Paul Klee, *The Thinking Eye: The Notebooks of Paul Klee*, Wittenborn, New York, 1961, edited by J. Spiller, translated by R. Manheim, p. 119.

6.36. Klee: *Dancing Master*, 1930, ink on paper, private collection.

6.37. Klee: *Laced into a Group*, 1930, ink on paper, 18½″ high, Paul Klee Foundation, Berne, © by A.D.A.G.P., Paris and COSMO-PRESS, Geneve, 1983.

6.38. Klee: *Rich Land*, 1931, crayon, 8¼ × 12″, Collection Felix Klee, Berne.

6.39. Moholy-Nagy: *Colored Segments*, 1922–23, watercolor and pencil on paper, 22 × 18″, Indianapolis Museum of Art, Gift of Mr. and Mrs. J. W. Alsdorf.

6.40. Overlapping planes showing transparency (First described in Fuchs, 1923). From Josef Albers, *The Interaction of Color*, Yale University Press, New Haven, 1962, plate X-1.

6.41. Blanc: Drawing of a human face (from deSuperville). From C. Blanc, *Grammaire des Arts du Dessin*, Librarie Renouard, Paris, 1876, 3d ed., p. 33.

6.42. de Superville, *Synpotic Table*, 1827–32. From W. I. Homer, *Seurat and the Science of Painting*, MIT Press, Cambridge, Massachusetts, 1964, p. 203.

6.43. Seurat: *L'Homme à Femmes*, 1889.

6.44. Seurat: *Le Cirque,* 1890–91, oil on canvas, 72¾ × 59″, Musée du Jeu de Paume, Paris.

6.45. Henry: Esthetic Protractor, 1888. From W. I. Homer, *Seurat and the Science of Painting*, MIT Press, Cambridge, Massachusetts, 1964, p. 193.

6.46. Diagram illustrating Charles Henry's Theory of Expression, 1888. From W. I. Homer, *Seurat and the Science of Painting*, MIT Press, Cambridge, Massachusetts, 1964, p. 206, figure 59.

6.47. Diagram illustrating Seurat's Theory of Expression. From W. I. Homer, *Seurat and the Science of Painting*, MIT Press, Cambridge, Massachusetts, 1964, p. 207.

6.48. Drawings from a letter by Seurat illustrating some of his Theory of Expression. 1890. From W. I. Homer, *Seurat and the Science of Painting*, MIT Press, Cambridge, Massachusetts, 1964, p. 204.

6.49. Seurat: *Invitation to the Side Show (La Parade)*, 1887–88, oil on canvas, 39¼ × 59″, Metropolitan Museum of Art, New York, Bequest of Stephen C. Clark, 1960.

6.50. Lipps: Line orientations in terms of their proposed dynamic psychological principles. From Lipps, "Raumaesthetik und Geometrische-Optische Tauschungen", in *Schriften der Gesellschaft für Psychologische Forschung* (Heft 9/10), 1897, p. 106, figure 35.

6.51. Kandinsky: Basic types of geometric straight lines, 1926. From W. Kandinsky, *Point and Line to Plane*, edited by H. Rebay and translated by H. Dearstyne and H. Rebay, Guggenheim Foundation, New York, 1947, p. 59, figure 14 (originally published in German, 1926).

6.52. Blanc: Diagram of the three basic types of lines — each with its own

associated feeling. From C. Blanc, *Grammaire des Arts du Dessin,* Librarie Renouard, Paris, 1876, 3d ed., p. 33.

6.53. Lipps: Diagram. From Lipps, "Raumaesthetik und Geometrische-Optische Tauschungen", in *Schriften der Gesellschaft für Psychologische Forschung* (Heft 9/10), 1897, p. 223, figure 80.

6.54. Kandinsky: Curve with uniform alternation of positive and negative pressure. From W. Kandinsky, *Point and Line to Plane*, edited by H. Rebay and translated by H. Dearstyne and H. Rebay, Guggenheim Foundation, New York, 1947, p. 85, figure 41.

6.55. Klee: *Burden,* 1939, pencil on paper, 11½ × 8¼", Collection Felix Klee, Berne.

6.56. Lipps: Diagram. From Lipps, "Raumaesthetik und Geometrische-Optische Tauschungen", in *Schriften der Gesellschaft für Psychologische Forschung* (Heft 9/10), 1897, p. 90, figure 21.

6.57. Lipps: Diagram with reference to perceptual effects of neighboring angles on the center angle. From Lipps, "Raumaesthetik und Geometrische-Optische Tauschungen", in *Schriften der Gesellschaft für Psychologische Forschung* (Heft 9/10), 1897, p. 139, figures 150 and 151.

6.58. Vertically oriented shapes with the empathetic quality of "warm rest" (according to Kandinsky, 1926). From W. Kandinsky, *Point and Line to Plane*, edited by H. Rebay, translated by H. Dearstyne and H. Rebay, Guggenheim Foundation, New York, 1947, p. 130.

6.59. Kandinsky: Angle made from the two forces of each line; acute angles are tensest and warmest. From W. Kandinsky, *Point and Line to Plane,* edited by H. Rebay, translated by H. Dearstyne and H. Rebay, Guggenheim Foundation, New York, 1947, (A) p. 69, figure 24; (B) p. 71, figure 27 (originally published in German in 1926).

6.60. Schoenmaekers: Diagram of opposed straight lines. From M. H. J. Schoenmaekers, *Het Nieuwe Wereldbeeld* (*The New World Image*), C. A. J. Dishoeck, Bussum, 1915, p. 41.

6.61. Schoenmaekers: Diagram of cross: both a cosmic "Gestalt" mathematical coordinate system for the universe and a religious system. From M. H. J. Schoenmaekers, *Het Nieuwe Wereldbeeld* (*The New World Image*), C. A. J. Dishoeck, Bussum, 1915, p. 56.

6.62. Schoenmaekers: Cross figure. From M. H. J. Schoenmaekers, *Beginselen der Beeldende Wiskunde* (*Foundations of Plastic Mathematics*), C. A. J. Dishoeck, Bussum, 1916, p. 72.

6.63. Schoenmaekers: Cross at center of elliptical representation of the universe. From M. H. J. Schoenmaekers, *Het Nieuwe Wereldbeeld* (*The New World Image*), C. A. J. Dishoeck, Bussum, 1915, p. 156.

6.64. Schoenmaekers: Cross at center of diamond-shaped representation of the universe. From M. H. J. Schoenmaekers, *Het Neiuwe*

Werenbeeld (*The New World Image*), C. A. J. Dishoeck, Bussum, 1915, p. 114.

6.65. Mondrian: *Composition 1916*, 1916, oil on canvas, 47¼ × 29½", The Solomon R. Guggenheim Museum, New York.

6.66. Mondrian: *Lozenge*, 1919, oil on canvas, 19⁵/₁₆ × 19⁵/₁₆", Collection Rijksmuseum Kroller-Muller, Otterlo, Holland.

6.67. Mondrian: *Church at Domburg*, 1914, India ink on paper, 24¹³/₁₆ × 19¾", Collection Haags Gemeentemuseum, The Hague.

6.68. Pritchard: Lines act independently in stabilized vision with breakage in the fading figure at an intersection of lines. Adjacent or parallel lines may operate as units. From R. M. Pritchard, "Stabilized Images on the Retina", *Scientific American,* June 1961.

6.69. Oscilliscope record of a cortical cell whose maximal response is to a vertically oriented straight line stimulus. At (A) the line produces no response; slight tilt at (B) produces a weak response; vertical stimulus at (C) produces a strong response. From P. Mussen and M. R. Rosenzweig, *Psychology: An Introduction*, D. C. Heath and Co., Lexington, Massachusetts, 1973, p. 627.

6.70. Cortical cell sensitive to the direction of motion of a straight line stimulus. The cell responds strongly only when moved down. The oscilloscope record shows a weak response when the stimulus is moved up and no response to sideways motion. From *Sensation and Perception: An Integrated Approach*, Harvey Richard Schiffman. N.Y.: Wiley, 2nd Ed., 1982, p. 206.

6.71. Olson and Attneave: Straight line stimuli perceptually segregated by orientation. From R. K. Olson and F. Attneave, "What Variables Produce Similarity Grouping", in *The American Journal of Psychology*, 1970, vol. 83, pp. 1–21.

6.72. Mondrian: *Composition of Lines*, 1917, oil on canvas, 42⅝ × 42⅝", Collection Rijksmuseum Kroller-Muller, Otterlo, Holland.

6.73. van der Leck: *Composition #5, 1917 (Donkey Riders)*, 1917, oil on canvas, 23¼ × 57⅞", private collection.

6.74. Olson and Attneave: Straight line stimuli perceptually segregated by orientation. From R. K. Olson and F. Attneave, "What Variables Produce Similarity Grouping", in *The American Journal of Psychology*, 1970 vol. 83, pp. 1–21.

6.75. Lewitt, Examples from *Location of Lines*, Lissan Publications, 1974.

6.76. Hubel: At top an oscilloscope recording shows strong firing by an "on-center" type of cell when a spot of light strikes the field center; if the spot hits an "off" area, the firing is suppressed until the light goes off. At bottom are responses of another cell of the "off-center" type. 1963. From D. H. Hubel, "The Visual Cortex of the Brain", *Scientific American,* November, 1963.

6.77. Kuffler: "Spot"-shaped receptive field of a ganglion cell located at the tip of electrode. The exploring spot was 0.2mm in diameter. In the central region "on" discharges (+) are found, while in the diagonally-hatched area only "off" discharges occur (0). In the intermediate zone discharges are "on-off". Note shape of receptive field, especially the "off" field is closer to an oval than a circle.

From S. W. Kuffler, "Discharge Patterns and Functional Organization of Mammalian Retina", in *Journal of Neural Physiology*, 1953, vol. 16, pp. 57–68.

6.78. Poons: *Northeast Grave*, 1964, synthetic polymer and pencil on canvas, 80⅛ × 90⅛″, Hirshhorn Museum and Sculpture Garden, Smithsonian Institution.

6.79. Miró: *The Wing of the Lark Encircled by Blue and Gold Rejoins the Heart of the Poppy Which is Sleeping on the Prairie Adorned with Diamonds*, 1967, oil on canvas, 76¾ × 51″, Courtesy Foundation Maeght.

6.80. Hubel and Wiesel: Angle-shaped stimuli to watch certain cortical neurons respond. From D. H. Hubel and T. Wiesel, "Receptive Fields and Functional Architecture in Two Non-Striate Visual Areas (18 & 19) of the Cat", in *Journal of Neurophysiology*, 1965, vol. 28, no. 2, p. 245, figure 9.

6.81. Lipps: Repeated angle pattern with dynamic properties. From Lipps, "Raumaesthetik und Geometrische-Optische Tauschungen", in *Schriften der Gesellschaft für Psychologische Forschung* (Heft 9/10), 1897, p. 318, figure 156.

6.82. Beck: L- and T-shaped stimuli used to study factors in perceptual grouping. From J. Beck, "Effect of orientation and of shape similarity in perceptual grouping", in *Perception and Psychophysics*, 1966, vol. 1, pp. 301–02.

6.83. Olson and Attneave: Angle stimuli used in study of perceptual grouping. From R. K. Olson and F. Attneave, "What Variables Produce Similarity Grouping," in *The American Journal of Psychology*, 1970, vol. 83, pp. 1–21.

6.84. Kandinsky: Complex of lines; repetition of an angular line. From W. Kandinsky, *Point and Line to Plane*, edited by H. Rebay and translated by H. Dearstyne and H. Rebay, Guggenheim Foundation, 1947, p. 94, figure 51 (originally published in 1926 in German).

6.85. Noland: *Drive*, 1964, acrylic on canvas, 69½ × 69½″, Collection The Saint Louis Art Museum.

6.86. Stella: *Quathlamba*, 1964, metallic powder in polymer emulsion on canvas, 77 × 163″, Collection Mr. and Mrs. S. Carter Burden, Jr. Photography Courtesy Leo Castelli Gallery, New York.

6.87. David Smith: *Cubi XXVI*, 1965, steel, 119½ × 151 × 25⅞″, Collection National Gallery of Art, Washington, D. C., Ailsa Mellon Bruce Fund.

7.1. Plateau: Spiral. From J. Plateau, "Quatrième note sur des nouvelles applications curieuses de la persistance des impressions de la rétine", in *Bulletin Academie Science Belgique*, 1850, vol. 16, no. 2, pp. 254–60.

7.2. Musatti: Stimulus circles which when rotated cause stereokinetic effect. From C. L. Musatti, "Sui Fenomeni Stereokinetici", in *Archivio Italiano di Psicologia*, 1924, vol. 3, pp. 105–20.

7.3. Duchamp: Optical disk from Anémic Cinema. From Arturo Schwarz, *Marcèl Duchamp*, Harry N. Abrams, New York, 1975, plate 161.

7.4. Duchamp: Frames from uncompleted stereofilm; left frame green, the right red, 1920, film with holder, $3\frac{3}{4} \times 7\frac{1}{4}''$, Estate of Man Ray. From A. d'Harnoncourt and K. McShine, *Marcel Duchamp*, New York and Philadelphia, Museum of Modern Art and Philadelphia Museum of Art, 1973, p. 293.

7.5. Breese: Green and red stimuli with oblique lines to study binocular rivalry. From B. B. Breese, "On Inhibition," in *Psychological Mongraphs*, 1899, vol. 3, no. 1.

7.6. Helmholtz: Concentric circle stimulus. First reproduced in H. Holmholtz, *Handbuch der Physiologischen Optik*, Voss, Leipzig, 1867, plate 2, figure 4.

7.7. Tadasky: *A-101*, 1964, synthetic polymer paint on canvas, $52 \times 52''$, Collection the Museum of Modern Art, New York. Larry Aldrich Foundation Fund.

7.8. Duchamp: *Revolving Glass*, 1920, mixed media, $47\frac{1}{2} \times 72\frac{1}{2}''$, Yale University Art Gallery, Gift of Collection Société Anonyme.

7.9. McKay: Ray pattern: moving image produced by a regular stationary pattern. From D. M. MacKay, *Nature*, 1957, vol. 180, p. 849. Reproduced from R. L. Gregory, *Eye and Brain*, World University Library, 1966, Weidenfeld & Nicolson Ltd., p. 134.

7.10. Schouten: Stimuli for investigating visual movement detectors. From J. F. Schouten, "Subjective Stroboscopy and a Model of Visual Movement Detectors", in *Models for the Perception of Speech and Visual Form*, edited by W. Wathen-Dunn, MIT Press, Cambridge, Massachusetts, 1967, p. 49, figure 4.

7.11. Ludwig: *Cinematic Painting*, 1964, oil on composition board, $24\frac{1}{8} \times 48\frac{1}{8}''$, Collection of the artist.

7.12. Schumann: First published subjective contour pattern: note the appearance of a vertical white stripe bounded by straight lines at the right and left where it is separated from the semi-circular figures. From F. Schumann, "Beitrage zur Analyse der Gesichtswahrnehmungen", in *Zeitschrift für Psychologie,* Berlin, 1900, vol. 23, p. 13, figure 7.

7.13. Kanizsa: Subjective contour pattern: note the enhanced whiteness of square in center (after Coren, 1972). From G. Kanizsa, "Subjective Contours", in *Scientific American*, April, 1976, vol. 234, no. 4, pp. 48–52, p. 5 of offprint.

7.14. Vasarely: *Betelgeuse II*, 1958, oil on canvas, 76¾ × 51", Courtesy the artist.

7.15. Penrose and Penrose: Impossible figures. From L. S. Penrose and R. Penrose, "Impossible objects: a special type of illusion", in *British Journal of Psychology*, 1958, vol. 49, p. 31. These examples from R. L. Gregory, *Eye and Brain,* World University Library 1966, Weidenfeld & Nicolson Ltd., p. 227.

7.16. Albers: *Structural Constellations*, 1953–58, from *Despite Straight Lines,* pp. 63, 79 (courtesy of the artist). Taken from R. G. Carraher and J. B. Thurston, *Optical Illusions and the Visual Arts*, Reinhold and Co., New York, 1966, p. 41.

7.17. Necker cube from German psychology text, ca. 1910. Source lost. (Original publication date of this cube is 1832.)

7.18. Impossible Necker cube: note how the treatment of the vertical "back" line with the horizontal "front" line creates the perceptual impossibility. From advertising flyer for psychology books, ca. 1975. Source lost.

7.19. Goethe: Checkerboard grid from R. Krauss, *Grids,* The Pace Gallery, exhibition catalogue, 2d ed., 1980, unpaged. Original Johann Wolfgang von Goethe, *Theory of Colour* Charles Eastlake (trans.) London: Murray, 1840.

7.20. Helmholtz: Grid stimulus for study of stereoscopic vision. First reproduced in H. Helmholtz, *Handbuch der Physiologischen Optik*, Voss, Leipzig, 1867, plate 7.

7.21. Muybridge, *First Ballet Action*, 1884–87. From G. Hendricks, *Eadweard Muybridge: The Father of the Motion Picture*, Grossman, New York, 1975, figure 157.

7.22. LeWitt: *Modular Drawings*. From LeWitt, *Modular Drawings*, Adelina von Furstenberg, Geneva, 1976, unpaged.

7.23. Matisse: *The Moroccans,* 1916, oil on canvas, 71⅜" × 9'2", Collection, Museum of Modern Art, Gift of Mr. and Mrs. Samuel A. Marx.

7.24. Picabia: *Venus and Adonis*, 1924–27. Location unknown. Reproduced in A. Schwarz, *New York Dada*, Prestel, Munich, 1973, p. 148.

7.25. Mondrian: *New York City, New York,* ca 1942, oil, pencil, charcoal, and painted tape on canvas, 42 × 43½", Courtesy Sidney Janis Gallery, New York.

7.26. Morellet: *16 Squares,* 1953, reproduced with permission of artist. From *Morellet,* exhibition catalog. Arles, France, 1978.

7.27. Warhol: *Dollar Bills*, 1962, acrylic on canvas, 82 × 92", Collection Robert C. Scull.

7.28. Jensen: *The Reciprocal Relation of Unity 20-40-60-80 That Forms the Beginning of the Vigesimal System*, 1969, oil on canvas, 49½ × 65", Collection Douglas and Carol Cohen.

7.29. André: *Aluminum-Steel Plain,* 1969, 18 aluminum and 18 steel plates, overall size ⅜ × 72 × 72″, Courtesy Sperone Westwater Fischer.

7.30. Cornelius: Drawings characterizing a vertical surface. From H. Cornelius, *Elementargesetze der Bildenden Kunst,* Teubner, Leipzig and Berlin, 1908, p. 123.

7.31. Cornelius: Strong and weak lines on vertical surfaces. (Clarity of the surface as affected by line orientation and shape.) From H. Cornelius, *Elementargesetze der Bildenden Kunst,* Teubner, Leipzig and Berlin, 1908, p. 124, figures 136,137,138,139.

7.32. Kandinsky: Repetition of a straight line at equal intervals—the primitive rhythm; in uniformly increasing intervals; in unequal intervals. From W. Kandinsky, *Point and Line to Plane,* edited by H. Rebay and translated by H. Dearstyne and H. Rebay, Guggenheim Foundation, New York, 1947, p. 95, figures 59,60,61.

7.33. Kandinsky: Decor for Mussorgsky's *Pictures at an Exhibition.* From Paul Overy, *Kandinsky: The Language of the Eye,* Elek, London, 1968, plate 58. Original work dated 1928.

7.34. Monet: *The Four Poplars,* 1891, oil on canvas, 32¼ × 32⅛″, Collection Metropolitan Museum of Art, New York. Bequest of Mrs. H. O. Havemeyer, 1929. The H. O. Havemeyer Collection.

7.35. J. J. Gibson: Gradients of vertical spacing corresponding to three types of surfaces. From J. J. Gibson, *The Perception of the Visual World,* Houghton Mifflin Co., Boston, 1950, p. 89, figure 37. Copyright © 1950, renewed 1977 by Houghton Mifflin Company. Used by permission.

7.36. Experimental arrangement for recording electrical potentials evoked in the brain by grating stimulus flashed on a screen. Electrodes are on back of head; with animals microelectrodes are surgically implanted in visual cortex. From F. W. Campbell and L. Maffei, "Contrast and Spatial Frequency" *Scientific American,* November, 1974.

7.37. The sine-wave grating in (b) has twice the spatial frequency in (a). When the two light distributions are added together, the distribution in (c) results. The intensity of each point in (c) is simply the sum of the intensities in the corresponding points in (a) and (b). From T. N. Cornsweet, *Visual Perception,* Academic Press, Inc., New York, 1970, p. 314, figure 12-2.

7.38. Simple square wave grating (left) with the shape of the light intensity (right). From D. H. McBurney and V. B. Collings, *Introduction to Sensation/Perception,* © 1977, p. 120. Reprinted by permission of Prentice Hall, Englewood Cliffs, NJ.

7.39. Goldstein: Grating or stripe visual environment for experiment with kittens. From E. Bruce Goldstein, *Sensation and Perception,* p. 293, figure 9.2, © 1980 by Wadsworth, Inc. Reprinted by per-

mission of Wasdworth Publishing Company, Belmont, California.

7.40. Horizontal grating image—from malfunctioning television set. Courtesy Scott Bowron.

7.41. Newman: *Vir heroicus sublimus*, 1950–51, oil on canvas, 7′11⅜″ × 17′9¼″, Collection, The Museum of Modern Art, New York, Gift of Mr. and Mrs. Ben Heller.

7.42. Noland: *Wild Indigo*, 1967, acrylic on canvas, 89 × 207″, Collection Albright-Knox Art Gallery, Buffalo, New York, Charles Clifton Fund.

7.43. Martin: *On a Clear Day #16*, 1973, silkscreen, 15 × 15″, edition of 50, Courtesy Pace Editions, Inc.

7.44. Johns: *Flag*, 1954–55, encaustic, oil, and collage on fabric mounted on plywood, 42¼ × 60⅝″, Collection of The Museum of Modern Art, New York, Gift of Philip Johnson in honor of Alfred H. Barr, Jr.

7.45. Johns: *Scent*, 1973–74, encaustic and oil on canvas, 72 × 14″ (3 panels), Ludwig Collection.

7.46. Dubuffet: *Compagnie Fallacieuse,* 1963, oil on canvas, 44⅞ × 57½″, Collection Robert and Jane Meyerhoff.

7.47. Goethe: Screens with black and white patterns used for prismatic experiments. At left is a meter scale to give an idea of the size, 1810. From *Goethe's Color Theory*, edited by Rupprecht Matthei, Van Nostrand Reinhold Co., New York, 1971, p. 61.

7.48. Helmholtz: Slightly distorted checkerboard pattern for stereoscopic vision experiment. First reproduced in H. Helmholtz, *Handbuch der Physiologischen Optik*, Leipzig, Voss, 1867, plate 6.

7.49. Wundt: Depth in "warped" checkerboard pattern. From W. Wundt, "Zur Theorie der raumlichen Gesichtswahrnehmungen", in *Philosophische Studien*, 1898, vol. 14, p. 42.

7.50. Gibson and Walk: The visual cliff. The apparatus consists of a board laid across a sheet of heavy glass, with a patterned material directly beneath the glass on one side and several feet below it on the other, 1960. From *Perception*, Lloyd Kaufman, New York: Oxford, 1979, p. 237.

7.51. Gibson and Walk: Child called from the "deep" side, pats the glass, but refuses to cross over to the mother. (1960). From E. J. Gibson and R. W. Walk, "The Visual Cliff," *Scientific American,* April, 1960. Courtesy William Vandivert and *Scientific American*.

7.52. Gibson and Walk: Kitten on visual cliff. From E. J. Gibson and R. W. Walk, "The Visual Cliff", *Scientific American,* April, 1960, cover. Courtesy William Vandivert and *Scientific American*.

7.53. Riley: *Movement in Squares*, 1961, tempera on board, 48 × 48″, Collection Arts Council of Great Britain.

7.54. Riley: *Static 3*, 1966, emulsion on canvas, 64½ × 64½″, Power Collection, Sydney, Australia.

7.55. Gibson: Spot distributions based on perfectly regular spacing of

the elements. (Change in density [left] causes perception of depth; constant density [right] does not.) From J. J. Gibson, *The Perception of the Visual World*, Houghton Mifflin Co., Boston, 1950, p. 88, figure 36. Copyright © 1950, renewed 1977 by Houghton Mifflin Company. Used by permission.

7.56. Anuszkiewicz: *Progression: In and Out*, 1965, acrylic on canvas, 48 × 48″, private collection.

7.57. Gibson: Reversal of shape due to reversed gradients of density. From J. J. Gibson, *The Perception of the Visual World*, Houghton Mifflin Co., Boston, 1950, p. 98, figure 46. Copyright © 1950, renewed 1977 by Houghton Mifflin Company. Used by permission.

7.58. Vitz and Todd: Families of reversible-perspective figures (adapted from Hochberg and Brooks, 1960). From P. Vitz and T. Todd, "A Model of Perception of Simple Geometric Figures", in *Psychological Review*, 1971, vol. 78, pp. 207–28.

7.59. Hochberg: Reversible-perspective figure presented in single vertical slices. (Top) Slice 2 (of above) showing intact corner as factor in creating perceived 3-dimensionality. From J. Hochberg, "In the Mind's Eye", in *Contemporary Theory and Research in Visual Perception*, edited by R. N. Haber. Holt, Rinehart, Winston, New York, 1968, p. 318, figure 5 (detail).

7.60. Hochberg: Views of a 3-D drawing behind an aperture. From J. Hochberg, "In the Mind's Eye", in *Contemporary Theory and Research in Visual Perception*, edited by R. N. Haber. Holt, Rinehart, Winston, New York, 1968, p. 320, figure 7 (detail).

7.61. Orbach, Ehrlich, Vainstein: Reversibility of the Necker cube. From J. Ohrbach, D. Ehrlich, and E. Vainstein, "Reversibility of the Necker Cube: III. Effects of interpolation in reversal rate of the cube presented repetitively," in *Perceptual and Motor Skills*, 1963, vol. 17, pp. 571–82, figure 4.

7.62. Held: *Southeast*, 1972, acrylic on canvas, 11′6″ × 14′, Collection of the artist.

7.63. Held: *Solar Wind V*, 1974, acrylic on canvas, 11′ × 16′, Collection of the artist.

7.64. Judd and Cowling: Nonsense figures used to study memory for shapes. From C. H. Judd and D. J. Cowling, *Psychological Monograph*, 1907, number 34, pp. 349–69.

7.65. Duchamp: *Network of Stoppages*, 1914, oil and pencil on canvas, 58⅝″ × 6′5⅝″, Collection, The Museum of Modern Art, New York, Abby Aldrich Rockefeller Fund and Gift of Mrs. William Sisler.

7.66. Vitz: Short random walks: stimuli for experiment on preference as a function of stimulus complexity. From P. Vitz, "Preference for Different Amounts of Visual Complexity," *Behavioral Science*, March, 1966, vol. ii, no. 2, p. 107, Figure 1.

7.67. André: Artist's studio, 1970. From D. Waldman, *Carl André*, Guggenheim Museum, exhibition catalogue, New York, 1970, p. 22.

7.68. Vanderplas and Garvin: Twenty-four point random polygons (After Attneave and Arnoult, 1954). From J. M. Vanderplas and E. A. Garvin, "The Association Value of Random Shapes", in *Journal of Experimental Psychology*, 1959, vol. 57, pp. 147–54.

7.69. Rubin: Ambiguous figure-ground. From E. Rubin, *Synooplevede figurer,* Gyldendalske, Copenhagen, 1915. Taken from German edition, 1921.

7.70. Kandinsky: Many angled (zig-zag) line of diverse parts. From W. Kandinsky, *Point and Line to Plane*, edited by H. Rebay, translated by H. Dearstyne and H. Rebay, Guggenheim Foundation, New York, 1947, p. 78.

7.71. Matisse: *Green Chasuble*, 1950–52, paper cut-out, $51^{3}/_{16} \times 78^{3}/_{4}$", Musée Matisse, Nice-Cimiez, S.P.A.D.E.M. - V.A.G.A.

7.72. Vanderplas and Garvin: Random polygons with six points (After Attneave and Arnoult, 1954). From J. M. Vanderplas and E. A. Garvin, "The Association Value of Random Shapes", in *Journal of Experimental Psychology*, 1959, vol. 57, pp. 147–54.

7.73. Kline: Untitled, 1952, oil and paper on aluminum, $32^{1}/_{4} \times 43^{3}/_{4}$", Collection Guggenheim Museum, New York.

7.74. Kelly: *Cowboy*, 1958, oil on canvas, $45 \times 43''$, Collection Jacques Neubauer, Paris.

7.75. Bochner: *Three Shapes*, 1976, pastel on paper, $38 \times 50''$, private collection. Photograph Courtesy Sonnabend Gallery.

7.76. Pollock: *One (Number 31, 1950)*, 1950, oil and enamel paint on canvas, $8'10'' \times 17'5^{5}/_{8}''$, Collection, The Museum of Modern Art, New York, Gift of Sidney Janis.

7.77. Attneave: A "random field" consisting of 19,600 cells. The state of each cell (black vs. white) was determined independently with a probability of .50. From F. Attneave, "Some Informational Aspects of Visual Perception", in *Psychological Review*, 1954, vol. 61, pp. 183–93.

7.78. Vitz: Long random walk: stimulus for experiment on preference as function of stimulus complexity. From P. Vitz, "Preference for Different Amounts of Visual Complexity", in *Behavioral Science*, 1966, vol. 11, pp. 105–14.

7.79. Dorfman and McKenna: Stimuli varying in complexity constructed by change procedures. For experiment on pattern preference as determined by pattern uncertainty. From D. Dorfman and H. McKenna, "Pattern Preference as a Function of Pattern Uncertainty", in *Canadian Journal of Psychology*, vol. 20, 1966, pp. 143–53.

7.80. Julesz: Random-dot stereogram (of 33×33 resolution). From

B. Julesz, *Foundations of Cyclopean Perception*, University of Chicago Press, Chicago, 1971, p. 339.

7.81. Morellet: *Chance Distribution of 40,000 Squares 50% White, 50% Black,* 1961, reproduced with permission of artist. From *Morellet,* exhibition catalog. Arles, France, 1978.

7.82. Kelly: *Seine,* 1951, oil on wood, 16½ × 45½″, collection the artist. Photograph Courtesy Malcolm Varon.

7.83. Kelly: *Spectrum Color Arranged by Chance,* 1952–53, oil on wood, 60 × 60″, Collection the artist. Photograph Courtesy Leo Castelli Gallery.

7.84. Vitz: Random lines in a square: stimulus for experiment on preference as a function of stimulus complexity. From P. Vitz, "Preference for Different Amounts of Visual Complexity," in *Behavioral Science,* 1966, vol. 11, pp. 105–14.

7.85. Morellet: *50 Random Lines,* 1967, reproduced with permission of artist. From *François Morellet,* exhibition catalog. Galerie in Bochum, 1976–77.

7.86. Kandinsky: Unbalanced lines, acentric. From W. Kandinsky, *Point and Line to Plane,* edited by H. Rebay and translated by H. Dearstyne and H. Rebay, Guggenheim Foundation, 1947, p. 20.

7.87. Black and white visual noise on television screen. Courtesy Scott Bowron.

7.88. Reinhardt: *Untitled,* 1956, oil on canvas, 60½ × 40½″. Courtesy The Pace Gallery, New York.

7.89. Klein: *Blue Monochrome,* 1961, oil on cotton cloth over plywood, 6′4⅞″ × 55⅛″, The Sidney and Harriet Janis Collection, Gift to The Museum of Modern Art, New York.

7.90. Rothko: *White Cloud,* 1956, oil on canvas, 66½ × 62½″, private collection.

7.91. Irwin: Untitled wall (installation), wood and sheetrock, 1973. Courtesy The Pace Gallery, New York.

7.92. Heron: Experimental cubicle construction to study the effects of perceptual isolation. The subject lies in bed 24 hours a day, with time out for meals and going to the bathroom. The room is always lighted. The visual perception of the subject is restricted by a translucent visor; his auditory perception, by a U-shaped pillow covering his ears and by the noise of an air conditioner and a fan. The subject's sense of touch is restricted by cotton gloves and long cardboard cuffs. From W. Heron, "The Pathology of Boredom", in *Scientific American,* January, 1957.

7.93. Warhol: *Sleep,* 1963, still from movie. Permission of artist.

8.1. Close: *Robert/Square Fingerprint II,* 1978, pencil and stamp pad

ink on paper, 29½ × 22½", Collection Mr. and Mrs. Julius E. Davis.

8.2. L. D. Harmon and B. Julesz: Computer-processed block portraits used to study visual recognition of portraits, 1973. Cover from *Science,* June 15, 1973, Vol. 180, no. 4091. Permission of L. D. Harmon.

8.3. Close: *Self-Portrait*, 1976–77, watercolor on paper mounted on canvas, 81 × 58¾", Ludwig Collection.

8.4. Chuck Close working on *Self-Portrait*, 1980. Courtesy Chuck Close.

Bibliography

Acton, H. B. "Hegel." In *The Encyclopedia of Philosophy,* edited by P. Edwards. Vol. 3. New York: Macmillan and Free Press, 1967.

Albers, J. *Interaction of Color.* New Haven: Yale University Press, 1963. (A clothbound text [80 pp.] and 80 color folders. Paperbound edition, 1971; revised edition, 1975.)

Albus, K. "A Quantitative Study of the Projection Area of the Central and Paracentral Visual Field in Area 7 of the Cat. II. The Spatial Organization of the Orientation Domain." *Experimental Brain Research* 24 (1975): 181–202.

Alexander, P. "Ernest Mach." In *The Encyclopedia of Philosophy,* edited by P. Edwards. Vol. 5. New York: Macmillan and Free Press, 1967.

Allen, G. *Physiological Aesthetics.* New York: Appleton, 1877.

Appelle, S. "Perception and Discrimination as a Function of Stimulus Orientation: The 'Oblique Effect' in Man and Animals." *Psychological Bulletin* 78 (1972): 266–78.

Argüelles, J. *Charles Henry and the Formation of a Psychophysical Aesthetic.* Chicago: University of Chicago Press, 1972.

Arnheim, R. "The Gestalt Theory of Expression." *Psychological Review* 56 (1949): 156–71. (Reprinted in R. Arnheim, *Towards a Psychology of Art: Collected Essays.* Berkeley: University of California Press, 1966.)

Arnheim, R. *Art and Visual Perception.* Berkeley: University of California Press, 1954.

Arnheim, R. *Film as Art.* Berkeley: University of California Press, 1957.

Arnheim, R. *Visual Thinking*. Berkeley: University of California Press, 1969.

Arnheim, R. *Entropy and Art: An Essay on Disorder and Order.* Berkeley: University of California Press, 1971.

Attneave, F. "Some Informational Aspects of Visual Perception." *Psychological Review* 61 (1954): 183–93.

Attneave, F. *Applications of Information Theory to Psychology.* New York: Holt, 1959.

Attneave, F. "Stochastic Composition Processes." *Journal of Aesthetics and Art Criticism* 17 (1959): 503–10.

Attneave, F. and Arnoult, M. D. "The Quantitative Study of Shape and Pattern Perception." *Psychological Bulletin* 53 (1956): 452–71.

Aubert, H. "Eine scheinbare bedeutende Drehung von Objekten bei Neigung des Kopfes nach rechts oder links." *Virchows Arch.* 20 (1861): 381–93.

Avant, L. L. "Vision in the Ganzfeld." *Psychological Bulletin* 64 (1965): 246–58.

Badt, K. *The Art of Cézanne*. Translated by S. A. Ogilvie. Berkeley: University of California Press, 1965 (originally published 1956).

Barr, A. *Cubism and Abstract Art*. New York: Museum of Modern Art, 1936.

Barrett, C. *An Introduction to Optical Art*. London: Studio Vista, 1971.

Bart, B. F. *Flaubert*. Syracuse: Syracuse University Press, 1967.

Bataille, G. *Manet: Biographical and Critical Study*. Translated by A. Wainhouse and J. Emmons. New York: Skira, 1955.

Battcock, G., ed. *The New Art: A Critical Anthology*. New York: Dutton, 1973.

Baudelaire, C. *Art in Paris 1845–1862. Salons and Other Exhibitions*. Translated and edited by J. Mayne. London: Phaidon, 1965.

Beck, J. "Effect of Orientation and of Shape Similarity in Perceptual Grouping." *Perception and Psychophysics* 1 (1966): 301–02.

Beckman, H. "Formative Years." In *Bauhaus and Bauhaus People,* edited by E. Neuman. New York: Van Nostrand Reinhold, 1970.

Behrens, R. "Camouflage, Art and Gestalt." *North American Review* 265 (1980): 8–18.

Bell, C. *Art*. London and New York: Putnam (Capricorn), 1958 (originally published 1913).

Berkson, W., ed. *Robert Motherwell*. New York: Museum of Modern Art, 1965.

Berlyne, D. E. "Novelty, Complexity, and Hedonic Value." *Perception and Psychophysics* 8 (1970): 279–86.

Berlyne, D. E., and Parham, L. C. C. "Determinants of Subjective Novelty." *Perception and Psychophysics* 3 (1968): 415–23.

Bexton, W. H.; Heron, T.; and Scott, T. H. "Effects of Decreased Variation in the Sensory Environment." *Canadian Journal of Psychology* 8 (1954): 70–76.

von Bezold, W. *Die Farbenlehre im Hinblick auf Kunst und Kunstgewerke*. Braunschweig: Westermann, 1874.

von Bezold, W. *Theory of Color in its Relation to Art and Art-Industry*. Translated by S. R. Koehler. Boston: Prang, 1876.

Biederman, C. *Art as the Evolution of Visual Knowledge.* Red Wing, Minn., 1948.

Birkhoff, G. D. *Aesthetic Measure.* Cambridge, Mass.: Harvard University Press, 1933.

Birren, F. *History of Color in Painting, with New Principles of Color Expression.* New York: Reinhold, 1965.

Birren, F., ed. *The Principles of Harmony and Contrast of Colors and Their Applications to the Arts by M. E. Chevreul.* (Based on the first English edition of 1854 as translated from the first French edition of 1839 with a special introduction and explanatory notes.) New York: Reinhold, 1967.

Birren, F., ed. *The Color Primer: A Basic Treatise on the Color System of Wilhelm Ostwald.* New York: Van Nostrand, 1969.

Blanc, C. *Grammaire des arts du dessein: Architecture, sculpture, peinture.* . . . Paris: Renouard, 1867; 2nd edition, 1870; 3rd edition, 1876.

Blanc, C. *The Grammar of Painting and Engraving.* Translated by K. N. Doggett. New York: Hurd and Houghton, 1874. (Translation of Blanc, 1870.)

Blank, A. A. "The Luneberg Theory of Binocular Space Perception." In *Psychology: A Study of a Science.* Vol. 1. Edited by S. Koch. New York: McGraw Hill, 1959.

Blanshard, F. B. *Retreat from Likeness in the Theory of Painting.* New York: Columbia University Press, 1949.

Blumenthal, A. L. "A Reappraisal of Wilhelm Wundt." *American Psychologist* 30 (1975): 1081–88.

Boring, E. G. *Sensation and Perception in the History of Experimental Psychology.* New York: Appleton-Century-Crofts, 1942.

Boring, E. G. *A History of Experimental Psychology,* 2nd edition. New York: Appleton-Century-Crofts, 1950 (originally published 1929).

Bornstein, M.; Kessen, W.; and Weiskopf, S. "The Categories of Hue in Infancy." *Science* 191 (1976): 201–02.

Breese, B. B. "On Inhibition." *Psychological Monographs* 3, no. 1 (1899) (whole no. 11).

Brewster, D. *The Stereoscope, Its History, Theory and Construction.* London: Murray, 1856. (Facsimile edition with introduction by R. Kingslake. Hastings-on-Hudson, N.Y.: Morgan & Morgan, 1971.)

Brücke, E. *Bruchstücke aus der Theorie der bildenden Kunste.* Leipzig: Brockhaus, 1877.

Brücke, E. *Principes scientifiques des beaux-arts: essais et fragments de théorie.* Paris: Bioliothèque Scientifique Internationale, Germer Baiilière, 1878. (Translation of Brücke, 1877.)

Buswell, G. *How People Look at Pictures.* Chicago: University of Chicago Press, 1935.

Cachin, F. *Paul Signac.* Paris: Bibliothèque des Arts, 1971.

Campbell, F. W., and Maffei, L. "Contrast and Spatial Frequency." *Scientific American,* November 1974, p. 109.

Carraher, R. G., and Thurston, J. B. *Optical Illusions and the Visual Arts.* New York: Reinhold/Studio Vista, 1966.

Chevruel, M. E. *De la loi du contraste simultané de couleurs, et de l'assortiment des objects colorés.* Paris: Pitois-Levrault, 1839.

Chevruel, M. E. *The Principles of Harmony and Contrast of Colours, and Their Application to the Arts.* Translated by

C. Martel (pseud.). London: Longman, Brown, Green and Longman, 1854; (3rd edition) London: Bohn, 1859.

Chevruel, M. E. *The Laws of Contrast of Colour and Their Application to the Arts of Painting.* Translated by J. Spanton. London: Routledge, 1857.

Chipp, H. B., ed. *Theories of Modern Art: A Source Book by Artists and Critics.* Berkeley: University of California Press, 1968.

Chipp, H. B. "Orphism and Color Theory." *Art Bulletin* 40 (1958): 50–63.

Chuck Close: Recent Work. Exhibition catalog. New York: Pace Gallery, 1977.

Cohen, A. A., ed. *The New Art of Color: The Writings of Robert and Sonia Delaunay.* New York: Viking, 1978.

Coke, van D. *The Painter and the Photograph.* Revised edition. Albuquerque: University of New Mexico Press, 1972.

Collins, M. *Colour-Blindness.* London: Kegan, Paul, Trench, Trubner, 1925; New York: Harcourt Brace, 1925.

Coren, S. "Subjective Contours and Apparent Depth." *Psychological Review* 79 (1972): 359–67.

Cornelius, H. "Über Gestaltqualitäten." *Zeitschrift für Psychologie* 22 (1899): 101–21.

Cornelius, H. *Psychologie als Erfahrungswissenschaft.* Leipzig: G. Teubner, 1897.

Cornelius, H. *Elementargesetze der Bildenden Kunst.* Leipzig & Berlin: Teubner, 1908.

Cornsweet, T. N. *Visual Perception.* New York: Academic Press, 1970.

Courthion, P. *Edouard Manet*. New York: Abrams, 1962.

Courthion, P. *Georges Seurat*. New York: Abrams, 1968.

Crone, R. "Malevich and Khlebnikov: Suprematism Reinterpreted." *Art Forum* 17 (1978): 38–47.

Delacroix, E. *The Journal of Eugène Delacroix*. Translated by W. Park. New York: Viking, 1972.

Dember, W. *Visual Perception: The Nineteenth Century*. New York: Wiley, 1964.

DeValois, R. L. "Contributions of Different Lateral Geniculate Cell Types to Visual Behavior." *Vision Research* 11 (1971): 383–96.

DeValois, R. L., and DeValois, K. K. "Neural Coding of Color." In *Handbook of Perception*. Vol. 5. Edited by E. C. Carterette and M. P. Friedman. New York: Academic Press, 1975.

D'Harnoncourt, A., and McShine, K., eds. *Marcel Duchamp*. New York: Museum of Modern Art and Philadelphia Museum of Art, 1973.

Diehl, G. *Vasarely*. New York: Crown, 1973.

Van Doesburg, T. *Grundbegriffe der neuen gestaltenden Kunst*. Munich: Langen, 1924 (Banhausbücher, no. 6).

Van Doesburg, T. *Prisma der Kunsten*. Orgaan van Nederlandsche, Kunstenaus, Vereenigingen, May 1936.

Dorfman, D., and McKenna, H. "Pattern Preference as a Function of Pattern Uncertainty." *Canadian Journal of Psychology* 20 (1966): 143–53.

Dudley, L. P. *Stereoptics: An Introduction*. London: MacDonald, 1951.

Ebbinghaus, H. *Über das Gedächtnis*. Leipzig: Dunker and Humblot, 1885.

Ebbinghaus, H. *Memory*. Translated by H. A. Ruger and C. E. Bussenius. New York: Teachers College, Columbia University, 1913.

von Ehrenfels, Christian. "Über Gestaltqualitäten." *Vierteljahresschrift für wissenschaftliche Philosophie* 14 (1890): 249–92.

Evans, R. M. *Introduction to Color*. New York: Wiley, 1948.

Everitt, C. W. F. *James Clark Maxwell: Physicist and Natural Philosopher*. New York: Scribner's, 1975.

Fechner, G. T. *Elemente der Psychophysik*. Leipzig: Breitkopf und Härtel, 1860.

Fechner, G. T. *Elements of Psychophysics*. Translated by H. E. Adler. New York: Holt, Rinehart, & Winston, 1966 (originally published 1860; this translation is only part of the original).

Fechner, G. T. *Vorschule der Aesthetik*. Leipzig: Breitkopf und Härtel, 1876.

von Fieandt, K. *The World of Perception*. Homewood, Ill.: Dorsey, 1960.

Finch, C. Introductory essay in *Concepts of Modern Art,* edited by T. Richardson and N. Stangos. New York: Harper & Row, Icon Editions, 1974.

Fischer, R. "Space-Time Coordinates of Excited and Tranquilized States." In *Psychiatry and Art*. Proceedings of the 4th International Colloquium of Psychopathology of Expression. Washington, D.C., 1966.

Fisher, G. H. "Ambiguous Figure Treatments in the Art of Salvador Dali." *Perception and Psychophysics* 2 (1967): 328–30.

Flaubert, G. *Madame Bovary*. Translated by F. Steegmuller. New York: Random House, 1957.

Forster-Hahn, F. "Marey, Muybridge, and Meissonier—The Study in Movement in Science and Art." In *Eadweard Muybridge: The Stanford Years, 1872–1882*. Palo Alto: Department of Art, Stanford University, 1972.

François Morellet. Exhibition catalog. Galerie in Bochum, 1976–77.

Friedman, M., and Lyons, L. *Close Portraits*. Exhibition Catalog. Minneapolis: Walker Art Center, 1980.

Fry, R. *Vision and Design*. London: Chatto and Windus, 1920.

Fuchs, W. "Experimentelle Untersuchen über das simultane Hintereinandersehen auf derselben Sehrichtung." *Zeitschrift für Psychologie* 91 (1923): 145–235. Reprinted as, "On Transparency." In *A Source Book of Gestalt Psychology*, edited by W. D. Ellis. New York: Humanities Press, 1950.

Gay, P. *Art and Act*. New York: Harper & Row, 1976.

Geelhaar, C. *Paul Klee and the Bauhaus*. Greenwich, Conn.: New York Graphic Society, 1973.

Gelb, A. "Theoretisches über 'Gestaltqualitäten." *Zeitschrift für Psychologie* 58 (1910): 1–58.

Geplante Malerei. Exhibition catalog. Milan: Galleria del Milione, 1974.

Gibson, E., and Walk, R. D. "The Visual Cliff." *Scientific American* 202 (1960): 64–71.

Gibson, J. J. *The Perception of the Visual World*. Boston: Houghton Mifflin, 1950.

Glimcher, A. B. *Louise Nevelson.* New York: Praeger, 1972.

Goethe, J. W. *Zur Farbenlehre.* Tübingen: Cotta, 1808–1810.

Goethe, J. W. *Goethe's Theory of Colours.* Translated by C. L. Eastlake. London: Murray, 1840.

Goldstein, E. B. *Sensation and Perception.* Belmont, Calif.: Wadsworth Publishing, 1980.

Gombrich, E. H. *Art and Illusion.* Princeton: Princeton University Press, 1960.

Gombrich, E. H. *The Sense of Order.* London: Phaidon, 1979.

Goosen, E. C. *Ellsworth Kelly.* New York: Museum of Modern Art, 1973.

Gottschaldt, K. "Über den Einfluss der Erfahrung auf die Wahrnehmungen von Figuren." *Psychologische Forschung* 8 (1926): 261–317. In English as "Gestalt Factors and Repetition." In *A Source Book of Gestalt Psychology,* edited by W. D. Ellis. New York: Humanities Press, 1950. (See also: Gottschaldt, K. "Über den Einfluss der Erfahrung auf die Wahrnehmungen von Figuren." II. *Psychologische Forschung* 12 (1929): 1–87.

Gowing, L. "The Logic of Organized Sensations." In *Cézanne—The Last Work,* edited by W. Rubin. New York: Museum of Modern Art, 1977.

Greenberg, C. *Art and Culture.* Boston: Beacon, 1961.

Greenberg, C. "Modernist Painting." *Art and Literature* 4 (1965): 193–201. (Reprinted in *The New Art,* edited by G. Battcock. New York: Dutton; revised edition, 1973.)

Gregory, R. L. *The Intelligent Eye.* New York: McGraw-Hill, 1970.

Gregory, R. L., and Gombrich, E. H., eds. *Illusion in Nature and Art*. London: Duckworth, 1973.

Grohman, W. *Klee*. New York: Abrams, 1955.

Guillemin, A. V. *La Lumière et les couleurs*. Paris: Hachette, 1874.

Hagen, M. A., ed. *The Perception of Pictures*. New York: Academic Press, 1980.

Hamerton, P. G. *Thoughts on Art*. Boston: Roberts Brothers, 1871.

Hamilton, G. M. *Manet and His Critics*. New Haven: Yale University Press, 1954.

Hanson, A. C. *Manet and the Modern Tradition*. New Haven: Yale University Press, 1977.

Harmon, L. D., and Julesz, B. "Computer-Processed Block Portraits Used to Study Visual Recognition of Portraits. *Science* 180 (1973): cover.

Hartmann, G. W. *Gestalt Psychology: A Survey of Facts and Principles*. New York: Ronald Press, 1935.

Hauser, A. *The Philosophy of Art History*. London: Routledge, Keegan Paul, 1959.

Hebb, D. O. *The Organization of Behavior*. New York: Wiley, 1949.

Hebb, D. O. "The Mammal and His Environment." *American Journal of Psychology* 3 (1955): 826–31.

Heelan, P. A. "Toward a New Analysis of the Pictorial Space of Vincent van Gogh." *Art Bulletin* 54 (1972): 478–92.

Heider, F. "Gestalt Theory: Early History and Reminiscences." In *Historical Conceptions of Psychology*, edited by M. Henle and J. Jaynes. New York: Springer, 1973.

Held, R. "Single Vision with Double Images: An Historic Problem." In *Vision and Artifact,* edited by M. Henle. New York: Springer, 1976.

von Helmholtz, H. *Handbuch der physiologischen Optik*. Leipzig: Voss, 1867.

von Helmholtz, H. *Helmholtz's Treatise on Physiological Optics,* 3 vols. Translated by J. P. C. Southall. Rochester: The Optical Society of America, 1924–1925 (originally published 1867).

von Helmholtz, H. *L'optique et la peinture.* In Brücke, E. *Principes scientifiques des beaux-arts: essais et fragments de théorie.* Paris: Bioliothèque Scientifique Internationale, Germer Baiilière, 1878. (Translation of Brücke, 1877.)

von Helmholtz, H. "The Origin and Nature of Geometric Axioms (1876)." In *Selected Writings of Herman von Helmholtz,* edited by R. Kahl. Middletown, Conn.: Wesleyan University Press, 1971.

von Helmholtz, H. *Popular Scientific Lectures.* Introduction by M. Kline. New York: Dover 1962; first published in German, 1865–1876.

Hendricks, G. *Eadweard Muybridge: The Father of the Motion Picture.* New York: Grossman, 1975.

Hendricks, G. *The Edison Motion Picture Myth.* Berkeley: University of California Press, 1961.

Henry, C. *Cercle chromatique.* Paris: Charles Verdin, 1888.

Henry, C. *Rapporteur esthétique.* Paris: Séguin, 1888.

Henry, C. *Eléments d'une théorie générale de la dynamogénie autrement dit du contraste, du rythme et de la mésure avec application spéciales aux sensations visuelle et auditive.* Paris: Charles Verdin, 1889.

Herbert, R. L., ed. *Modern Artists on Art.* Englewood Cliffs: Prenctice-Hall, 1964.

Hering, E. *Spatial Sense and Movements of the Eye.* Translated by A. Radde. Baltimore: American Academy of Optomology, 1942. (Originally published in German, 1861.)

Heron, W. "The Pathology of Bordom." *Scientific American* 196 (1957): 52–56.

Heron, W.; Doane, B. K.; and Scott, T. H. "Visual Disturbances after Prolonged Perceptual Isolation." *Canadian Journal of Psychology* 10 (1956): 13–18.

Herrnstein, R. J., and Boring, E. G. *A Source Book in the History of Psychology.* Cambridge, Mass.: Harvard University Press, 1965.

Hertel, E., ed. *Stilling's pseudo-isochromatische Tafeln zur Prüfung des Farbensinnes.* Leipzig: Thieme, 1926.

Hildebrand, A. *The Problem of Form in Painting and Sculpture.* New York: Garland, 1978 (first published 1893).

Hochberg, J. "In the Mind's Eye." In *Contemporary Theory and Research in Visual Perception,* edited by R. Haber. New York: Holt, Rinehart and Winston, 1968.

Hochberg, J. "Perception II. Space and Movement." In *Woodworth and Schlosberg's Experimental Psychology,* 3rd edition. Edited by J. W. Kling and L. A. Riggs. New York: Holt, Rinehart, and Winston, 1971.

Hochberg, J. E.; Triebel, W.; and Seaman, G. "Color Adaptation

under Conditions of Homogeneous Visual Stimulation (Ganzfeld)." *Journal of Experimental Psychology* 41 (1951): 153–59.

Holloway, J. H., and Weil, J. A. "A Conversation with Joseph Albers." *Leonardo* 3 (1970): 459–64.

Homer, W. I. *Seurat and the Science of Painting*. Cambridge, Mass.: MIT Press, 1964.

Homuch, P. Beiträge zur Kenntnis der Nachbilder scheinungen. I Teil; Langerdauernde Rezie: Das Abklingen der Farben, "Versuche, Geschichte, und Theorie." II Teil. *Archiv für die Gesamte Psychologie* 26 (1913): 181–238; 239–69.

Hoog, M. *Robert Delaunay*. Translated by A. Sachs. New York: Crown, 1976.

Howard, I. P., and Templeton, W. B. *Human Spatial Orientation*. New York: Wiley, 1966.

Hubel, D. H., and Weisel, T. N. "Receptive Fields, Binocular Interaction and Functional Architecture in the Cat's Visual Cortex." *Journal of Physiology* 160 (1962): 106–54.

Hubel, D. H., and Weisel, T. N. "Receptive Fields of Cells in Striate Cortex of Very Young, Visually Inexperienced Kittens." *Journal of Neurophysiology* 26 (1963): 994–1002.

Hubel, D. H., and Weisel, T. N. "Receptive Fields and Functional Architecture in Two Nonstriate Visual Areas (18 and 19) of the Cat." *Journal of Neurophysiology* 28 (1965): 229–89.

Hunter, S.; Krauss, R.; and Tucker, M. *Critical Perspectives in American Art*. Amherst, Mass.: Fine Arts Center Gallery, 1976.

Hurvich, L. M., and Jameson, D. "Opponent Processes as a Model

of Visual Organization." *American Psychologist* 64 (1957): 384–404.

Huysmans, J. L. "L'exposition des independents en 1880." In *L'art moderne.* Paris, 1883.

Ihde, A. J. *The Development of Modern Chemistry.* New York: Harper & Row, 1954.

Jaffe, H. L. *De Stijl: 1917–1931.* London: Thames and Hudson, 1970 (originally published 1959).

Judd, C. H., and Cowling, D. J. "Nonsense Figures Used to Study Memory for Shapes." *Psychological Monographs* 34 (1907): 349–69.

Julesz, B. *Foundations of Cyclopean Perception.* Chicago: University of Chicago Press, 1971.

Jung, R., and Spillman, L. "Receptive Field Estimation and Perceptual Integration in Human Vision." In *Early Experience and Visual Information Processing in Perceptual and Reading Disorders,* edited by F. A. Young and D. B. Lindsay. Washington, D.C.: National Academy of Sciences, 1970.

Kahn, R., ed. *Selected Writings of Hermann von Helmholtz.* Middletown, Conn.: Wesleyan University Press, 1971.

Kandinsky, W. *Der Blaue Reiter.* Munich: Piper-Verlag, 1912.

Kandinsky, W. *Über das Geistige in der Kunst.* Munich: Piper, 1912.

Kandinsky, W. *Concerning the Spiritual in Art.* Translation and introduction by M. T. H. Sadler. New York: Dover, 1977 (originally published 1912).

Kandinsky, W. *Rückblick 1901–1913.* Berlin: Der Sturm, 1913.

Kandinsky, W. *Punkt und Linie zu Fläche.* Munich: Langen, 1926.

Kandinsky, W. *Point and Line to Plane.* Translated by H. Dearstyne and H. Rebay; edited by H. Rebay. New York: Guggenheim, 1947 (originally published 1926).

Kandinsky, W. "Reminiscences." In *Modern Artists on Art,* edited by R. L. Herbert. Englewood Cliffs: Prentice-Hall, 1964.

Kandinsky, W., and Marc, F., eds. *Blaue Reiter Almanac,* new documentary edition by Klaus Lankheit. New York: Viking, 1974.

Kanizsa, G. "Subjective Contours." *Scientific American* 234 (1976): 48–52.

Kant, E. *Kant's Critique of Aesthetic Judgment.* Translated by J. C. Meredith. Oxford: Clarendon Press, 1911.

Karshan, D. *Malevich, the Graphic Work, 1918–1930.* Jerusalem: Israel Museum, 1975.

Kaufman, L. *Sight and Mind.* New York: Oxford, 1974.

Kirschmann, A. "Über die Erkennbarkeit geometrischer Figuren and Schriftzeichen im indirekten Sehen." *Archiv für Gesamte Psychologie* 13 (1908): 352–88.

Klaaren, E. M. *Religious Origins of Modern Science.* Grand Rapids, Mich.: Eerdmans, 1977.

Klee, P. *The Thinking Eye: Paul Klee Notebooks, Vol. 1,* edited by J. Spiller; translated by R. Manheim. New York: Wittenborn, 1961.

Klee, P. *The Nature of Nature. Paul Klee Notebooks, Vol. 2,* edited by J. Spiller; translated by R. Norden. New York: Wittenborn, 1972.

Kleine, M. *Mathematics in Western Culture.* New York: Oxford, 1953.

Koffka, K. *Principles of Gestalt Psychology.* New York: Harcourt, Brace, and World, 1935.

Kohler, W. *Die Physichen Gestalten in Ruhe und im Stationaren Zustand.* Erlangen: Philosophische Akademie, 1920. Reprinted in English as Physical Gestalten. In *A Source Book of Gestalt Psychology,* edited by W. D. Ellis. New York: Humanities Press, 1950.

Kohler, W. *Gestalt Psychology.* New York: Horace Liveright, 1929.

Kramer, H. "Realism: 'The painting is fiction enough'." *New York Times,* April 28, 1974, section 2, p. 19.

Krauss, P. *Grids: Format and Image in 20th-Century Art.* New York: Pace Gallery, 1979.

Kudielka, R. B. *Bridget Riley: Works 1959–1978.* London: British Council, 1978.

Kuffler, S. W. "Discharge Patterns and Functional Organization of Mammalian Retina." *Journal of Neurophysiology* 16 (1953): 37–68.

Kuh, K. *Break-up: The Core of Modern Art.* Greenwich, Conn.: New York Graphics Society, 1965.

Lane, J. R. *Stuart Davis: Art and Art Theory.* Brooklyn, N.Y.: Brooklyn Museum, 1978.

van Laue, M. *History of Physics.* Translated by R. Oesper. New York: Academic Press, 1950.

Lee, A. "A Critical Account of Some of Joseph Albers' Concepts of Color." *Leonardo* 14 (1981): 99–105.

Lettvin, J. Y.; Maturana, H. R.; McCulloch, W. S.; and Pitts,

W. H. "What the Frog's Eye Tells the Frog's Brain." *Proceedings of the Institute of Radio Engineers* 47 (1959): 1940–51.

LeWitt, S. *Location of Lines.* London: Lisson Gallery, 1974.

LeWitt, S. *Modular Drawings.* Geneva: Adelina von Furstenberg, 1976.

Leymaire, J. *Impressionism: A Biographical and Critical Study.* Translated by J. Emmons. Paris: Skira, 1955.

Lindemann, E. "Beiträge zur Psychologie der Gestalt." *Psychologische Forschung* 2 (1922): 5–60.

Lipman, J., and Marshall, R. *Art about Art.* New York: Dutton with the Whitney Museum, 1978.

Lipps, T. "Raumästhetik und Geometrische-Optische Täuschungen." *Schriften der Gesellschaft für Psychologie Forschung* (Heft 9/10), 1897; also published as book. Leipzig: Barth, 1893–1897.

Lipps, T. "Zu den 'Gestaltqualitäten'." *Zeitschrift für Psychologie* 22 (1900): 383–85.

Lipps, T. "Ästhetik." In *Systematische Philosophie,* edited by W. Dilthey, et al. Berlin: Teubner, 1907.

Lipps, T. *Ästhetik.* Hamburg and Leipzig: Voss, 1903 (vol. 1), 1906 (vol. 2).

Lisson Gallery Catalog. New York and London: Lisson Gallery, 1977.

Loran, E. *Cézanne's Composition.* Berkeley: University of California Press, 1943.

Lovejoy, A. O. *The Great Chain of Being.* New York: Harper & Row, 1960 (originally published 1936).

Lucie-Smith, E. *Symbolist Art.* New York: Praeger, 1972.

Lunde, K. *Anuskiewicz.* New York: Abrams, 1977.

MacKay, D. M. "Moving Visual Images Produced by Regular Stationary Patterns." *Nature* 180 (1957): 849–50.

MacLachlan, H. *The Religious Opinions of Milton, Locke, and Newton.* Folcroft: Folcroft Press, 1970.

Mach, E. *Beiträge zur Analyze der Empfindungen.* Jena: Fischer, 1886.

Mach, E. *Contributions to the Analysis of Sensations.* Translated by C. M. Williams and S. Waterloo. Chicago: Open Court, 1914 (first published in English in 1897).

Malevich, K. *The Non-Objective World.* Translated by H. Dearstyne, introduction by L. Hilberseimer. Chicago: Theobald, 1959 (originally published in German, Munich: Langen, 1927).

Manuel, F. E. *Isaac Newton, Historian.* Cambridge, Mass.: Harvard University Press, 1973.

Marey, E. J. *Animal Mechanism: A Treatise on Terrestrial and Aerial Locomotion.* London: King, 1874.

Marey, E. J. "Photography of Moving Objects and the Study of Animal Movement by Chronophotography." *Scientific American Supplement,* February 5 and 12, 1887.

Marey, E. J. "Decomposition of the Phases of a Motion by Means of Successive Photographic Images Received on a Strip of Sensitive Paper." *Wilson's Photographic Magazine,* January 5, 1889.

Marey, E. J. "The History of Chronophotography." *Smithsonian Institution Annual Report,* 1901, pp. 317–41.

Matthaei, R. *Das Gestalt Problem*. Munich: Bergmann, 1929.

Matthaei, R., ed. *Goethe's Color Theory*. New York: Van Nostrand, 1970.

Mauner, G. *Manet: A Study of the Painter's Themes*. University Park, Pa.: Penn State University Press, 1975.

McBurney, D. H., and Collings, V. B. *Introduction to Sensation Perception*. Englewood Cliffs: Prentice-Hall, 1977.

McCollough, C. "Color Adaptation of Edge-Detectors in the Human Visual System." *Science* 149 (1965): 1115–16.

Metelli, F. "The Perception of Transparency." *Scientific American* 230 (1974): 91–98.

Metzger, W. "Optische Untersuchungen und Ganzfeld: II. Zur phänomenologie des homogenen Ganzfelds." *Psychologische Forschung* 13 (1930): 6–29.

Metzger, W. "Beobachtungen über phänomenale Identität." *Psychologische Forschung* 19 (1934): 1–60.

Miller, G. *California White Walls*. Private printing, 1974.

Mladek, M., and Rowell, M. *Frantisek Kupka: A Retrospective*. New York: Solomon R. Guggenheim Museum, 1975.

Mondrian, P. *Plastic Art and Pure Plastic Art*. New York, 1945.

Morellet. Exhibition catalog. Introduction by M. Moutashar. Arles, France: Salle romances du cloître Saint-trophime, 1978.

Mozley, A. V.; Haas, R. B.; and Forster-Hahn, F. *Eadweard Muybridge: The Stanford years, 1872–1882*. Exhibition catalog. Palo Alto: Art Department, Stanford University, 1972.

Mozley, A. V., and Porter, J. S. "Documents." In *Eadweard Muy-

bridge: The Stanford Years, 1872–1882. Palo Alto: Art Department, Stanford University, 1972.

Musatti, C. L. "Sui fenomeni stereokinetici." *Archivio Italiano di Psicologia* 3 (1924): 105–20. ("Stereokinetic phenomena." Translated by H. R. Flock and C. Bartoli.) Ithaca: Cornell University Department of Psychology, 1962.

Naaman, Y. *Les lettres d'Egypte de Gustave Flaubert.* Paris: Nizet, 1963.

Necker, L. A. "Observations on . . . an optical phenomenon which occurs on viewing a figure of a crystal or geometrical solid." *Philosophical Magazine* 1 (1832): 329–37, 3rd series.

Needham, G. "Manet's Olympia, and Pornographic Photography." In *Woman as Sex Object,* edited by T. Hess and L. Nochlin. New York: Newsweek, 1972.

Newhall, B. *The History of Photography.* New York: Museum of Modern Art, 1949.

Newton, I. *Observations upon the Prophecies of Daniel and the Apocalypse of John.* London: Darby and Browne, 1733.

Nichols, E. L. "Biographical Memoir of Ogden Nicholas Rood (1831–1902)." *National Academy of Science Bibliographical Memoirs,* vol. 6. Washington, D.C.: 1909.

Nodine, C. F. and Fisher, D. F., eds. *Perception and Pictorial Representation.* New York: Praeger, 1979.

Noll, A. M. "Human or Machine: A Subjective Comparison of Piet Mondrian's *Composition with Lines* (1917) and a Computer-Generated Picture." *Psychological Record* 16 (1966): 1–10.

Nordenskiold, E. *The History of Biology.* New York: Knopf, 1928.

Olson, R. K., and Attneave, F. "What Variables Produce Similarity Grouping." *The American Journal of Psychology* 83 (1970): 1–21.

Orbach, J.; Ehrlich, D.; and Vainstein, E. "Reversibility of the Necker Cube: III. Effects of Interpolation on Reversal Rate of the Cube Presented Repetitively." *Perceptual and Motor Skills* 17 (1963): 571–82.

Ostwald, W. *Die Farbenfibel*. Leipzig: Unesma, 1917.

Ostwald, W. *Colour Science*. Translated by J. S. Taylor. London: Winsor and Newton, 1933.

Otis, M. "Aesthetic Unity." *American Journal of Psychology* 29 (1918): 291–315.

Overy, P. *Kandinsky: The Language of the Eye*. London & New York: Elek and Praeger, 1969.

Painting of the Bauhaus. Exhibition catalog. London: Marlborough Gallery, 1962.

Partington, J. R. *A History of Chemistry,* vol. 4. London: Mac-Millan, 1964.

Pearson, K. *The Grammar of Science*. London: Walter Scott, 1892.

Penrose, L. S., and Penrose, R. "Impossible Objects: A Special Type of Illusion." *British Journal of Psychology* 49 (1958): 31.

Perruchet, H. *Manet*. Cleveland: World, 1962.

Perry, L. C. "Reminiscences of Claude Monet from 1889 to 1901." *The American Magazine of Art* 18 (1927): 119–25.

Pirenne, M. H. *Optics, Painting, and Philosophy*. Cambridge: Cambridge University Press, 1970.

Pissarro, C. *Camille Pissarro: Letters to His Son.* Edited by J. Rewald; translated by L. Abel. New York: Pantheon, 1943.

Plateau, J. "Quatrième nôte sur des nouvelles applications curieuses de la persistance des impressions de la retine." *Bulletin Academie Science Belgique* 16 (1850): 254–60.

Poling, C. V. *Bauhaus Color.* Atlanta: High Museum of Art, 1975.

Pope, A. *An Introduction to the Language of Drawing and Painting* (revised edition). Cambridge, Mass.: Harvard University Press, 1949. (First published 1929.)

Prinet, J. and Dilassu, A. *Nadar.* Paris: Armand Colin, 1966.

Pritchard, R. M. "Stabilized Images on the Retina." *Scientific American* 204 (1961): 72–77.

Purkinje, J. *Beobachtungen und Versuche zur Physiologie der Sinne. Beiträge zur Kenntniss des Sehens in subjectiver Hinsicht.* Prague: Calve, 1823.

Rand, B., ed. *The Classical Psychologists.* Boston: Houghton-Mifflin, 1912.

Ratliff, F. *Mach Bands: Quantitative Studies on Neural Networks in the Retina.* San Francisco: Holden-Day, 1965.

Ratliff, F. "On Mach's Contributions to the Origins of Sensations." In Ernest Mach, physicist and philosopher, *Boston Studies in the Philosophy of Science* 6 (1970): 23–41.

Ratliff, F. "Contour and Contrast." *Proceedings of the American Philosophical Society* 115 (1971): 150–63.

Ratliff, F. "On the Psychophysiological Bases of Universal Color Terms." *Proceedings of the American Philosophcial Society* 120 (1976): 311–30.

Read, H. *The Philosophy of Modern Art*. London: Faber and Faber, 1952.

Reff, T. *Manet: Olympia*. New York: Viking, 1976.

Rewald, J. *Georges Seurat*. New York: Wittenborn, 1946.

Rewald, J. *The History of Impressionism*. New York: Museum of Modern Art, 1961.

Richardson, B. *Mel Bochner: Number and Shape*. Baltimore: Baltimore Museum of Art, 1976.

Richardson, J. *Edouard Manet, Paintings and Drawings*. London: Phaidon, 1958.

Richardson, J. A. *Modern Art and Scientific Thought*. Urbana: University of Illinois, 1971.

Richter, P. E., ed. *Perspectives in Aesthetics*. New York: Odyssey, 1967.

Robbe-Grillet, A. *Jealousy*. In *Two Novels by Robbe-Grillet*. Translated by R. Howard. New York: Grove, 1965.

Rood, O. N. "On the Relation between Our Perception of Distance and Color." *American Journal of Science* 32, no. 95, second series (September 1861): 184–85. (Also listed as *Silliman's Journal*.)

Rood, O. N. *Modern Chromatics, with Applications to Art and Industry*. New York: Appleton, 1879. (Later versions often called *The Student's Handbook of Color*.)

Rood, O. N. *Théorie Scientifique des Couleurs*. Paris: Baillière, 1881. (French translation of Rood, 1879.)

Rose, B. "ABC Art." *Art in America,* October–November 1965.

Reprinted in G. Battcock, ed. *Minimal Art: A Critical Anthology*. New York: Dutton, 1968.

Rose, B. "Interview with Jack Youngerman." *Art Forum,* January 1966, pp. 27–30.

Rose, B. Wolfeburg. *The New York Review of Books,* June 26, 1975, pp. 26–28.

Rose, B., ed. *Art and Art: The Selected Writings of Ad Reinhardt.* New York: Viking, 1975.

Rosenberg, H. *Artworks and Packages.* New York: Dell, 1969.

Rosenberg, P. Preface in *French Painting 1774–1830: The Age of Revolution.* Detroit: Detroit Institute of Arts and Metropolitan Museum of Art, 1975.

Rosenblum, R. *Modern Painting and Northern Romantic Tradition.* New York: Harper & Row, 1975.

Rosenblum, R. *Cubism and Twentieth Century Art.* Englewood Cliffs: Prenctice-Hall, 1976.

Rousset, J. "*Madame Bovary* or the Book about Nothing." In *Flaubert: A Collection of Critical Essays,* edited by R. Giraud. Englewood Cliffs: Prentice-Hall, 1964.

Rubin, E. *Synsoplevede Figurer.* Copenhagen: Gyldendalske, 1915.

Rubin, E. *Visuell wahrgenomene Figuren.* Copenhagen: Gyldendalske, 1921. (Originally published in Danish, 1915.)

Russell, J. *Seurat.* New York: Praeger, 1965.

Russell, J. "Review of *The Painted Word*." *New York Times Book Review,* June 15, 1975, pp. 4–5.

Sandblad, N. G. *Manet: Three Studies in Artistic Conception.* Translated by Walter Nash. Lund, Sweden: New Society of Letters at Lund, 1954.

Sander, F. "Elementar-aesthetische Wirkungen zusammengesetzten geometrische Figuren." *Psychologische Studien* 9 (1914): 1–34.

de Sausmarez, M. *Bridget Riley.* Greenwich, Conn.: New York Graphic Society, 1970.

Schapiro, M. *Vincent van Gogh.* New York: Abrams, 1950.

Schapiro, M. *Paul Cézanne.* New York: Abrams, 1952.

Schapiro, M. *Modern Art: 19th and 20th Centuries.* New York: George Braziller, 1978.

Scharf, A. *Art and Photography.* London: Pelican Books, 1974.

Schiffman, H. R. *Sensation and Perception.* New York: Wiley, 1982.

Schoenmaekers, M. H. J. *Het Nieuwe Wereldbeeld* [The New World Image]. Bossum: C. A. V. van Dishoeck, 1915.

Schoenmaekers, M. H. J. *Beginselen der Beeldende Wiskunde* [The Foundations of Plastic Mathematics]. Bossum: C. A. V. van Dishoeck, 1916.

Schouten, J. F. "Subjective Stroboscopy and a Model of Visual Movement Detectors." In *Models for the Perception of Speech and Visual Form,* edited by W. Wathen-Dunn. Cambridge, Mass.: MIT Press, 1967.

Schneider, P. *The World of Manet 1832–1883.* New York: Time-Life, 1968.

Schumann, F. "Beiträge zur Analyse der Gesichtswahrnehmungen. I." *Zeitschrift für Psychologie* 23 (1900): 1–32; II. Ibid. 24

(1900): 1–33; III. Ibid. 30 (1902): 241–91; IV. Ibid. 36 (1904): 161–85.

Schwarz, A. *Marcel Duchamp.* New York: Harry N. Abrams, 1975.

Seitz, W. C. *Claude Monet.* New York: Museum of Modern Art, 1960.

Seitz, W. C. *The Responsive Eye.* New York: Museum of Modern Art, 1965.

Sekuler, R., and Levinson, E. "The Perception of Moving Targets." *Scientific American* 236 (1977): 60–64, 70–73.

Selz, P. "The Aesthetic Theories of Wassily Kandinsky and Their Relationship to the Origin of Non-Objective Painting." *Art Bulletin* 39 1957: 127–36.

Seuphor, M. *Piet Mondrian: Life and Work.* New York: Abrams, 1956.

Sklar, R. *The Movie-Made American: A Social History of American Movies.* New York: Random House, 1975.

Signac, P. *D'Eugéne Delacroix au neo-impressionisme.* Paris: Revue Blanche, 1899.

Soby, J. T. *Arp.* New York: Museum of Modern Art, 1958.

Spiegel, A. *Fiction and the Camera Eye.* Charlottesville: University of Virginia Press, 1976.

Steegmuller, F. *Flaubert in Egypt.* London: Bodley Head, 1972.

Steinberg, L. *Other Criteria.* New York: Oxford, 1972.

Stilling, J. *Die Prüfung des Farbensinnes beim Eisenbahn und Marinepersonal.* (zweite Auflage) Cassel: Fischer, 1877.

Stilling, J. *Über das Sehen der Farbenblinden*. Cassel: Fischer, 1880.

Stout, G. F. *Analytic Psychology*. London: Swan Sonnenschein, 1902.

Sutter, D. "Les phénomènes de la vision." *L'Art* 1 (1880): 74–76, 124–28, 147–49, 195–97, 216–20, 268–69.

Sweeney, J. J. "Eleven Europeans in America." *Bulletin of the Museum of Modern Art* 13 (1946): 19–21.

Teuber, M. L. "Sources of Ambiguity in the Prints of Maurits D. Escher." *Scientific American* 231 (1974): 90–104.

Teuber, M. L. "Blue Night by Paul Klee." In *Vision and Artifact,* edited by M. Henle. New York: Springer, 1976.

The Pressure to Paint. Exhibition catalog. New York: Marlborough Gallery, 1982.

Thomson, S. P. "Optical Illusions of Motion." *Brain* 3 (1880): 289–98. (Reprinted in *Popular Science Monthly* 18 (1881): 519–26.

Titchener, E. B. *An Outline of Psychology*. New York: Macmillan, 1896.

Trapp, F. A. "The Art of Delacroix and the Camera's Eye." *Apollo* 73 (1966): 278–88.

Tucker, M. *Al Held*. New York: Whitney Museum, 1974.

Uttal, W. R. *The Psychobiology of Sensory Coding*. New York: Harper & Row, 1973.

Vachtova, L. *Frank Kupka*. New York: McGraw-Hill, 1965.

Vanderplas, J. M., and Garvin, E. A. "The Association Value of Random Shapes." *Journal of Experimental Psychology* 57 (1959): 147–54.

Venturi, L. *History of Art Criticism*. New York: Dutton, 1964 (originally published 1936).

Venturi, M. *L'opera pittorica di Edouard Manet*. Milan: Rizzoli, 1967.

Vischer, R. *Über das optische Formgefühl*. Stuttgart: Galler, 1873.

Vitali, L. *Nadar*. Turin: Guilio Einaudi, 1973.

Vitz, P. C. "Preference for Different Amounts of Visual Complexity." *Behavioral Science* 2 (1966): 105–14.

Vitz, P. C. "Visual Science and Modernist Art: Historical Parallels." In *Perception and Pictorial Representation,* edited by C. F. Nodine and D. F. Fisher. New York: Praeger, 1979.

Vitz, P. C., and Todd, T. C. "A Model of Perception of Simple Geometric Forms." *Psychological Review* 78 (1971): 207–28.

Vrisen, G., and Imdahl, M. *Robert Delaunay: Light and Color*. New York: Abrams, 1967.

Wade, N. "Op Art and Visual Perception." *Perception* 7 (1978): 21–46.

Wallach, H., and O'Connell, D. W. "The Kinetic Depth Effect." *Journal of Experimental Psychology* 45 (1953): 205–17.

Ward, J. L. "A Reexamination of van Gogh's Pictorial Space." *Art Bulletin* 58 (1976): 593–604.

Ward, J. L. Letter to editor. *Art Bulletin* 59 (1977): 465.

Wechsler, J., ed. *Cézanne in Perspective*. Englewood: Prentice-Hall, 1975.

Wertheimer, M. "Untersuchungen zur Lehre von der Gestalt. I." *Psychologische Forschung* 1 (1922): 47–58; II. Ibid. 4 (1923): 301–50. In English as "Laws of Organization in Perceptual

Forms." In *A Source Book of Gestalt Psychology,* edited by W. D. Ellis. New York: Humanities Press, 1950.

Wertheimer, M. "Über Gestalt Theorie." *Symposium* 1 (1925): 39–60. In English as "Gestalt Theory." In *A Source Book of Gestalt Psychology,* edited by W. D. Ellis. New York: Humanities Press, 1950.

Wheatstone, C. "Contributions to the Physiology of Vision. Part the first. On some remarkable, and hitherto unobserved, phenomena of binocular vision." *Philosophical Transactions* 128, Royal Society of London, 1838, pp. 371–94.

Whitehead, A. N. *Science and the Modern World.* New York: Macmillan, 1925.

Whyte, L. L. *The Unconscious before Freud.* New York: Doubleday, 1962 (originally published 1960).

Wiesel, T. N., and Hubel, D. H. "Spatial and Chromatic Interactions in Lateral Geniculate Body of the Rhesus Monkey." *Journal of Neurophysiology* 29 (1966): 1115–56.

Wijsenbeek, L. J. F. *Piet Mondrian.* Greenwich, Conn.: New York Graphic Society, 1968.

Wolfe, T. *The Painted Word.* New York: Farrar, Straus and Giroux, 1975.

Woodworth, R. S. *Experimental Psychology.* New York: Holt, 1938.

Worringer, W. *Abstraction and Empathy.* Translated by Michael Bullock. London: Routledge and Kegan Paul, 1953 (originally published 1918).

Wulf, F. "Über die Veränderung von Vorstellungen." *Psychologische Forschung* 1 (1922): 333–73.

Wundt, W. "Zur theorie der raumlichen Gesichtswahrnehmungen." *Philosophische Studien* 14 (1898): 1–118.

Yarbus, D. L. *Eye Movement and Vision*. New York: Plenum, 1967.

Youngerman at Pace. Exhibition catalog. New York: Pace Gallery, 1971.

Zusne, L. *Visual Perception of Form*. New York: Academic Press, 1970.

Index

Naaman, A., 267

Nadar, 46, 50, 53, 57–59, 62, 269, 271–72

Nash, W., 271

Neil, 201

Necker, L., 311

Needham, G., 52–53, 110, 270, 290

Nègre, E., 63, 65, 272

Neoimpressionism, 23–24, 37, 81, 83, 85, 90–91, 97, 281, 283

Neuman, E., 301

Newman, B., 217–18

Newton, I., 25–27, 97–98, 265, 275

Nichols, E., 268

Nochlin, L., 270, 290

Nodine, C., 264, 316

Noland, K., 193–94, 217–18, 311

Noll, A., 312

Norden, H., 301, 310

Nordenskiold, E., 265

O'Connell, D., 308

Oesper, R., 265

Ogilvie, S., 294

Ohrbach, 227–28

Olson, 183, 185, 187, 191, 193

Orienti, S., 272

Orphism, 284

Ostwald, W., 101–2, 104, 288

Otis, M., 299

Overy, P., 284, 305

Pach, W., 264, 277

Parham, L., 312

Partington, J., 265–66

Pasteur, L., 23

Pearson, K., 134–35, 295

Penrose, L., 203, 309

Perruchet, H., 272

Perry, L., 273

Picabia, 205, 208

Picasso, P., 6, 19, 33, 112, 123–24, 126, 131, 136, 139, 141, 149–50, 152, 162–63, 249, 257, 311

Pierce, 155, 198, 299

Pirenne, M., 278

Pissarro, C., 76, 78, 105, 277, 307

Pissarro, L., 289

Pitts, W., 307

Plateau, J., 115–16, 196, 293, 307–8

Poe, E. A., 54, 56–57, 271

Poincaré, H., 297

Pointillism, 20, 81–83, 89–90, 97, 191, 255, 287

Poling, C., 102, 286–88, 301–2

Pollock, J., 4, 230, 233, 239–40

Poons, L., 189

Pope, Alexander, 13

Pope, Arthur, 104

Porter, J., 292–93

Pre-Raphaelites, 1n

Priestly, 29

Prinet, J., 272

Pritchard, R., 183, 305

Purkinje, J., 198, 286, 308

Radde, A., 291

Rand, B., 279

Ratliff, F., 87, 279–80, 287

Rauschenberg, R., 313

Read, H., 126, 294

Rebay, H., 302

Redon, 89

Reff, T., 48, 53, 269–70

Regnault, H., 270

Reinhardt, A., 4, 42, 241, 244, 248, 314

Rembrandt, 12